REFLECTIONS IN BLACK

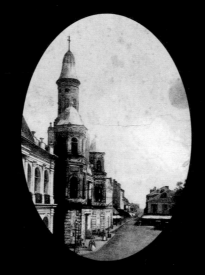

A HISTORY OF
BLACK
PHOTOGRAPHERS
1840 TO THE PRESENT

Deborah Willis

W · W · Norton & Company · New York · London

The text of this book is composed in Filosofia,
with the display set in Oneioda
Composition by Allentown Digital Services
Manufactured by Arnoldo Mondadori Editore, Verona
Book design by Antonina Krass
Page makeup by Carole Desnoes

Library of Congress Cataloging-in-Publication Data
 Willis, Deborah, 1948–
 Reflections in Black : a history of Black photographers, 1840–1999 / Deborah Willis.
 Includes bibliographical references and index.
 ISBN 0-393-04880-2
 1. Photography—United States—History—19th century. 2. Photography—United
States—History—20th century. 3. Afro-American photographers—History—19th century.
4. Afro-American photographers—History—20th century. 5. Afro-Americans in art. I.
Title.
 TR23 .W55 2000
 770'.8996'073—dc21

 99-055185

W. W. Norton & Company, Inc., 500 Fifth Avenue, New York, NY 10110
www.wwnorton.com

W. W. Norton & Company Ltd., 10 Coptic Street, London WC1A 1PU
1 2 3 4 5 6 7 8 9 0

CONTENTS

for Winston and Hank

FOREWORD

by Robin D. G. Kelley

If a picture truly is worth a thousand words, then Deborah Willis has given us nothing less than an epic history of Homeric proportions. Taken together, Willis's magnificent gathering of images accompanied by her powerful narrative overturns many common ideas about black life during the last century and a half, and in so doing rewrites American history. Indeed, the photographers discussed herein may be our most important historians, high-tech griots with the unique power to shape collective memory. Like all griots, they were also poets whose rare ability to "see" what the rest of us cannot enabled them to create forceful, visionary imagery comparable to the great works of a Paul Laurence Dunbar, a Langston Hughes, a Sonia Sanchez, or a Gwendolyn Brooks. And like all poets, they were—and continue to be—genuine artists who not only tried to capture an authentic reality but created what we'd never seen. Light was their medium, the camera their pencil or paintbrush—or, more fittingly, their wand or bag of tricks, for are not all true artists alchemists, magicians, shamans who perform miracles?

In a time when the deliberate distortion of black images in popular culture was as common as ice vendors in turn-of-the-century cities in August, the camera became a mighty weapon in the hands of pioneering black photographers. The same photographic technology responsible for the circulation of minstrel caricatures, of dim-witted watermelon-eating Negroes, of alleged African cannibals, of happy-go-lucky darkies whose lives revolved around dice and razors, was used to create counterimages of African-American life—images of dignity, pride, success, and beauty. A wide array of figures such as James Presley Ball and Augustus Washington of the nineteenth century, and Robert McNeill and Chuck Stewart of the twentieth, wielded their cameras against the Goliath of white supremacy.

PHOTOGRAPHER:
J.P. (JAMES PRESLEY) BALL & SON

ix

Some of these artists fought back by creating respectable and dignified images of black folk; others caught the viciousness and drama of racism through depictions of violent acts or by documenting inequality.

Black photographers waged war, to be sure, but this is only part of the story. Most of the men and women responsible for visually documenting black America were not simply obsessed with race. As modern visual poets, they were equally concerned with locating and reproducing the beauty and fragility of the race, the ironic humor of everyday life, the dream life of a people. Whether through portraiture or impromptu "street" shots, black photographers sought to capture something deeper than victimization, more complex than a heroic rebellion against the Man. And they found it: the interior life of Black America, the world either hidden from public view or forced into oblivion by the constant flood of stereotypes.

That black photographers were not obsessed with race and racism should not surprise us. After all, the people depicted in these photographs were not obsessed with race either. One might even argue that the subjects contributed as much to the shaping of a black collective photographic document as the men and women who snapped the shutters. Although racism certainly circumscribed their lives, their interior world was far more meaningful to them than the rantings of a white-robed Grand Wizard or the visible signs of Jim Crow. Study these photographs and you'll discover in the gaze and gestures of ordinary African-Americans a complex and diverse community too busy loving, marrying, dancing, worshiping, dreaming, laughing, arguing, playing, working, dressing up, looking cool, raising children, organizing, performing magic, making poetry to be worried about what white folks thought about them. And a new generation of contemporary photographers has dug even deeper into the interior—into the realm of sexuality, into the world of secrets and dirty laundry—exploring complex issues that trouble any easy definitions of blackness or black desire.

Finally, just as black photographers and their subjects have rewritten American history, Deborah Willis rewrites the history of American photography by demonstrating that the descendants of slaves were among the genre's chief innovators. Of course, here you will find the familiar masters of light and shadow—James VanDerZee, Gordon Parks, Roy DeCarava, Carrie Mae Weems, Lorna Simpson, Dawoud Bey, and others. But Willis performs a greater service by unearthing dozens upon dozens of unknown or little-known black photographers: the anonymous photojournalists, the men and women who maintained studios in black neighborhoods across the country, the up-and-coming artists using technology in new ways. Black photographers pioneered in the development of daguerreotype, contributed to the "pictorial aesthetic" dominant during the early twentieth century, breathed new life into urban realism, and through college programs and apprenticeships kept traditions of black photography alive by training new generations to take up the camera.

Twenty-five years in the making, Deborah Willis's majestic *Reflections in Black*

PHOTOGRAPHER: P. (PRENTICE) H. POLK

PHOTOGRAPHER: ADDISON N. SCURLOCK

is a scenic journey into the heart of America, into a world of immense complexity and diversity, fiction and reality, triumph and tragedy, a world of shadow and light as seen by black eyes, mediated by viewfinders, lenses, and the prism of history. It is not an easy journey, but one well worth taking if you want to know America. And if you travel through these pages with your eyes wide open, you will quickly discover that, as novelist Richard Wright once put it, "our history is far stranger than you suspect, and we are not what we seem."

ACKNOWLEDGMENTS

Since 1969, I have made images and have written about photography, specifically African-American photographers. As a young girl, I often took snapshots of family members, and the very event of placing these images in family albums became cause for discussion, interpretation, and examination. These family photographs remained important to me as I pursued photography professionally, and the images took on an iconic and folkloric meaning, visually telling stories about my personal life as well as the shared histories of African-American peoples. Inspired by these family stories, I feel as if I have always been reworking and revising the past as I scrutinized the photographic history of images of African-Americans my entire professional life.

I began my formal studies on American photographers and images of African-Americans, as an undergraduate at the Philadelphia College of Art. My interest broadened considerably in 1980 when I was appointed the head of the photographic archives at the New York Public Library's Schomburg Center for Research in Black Culture. In 1994, I became a curator at the Smithsonian Institution's Center for African American History and Culture and extended my studies into the African diaspora. The initial idea for this project was an outgrowth of the many book projects and exhibitions I have undertaken over the past twenty years on the varying themes relating to black people and the African migration. This, my final volume on African-American photography, owes its existence to a number of important people in my life—family members, friends, and teachers. Because of their continued support and belief in my work, I was able to sustain the inspiration necessary for completing this project. I am also grateful to the many individuals and institutions that helped me throughout the years. As with any project of this scope, a few photographers are regrettably

missing from this volume. A few have chosen not to be included, a decision I respected, although I lament their absence; several others did not respond to my request. I am, however, gratified by the incredible body of work represented and am proud that the great majority of the photographers included here are internationally known. Such recognition did not exist when I began my studies.

I wish to thank all of these photographers, and I offer the following list with apologies to anyone I have neglected to mention; please note that your generosity remains in my heart. First, I thank my editor, Bob Weil; agent and friend, Faith Childs; and at Norton Tom Bissell, Toni Krass, Neil Giordano, Debra Morton-Hoyt, and Joe Crawford, whose memory continues to guide me through the process of writing about black photographers. I am humbled by the support I received from all of the photographers I contacted: I thank all of you most sincerely. I also wish to thank the staffs of the museums, libraries, and historical societies, particularly the St. Louis Museum of Art; Haverford College; the Museum of Fine Arts, Houston; the University of Maryland, Baltimore County; the Smithsonian Institution's National Portrait Gallery; Patricia Brady and the Historic New Orleans Collection; the Library of Congress, Prints and Photographs Division, and especially Verna Curtis, Beverly Brannan, and Maricia Battle; Delores Morrow at the Photograph Archives in the Montana Historical Society; Therese Mulligan of the George Eastman House; John Jezierski at Saginaw Valley State University; Bonnie Wilson at the Minnesota Historical Society; my former colleagues and the entire staff of the New York Public Library's Schomburg Center for Research in Black Culture; Donna Wells at Howard University's Moorland-Spingarn Research Center; David Haberstitch, photo curator of the Archives Center at the National Museum of American History, Smithsonian Institution; Arthé A. Anthony at Occidental College; Chandra Harrington at the Museum of Afro American History; Philip Brookman at the Corcoran Gallery of Art; Laura Lakeway at Panopticon, Inc.; Terrie Rouse and Aileen S. Rosenberg at the African American Museum in Philadelphia; Susan Knoer at the Ekstrom Library, University of Louisville; Teresa Roane at the Valentine Museum; Samuel W. Black and Ann Sindelar at the Western Reserve Historical Society Library; Page Edwards, Jr., at the St. Augustine Historical Society; Sharon E. Robinson and Dr. Constance J. Carter at the Auburn Avenue Research Center, Atlanta-Fulton Public Library System; Honore Ervin at the Carnegie Museum of Art; Charles L. Blockson, the Charles L. Blockson Afro-American Collection, Temple University; Marci Brennan and Taj Johnson of Corbis-Bettman; Susan Cahan of the Peter and Eileen Norton Foundation; Herman "Skip" Mason, Jr., of Digging It Up, Inc.; Jeff Hoone at Light Works; Roland Charles of the black gallery of California; P. Celina Lunsford of the estate of Vincent Alan W; Michael and Erica Cryor of the estate of Cary Beth Cryor; Vivian Patterson at the Williams College Museum of Art; Claude L. Elliott at the Rhode Island School of Design Museum; Deslyn Downes at the Louis Armstrong House & Archives, Queens College; Alma D. Williams at the Hogan Jazz Archive, Howard-Tilton Memorial Library, Tulane

University; the Amistad Foundation at the Wadsworth Atheneum; Alan Govenar of Documentary Arts, Inc.; Giroud Mouton; Eric Waters; Paul R. Jones; Donna Mussenden VanDerZee; David G. Berger, and Milt and Mona Hinton of the Milton J. Hinton Photographic Collection; and Edwina Harleston Whitlock of Atlanta, Georgia.

Several friends and colleagues read drafts, offered encouragement, and helped in various ways. They include: Jane Lusaka, Carla Williams, Derrick Beard, Shirley Solomon, Sharon Howard, Melissa Rachleff, Cheryl Finley, Kellie Jones, Leslie King Hammond, Lowery Stokes Sims, Renata Bettencourt, Robert H. McNeill, Chester Higgins, Jr., Cheryl Younger, Chuck Stewart, Robert L. Haggins, Marvin Smith, Mrs. Monica Smith, Bobby Sengstacke, C. Daniel Dawson, Clarissa Sligh, Jeffrey and Meg Scales, Kathe Sandler, Lou Jones, Mei-Tei Sing Smith, Thomas and Lyle Harris, Roshini Kempadoo, Lorna Simpson, Albert Chong, Coreen Simpson, Jeanne Moutoussamy-Ashe, Stephen DeWindt, Francille Wilson, Sharon Harley, Carrie Mae Weems, Dawoud Bey, and Sharon Watson-Mauro.

In addition, I would like to acknowledge my professors, colleagues, and mentors over the years, especially Anne Wilkes Tucker, David C. Driskell, Lawrence W. Levine, Zofia Burr, Jeffrey Stewart, Steven C. Newsome, Claudine K. Brown, Shireen Dodson, Diana Lachatanere, Catherine J. Lenix-Hooker, Mark Wright, Deirdre Cross, Portia James, and Jennifer Morris.

Finally, I thank my family for allowing me to lean on them: my husband, Winston Kennedy, and son, Hank; my mother, Ruth Willis, and my sisters, Yvonne, Eleanor, Melvina, and Leslie; my nephew and nieces, Songha, Caran, Mecca, Medea, and Kalia.

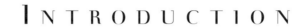

INTRODUCTION

Photographers played an integral role in how blacks visualized themselves. . . .
Photographs provided accessible imagery for virtually all levels of the community.
Photographers . . . were therefore natural witnesses to an extraordinary banquet of
lives, from great public occasions, such as the return of World War I black regi-
ments to intimate events such as the funeral of a child. The photographer, with
reasonable technical expertise, could not only document events, he could also pro-
ject how the client wanted to remember the event. Reflecting their close relationship
with clients, photographers gave direct expression to client visualizations.[1]

—*E. Barry Gaither*

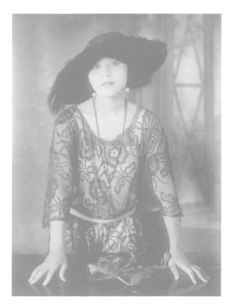

PHOTOGRAPHER: RICHARD ALOYSIUS
TWINE

While there is a growing awareness of works by contemporary black photogra-
phers, there has been very little historical research or critical analysis of the im-
ages produced by nineteenth- and early-twentieth-century African-Americans.
Few art historians and scholars in the field of nineteenth-century photography
have focused on the fine works and activities of African-American photogra-
phers. Given this lack, *Reflections in Black* is perhaps the first general history of
African-American photographers to be assembled and published, notwithstand-
ing the last two decades' unprecedented efforts by curators, artists, and histori-
ans to identify and preserve the works of early black photographers.

The reality is that African-Americans have produced photographs since 1840,
the year after Louis J. M. Daguerre (1787–1851) invented his daguerreotype, a
device that could produce a likeness on iodized copper. According to art histori-
ans Margaret Denton Smith and Mary Louise Tucker, a freeman of color, Jules
Lion (1810–1866), first introduced the daguerreotype process to the city of New
Orleans in 1840. Seeing this innovative medium as an opportunity for entrepre-

neurship, other Americans immediately began to apply their talents to "making a likeness."[2]

The American public became quickly fascinated with the medium after Daguerre first published the process in France in January 1839.[3] He had successfully fixed an image and named the process after himself, calling it a daguerreotype. Through an arrangement with the French ministry, Daguerre made the process available not only in France but in countries throughout the world. By the spring of 1839, newspapers in the United States began to publish accounts of Americans experimenting with the daguerreotype process. On August 19, 1839, Daguerre himself published an instruction manual; by late August, newspapers in Paris and London were describing Daguerre's process in detail. So extraordinary was this development that the *Great Western*, one of the fastest transatlantic steamers of the early Industrial Age, docked in New York on September 10, 1839, carrying aboard French and English newspapers filled with descriptions of the daguerreotype process.

As with many scientific discoveries, experimentation does not reside solely in one process. Likewise, the study of photography's beginnings is one of duality. At the end of January 1839, William Henry Fox Talbot (1800–1877), an English aristocrat and inventor, read before the exclusive Royal Society in London a paper on his own experiments with photomechanical processes. Calling his experiments the "art of photogenic drawing," or the "pencil of nature," Talbot stated his claim as photography's inventor. In contrast to Daguerre, Talbot did not license his process, preferring instead to patent what he called the calotype process. The calotype was the first negative-positive process in photography, which offered the duplication of prints from a single negative, while daguerreotypes were unique direct-positive images on metal plates. Because Talbot closely guarded the methodology of the calotype, the daguerreotype became for a time the more popular of the two methods.[4]

The first photographs made by black photographers are, like all photographs of this period, significant in terms of their contributions to American history and culture. What makes them particularly significant is that the inhumane institution of slavery existed in the 1840s and would survive another twenty-five years. In this post-Jacksonian age, the United States had entered a third year of a severe economic depression, but the novelty of the "new art," despite its great expense, attracted many people to the daguerreotype invention.[5] Although pervasive racial discrimination existed throughout the United States, hundreds of free men and women of color established themselves as professional artists and daguerreotypists during the first twenty-five years of photography's existence. As they began to record the essence of their communities mainly through portraiture, a few photographers gained national recognition. Throughout the North, South, and the developing West, these photographers celebrated the ethnic diversity of American families—the common man and woman, free and enslaved Africans, newly arrived immigrants, and slave owners and their

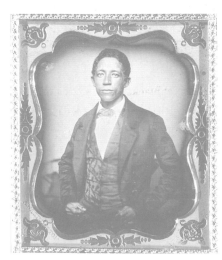

PHOTOGRAPHER: AUGUSTUS WASHINGTON

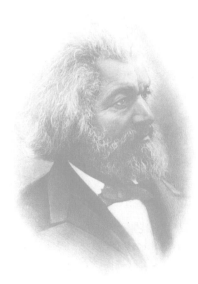

PHOTOGRAPHER: C. M. (CORNELIUS MARION) BATTEY

descendants, depicted in photographers' studios, in private homes, and in public classrooms.

It is astonishing for us to look back with a late-twentieth-century perspective at the lives and works of these early-nineteenth-century black photographers. Concerned about how black people were portrayed in a world of rank racist imagery, black photographers were especially sensitive to negative depictions of black Americans during the mid-1800s. One need only peruse the visual representations of black people commonly produced on postcards and sheet music to realize that the exaggerated features and demeaning situations depicted there left an enduring negative impact, one that has endured to this day. Commenting on the offensive caricatures, Frederick Douglass, the great orator and champion of civil rights, wrote:

> Negroes can never have impartial portraits at the hands of white artists. It seems to us next to impossible for white men to take likenesses of black men, without most grossly exaggerating their distinctive features. And the reason is obvious. Artists, like all other white persons, have developed a theory dissecting the distinctive features of Negro physiognomy.[6]

Many black photographers contradicted these depictions by making representative portraits of their subjects. Most of their African-American clients wanted to celebrate their achievements and establish a counterimage that conveyed a sense of self and self-worth. Obligingly, many black photographers recorded the significant events in African-American life—celebratory as well as unsettling. For most of these photographers, their cameras were most often focused on the free black communities throughout the country, but mainly in the North. A small percentage of these pioneer photographers, however, were supported by commissions from white patrons. Social historian Douglas Daniels observed:

> While historians have used literary documents to depict Blacks as helpless subjects, photographs allow us to see many of them as confident human beings. Occupation, income, education, and similar variables are important for assessing accomplishments and status, but I would also emphasize the public image or self-image that is presented. Scholars can use photographs to study historically "inarticulate" segments of our population. Since most ordinary Americans leave few, if any, written records—diaries, autobiographical memoirs, or letters—historians and others must start taking seriously such seeming inconsequential materials as family photographs. . . . For understanding the self-image of Blacks, photographs are especially useful when they are portraits approved by the subjects because they find the likenesses flattering.[7]

Thus, the photographs made of black subjects often preserved the appearance and notability of the sitters. Indeed, African-Americans have been a part of photographic history for over 160 years, since its inception. As with the general his-

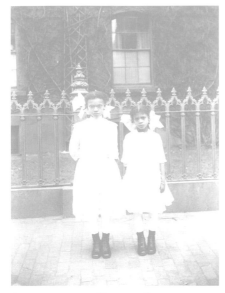

PHOTOGRAPHER: HERBERT COLLINS

tory of photography, many names and personal histories have been lost, an un-surprising fact considering the numerous studios proliferating through the country. While little is known about the nineteenth-century practitioners, some of their photographs still survive. This book demonstrates the exceptional range of work by black photographers produced since 1840. Because of technical and commercial limitations, most nineteenth-century black photographers suc-ceeded at portraiture or studio photography, rather than at creating news, indus-trial, or landscape images.

Reflections in Black presents the best examples I have found of the surviving works of mid-nineteenth-century photographers, as well as biographical infor-mation on each known photographer. Luckily, a few photographers preserved their records and I have indicated that in the accompanying text. The first sec-tion of this book will provide the reader with an understanding of the nineteenth-century black photographer, as well as his craft and client base. My interest extends beyond mere history, and I have selected photographs that I be-lieve contain the most expressive power, whether made for documentary or artistic purposes. The twentieth-century section of this volume serves as a visual record of not only the social concerns of the majority of black Americans but also the reflexive experiences of both the photographers and their communities. This book, then, is *a history of black photographers* that is shaped by visual evi-dence—diaries, images, newspapers—and is made possible by the repositories of visual history and the living photographers.

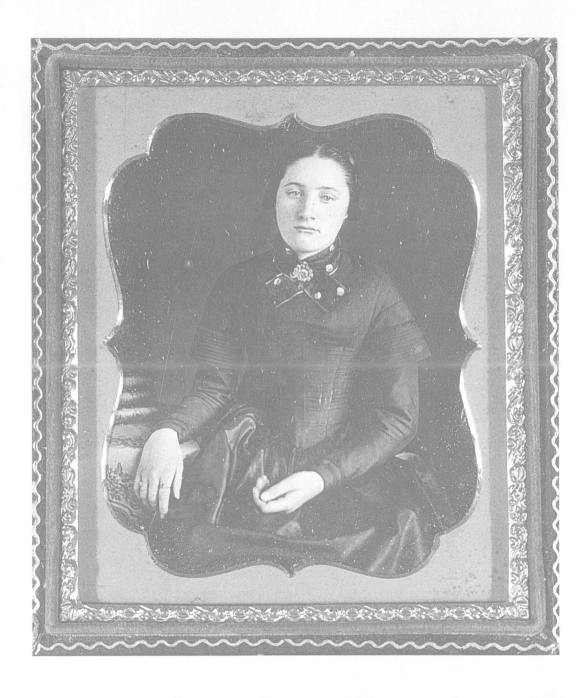

Part 1

THE FIRST SIXTY YEARS:
1840 — 1900

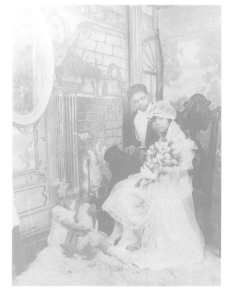

PHOTOGRAPHER: JAMES VANDERZEE

Once technology made it viable to do portraiture, African-American photographers produced idealized glimpses of family members set in romanticized or dramatic poses. Photographers sought to integrate elements of romanticism and classicism into their work, echoing the work of painters in the eighteenth century. Early photographers created genre scenes and landscapes, and they made elaborate backdrops for studio portraits. Most of these early photographs were taken to commemorate a special occasion in the sitter's life, such as birth, confirmation, graduation, courtship, marriage, military service, anniversaries, death, or some social or political success.

The photographic business indeed varied. Some photographers owned and operated studios in small towns and major cities, while others worked as itinerants. They photographed people from all walks of life—the prosperous, laborers, and the poor. Significantly, African-American photographers documented the activities of nineteenth-century abolitionists, and thus their work took on a political and historical meaning early on. The artistic legacy of this work reflects the dominant techniques of nineteenth-century American photography—that is, daguerreotypes and the other early processes, including ambrotypes, tintypes, and the popular stereographs, as well as composite printing and hand tinting. The images that survive convey an intimacy between subject and photographer. There is a conscious effort on the part of the photographers to express naturalistic poses in interpreting the personality of their subjects. As with most portraiture, the photographs made in the nineteenth century were not intended for publication or public presentation. The African-American clients merely wanted to have their likenesses preserved for future generations. Thus, it is only now, more than a hundred years later, that these photographs represent a vital part of African-American history. One recognizes the trappings of artifice but is inspired nonetheless by the enthusiasm and positive spirit inherent in these portraits.

3

4

PHOTOGRAPHER: JULES LION

During the 1840s, photography's first decade, Jules Lion (1810–1866), James Presley Ball (1825–1904/5?), and Augustus Washington (1820–1875) were among the fifty documented black daguerrotypists who operated successful galleries in American cities. They worked in major cities—New Orleans, Cincinnati, and Hartford, respectively. Originally a lithographer and portrait painter, Jules Lion moved to New Orleans from his native France in 1837. Lion had exhibited at the Exposition of Paris in 1833, where he was awarded an honorable mention for his lithograph *Affut aux Canards (The Duck Blind)*. By 1840, he was fairly well established in the business of making pictures. In 1841, he and M. Canova, another artist, founded an art school in New Orleans, and from 1852 to 1865, Lion was listed as a professor of drawing at the College of Louisiana. Lion first exhibited his daguerreotypes in New Orleans in 1840. He advertised his work in the *New Orleans Bee*, "the likeness[es] of the most remarkable monuments and landscapes existing in New Orleans . . . all made by means of the Daguerreotype."[1] Through his advertising campaign, Lion generated a public interest in his daguerreotypes. On March 15, 1840, Lion organized his first public exhibition in the Hall of the St. Charles Museum in New Orleans. This was the first exhibition to be shown prominently by a freeman of color. Lion had promoted the event by advertising in the *New Orleans Bee* on the previous day:

> DAGUERREOTYPE.—Mr. J. LION, Painter and Lithographer, Royal Street. No. 10—To comply with the wishes of his friends and acquaintances, has the honor to announce to the public, that on Sunday next, 15th March, at 11 o'clock precisely, he will give, in the Hall of the St. Charles Museum, opposite the St. Charles Hotel, a public exhibition, in which shall be seen the likeness of the most remarkable monuments and landscapes existing in New Orleans, viz:—the Cathedral, Exchange, St. Charles Hotel, Royal Street, Town House, etc., all made by means of the Daguerreotype. Mr. J. Lyon [*sic*] will, during the exhibition, make a drawing which shall be put up at lottery.—There shall be as many chances as persons present. The price of the lottery tickets is $1. Said tickets delivered at the entrance.[2]

As far as we can surmise, Lion himself organized and sponsored this exhibition, which was reported to have drawn a large crowd.

Patricia Brady, a historian specializing in New Orleans's free artists of color, has described Lion's subsequent activities: "The next month, he organized a *fête champêtre* to celebrate another exhibition, complete with a balloon ascension, orchestra, and fireworks. The first to show daguerreotypes in New Orleans, Lion became a local celebrity and received widespread and admiring newspaper coverage."[3] Sadly, according to Patricia Brady, no known daguerreotypes produced by Jules Lion survive. Museums and historical society collections, however, preserved documents of Lion's exploits and a number of his lithographs—including a view of St. Louis Cathedral as it looked in 1840, believed to have been made after a daguerreotype. He lived in New Orleans until his death in 1866, and much of his work featured the city's architecture and portraits of its leaders and people.

While Lion was a forerunner, other free black men and women in cities around the country also established themselves as daguerreotypists, photographers, inventors, artists, and artisans and gained local and national recognition. Portraits of preachers, soldiers, writers, and prominent and lesser-known African-Americans were produced regularly in galleries and studios throughout the United States. Increasingly, people chose to sit for daguerreotypes or photographs rather than for painted portraits.

In contrast to Lion, photographers James Presley Ball and Augustus Washington were politically engaged abolitionists and used their photographic skills to expose the abhorrent institution of slavery by promoting antislavery activities. Ball, a free black man, was a photographer and a businessman, and he created a moving account of slave life for the sole purpose of lecturing on the brutality of the institution. Born in Virginia in 1825, Ball met John B. Bailey, a black daguerreotypist from Boston, in the mid-1840s, and his interest in photography began at that time. In the fall of 1845, Ball opened a one-room studio in Cincinnati, Ohio, a city bordering the slaveholding state of Kentucky. This early studio venture proved unsuccessful. In three months, he managed to attract only two sitters, one of whom he photographed on credit.

Like many daguerreotypists in the early years, Ball was forced to close his one-room studio and began to work as an itinerant, traveling from city to city before settling for a time in Pittsburgh, Pennsylvania, and, later, in Richmond, Virginia. Many traveling daguerreotypists set up their cameras in rented rooms, or drove their wagon-studios into town and set up temporary portrait studios in public areas. As John Wood notes, it is difficult to identify a regional style developed by a particular daguerreotypist. "Daguerreotypists were too busy going from North to South, opening galleries, and training other daguerreotypists to develop regional styles."[4] Ball arrived in Richmond, Virginia, in the spring of 1846, along with his equipment and technical apparatus—a small trunk, a tripod, a headrest to clamp on the back of a chair, and a few plates—and a single "shilling."[5] Giving his last coin to a porter who carried his belongings to his rented room, Ball found employment in a dining room in Richmond. After a time, he invested part of his modest earnings of one hundred dollars in a furnished room near the state capitol building and photographed clients there. Evidently, Ball experienced greater success in Richmond, as an early study noted: "The Virginians rushed in crowds to his room; all classes, white and black, bond and free sought to have their lineaments stamped by the artist who painted with the Sun's rays."[6]

Ball's sojourn to Richmond lasted a year. In 1847, Ball returned to Ohio, which was a leading state of abolitionist activity, and he traveled throughout the state photographing before resettling in Cincinnati in 1849. He opened a studio, hiring his brother, Thomas Ball, as an operator. Considered by most Americans as the "gateway to the West," Cincinnati had a reputation for its sophisticated culture, and prosperous businessmen emulated their wealthy competitors back east

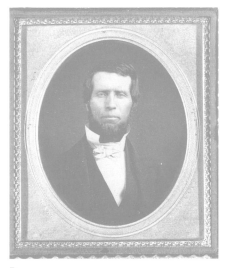

PHOTOGRAPHER:
J. P. (JAMES PRESLEY) BALL

by becoming patrons of the arts.[7] The city also was strategically placed for anti-slavery activism and abolitionists' foment.

Prior to 1800, enslaved blacks escaping from bondage in the South had sought freedom and refuge in what was then called the Northwest Territory, because the laws requiring a runaway slave to be sent back to his owner were seldom enforced there.[8] Cities, like Cincinnati, with easy access to major waterways, were key to the transition from slavery to freedom. In Ohio, the Underground Railroad, a network of safe houses harboring blacks escaping slavery, helped many reestablish their lives along the Great Lakes and in Canada.

Ball's photographs of the white citizens of Cincinnati reveal that he was a major recipient of white abolitionist patronage. Although Ball would eventually publish a powerful antislavery pamphlet, he put his energy into establishing what would become the most successful photography gallery in Cincinnati. Ball's Great Daguerrean Gallery of the West was one of the largest photography studios in that city. A contemporary description from *The American Daguerreotype* sums up Ball's success in this way:

> Perhaps no other city was more of a focal point for inland daguerreotyping than Cincinnati. Many skilled artists of the camera had settled there, including the pioneers Ezekiel Hawkins and Thomas Faris in 1843, Charles Fontayne in 1846, and the black James P. Ball, who opened a one-room studio in 1847 . . . and, of all the galleries to be established in Cincinnati, the most famous and certainly the most ornate was Ball's Great Daguerrian [sic] Gallery of the West. Ball's ascent from a small gallery to one of the great galleries of the Midwest makes an excellent example of a successful enterprise far from the Eastern centers of daguerreotyping.[9]

Ball soon gained the interest and support of black newspapers, including Rochester, New York's *Frederick Douglass' Paper*. A favorable description was published in an article titled "The Colored People of Cincinnati":

> We were quite struck with the variety of employments engaged in by colored men in Cincinnati. . . . One of the most credible indications of enterprise, furnished on behalf of our people, is the flourishing business and magnificent Daguerrean Gallery of Mr. Ball in Cincinnati. We shall treat our readers and friends to a picture of this gallery, with a particular account of it on the first page of our next week's edition. It is one of the best answers to the charge of natural inferiority we have lately met with. . . .[10]

A noted nineteenth-century mass-produced periodical, *Gleason's Pictorial*, published the following description of the studio:

> Mr. Ball employs nine men in superintending and executing the work of the establishment. Each man has his own separate department, and each is perfect in his peculiar branch. We are so well aware of the indomitable industry displayed by the proprietor that it is no conjecture of ours but our fixed opinion that it will not be

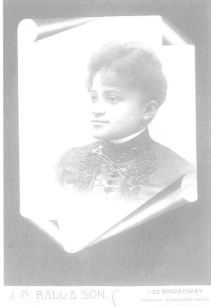

PHOTOGRAPHER:
J. P. (JAMES PRESLEY) BALL & SON

very long before Mr. Ball will be obliged, from the great increase of his business, to have rooms twice as large as he now occupies. His fame has spread, not only over his own but through nearly every State of the Union; and there is scarcely a distinguished stranger that comes to Cincinnati but, if his time permits, seeks the pleasure of Mr. Ball's artistic acquaintance."

In 1855, Ball published *Ball's Splendid Mammoth Pictorial Tour of the United States Comprising Views of the African Slave Trade; of Northern and Southern Cities; of Cotton and Sugar Plantations; of the Mississippi, Ohio and Susquehanna Rivers, Niagara Falls, & C.*, a pamphlet that addressed the horrors of slavery, from capture in Africa, through the Middle Passage, and then to bondage. The publication accompanied the display of a six-hundred-yard panorama of paintings and pictures based on the experiences depicted in the pamphlet. It was on exhibit in Ball's gallery. During the nineteenth century and until the invention of movies at the beginning of the twentieth, panoramas were forms of popular entertainment. Operated by rotating the canvas between two poles, as in a scroll, the panoramas told stories in picture form, adopting a style similar to the polemical but intimate narratives that were being published in the nineteenth century. Ball focused his text on the enslaved person's experience, such as the story of Frederick Douglass, as described in *Narrative of the Life of Frederick Douglass, an American Slave, Written by Himself* (1845) or the portrait of Harriet A. Jacobs in *Incidents in the Life of a Slave Girl* (1861). Gaining national recognition, Ball exhibited the panorama as far away as Boston's Armory Hall in the spring of 1855.

Several months later, Ball displayed his daguerreotypes and other photographs at the Ohio state fair. The *Provincial Freeman* (formerly *Herald of Freeman*), a black newspaper, noted on June 23 that "Ball exhibits his Daguerreotypes at the Ohio Mechanics Annual Exhibition." Like most photographers of that period, Ball probably used this opportunity to promote his gallery.

Ball's business prospered in the late 1850s as the city of Cincinnati grew and its residents increased their patronage of the daguerreotype process. He soon opened another gallery, hiring his brother-in-law, Alexander Thomas, as a reception clerk. Thomas had moved to the city from New Orleans in 1852 and married Ball's sister, Elizabeth. Before the decade ended, Thomas had become extremely popular with clients and soon became Ball's partner. Together, they opened another gallery under the name of Ball & Thomas. Ball also had short-lived partnerships with white photographers in the city, including Robert Harlan, another early daguerrean practitioner.

As Ball and Thomas's patronage escalated, they increased their advertising. Tragically, the renowned Ball & Thomas Photographic Art Gallery was destroyed by a tornado in May 1860, less than a year before the outbreak of the Civil War. According to a history of the period, the roof of the buildings where their studio complex was housed

. . . was carried away; part passed over the gallery of Ball & Thomas, while part went through the operating room, and some fragments of timber, etc., penetrated a salon in the rear of the photographic gallery, and killed a child and a woman. The gallery was a complete wreck, the instruments, chemicals, scenery, cases, pictures, carpets, furniture, and everything else, were ruined. This was in the early days of the firm. All their available capital had been converted into stock, used in fitting up the gallery. Ball and Thomas were young men—and they were Colored men. They faced financial ruin. Apparently their business was at an end. But they were artists; and many white families in Cincinnati recognized them as such. Their white friends came to the rescue. The gallery was fitted up again most elaborately, and within a short time was known as the "fine finest photographic gallery west of the Alleghany Mountains."[12]

This remarkable resurrection attests to Ball's prominence in the Cincinnati community. Indeed, public sentiment and support from the community helped the partnership to recover. Soon after their studios were rebuilt, Ball and Thomas hired additional operators, and rapidly they had more business than they could manage. According to business records, they averaged more than one hundred dollars a day. With the success of the gallery, the two men became quite affluent. They maintained a partnership for the next twenty years. The studio remained a family enterprise over the years: Thomas Carroll Ball, a brother, worked there as an operator until his death, and Ball Thomas, the son of Alexander Thomas, was a retouch artist. Ball continued to advertise his superior daguerreotypes, ambrotypes, and cartes-de-visite (visiting cards) in local newspapers. His reputation drew several renowned sitters to his studio, including Frederick Douglass, the actress Jenny Lind, the mother and sister of Ulysses S. Grant, and many Union officers and enlisted men during the Civil War. Despite his grand successes in Cincinnati in the late 1870s and early 1880s, Ball apparently dissolved his partnership with Alexander Thomas, for reasons not known, and moved to Minneapolis.

Arriving in the Twin Cities nearly forty years after he had settled in Cincinnati, Ball confronted a sophisticated urban world with many successful commercial photography studios that had emerged in the last quarter of the nineteenth century. The People's Photo Gallery, for example, was owned by R. Harry Shepherd, one of the first black photographers in the city, who opened his studio in the fall of 1887. Because of his national reputation, enhanced by his own ads and steady coverage in black newspapers, Ball was well received by the citizens of Minneapolis. He advertised regularly in the *St. Paul Western Appeal*, highlighting the types of photographs he made, including tintypes and cabinet cards. One ad proclaimed that all were "just raving over Ball's artistic pictures. . . . Ball is one of the oldest and best photographers in the Northwest and is the only colored man in the business."[13] A celebration in honor of the twenty-fifth anniversary of the emancipation proclamation was held in Minneapolis in September 1887. Ball was the official photographer for this momentous occasion.

In October of the same year, notices of Ball's "removal" (a popular nineteenth-century term for relocating) to Helena, Montana, began to appear frequently in the *St. Paul Western Appeal*. There is no information on why Ball moved to Montana, but on September 3, 1894, a lengthy notice about J. P. Ball's early years in Helena appeared in *The Colored Citizen:*[14]

> Helena enjoys the notoriety of having the only colored photographer in the North-west. Mr. J. P. Ball, who has had a studio here for a number of years, has a large patronage among many of our best citizens. He is one of the oldest members now in the profession, dating back to 1845, the famous daguerreotype era, and has had the satisfaction of taking numerous medals for superior work over many of the most skillful and artistic competitors in the largest eastern cities. Prior to, during, and for several years after the war Mr. Ball had one of the largest and best equipped studios in Cincinnati.

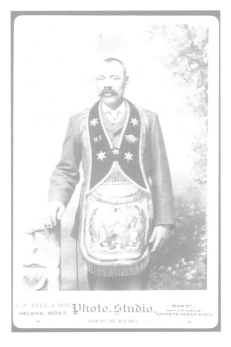

PHOTOGRAPHER:
J. P. (JAMES PRESLEY) BALL & SON

From his arrival in October 1887 until September 1894, Ball produced hundreds of photographs of the white, black, and Chinese community in Helena, documenting in the process the construction of the state capitol. Most likely, the sizable black community in Helena during this period had attracted Ball. As historian William L. Lang points out, "From the time of its founding as a gold mining camp called 'Last Chance Gulch' in the early 1860s, blacks lived in Helena. They came as miners, servants of white families, and cowboys and soldiers who wanted to settle down."[15] Ball photographed, among others, attendees at local conventions and recent migrants to the area. Particularly noteworthy are his photographs of the public execution of John Biggerstaff, a black man, and William Gay, a white man, by the sheriff and townspeople.

Ever the itinerant, the septuagenarian Ball moved to Seattle around 1900. Newspaper accounts in the *Seattle Republican*, a weekly black newspaper, frequently mention the activities of James P. Ball, Sr., and his son, James P. Ball, Jr. The younger Ball was a lawyer and had a practice based in Seattle for a number of years, although he maintained his interest in photography. At the age of seventy-five, James P. Ball, Sr., opened another photographic studio under the firm name of Globe Photo Studio, which remained active through 1904. During this time, Ball suffered crippling rheumatism and sought relief in warmer climates outside the state of Washington. Little is known about the circumstances surrounding Ball's death; however, he continued his ever-westward migration, and his obituary notes that his long and productive career ended in Hawaii in 1904. Because Ball was greatly celebrated in his lifetime, it is possible today to reconstruct his life, although one must go through newspaper clippings, citations from books, and portrait collections in the cities where Ball was based.

In the 1840s, Augustus Washington advertised his studio in one of Connecticut's antislavery newspapers, as well as in other Hartford papers, stating that his was

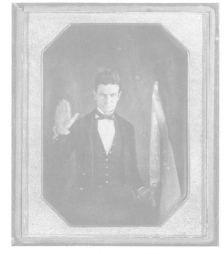

PHOTOGRAPHER: AUGUSTUS WASHINGTON

the oldest daguerrean establishment in the city[16] and that he employed some of the best artists in the country. Washington's father, an ex-slave, and his Asian mother lived in Trenton, New Jersey, where he was born. Washington was well educated by the time he reached his teenage years, and he studied diligently, in his words, "to elevate the social and political position of the oppressed and unfortunate people with whom I am identified."[17] He was influenced by both antislavery publications and by local abolitionists. After a brief career as a teacher in Brooklyn, Washington moved to Hartford in 1843 and opened a daguerrean studio to help finance his education at the Kimball Union Academy and later at Dartmouth College in Hanover, New Hampshire. Four years later, Washington opened another daguerrean studio in Hartford, but he left it the following year to travel, an indication of how precarious a business studio portraiture was throughout the United States. By 1850, Washington was operating the studio once again, and he was very successful, attracting clients in Hartford and occasionally from New Hampshire. Nineteenth-century historian and abolitionist Martin R. Delaney wrote:

> Augustus Washington, an artist of fine taste and perception, is numbered among the most successful Daguerreotypists in Hartford. His establishment . . . is perhaps the only one in the country that keeps a female attendant and dressing room for ladies. He recommends, in his cards, black dresses to be worn for sitting and those who go unsuitably dressed are supplied with drapery and properly enrobed.[18]

Washington's political interests were reflected in his photography—he made portraits of many abolitionists, including John Brown (1800–1859), an activist for the abolition of slavery and the education of blacks. Recently, scholars have remarked on the symbolic power of Washington's image. Washington had Brown stand next to a flag. His right hand, raised as if he was being sworn into service, represents the abolitionist as a passionate young crusader for justice. By his use of the American flag in this portrait, Washington linked Brown to the democratic ideals upon which this country was founded. Exuding solemnity, Brown raised his right hand, this gesture underscoring the commitment necessary to win the abolishment of slavery.

In her essay "Faces of Freedom: Portraits from the American Colonization Society Collection," historian Carol Johnson recounts two significant events that probably influenced Washington's life's choices. As she explains:

> In an 1851 letter to the *New York Tribune*, Washington expressed pessimism about the prospects for African Americans in American society. He wrote, "Strange as it may appear, whatever may be a colored man's natural capacity and literary attainments, I believe that, as soon as he leaves the academic halls to mingle in the only society he can find in the United States, unless he be a minister or lecturer, he must and will retrograde. . . ." Disenchanted with the opportunities available to blacks in

the United States, Washington planned to seek liberty in another land. He investigated and relocated to Canada, Mexico, the West Indies, British Guiana, and various parts of South America before deciding to emigrate to Liberia, which he was able to do under the auspices of the American Colonization Society.[19]

Believing that only Africa could truly be the black man's home, Washington emigrated to Liberia in early 1853. There, he worked as a schoolteacher, farmer, store proprietor, and daguerreotypist. Described in Frederick Douglass's newspaper as a prosperous member of the newly formed Liberian colony, he is reported to have been ". . . a successful merchant, having discontinued his daguerreotype business, when his first stock of material was exhausted as he could do better in other ways, although he received upwards of $1,000 for daguerreotypes the first years of his residence there. He has now a fine sugar farm on the St. Paul's river. . . ."[20] Johnson's research has unearthed evidence of Washington's success as a photographer in Africa:

> Washington's portrait business was an immediate success. He sold roughly $500 worth of portraits during his first five weeks of business in Liberia. Prices for his daguerreotypes started at $3. Washington made between $20 and $40 per day for his pictures. News of Washington's photo studio spread by word of mouth, with the studio hiring young boys to go out into the community and attract customers.[21]

Isolated from their families in the United States, these nineteenth-century emigrés wanted photographs to send to their families. Washington's portraits of families who emigrated to Liberia, such as the Urias A. McGill family, are works of visual poetry. The McGill portraits reveal a prosperous couple; the woman is holding a daguerreotype case, which suggests that she was concerned about preserving or collecting photographic images. Washington's carefully composed stoic portraits of men exemplify the sense of pride that he and his subjects sought in their newfound country. In an 1854 letter, Washington expressed his enthusiasm about his adopted land: "I love Africa, because I can see no other spot on earth where we can enjoy so much freedom. . . . I believe that I shall do a thousand times more good for Africa, and add to our force intelligent men. . . ."[22]

With the introduction of the glass-plate negative and the paper prints that were commonly mounted as cabinet cards, cartes-de-visite, and stereographs, photographic technology advanced swiftly between 1859 and 1899. As a result of these new methods, a growing number of photographers and itinerants flourished in the North, South, and the emerging West. New studios opened for business, producing both paper prints and tintypes, the newer and faster processes of the period.

The Goodridge Brothers, Glenalvin (1829–1867), Wallace (1840–1922), and William (1846–1890), all began their careers in York, Pennsylvania, in the

1850s, a period marked by rapid advances in photography. Two new techniques—the ambrotype process (1852–1870)[23] and the advent of novelty stereoscopic photographs (1850–1890)[24] —contributed to the success of the Goodridges' studio. In 1863, shortly before the entire family was forced to leave York because of their father's activities in the Underground Railroad,[25] Glenalvin won the prize for "best ambrotypes" at the York County Fair. Three years later and one year after the end of the Civil War, the brothers settled in East Saginaw, Michigan. By 1867, they had opened a studio at 104 N. Washington Street. There are no records of Glenalvin's activities in East Saginaw in these early years, but in 1872, Wallace and William built a new studio at 220–222 S. Washington Street, after a fire destroyed the original studio. Wallace and William advertised their technical talents by emphasizing their skill with flash photography, which enabled them to take photographs at evening events. Their biographer, historian John Jezierski, writes:

> They were among the Saginaw Valley's most popular and important photographers. . . . [I]t is clear that the significance of the Goodridge brothers and their work lies not only in the fact that they are among the first black men to work as professional photographers in the United States, but also that their work was most definitely in the mainstream of the development of photography as a profession and as an art form in the nineteenth century.[26]

In 1884, the brothers were commissioned by the Department of Forestry to photograph views of the Saginaw Valley. Today, over a century later, the Goodridges are noted for their portraits of the citizens of Saginaw and their pictorial views of the Saginaw Valley.

Born in 1856, Harry Shepherd was the first black photographer to own a studio in St. Paul, Minnesota. Even before Ball's arrival, he had established a studio in 1887, when he was thirty-one, and employed eight attendants. Records from Shepherd's first year in business are impressive. Profits were listed at $7,587.50, a considerable sum in the late nineteenth century. Shepherd's advertising included the breadth of clientele "—from the millionaire to the day wage worker."[27] With the profits from his business, Shepherd opened two more studios in 1888: the People's Gallery and the Annex. Shepherd boasted that "the Annex studio is prepared to take tintypes by electric light at night, this is a novel feature in the business and is doing well."[28] Although he was a leading photographer in St. Paul, Shepherd had to contend with price wars common in larger metropolises. His competitors sought to undersell Shepherd and sold photographs for less than the three to five dollars that Shepherd charged for his cabinet cards. Yet Shepherd's studios' business did not suffer. In 1889, his end-of-year profit had increased to nine thousand dollars.

Two years later, Shepherd won the gold medal at the 1891 Minnesota State Fair

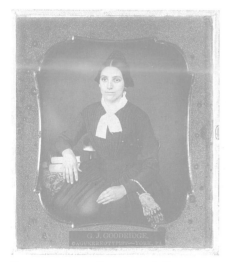

PHOTOGRAPHER: GLENALVIN J. GOODRIDGE

PHOTOGRAPHER: HARRY SHEPHERD

for the "best collection of cabinets and largest portraits and views."[29] Shepherd capitalized on this prize by embossing a replica of the gold medal on the front of his cabinet cards. Encouraged by his exhibition success, he exhibited photographs of the Tuskegee Institute at the Paris Exposition in 1900, but he was dismissed as the exposition's official photographer after he attempted to organize the black southerners with his openly expressed antisegregationist views. A blistering attack on Shepherd's race activities by a black journalist was published in the *Afro American Advance:*

> Shepherd has been in the southern states for some time securing photographs for use in his department, but he took occasion while there to preach anarchy and advised the Negroes to combine against the United States in the event of war with foreign powers. This, he says, is the only solution of the race problem. When taxed with his misconduct he made no denials and after his discharge openly boasted to a reporter of a local paper of circulating inflammatory circulars while in the South. . . . We regret to learn that Mr. Harry Shepherd has lost that "fat position." This race problem is a delicate question to deal with, particularly when a good position is at stake. Fortunate people are not without an army of enemies and conservatism ought always to be the watchword of the lucky.[30]

Shepherd's response to the attack was published in a rival newspaper. According to Bonnie Wilson's essay, the editorial exaggerated Shepherd's loss of the prestigious or "fat" position at the Paris Exposition, claiming Shepherd "had quit after his small commission ($4 per day) had been exhausted within four weeks and he was not likely to have been paid more." The piece went further, asserting that the conflict ". . . was created by the paragraphs under the pictures of Shepherd's *Unsung Heroes* with which he had flooded the South two years earlier."[31] These accounts of Shepherd's militancy and his financial situation provide considerable insights about this outspoken businessman and artist, who operated ambitiously, cultivating a range of subject matter without compromising his convictions. Shepherd's photographs exhibited passionate feelings. For example, a portrait of a black lawyer, Frederick McGhee, one of the organizers of the Niagara Movement,[32] exudes a confidence that reflects shared political sympathies between artist and client. Nationally renowned, Shepherd was also one of the few black members of the National Photographer Association of Americans at the turn of the century.

In Richmond, Virginia, George O. Brown (ca. 1850–1910) operated a successful portrait studio in the 1870s through the turn of the century. His photographs documented black life in that city as well as in surrounding counties. In 1907, Brown received the silver medal for his photographs at the Jamestown Tercentennial. One of his most celebrated portraits is of the businesswoman Maggie Lena Walker (1867–1934), founder of the St. Luke Penny Savings Bank. Brown's

early work focused on portraiture. He advertised that their studio practitioners were "makers of portraits that please."[33] The Brown family studio, operated by his son and daughter after his death, was prominent in Richmond from 1875 to 1977.

Three other photographers working in the nineteenth century deserve particular mention. Little is known about the photographic career of Thomas E. Askew (ca. 1850s–1914). His existing photographs, held in private collections in Atlanta, reveal a mastery of lighting and composition. A portrait entitled *The Summit Avenue Ensemble* portrays young classical musicians holding instruments and wearing boutonnieres. The formal composition conveys his sensitivity to his subjects' artistry and a concern for portraying them accurately.

Daniel Freeman (1868–after 1919?) was born in Alexandria, Virginia, and was active in Washington, D.C., from 1881 through 1919. Freeman studied photography at an early age with the well-known Washington, D.C., photographer E. J. Pullman. He also studied painting and drawing in Washington's public schools and later, reflecting his habit of combining his artistic interests, painted the scenic sets in his studio and handcrafted the portrait frames. Freeman was described as "a natural born artist" and a photographer of "high order and merit."[34]

Freeman opened his first studio in the District of Columbia in 1885, claiming to be the first black photographer in that city. Advertisements stated that "his gallery is fitted up with all the latest and most approved apparatus; his instruments alone costing over $500."[35] In 1895, Freeman participated in the District of Columbia's exhibit in the Negro Building at the Cotton States and International Exposition held in Atlanta, where Booker T. Washington delivered an important speech for the time, often called the "Atlanta Compromise."

Freeman was an active member of Washington's black artistic community. He taught photography at the now-defunct Frelinghuysen University.[36] He also held daily classes in fine arts and photography in his studio at 1833 Fourteenth Street, NW. In addition, he was the founder of the Washington Amateur Art Society.[37] His graceful photographs detailed the facial expressions of his well-groomed subjects, conveying the fact that they were respectable and successful people. Freeman also used the portrait format to make allegorical statements. One image, obviously orchestrated, shows an older woman in mourning clothes, with a young man standing nearby holding a hat. The matriarch is holding a fan in one hand. The photograph reveals the solemnity of the moment. The young man, perhaps her son, represents the love lost. Another image shows an interior view of a tobacco and newspaper shop. The shop owner is surrounded by newspapers and periodicals from cities across the country. Across from a bench, a calendar hangs prominently in the center of the store and includes photographs of Frederick Douglass, Booker T. Washington, and Paul Laurence Dunbar taken by photographer C. M. Battey, who later became well known for his association with Tuskegee Institute. By rendering these seeming ancillary details so carefully,

PHOTOGRAPHER: GEORGE O. BROWN

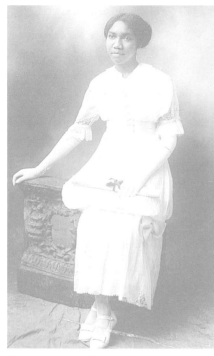

PHOTOGRAPHER: DANIEL FREEMAN

Freeman constructed an image that shows African-Americans as affluent and well read.

What is significant about this late-nineteenth-century period is that the clientele of African-American photographers reflected the diversity of the large community. A few of the accomplished photographers found work photographing black and white leaders while others involved in studio portraits documented their local communities, skillfully making portraits for their sitters. Some of these photographers went beyond the commonplace standards and achieved an artistry and style that make their work stand out; some of this work is preserved today in museums, libraries, and private collections. As evidenced in this period, black photographers searched for both a particular style and a successful business. Their photographs realized visually the dreams and desires of their individual communities, which included a spirit of transformation contrasting the mass-produced stereotypical images. As photographic curator Colin L. Westerbeck said, "The daguerreotype was highly regarded in its own day as a kind of democratization of art, for it permitted those who had neither the time nor the money for painted portraits to obtain a likeness nonetheless."[38] Early photographers like Lion, Ball, Washington, and Shepherd followed that credo by expanding the notion of "democratizing" by allowing their subjects to collaborate with the photographer in defining their own image. One can only hope that more images of the early practitioners will be discovered as their descendants unearth more of the work and records of these photographic pioneers.

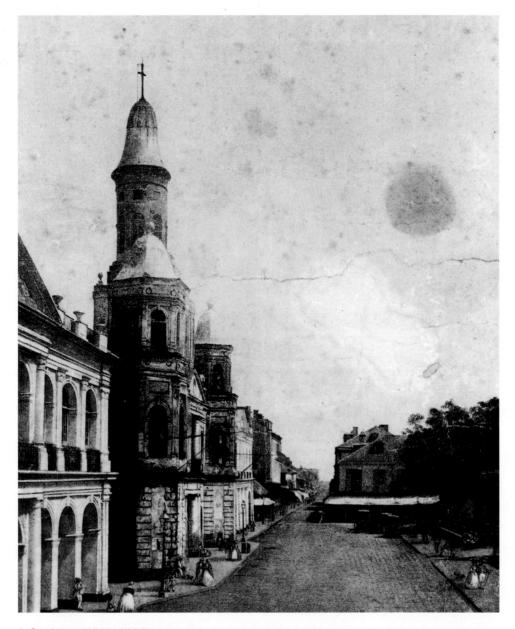

Jules Lion (1810–1866)

1. St. Louis Cathedral

Lithograph from a daguerreotype, 1842

Historic New Orleans Collection

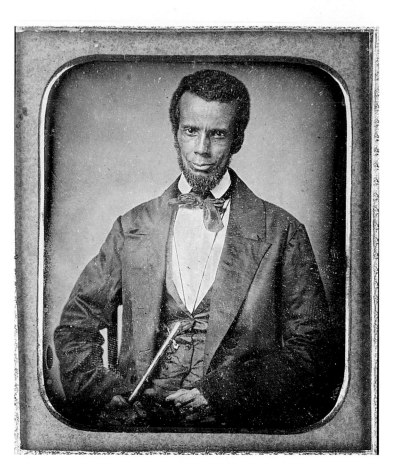

Augustus Washington (1820–1875)

2. Unidentified man with beard

Daguerreotype, sixth plate, ca. 1854–1860

Daguerreotype Collection

American Colonization Society Records

Prints and Photographs Division

Library of Congress

LC-USZ6-1934

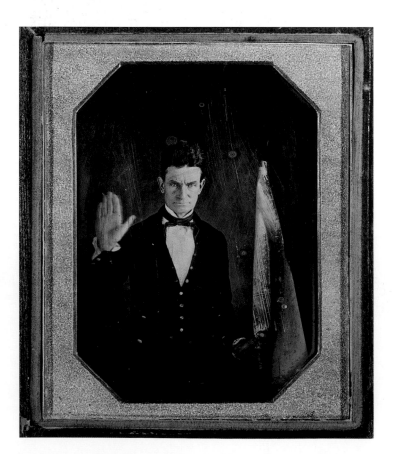

Augustus Washington (1820–1875)

3. Portrait of John Brown, abolitionist (1800–1859)

Daguerreotype, 1847

National Portrait Gallery

Smithsonian Institution

NPG.96.123

Purchased with major acquisition funds and with funds
donated by Betty Adler Schermer in honor of her
great-grandfather August M. Bundi.

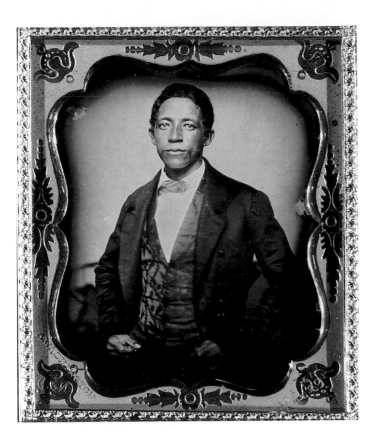

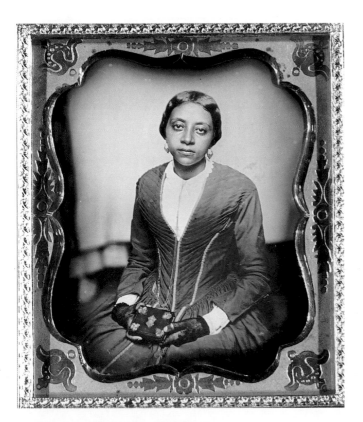

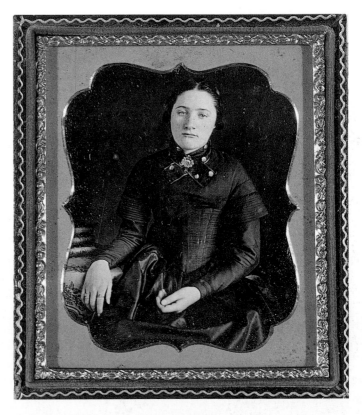

Augustus Washington (1820–1875)
4. Urias A. McGill
Daguerreotype, sixth plate, hand-colored, ca. 1854 and 1860
Daguerreotype Collection
American Colonization Society Records
Prints and Photographs Division
Library of Congress
LC-USZ6-1948

Augustus Washington (1820–1875)
5. Unidentified portrait of a woman, probably a member of the Urias
McGill family
Daguerreotype, sixth plate, 1855
Daguerreotype Collection
American Colonization Society Records
Prints and Photographs Division
Library of Congress
LC-USZC4-3939

Augustus Washington (1820–1875)
6. Unidentified woman
Daguerreotype, n.d.
Amistad Foundation Collection
Wadsworth Atheneum, Hartford, Connecticut

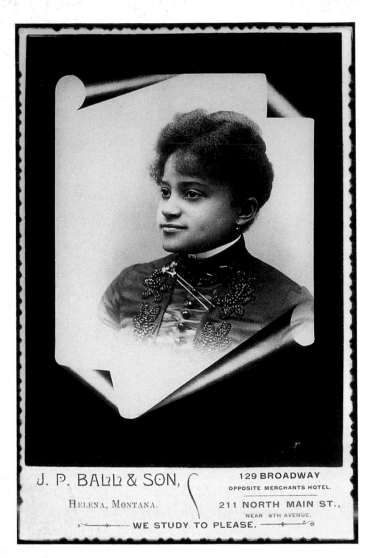

J. P. (James Presley) Ball & Son (1825–1905)

7. Vignette (scroll) portrait of an unidentified black woman in a high-necked dress with a decorated beaded bodice
Albumen cabinet card, ca. 1890s
Montana Historical Society, Helena
957-608

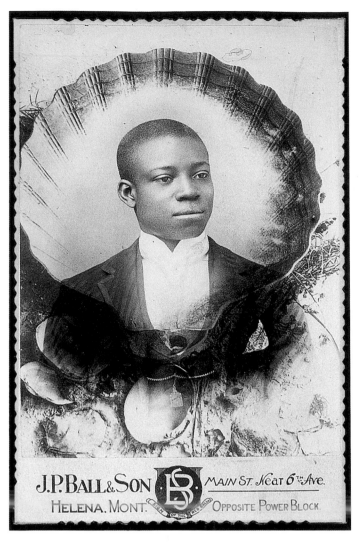

J. P. (James Presley) Ball & Son (1825–1905)

8. Portrait of an unidentified young black man in a high-color shirt (portrait superimposed on a seashell)
Albumen cabinet card, ca. 1890s
Montana Historical Society, Helena
957-600

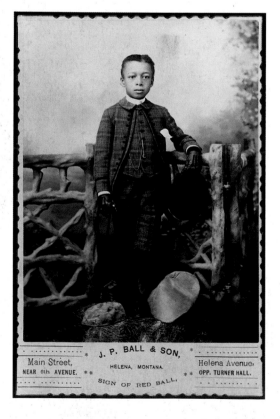

J. P. (James Presley) Ball & Son (1825–1905)

9. Portrait of an unidentified young man in a plaid suit and gloves
Albumen cabinet card, ca. 1890s
Montana Historical Society, Helena
957-607

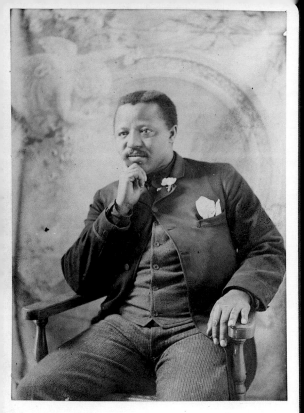

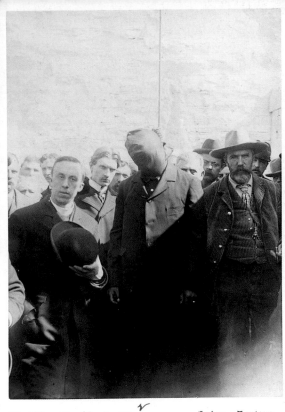

J. P. (James Presley) Ball & Son (1825–1905)

10. Portrait of William Biggerstaff seated in a chair with his hand on his face, wearing a flower in his lapel
Albumen cabinet card, 1896
Montana Historical Society, Helena
957-610

J. P. (James Presley) Ball & Son (1825–1905)

11. Photograph of the execution of William Biggerstaff, hanged for the murder of "Dick" Johnson, flanked by the Reverend Victor Day and Henry Jurgens, sheriff
Albumen cabinet card, 1896
Montana Historical Society, Helena
957-611

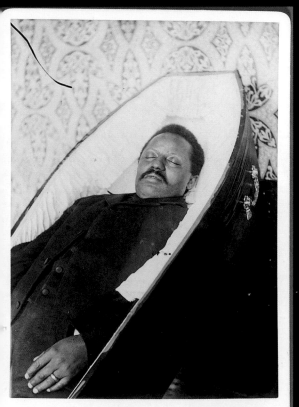

J. P. (James Presley) Ball & Son (1825–1905)

12. Photograph of William Biggerstaff (A former slave, born in Lexington, Kentucky, in 1854. He was convicted of killing "Dick" Johnson after an argument that took place on June 9, 1895. Biggerstaff pleaded self-defense.)
Albumen cabinet card, 1896
Montana Historical Society, Helena
957-613

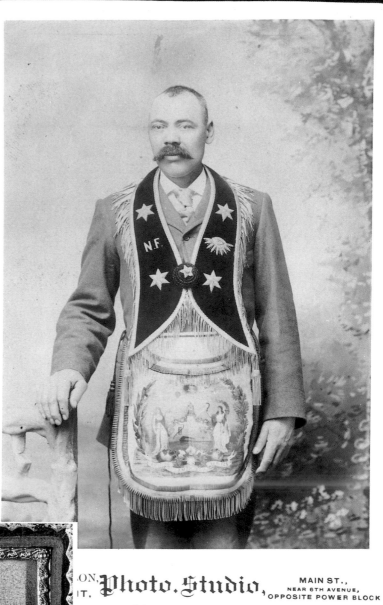

J. P. (James Presley) Ball & Son (1825–1905)

13. Portrait of an unidentified black man wearing a
Masonic apron and vest (Helena's black community had
two Masonic lodges, an Odd Fellow's lodge, the
Household of Ruth and the Eastern Star.)

Albumen cabinet card, ca. 1890s

Montana Historical Society, Helena

957-605

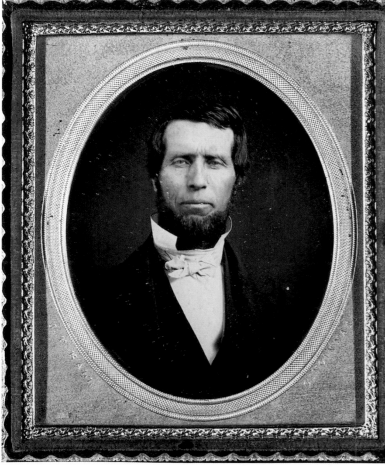

J. P. (James Presley) Ball (1825–1905)

14. Portrait of an unidentified man with high collar and
plain cravat

Daguerreotype, sixth plate, n.d.

International Museum of Photography at George
Eastman House, Rochester, New York

77:240:11

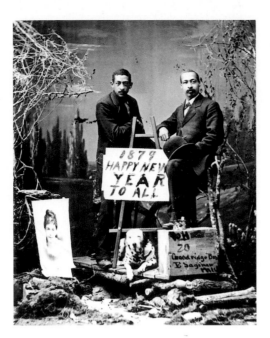

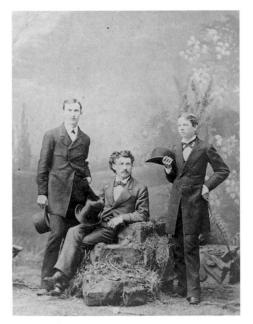

Goodridge Brothers (William, 1846–1890; Wallace, 1840–1922)

15. Portrait of William and Wallace Goodridge

Albumen print, 1879

Courtesy of John V. Jezierski, Saginaw, Michigan

Goodridge Brothers (William, 1846–1890; Wallace, 1840–1922)

16. Unidentified group portrait

Albumen print on cabinet card, ca. 1880

Courtesy of John V. Jezierski, Saginaw, Michigan

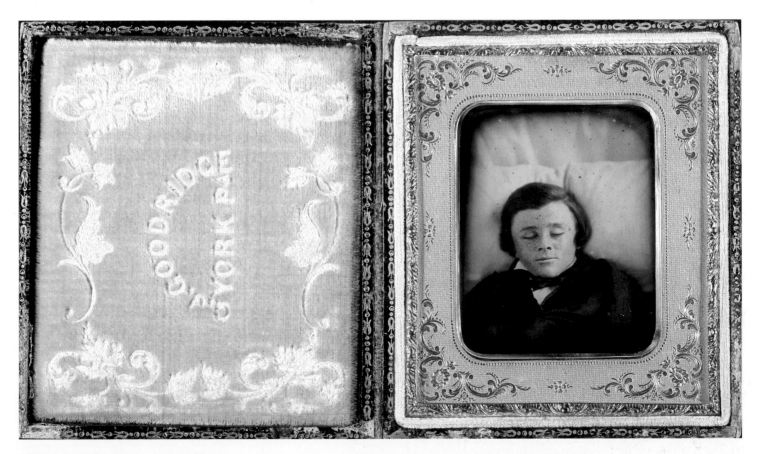

Glenalvin J. Goodridge (1829–1867)

17. Unidentified mortuary portrait

Daguerreotype, ca. 1845

Courtesy of the Center for African American Decorative Arts

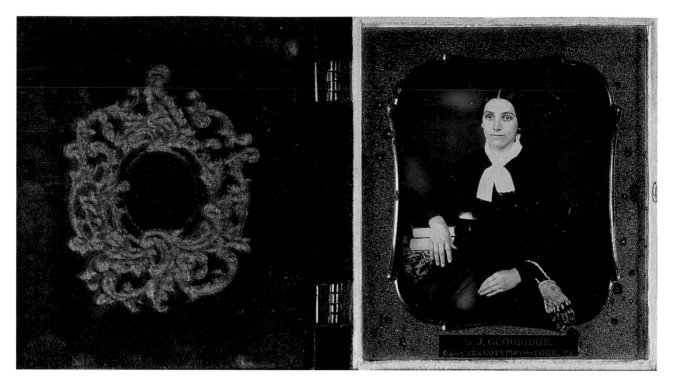

Glenalvin J. Goodridge (1829–1867)

18. Unidentified portrait of a woman with books and purse

Daguerreotype (hand-tinted), ca. 1845

Courtesy of the Center for African American Decorative Arts

Glenalvin J. Goodridge (1829–1867)

19. Unidentified portrait of a woman with books

Daguerreotype, ca. 1845

Courtesy of the Center for African American Decorative Arts

Daniel Freeman (1868– after 1919?)
20. Portrait of a couple
Gelatin silver print, ca. 1899
Courtesy of Dr. James K. Hill, Washington, D.C

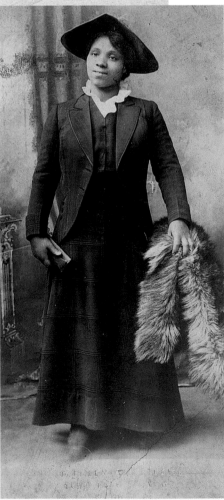

Daniel Freeman (1868–after 1919?)
21. Portrait of a baby in wicker stroller
Albumen print, ca. 1895
Courtesy of Dr. James K. Hill, Washington, D.C.

Daniel Freeman (1868–after 1919?)
22. Graduate portrait (young woman wearing white dress and holding diploma)
Gelatin silver print, ca. 1900
Courtesy of Dr. James K. Hill, Washington, D.C.

Daniel Freeman (1868–after 1919?)
23. Portrait of a woman holding purse
Gelatin silver print, ca. 1900
Courtesy of Dr. James K. Hill, Washington, D.C.

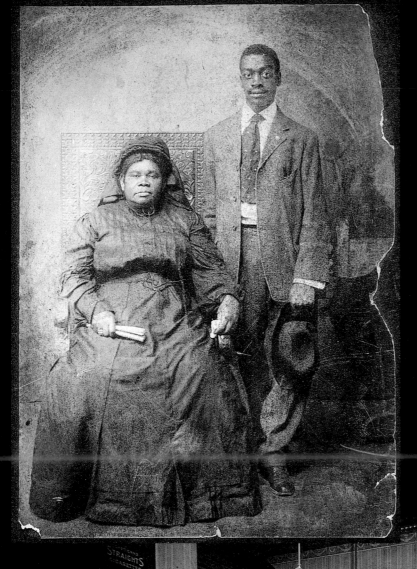

Daniel Freeman (1868–after 1919?)
24. Couple, man and woman (woman seated, wearing
mourning dress; man holding hat)
Albumen print, ca. 1900
Courtesy of Dr. James K. Hill, Washington, D.C.

Daniel Freeman (1868–after 1919?)
25. Interior view of tobacco and newspaper store (display
includes wall calendar showing C. M. Battey's photographs
for National Benefit Association, April 1917)
Albumen print, ca. 1917
Courtesy of Dr. James K. Hill, Washington, D.C.

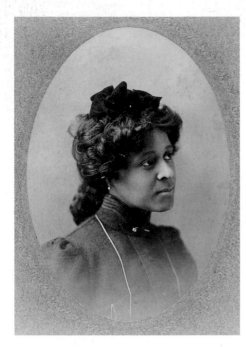

Harry Shepherd (1856–?)
26. Portrait of Mattie McGhee (wife of St. Paul lawyer Frederick McGhee)
Albumen print, ca. 1900
Minnesota Historical Society, St. Paul

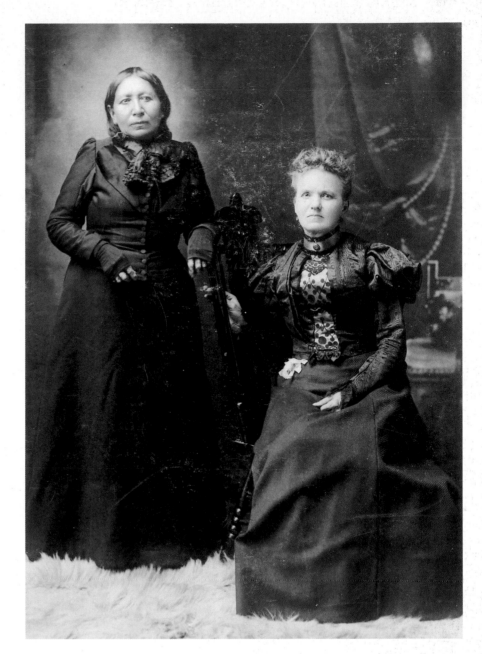

Harry Shepherd (1856–?)
27. Portrait of Mary Schwandt Schmidt and Snana (Dakota Indian, wife of Good Thunder)
Albumen print, 1895
Minnesota Historical Society, St. Paul

Harry Shepherd (1856–?)
28. Portrait of Booker T. Washington (1856–1915)
Albumen print, ca. 1892
Booker T. Washington Collection
Prints and Photographs Division
Library of Congress
Lot 13164-A, no. 1

Harry Shepherd (1856–?)
29. Portrait of Frederick McGhee (attorney at law and co-founder of the Niagara Movement in 1905)
Albumen print, ca. 1900
Minnesota Historical Society, St. Paul

Harry Shepherd (1854–?)
30. Wedding party
Gelatin silver print, ca. 1905
Minnesota Historical Society, St. Paul

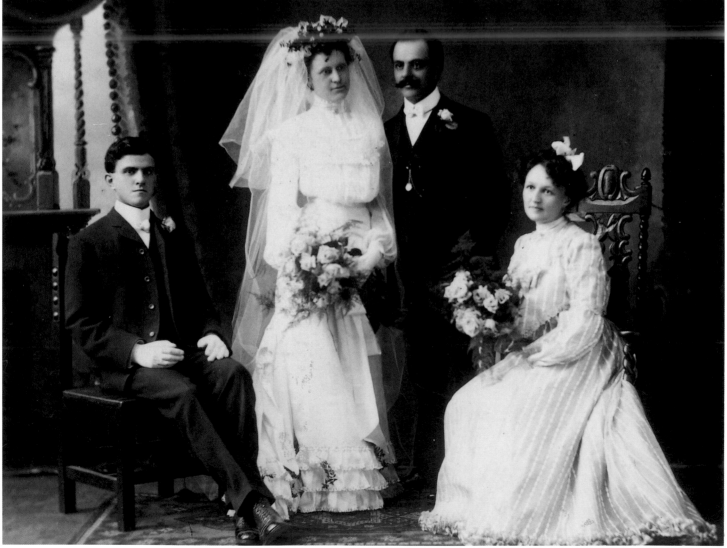

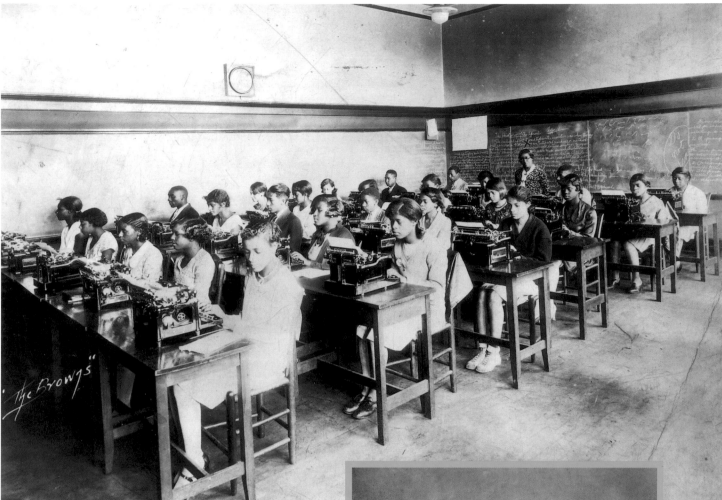

The Browns' Studio (active 1875–1977)
31. Typewriting club, Armstrong High School, Mrs. Mabel M. Winston, director
Gelatin silver print, ca. 1930
Witherspoon Collection
Valentine Museum, Richmond, Virginia

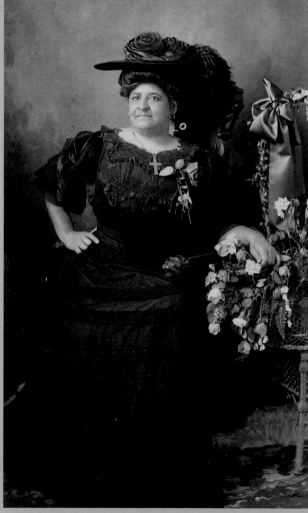

George O. Brown (d. 1910)
32. Portrait of Maggie L. Walker
Gelatin silver print, n.d.
Witherspoon Collection
Valentine Museum, Richmond, Virginia

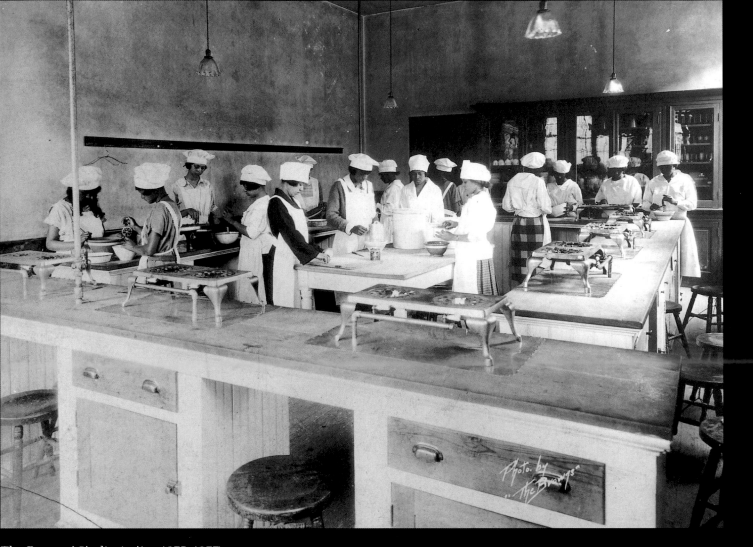

The Browns' Studio (active 1875–1977)

33. Cooking class. Armstrong High School

Gelatin silver print, ca. 1925

Witherspoon Collection

Valentine Museum, Richmond, Virginia

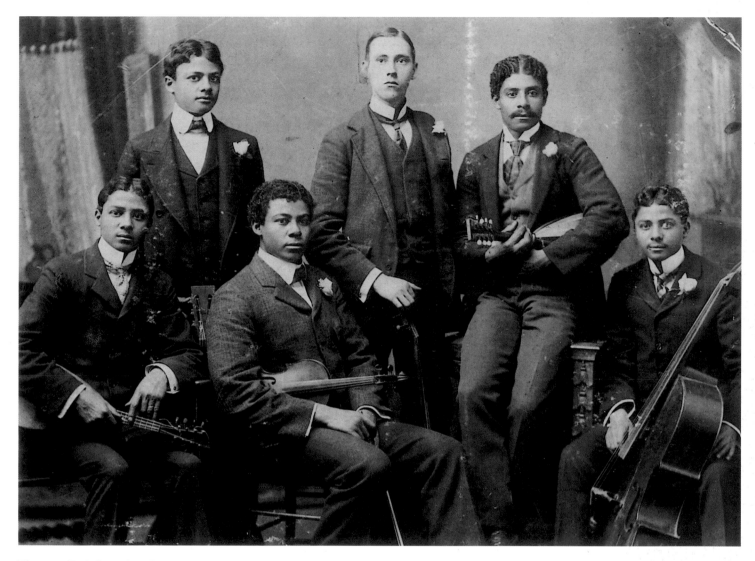

Thomas E. Askew (ca. 1850s–1914)

34. The Summit Avenue Ensemble

Albumen print, ca. 1880s

Isaiah S. Blocker Collection

Courtesy of Herman ("Skip") Mason, Jr.

Digging It Up, Inc., Atlanta, GA

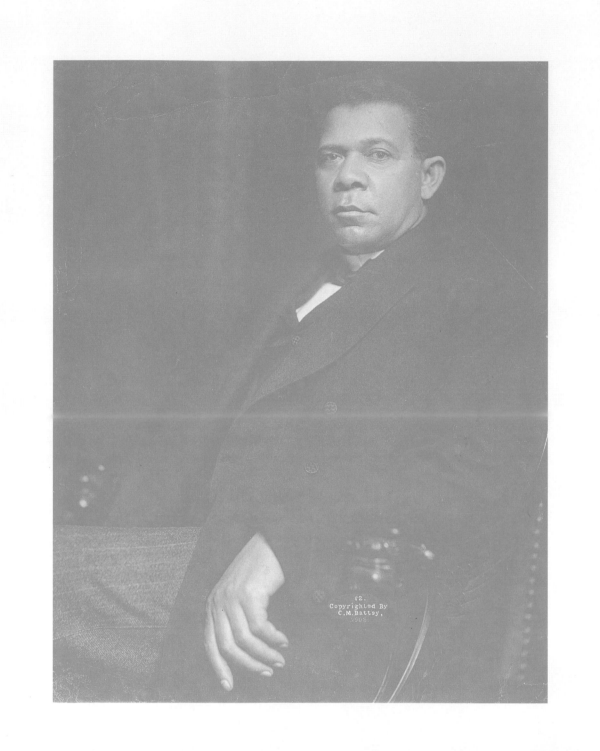

Part II

THE NEW NEGRO IMAGE:
1900 — 1930

etween 1900 and 1940, African-American photographers flourished in businesses established in larger cities. Generally, these photographers were the ambassadors to African-American communities. Through their studio doors came rural, urban, and foreign-born blacks, including members of the working class, such as laborers and domestic workers, as well as artists and educators. Photography did not discriminate, and its low cost made the portrait available to many. At the turn of the century, photography moved more directly into the national psyche. With the discovery of halftone printing, newspapers, journals, and books were able to publish photographic images directly, whereas in the past, etchers had to create a rendering from a photograph. Likewise, courses in photography began being offered in schools and colleges, and correspondence courses were available, as well. It was also a period defined as the time of the "New Negro," reflecting the explosion of creative endeavors that gave national prominence to artists, educators, historians, and philosophers. Historian Cary D. Wintz has noted that the term *New Negro* was first used on June 28, 1895, in an editorial in the *Cleveland Gazette.* The article spoke about the "new class of blacks with education, class, and money that had arisen since the Civil War."[1] Wintz has also noted, "From the moment that this concept originated around the turn of the century there were conflicting interpretations about precisely what the term meant."[2] Black photographers focused their cameras on the black middle class, visualizing the diversity of the black community. This new black intellectual community, which was based in urban cities, emerged at a time when photographers were actively photographing the artistic and political leaders of their communities. The images reflected people who were proud of their race, self-reliant, and demanded full citizenship rights.

Examining this period, scholar Henry Louis Gates, Jr., writes, "The New Negro was a paradoxical metaphor that combined a concern with history and cultural antecedents with a deep concern for an articulated racial heritage that would es-

tablish once and for all the highly public faces of a once-subjugated but now proud race."[3] In 1904, artist and professor John Henry Adams, Jr., proposed his own definition of the term *New Negro*. Gates describes Adams's definition in this way:

> Professor John Henry Adams, Jr., in an essay in *Voice of the Negro* titled "Rough Sketches: A Study of the Features of the New Negro Woman" . . . even went so far as to reproduce images of seven ideal new Negro women so that other women might pattern themselves after these prototypes. One photograph bears the following caption: *An Admirer of Fine Art, a performer on the violin and the piano, a sweet singer, a writer mostly given to essays, a lover of good books, and a home making girl, is Gussie.* . . . The New Negro Man found his identity through individual achievements in work and creative expression: *Here is the real new Negro man. Tall, erect, commanding, with a face as strong and expressive as Angelo's Moses and yet every whit as pleasing and handsome as Rubens's favorite model. There is that penetrative eye about which Charles Lamb wrote with such deep admiration, that broad forehead and firm chin. . . . Such is the new Negro, and he who finds the real man in the hope of deriving all the benefits to be got by acquaintance and contact does not run upon him by mere chance, but must go ever the paths of some kind of biography, until he gets a reasonable understanding of what it actually costs of human effort to be a man and at the same time a Negro.* As he had done in his essay on the New Negro Woman, Adams printed seven portraits of the New Negro Man, so that readers might be able to recognize and emulate him.[4]

Nearly a quarter century later, philosopher Alain Locke (1885–1954) became identified with the phrase in art and literature following the publication of his 1925 essay, "The New Negro." Historian Cheryl Wall has examined Locke's definition. She writes: "To a degree only tacitly acknowledged in reality and in Alain Locke's analysis, New Negro consciousness resulted from 'an attempt, fairly successful on the whole, to convert a defensive into an offensive position, a handicap into an incentive.' "[5]

In contrast to those images made by African-American photographers, a large number of stereotypical images produced by the dominant culture depicted black men, women, and children as caricatures. The architects of the "New Negro" doctrine could not, quite naturally, define the African-American experience through these images, and so there was a concerted effort to find the "self" in visual images. Photographs made by the black studio photographers during this period reveal both the creation of the photographer and the self-image projected by the sitter, producing the articulation of Wall's "offensive position." By exploring the *New Negro* through text and images, black Americans offered a new paradigm through which to explore the significance of the photographic image and further helped to transform the mythos projected on black communities by the larger society.

From the turn of the century through the 1940s, black photographers wit-

nessed the systematic denial of human rights of African-Americans after modest gains during the Reconstruction period. Between 1917 and 1918, some 400,000 black Americans volunteered for a racially segregated army during World War I. Many wanted to prove their patriotism by joining the U. S. armed services. But army officials maintained that black soldiers were ill-equipped and unable to participate in combat, and they assigned blacks to work as laborers and servants for the white officers. Though only 10 percent of the black American soldiers saw combat in France, black photographers' images of World War I servicemen in full dress exemplify their pride and determination.

Beginning immediately after World War I, a large number of black Americans from the rural South moved to urban centers there as well as in the North and Midwest. With this new migration, cities on the East Coast and as far west as Chicago reflected a markedly new complexion. The changing landscape was explored most evocatively through art and photography. Gates writes:

> African Americans reinvented themselves, as more than a million souls removed themselves from the provinces to the metropole, from the periphery to the center, from South to North, from agriculture to industrial, from rural to urban, from the nineteenth century to the twentieth. The greatest transformation of all, of course, was a "new" Negro culture, the outcome of the exchange of traditional southern and northern black cultures and the resulting synthesis of the two.[6]

PHOTOGRAPHER: ADDISON N. SCURLOCK

This synthesis was a crucial part of the new imagery created by photographers such as C. M. Battey (1873–1927), Arthur P. Bedou (1882–1966), Villard Paddio (ca. 1894 1947), Addison N. Scurlock (1883 1964), Scurlock Studios (1911–1994), Florestine Perrault Collins (1895–1987), Herbert Collins (active ca. 1890–1920), Perry A. Keith (active 1900–1910), James VanDerZee (1886–1983), King Daniel Ganaway (1883–?), James Latimer Allen (1907–1977), Elise Forrest Harleston (1891–1970), Eddie Elcha (active ca. 1900–1930s), Prentice Herman Polk (1898–1984), Morgan Smith (1910–1993) and Marvin Smith (b. 1910), Richard S. Roberts (1881–1936), Robert McNeill (b. 1917), Andrew T. Kelly (ca. 1890–1965), Paul Poole (1886–ca. 1955), Lucius S. Henderson (1886–1957), Richard Aloysius Twine (1896–1974), Ellie Lee Weems (1901–1983), and countless others. These photographers challenged the popular cultural myths concerning early-twentieth-century African-Americans' visual culture. Their photographs are models of the New Negro vision that Locke, Adams, and others described. As Cheryl Wall writes:

> The New Negro was self-defined; indeed, "self" appears as a hyphenated prefix in the essay eleven times in thirteen pages. Self-understanding, self-direction, self-respect, self-dependence and self-expression supplanted the self-pity that is the sole emotion with which the Old Negro seems to have been entitled. Ironically, the new positive sense of self was motivated by a "deep feeling of race," not altogether unlike the one that had inspired the self-hatred it replaced.[7]

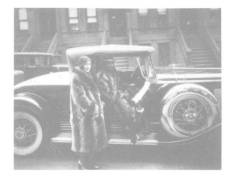

PHOTOGRAPHER: JAMES VANDERZEE

Challenging the New Negro vision during this period were the postcards, advertisements, and popular cultural artifacts of African-Americans produced by the dominant culture which were crude, demoralizing, and racist. As Jan Nederveen Pieterse observed: "In most product advertising, blacks are shown as producers (workers, cooks) or servants, or as decorative elements, but *not* as *consumers* of the product."[8] The camera in the hands of black photographers during the first part of the twentieth century was essential in countering this stereotyping of black society. Cultural critic bell hooks writes:

> The camera was the central instrument by which blacks could disprove representations of us created by white folks. . . . For black folks, the camera provided a means to document a reality that could, if necessary, be packed, stored, moved from place to place. It was documentation that could be shared, passed around. And, ultimately, these images, the worlds they recorded, could be hidden, to be discovered at another time.[9]

Furthermore, hooks suggests that the fact that photographs could be stored, shared, and passed around echoes the oral tradition of preserved memory in the black culture. More important, her assertion that "these images, the worlds they recorded, could be hidden, to be discovered at another time" indicates that photographs could encourage future generations to reexamine the past with a more discerning eye. In addition, hooks demonstrates that the black photographers' vision was a powerful tool used to challenge the blatantly commercialized stereotypical cultural products that portrayed black Americans. Their vision demonstrated that black Americans in the early twentieth century were as multidimensional as everyone else.

Through text and images, black photographers, artists, and intellectuals expressed their frustrations and exposed the injustices their communities experienced. They reflected and represented the dreams and ideals of the black working class by making socially relevant and class-conscious images of the African-American community. There is a stylish, cosmopolitan quality to the photographs of this period. Northern photographers, like VanDerZee, the Smiths, and Elcha, documented the black immigrants from the Caribbean and African-Americans from the rural South, and forever changed the visual representation of the community. Both the northern and southern photographers, like Battey, Bedou, Scurlock, Poole, Paddio, and Freeman, depicted how migrant and immigrant newcomers to urban areas became middle-class citizens with aspirations of economic success, educational advancement, and lives of leisure. Photographs clearly documented how diverse citizens met their responsibilities by attending political rallies, church events, funerals, and cultural events; these images further illustrated the economic and political success of these struggling residents.

Although he was born in Augusta, Georgia, Cornelius Marion Battey lived most

of his life in the North. By 1900, he had established his reputation as a photographer in portrait studios in Cleveland and New York City. Known for his early portraits of musicians, black statesmen, and members of the Masonic temple, Battey was also a noted educator. In 1916, he was hired to direct the Photography Division at the Tuskegee Institute in Alabama. According to author Elizabeth Brayer:

> In 1916 trustee William Schieffelin suggested that a department for teaching photography be established at Tuskegee as a "new outlet for creditable employment of talented colored men and women." As head of its new photography school, Tuskegee officials had in mind "C. Marion Battey, a colored man with good education and character, [who] has had experience in various branches of photography and is familiar with the technical work, legal and commercial photography, as well as portraiture and other artistic branches."[10]

Battey exhibited his portraits and won awards in both American and European galleries. An editorial in the May 1927 issue of *Opportunity* described Battey's life "as one increasing struggle to liberate, through a rigid medium, the fluid graces of an artist's soul. For paint brush and palette, he used a lens and shutter."[11] He revealed the remarkable variety of his sitters' characters in his portraits. Between 1915 and 1927, Battey's photographs were published on the covers of the magazines *Crisis*, *The Messenger*, and *Opportunity*. In 1917, *Crisis* highlighted Battey in its "Men of the Month" column as "one of the few colored photographers who has gained real artistic success."[12]

Battey produced the most accomplished portraits of African-American leaders in the late nineteenth and early twentieth centuries. His photographic portraits of black statesmen and writers such as Frederick Douglass (1817–1895), John Mercer Langston (1829–1897), Booker T. Washington (1856–1915), W. E. B. Du Bois (1868–1963), and Paul Laurence Dunbar (1872–1906) were produced in the early 1900s as a series entitled *Our Heroes of Destiny*, later retitled, *Our Master Minds*. The images, printed as photogravure and in postcard format, were sold throughout the country. The collective visual message was that of racial pride and dignity.

Arthur P. Bedou was born in New Orleans, the city where Jules Lion had gained prominence, and was listed in the city's directory as a photographer for more than fifty years. In 1922, he became cofounder of the People's Life Insurance Company of Louisiana. Recognized as an artist and journalist, Bedou won awards for his work, which was published in numerous periodicals. He is also known for his portraits of jazz musicians and for documenting the public and private life of Booker T. Washington, then president of Tuskegee Institute. A Bedou photograph of Washington speaking before a large crowd draws the viewer to Washington's gesture and the audience's response. Such striking crowd scenes offer a contemporary viewer the opportunity to relive the event visually. Another photo-

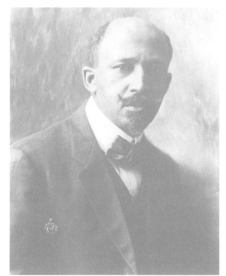

PHOTOGRAPHER:
C. M. (CORNELIUS MARION) BATTEY

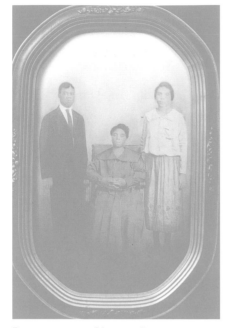

PHOTOGRAPHER: VILLARD PADDIO

graph of Washington seated on his horse shows the leader in front of his home, an unusual private moment documented by this photographer.

Photo historians Girard Mouton and Alma Williams write that Bedou "adds a touch of romanticism enhancing a style of classic composition, [he] showed the serious self-perception that jazz musicians brought to bear when they named their groups 'orchestras' rather than 'bands.' "¹³ Bedou also photographed local rallies, celebrations, individual and school portraits, and the Mississippi and Louisiana countrysides. *The Louisiana Weekly* noted, "In the area of photography, Mr. Bedou . . . was considered the 'dean' of professional photographers, and his work was sought by all races and stations in life. Photography to him was a thing of art and his works are still considered as hallmarks."¹⁴

Also known for his photographs of New Orleans jazz musicians, Villard Paddio was a student of Arthur Bedou. In 1917, he owned a studio in the Treme district, a black section of New Orleans. Paddio's most significant photographs are of jazz trumpeter and singer Louis Armstrong (1901–1971). A popular photographer, Paddio was hired to photograph Armstrong when he was a young musician. Mouton and Alma Williams write:

> The first time he photographed Armstrong was when Captain [Joseph] Jones hired him for the Waif's Home photo session in 1912, when young Louis was a member of the band. Later, as a young adult, Armstrong took his mother Mayann, and his sister, Beatrice to Paddio's studio for a family portrait.¹⁵

Paddio's hand-colored portrait depicts a young musician surrounded by proud family members. The photograph was taken just before Armstrong moved to Chicago, and as his biographer Marc Miller points out the significance of the image: "[It] is the only surviving portrait of Armstrong's family."¹⁶ The photograph reinforces a quote from Armstrong published in *Life* on April 16, 1966: "My father left home when I was real little. I had a great mother. She didn't have much power, but she did all she could for me."¹⁷

Herbert Collins was active in Boston, Massachusetts, in the early 1900s. Collins photographed Boston's black community from the turn of the century through the early 1920s. His photographs transcend straight documentation; one image shows two children posed in front of the family house. The girls, wearing white dresses, stand in front of a black wrought-iron fence, whose form is mimicked in the girls' hair ribbons and in the fence rows. Two other Collins photographs, also taken outside, convey the photographer's concern with recording a moment in time. In one, possibly a self-portrait, a man wearing a bowler hat and holding a baby sits in the yard of his home. Depicted in his garden, which is in full bloom, he appears to be a proud parent. A sense of pride is also conveyed in Collins's portrait of the three men in formal dress. Incorporating architectural detail and other framing devices, such as posing the group of the men outside of the brick building, the photographer makes reference to the group's

connection with the building, possibly their organization's headquarters or one member's family home. It also suggests the importance of social groups and the organizations of Freemasons that thrived in Boston's black community during this period.

Perry A. Keith was an active portrait photographer working in Atlanta during the first decade of the twentieth century. Unfortunately, his studio was short-lived. His photograph of Frank and George Powell, one man leaning on a cane and the other holding what appears to be a diploma, is an example of Keith's attempt to create mood and character in his portraits. The black community in Atlanta during this period thrived as a result of the concerted efforts of individuals and religious and fraternal organizations. Portraits of young men and women holding their diplomas exemplified the community's concern with self-help through education.

Born in Murfeesboro, Tennessee, King Daniel Ganaway practiced photography in Chicago from 1914 through the 1930s. His subjects ranged from the crowded waterways of the Chicago River to sentimental portraits of family and working-class life, similar to works created by European painters in the late nineteenth and early twentieth centuries. Using high contrasts of light and shade and a soft focus, Ganaway romanticized the industrialization of America's port cities.

Ganaway's talent developed late in life. Arriving in Chicago in 1914, he worked as a butler for one of Chicago's wealthiest families before becoming interested in the art of photography. He was a serious student and spent all his spare time experimenting and observing: "I see pictures and designs in everything . . . as I am riding on a streetcar, I am constantly watching the changing lights and shadows along the streets. Using the car as a frame, I compose pictures. . . ."[18] Nonetheless, Ganaway felt that the subjects of his pictures were uninteresting to other photographers. He was not recognized in any of the well-known photographic journals, such as Alfred Stieglitz's *Camera Work*, or by groups such as the Photo-Secession, although his intent and style aligned him with the Pictorialist movement.

Ganaway did have admirers, however. In 1918, he received first prize in the John Wanamaker Annual Exhibition of Photographs, and his work was shown frequently at the Harmon Foundation's annual exhibitions. In 1928, Alain Locke characterized Ganaway as a Pictorialist and as a "most promising and serious craftsman."[19] He also participated in the International Photographic Salon at Chicago's 1933 A Century of Progress Exposition and at the New Jersey State Museum in Trenton. Ganaway was intrigued with industrial life on the waterfront and equally fascinated with water, massive structures, angles, and elements of mysticism. Recognition of his photographs by the Chicago community eventually led to a position with a Chicago newspaper, *The Bee*, where he produced a weekly rotogravure section depicting scenes and events in the Chicago area.

Addison Scurlock of Washington, D.C., was Howard University's official photographer. He opened his studio in 1911, which he operated with his wife and sons until his death in 1964. According to historian Jane Freundel Levey:

PHOTOGRAPHER: KING DANIEL GANAWAY

The Washington, D.C. that Addison Scurlock began to photograph had a large black community (one-third of the total population) with strong institutions and long traditions. This black community counted many generations of residence in the capital area and ancestors who had lived as free people in the years before the Civil War.[20]

Addison's sons, Robert (1916–1994) and George (b. 1919), worked with him in the Scurlock Studios from the 1930s until his death in 1964 and continued the studio until Robert's death thirty years later. When both sons were high school students, they apprenticed with their father, receiving extensive training in portrait photography under his direction. While Addison did a substantial amount of studio photography, Robert and George were drawn to news photography. Their journalistic photographs appeared in black newspapers and magazines across the country. During the 1940s, Scurlock Studios worked diligently to increase the visibility of black intellectuals, artists, musicians, and politicians in the Washington, D.C., area. The studio also documented community life: activities at Howard University, conventions and banquets, sorority and social club events, dances, weddings, cotillions, and local business affairs. In 1948, Robert and George established the Capitol School of Photography, which opened its doors to World War II veterans and others who wanted to learn photography. They offered both day and evening classes to hundreds of students until the school closed in 1952. The Scurlocks' portraits, for the most part, were of images of self-empowerment and self-determination. They paralleled Locke's New Negro ideal.

Looking at Scurlock's photographs and others from this period, one can see an African-American community that is spiritually and economically healthy, diverse, and productive. As Levey states, "Perhaps the most distinctive hallmark of the Scurlock photograph is the dignity, the uplifting quality, of the demeanor of every subject, captured by photographers who clearly saw each one as above the ordinary."[21] This was a radical notion, considering that many of these photographs were created within sixty years of the abolition of slavery.

James VanDerZee, undoubtedly the most well known of the black studio photographers, captured the spirit and life of New York's Harlem for more than fifty years. A number of VanDerZee's photographs, made of family and friends, exemplify the Pictorial aesthetic—the dominant mode of fine-art photographic expression at the turn of the century—and contain the quiet and meditative quality that is its hallmark. Remarkably, however, VanDerZee had no direct contact with any of the artistic movements of the era. The formal construction of his portraits and his use of props (including simulated fireplaces, cardboard dogs, and elaborately painted backdrops) also suggest that his work was rooted in the exaggerated sentimentality of Pictorialism. This is most apparent in his images of funerals, where he often created memorial allegories by juxtaposing images of the deceased's family members with biblical figures in multiple-image pho-

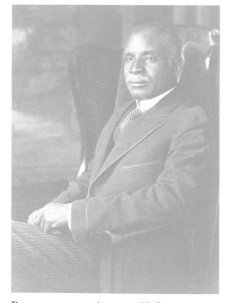

PHOTOGRAPHER: ADDISON N. SCURLOCK

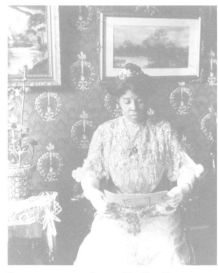

PHOTOGRAPHER: JAMES VANDERZEE

tographs. His skillfully manipulated photographs reflect the communal significance of African-American spirituality and the concept that the deceased is ever present in the daily activities of the living. Missing from VanDerZee's best works is the forced sentimentality that makes many Pictorial works seem simplistic and contrived.

Despite their romanticism, VanDerZee's photographs were based in the political and social upheaval of the early twentieth century. His images define a people and culture in transition and reflect their subjects' sense of identity and self-consciousness. In one of VanDerZee's best-known works, created in 1932, a couple are dressed in fur coats and hats; the man sits inside an expensive shiny car, while the woman stands nearby. The slick lines of the car fill the picture frame, and the car's door is ajar, seemingly welcoming the viewer. The woman is pictured in a full-length pose, gazing at the camera. This image of African-American material success implies that the migrant's northern experience has been positive and productive; it depicts pride, achievement, and ownership. Observing how photographs could be used to change or infer an experience of success, short story writer Edward P. Jones wrote about a photograph of his mother:

> My mother was no different from thousands upon thousands of other poor blacks who, in the first decades of the twentieth century, left peasant parents and grandparents and a southern history that was born in chains to come to northern cities—to Detroit, to Chicago, to New York, to Baltimore, to Boston, to Washington—to those places where they hoped to claim as their own a bit more of the sun, where a person could work and walk with a more straightened back; places where white people would have less say about how the sun was doled out and about how far a person should bend her back when she picked tobacco or walked down a one-street, two-dog town.[22]

It is such visualizations, both fictive and real, of middle-class life that give VanDerZee's images much of their power to enchant and engage the viewer. His most ambitious portraits utilized the conventions and forms of nineteenth-century studio photography. His studio portraits were formal and carefully composed works, in which the subjects often appear both heroic and self-aware. His use of nineteenth-century formalist compositional elements to photograph twentieth-century subjects was an elegant and intelligent way of devising a revisionist and optimistic overview of the African-American experience.

Like VanDerZee, Edward "Eddie" Elcha drew inspiration from the rich imagery of Harlem. He photographed the nightlife there, particularly its theatrical figures. Little is known of his career, other than his collaboration with James VanDerZee in the construction of painted backdrops. A painter as well as a photographer, Elcha's interest in environmental and atmospheric portraiture is evidenced in his work. In one dramatically posed photograph of two dancers frozen in motion, the viewer can easily identify with the subjects. The painted

backdrop, a landscape, heightens the composition's theatricality. Another striking image by Elcha is of a partially nude model draped in velvet and holding a small whip. Again, the dramatic landscape backdrop enhances the portrait. Though contrived, Elcha's elegant portraits create a tension between biography and fiction.

James Latimer Allen also produced character studies of African-American men, women, and children living in Harlem. He published his work in art journals and exhibited it in galleries. In addition, he photographed such writers of the period as Alain Locke (1885–1954), Langston Hughes (1902–1967), Countee Cullen (1903–1946), and Claude McKay (1890–1948). Born in New York City, Allen developed an interest in photography in grade school. A member of a camera club called the Amateur Cinema League, Allen attained public recognition at an early age. During the 1920s, there were many camera clubs in the New York area, where members came together to discuss the latest techniques in photography. While a student at the De Witt Clinton High School, Allen served as an apprentice with a large and well-known New York photographic firm, Stone, Van Dresser and Co., receiving substantial training in portrait and still-life photography. Allen received his first critical review in 1927 when a group of young black artists in the New York area organized a small exhibition of their work, which received "very favorable press comments."[23] Allen's portraits of artists are character studies, moody and reflective; he described them as "portraits of distinction." In 1928, Langston Hughes summed up Allen's work in this manner:

> . . . to [Allen] his work is an art. Through the medium of the camera, and with Negro subjects, he is seeking to achieve beauty. So few photographers know how to capture with the lens the shades and tones of Negro skin colors, and none make of it an art, since the death of the late Mr. Battey. This young man's work will stand comparison with that of any of the best photographers in the country—and with racial subjects. I know of none to surpass him. . . . So few of the young Negro artists in any line care about bringing to light the beauties that are peculiarly racial. . . . Mr. Allen does desire to do this, to capture beauty and to glorify the race.[24]

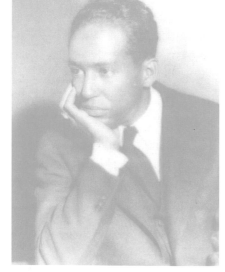

PHOTOGRAPHER: JAMES LATIMER ALLEN

Continuing a New Orleans tradition begun by Jules Lion and Arthur Bedou, Florestine Perrault Collins owned and operated a studio there from 1920 to 1949, photographing families and visiting soldiers. One of the earlier female photographers to gain prominence, she opened her first studio in the living room of her family home, experimenting early on by making portraits of her family. In 1909, she began working as a photographer's assistant. Her biographer, Arthé Anthony, writes that her employers often left her alone in the studio. Collins remembered:

> I worked for a studio on Canal and St. Charles Streets. This man was so lazy that he would go out and want to go to a show. So he saw that it was to his advantage to teach

PHOTOGRAPHER: P. (PRENTICE) H. POLK

me how to make pictures so that he could go and leave me in charge, which he did. . . . He saw that I was apt and learned easily. He left me in charge. . . . And that's how I began to pick it up, I began to learn. In fact, he started me doing the finishing part of the work, the developing, and the printing. . . . Then finally when he got pushed he started teaching me how to take pictures.[25]

According to Anthony, Collins, a "creole of color," would sometimes be mistaken for white. Collins would use this misidentification to her benefit; she knew that a black woman would not have had the opportunity to work as a photographer's assistant in the South. "If they thought that I was colored they probably wouldn't have allowed me to take pictures,"[26] she recalled. Later, she supported herself full-time as a photographer, making sensitive and delicate portraits of her family as well as of members of the New Orleans community in general.

Prentice Herman Polk, one of C. M. Battey's students at Tuskegee Institute, opened his first studio there in 1927. Soon afterward, he was appointed to the faculty of Tuskegee Institute's Photography Department, where he photographed such prominent visitors as Langston Hughes and Zora Neale Hurston (1903–1960). Polk began a special project photographing the former enslaved residents in the Tuskegee community. Though his portraits had a limited tonal range, they revealed a great sensitivity and clarity on the part of the photographer. His intent was to capture the character of these elders, and he called these portraits his *Old Characters*. Meredith K. Soles, an art historian, writes:

> Polk strove to maintain an air of authenticity and directness with his "Old Character" photographs. He did not evidence any concerns with altering their appearances or act to soften their weather-worn complexions with retouching. In fact, Polk sought them out (and not they him) because he found comfort in their naturalness.[27]

Polk's portraits offer a revised paradigm that allows the contemporary viewer to assess how culture and identity were manifested in the Tuskegee community, where rural life existed within the confines of a college campus. One of his most discussed images is entitled *The Boss*. The photograph is of a woman standing facing the camera with her hands on her hips. In this superbly constructed pose, Polk allowed his subject to project her own image. Wearing a tattered sweater, an apron, and a scarf, her body language and facial expression represent a woman in control of her identity. According to art historian and photographer Amalia Amaki:

> Polk called *The Boss* his "front-runner." It is his most renowned image, one which is both aesthetically and psychologically provocative. . . . Her assertive posture, dress, and expression appear completely natural, even in relation to the solid black field around her. . . . Like all of Polk's portraits of rural models, *The Boss* reflects

PHOTOGRAPHER:
RICHARD ALOYSIUS TWINE

the photographer's overarching commitment to capturing the uniqueness and integrity of each subject, and his insistence on using shadow and light to striking perfection.[28]

His portraits of the students and their families reflect his interest in the sculptural form of the human body and middle-class life in Tuskegee.

Elise Forrest Harleston, another Battey student, worked in Charleston, South Carolina, with her husband, genre painter Edwin Harleston. Harleston studied at Tuskegee in 1921. She later opened a photographic studio with her husband, who also had a painting studio in their home. Harleston made photographic portraits for her husband's paintings. Her own work consisted of portraits of the older women and men living in Charleston.

Richard S. Roberts worked as a stevedore and, later, as a custodian at the Fernandina, Florida, post office. He studied photography through correspondence courses and books and opened his first studio in his home in Fernandina with the assistance of his wife, Wilhelmina Williams Roberts. After he moved to Columbia, South Carolina, he opened a larger studio downtown while working at night as a custodian in the post office there. Roberts advertised that his studio took superior photographs by day or night:

> To those who desire photographs made of parents and grandparents but can't persuade them to visit the studio, we say: Leave them at home. They probably love their home surroundings. Engage us to make that sitting at home. We will respond with pleasure.[29]

With his wife acting as assistant, Roberts traveled throughout South Carolina in the 1920s and 1930s, photographing church groups, schools, and community organizations. He also made portraits of the dead for family members. Roberts operated the Roberts' Studio until his death in 1936.

Richard Aloysius Twine lived and worked in St. Augustine, Florida, from 1922 to 1927. Twine photographed in Lincolnville, the black section of the city. Twine's photographs of that community preserve a visual record of an Emancipation Day celebration, along with interior shots of a home belonging to a middle-class black family. His portraits of women, such as that of Mary "Mae" Martin standing in the living room of her home on Bridge Street, are elegant examples of how the arts, both visual and performing, are preserved in a typical middle-class home. More importantly, it is an "insider's" depiction of this lifestyle. The piano is laced not only with photographs of family members but with sheet music, as well. Photographs and paintings are hung on walls and placed on an easel. Books and ceramic vases are delicately reflected in the morning light.

Two examples of community spirit photographed by Twine include a group portrait of the Roman Catholic Order of the Knights of St. John in full dress with

swords, epaulets and special headgear and a street scene of an Emancipation Day parade. Anthropologists Patricia Griffin and Diane Edwards write that "Lincolnville's essential unity was symbolized by everyone joining together in the big event of the year, Emancipation Day."[30] Black communities around the country commemorated the end of slavery as a major holiday. This celebration probably marked the sixtieth anniversary of emancipation. Twine's subjects appear at ease with the photographer, they engage with him as he attempts to capture their characters.

Andrew T. Kelly was known as the "Dean of Negro Photographers" in Atlanta, Georgia. He also studied photography at Tuskegee and later moved to Atlanta, opening up a studio, where he photographed his clients; he also went to homes and churches in the area to photograph on location. He worked for the black press, as well, where he published his photographs as weekly rotogravures.[31] One of Kelly's photographs of a home interior depicts the moment before dinner. The hosts stand while the guests are seated; the unlit candles and floral arrangement, along with the silver trays, carpet, and lace tablecloth, signify that element of black aristocracy as defined in Adam's sketch of the New Negro. Atlanta historian Skip Mason wrote that "to go to Kelly's studio on the third floor of the Herndon Building, was 'big cotton'," the vernacular term for high society. Mason says that Kelly's reputation as an outstanding photographer was clearly evident throughout the Atlanta community. Each year, Kelly's Studio would photograph hundreds of individuals, groups, and organizations.[32]

Paul Poole, also a prominent Atlanta photographer, opened his studio in the 1920s. An active and engaging photographer, he was known as the "Official Photographer of all Colored Colleges in Atlanta" and publicized that his "success in making portrait photographs of remarkable quality [was] due to the characteristics of our subjects."[33] Poole was particularly interested in portraiture, photographing many of the middle-class families in Atlanta. His delicate and fanciful portrait entitled *Southern Belles* depicts five young women possibly posing before a cotillion or graduation ceremony. Fantasy and class status were stressed in his portraits.

Ellie Lee Weems was born in McDonough, Georgia, and he, too, attended Tuskegee Institute, studying with C. M. Battey. Moving to Atlanta in 1922, Weems soon opened a studio. He later moved to Jacksonville, Florida, where he operated a studio there for more than fifty years. His photographs range from rural scenes to black baseball leagues to family celebrations. A sense of pride, ownership, and the importance of educational and business achievements are conveyed in Weems's works: A couple standing on the steps of their home, a woman reading a book, and three nursing school graduates are symbolic of his images.

A significant number of black photographers played an important role in making the black community visible in the first two decades of the twentieth century. They played a crucial role in examining and reinterpreting the dreams and ideals of both the black intelligentsia and the working class by making socially relevant

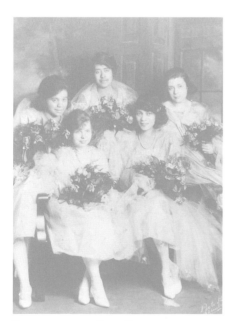

PHOTOGRAPHER: PAUL POOLE

48

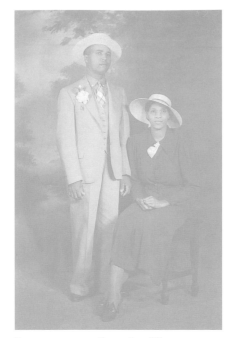

PHOTOGRAPHER: ELLIE LEE WEEMS

and class-conscious images of the African-American community. Their work not only counters the negative black imagery typically promoted in popular culture[34] but also documents a vibrant family life and a growing middle class. This extraordinary body of work transcends the subjugated black imagery and forces all Americans to reexamine history as they learned it. Not only aesthetically significant, these images do what only the finest photography can achieve: they create a new awareness or historical consciousness that has the power to rewrite history itself. No doubt this informed consciousness possessed an undeniable and collective power. As art historian Camara Holloway argues about James Latimer Allen's photographs (which I would apply to the photographers of this period):

> Producing photographs that glorified the black body and hailed black achievement was a transgressive act in Allen's day. His image of the New Negro destroyed the illusions required to justify segregation. . . . Blacks needed a means to affirm themselves, and the portrait as symbol provided a critical psychical armature upon which to build a valorized identity. Photography and other means of publicly displaying this identity formed a wellspring for blacks to draw upon that remains central to how they envision themselves today.[35]

C. M. (Cornelius Marion) Battey (1873–1927)
35. Mrs. Booker T. Washington (Margaret Murray ca. 1865–1925)
Gelatin silver print, ca. 1914 (photogravure, original)
Biography File, Prints and Photographs Division
Library of Congress
LC-USZ621683

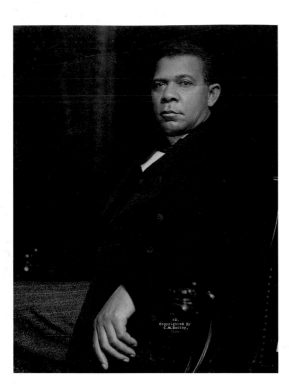

C. M. (Cornelius Marion) Battey (1873–1927)
36. Portrait of Booker Taliaferro Washington (1856–1915)
Gelatin silver print, ca. 1908 (photogravure, original)
Courtesy of Dr. James K. Hill, Washington, D.C.

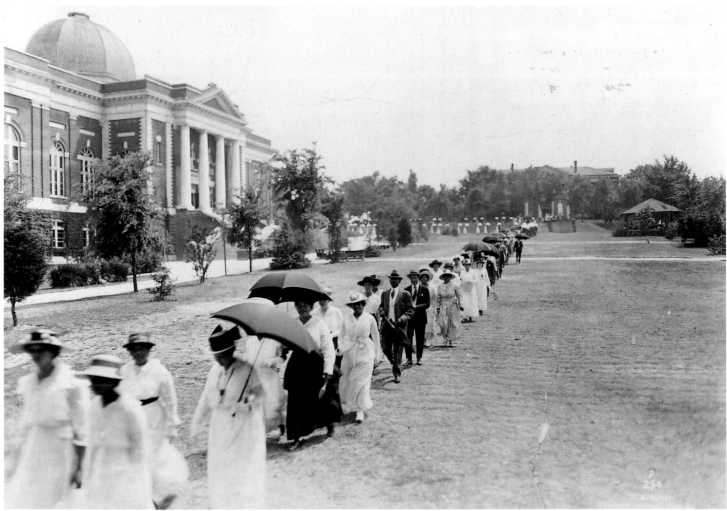

C. M. (Cornelius Marion) Battey (1873–1927)
37. Commencement Sunday, May 20
Gelatin silver print, 1917
Booker T. Washington Collection
Prints and Photographs Division
Library of Congress
LC-USZ62-12167

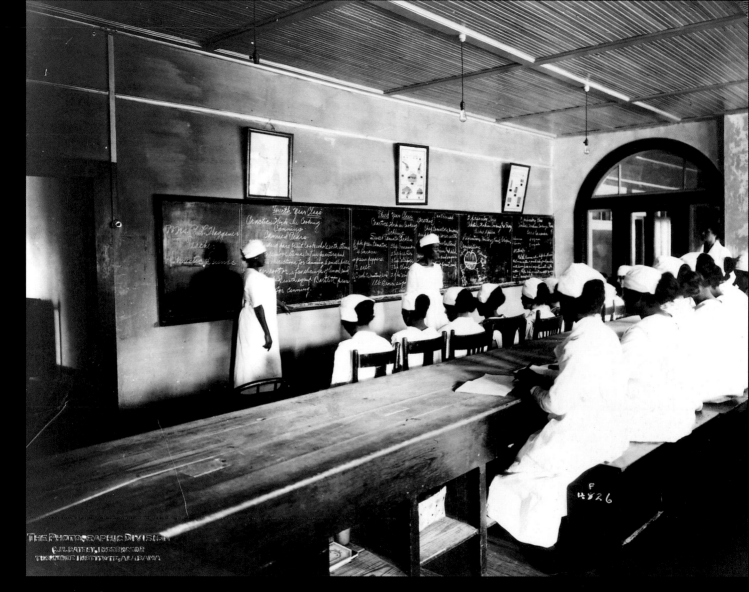

C. M. (Cornelius Marion) Battey (1873–1927)

38. Domestic Services Class, Tuskegee Institute

Gelatin silver print, ca. 1917

Booker T. Washington Collection

Prints and Photographs Division

Library of Congress

LC-USZ62-121681

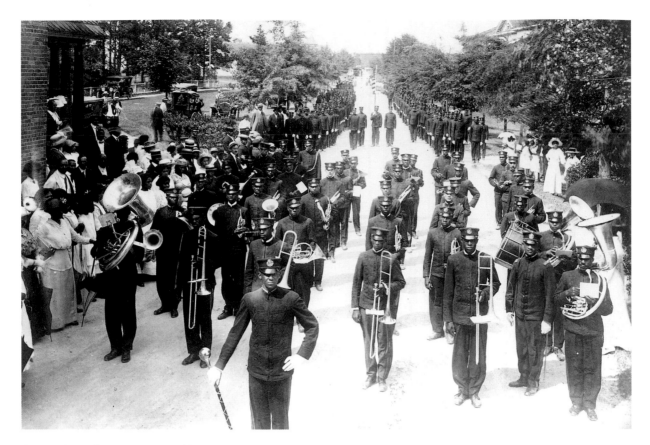

C. M. (Cornelius Marion) Battey (1873–1927)
39. Commencement Sunday, May 20
Gelatin silver print, 1917
Booker T. Washington Collection
Prints and Photographs Division
Library of Congress
LC-USZ62-25650

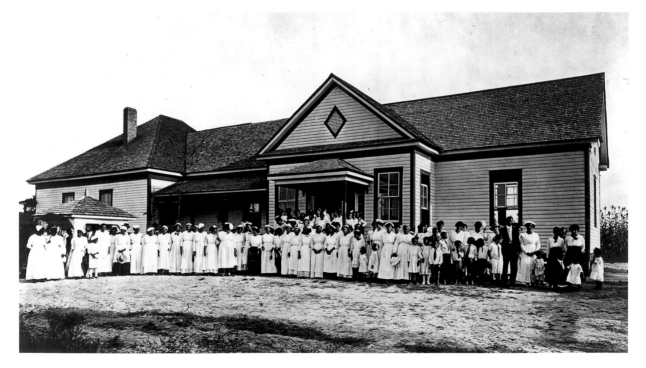

C. M. (Cornelius Marion) Battey (1873–1927)
40. New Rising Star School, Macon County, Alabama
Gelatin silver print, n.d.
Booker T. Washington Collection
Prints and Photographs Division
Library of Congress
LC-USZ62-121678

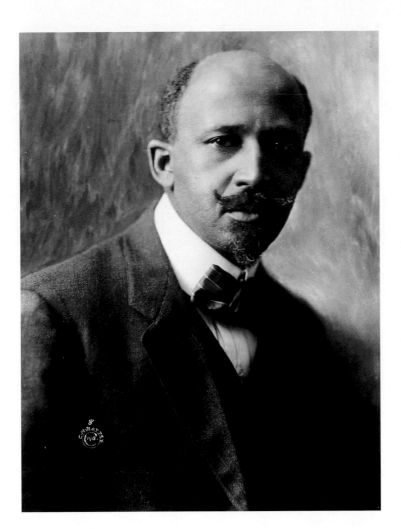

C. M. (Cornelius Marion) Battey
(1873–1927)
41. Portrait of W. E. B. DuBois (1868–1963)
Gelatin silver print, 1918 (photogravure, original)
Biography File, Prints and Photographs Division
Library of Congress
LC-USZ62-16767

C. M. (Cornelius Marion) Battey (1873–1927)
42. Portrait of Frederick Douglass (1817–1895)
Gelatin silver print, ca. 1895 (photogravure, original)
Prints and Photographs Division
Schomburg Center for Research in Black Culture
New York Public Library

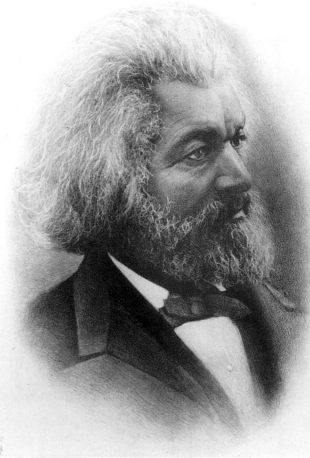

A. (Arthur) P. Bedou (1882–1966)
43. Booker Taliaferro Washington (1856–1915)
Last southern tour in Shreveport, Louisiana
Gelatin silver print, 1915
National Portrait Gallery
Smithsonian Institution

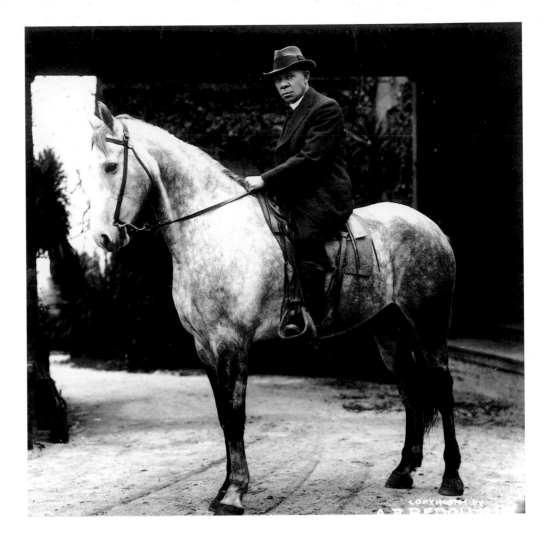

A. (Arthur) P. Bedou (1882–1966)

44. Booker Taliaferro Washington
(1856–1915)

Portrait of the educator on his horse

Gelatin silver print, 1915

Biography File

Prints and Photographs Division

Library of Congress

LC-USZ62-7354

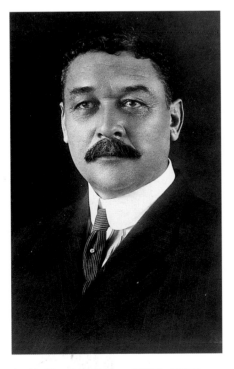

A. (Arthur) P. Bedou (1882–1966)

45. Portrait of Warren Logan

Gelatin silver print, n.d.

Alain Locke Collection

Prints and Photographs Department

Moorland-Spingarn Research Center

Howard University, Washington, D.C.

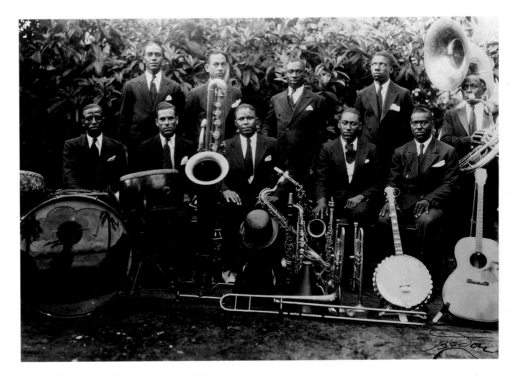

A. (Arthur) P. Bedou (1882–1966)

46. The Louisiana Shakers

Gelatin silver print, ca. 1920

Hogan Jazz Archives, Howard-Tilton Memorial Library

Tulane University, New Orleans, Louisiana

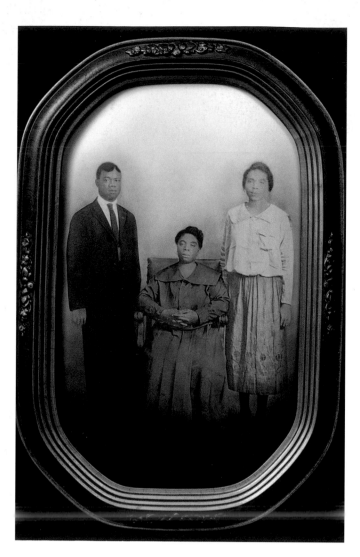

Villard Paddio (ca. 1894–1947)
47. Portrait of Louis Armstrong, his mother, Mayann,
and sister, Beatrice
Gelatin silver print, 1922
Louis Armstrong House Archives
Queens College, City University of New York

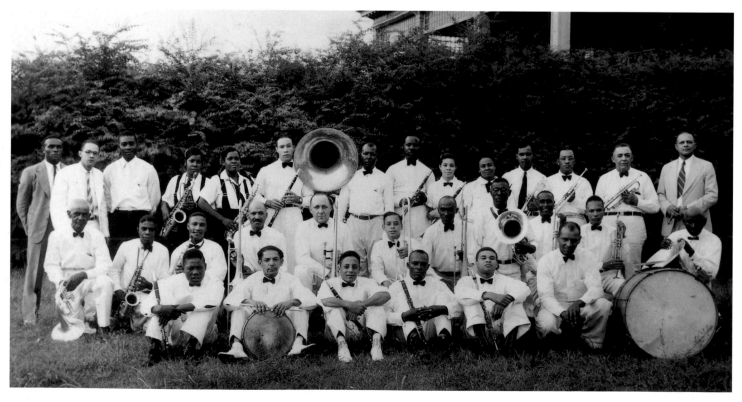

Villard Paddio (ca. 1894–1947)
48. Portrait of Professor Henry Pritchard's Tonic Triad Band
Gelatin silver print, 1928
Hogan Jazz Archives, Howard-Tilton Memorial Library
Tulane University, New Orleans, Louisiana

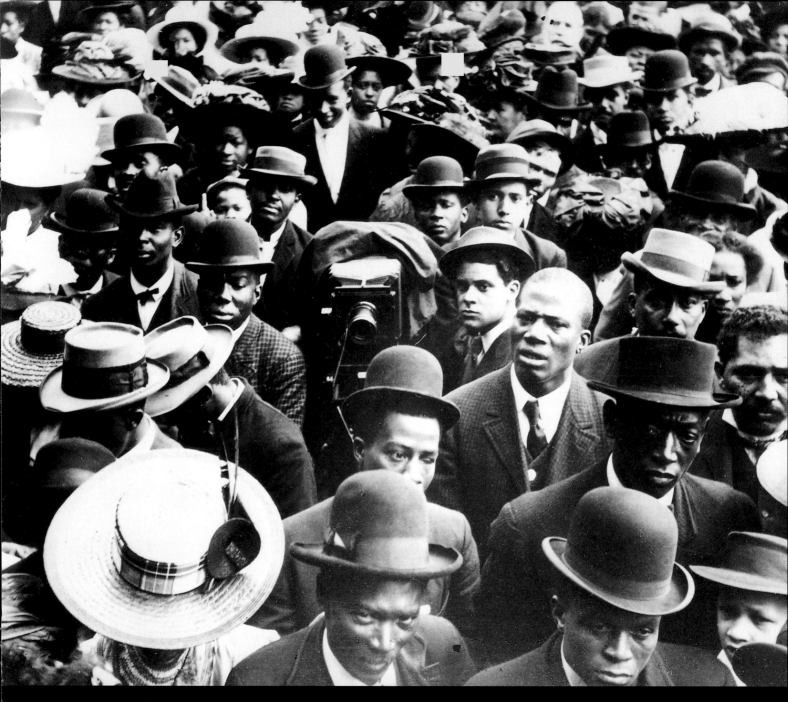

A. (Arthur) P. Bedou (1882–1966)
49. View of crowd with photographer in center

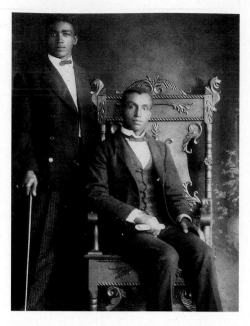

Perry A. Keith, Auburn Avenue Studios
(active 1900–1910)
50. Portrait of Frank and George Powell
Gelatin silver print, ca. 1906–1909
Ellen J. Hailey Collection
Courtesy of Herman ("Skip") Mason, Jr.
Digging It Up, Inc., Atlanta, Georgia

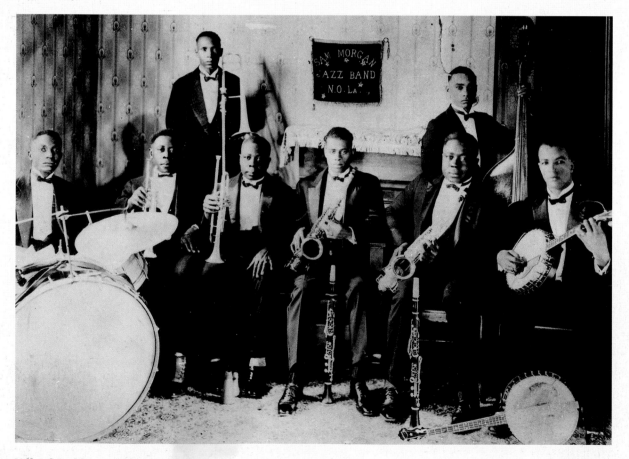

Villard Paddio (ca. 1894–1947)
51. The Sam Morgan Jazz Band
Gelatin silver print, ca. 1928
Hogan Jazz Archives, Howard-Tilton Memorial Library
Tulane University, New Orleans, Louisiana

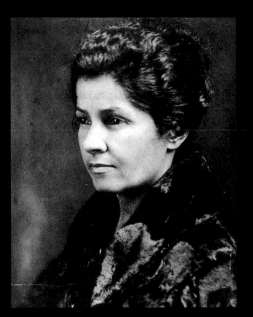

Florestine Perrault Collins
(1895–1987)
52. Emily Jules Perrault (Collins's mother)
Gelatin silver print, ca. 1920s
Courtesy of Arthé A. Anthony, Pasadena,
California

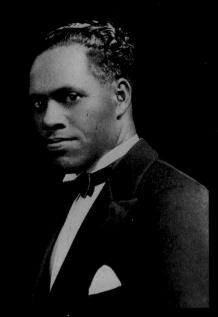

Florestine Perrault Collins
(1895–1987)
53. Herbert W. Collins (Collins's second husband)
Gelatin silver print, ca. 1932
Courtesy of Germaine Gardina Vavasseur,
Pasadena, California

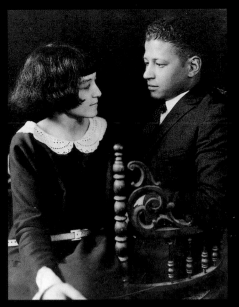

Florestine Perrault Collins
(1895–1987)
54. Jeannette Warburg Altimus and Arthur
Joseph Perrault (Arthur Perrault was one of
Collins's two younger brothers; he opened his
own photography studio first in Atlanta and then
in New Orleans in the mid-1930s, operating
Perrault's Studio until his death in 1961.)
Gelatin silver print, 1925
Courtesy of Arthé A. Anthony, Pasadena,
California

Florestine Perrault Collins
(1895–1987)
55. Mae Fuller Keller
Gelatin silver print, ca. 1925
Courtesy of Arthé A. Anthony, Pasadena,
California

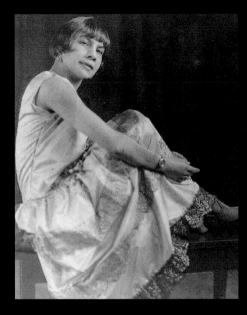

Florestine Perrault Collins
(1895–1987)
56. Unidentified World War II Merchant marine
Gelatin silver print, n.d.
Courtesy of Arthé A. Anthony, Pasadena,
California

Florestine Perrault Collins
(1895–1987)
57. Lastinia Martinez Warren, a bridesmaid
in the DeCuir wedding, New Orleans
Gelatin silver print, 1939
Courtesy of Lastinia Martinez Warren,
Pasadena, California

Addison N. Scurlock (1883–1964)
59. Wedding couple
Gelatin silver print, ca. 1920
Courtesy of Dr. James K. Hill, Washington, D.C.

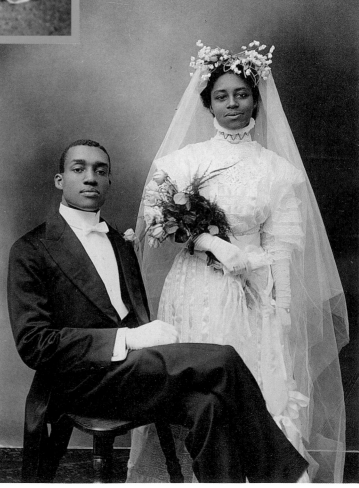

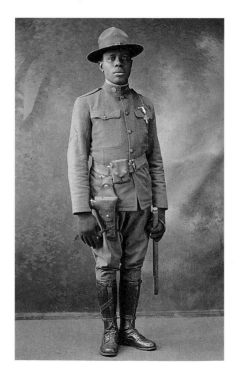

Addison N. Scurlock (1883–1964)
58. Sgt. Martin L. Hart, World War I
Gelatin silver print, ca. 1919
Courtesy of Dr. James K. Hill, Washington, D.C.

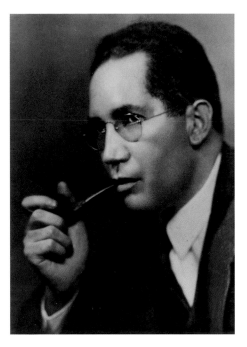

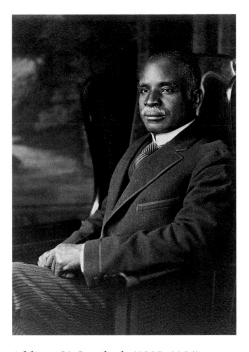

Addison N. Scurlock (1883–1964)
60. Portrait of Sterling Brown, poet (1901–1989)
Gelatin silver print, ca. 1930s
Prints and Photographs Department
Moorland-Spingarn Research Center
Howard University, Washington, D.C.
Courtesy of the National Museum of American
History
Smithsonian Institution

Addison N. Scurlock (1883–1964)
61. Portrait of Kelly Miller, historian and educator (1863–1939)
Gelatin silver print, ca. 1920s
Kelly Miller Collection
Prints and Photographs Department
Moorland-Spingarn Research Center
Howard University, Washington, D.C.
Courtesy of the National Museum of American History
Smithsonian Institution

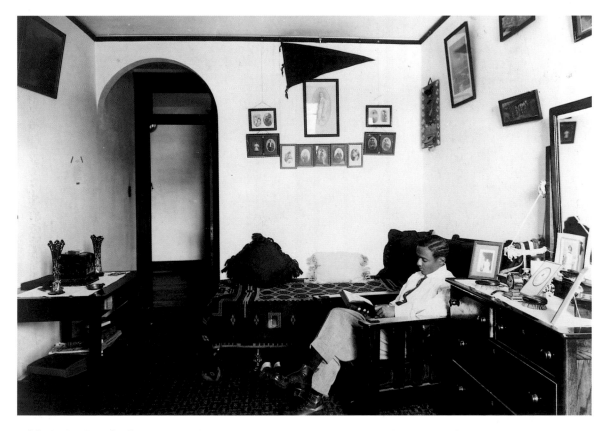

Addison N. Scurlock (1883–1964)
62. Male student surrounded by framed photographs in dormitory room, Washington, D.C.
Gelatin silver print, ca. 1915
Booker T. Washington Collection
Prints and Photographs Division
Library of Congress
LC-USZ 62-121679, Lot 13164-H, no. 11

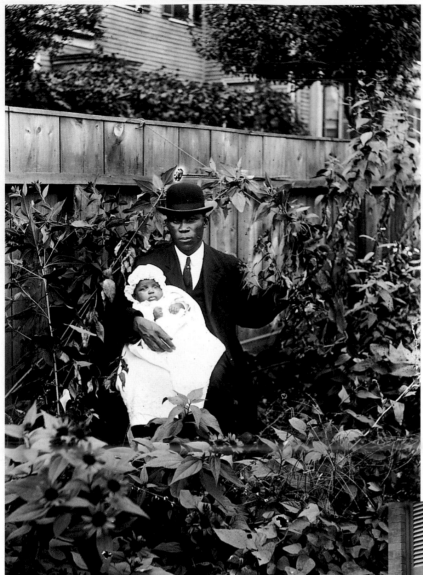

Herbert Collins (active ca. 1890–1920)
63. Portrait of Herbert C. Collins (?) holding a baby
Gelatin silver print, ca. 1910–1916
Museum of Afro American History, Inc., Boston,
Massachusetts

Herbert Collins (active ca. 1890–1920)
64. Three top-hatted men
Gelatin silver print, ca. 1910–1916
Museum of Afro American History, Inc., Boston,
Massachusetts

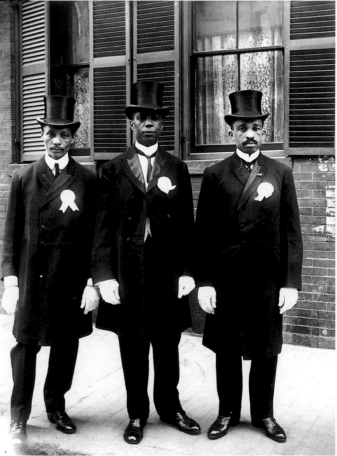

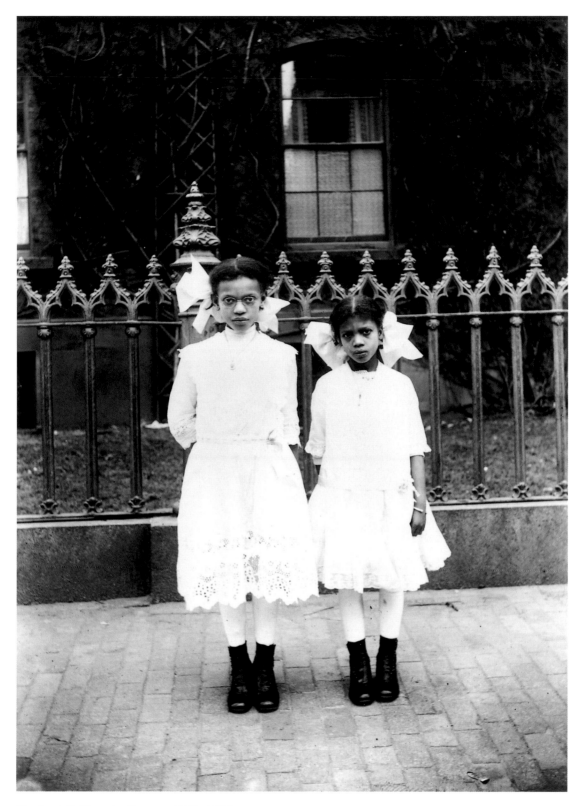

Herbert Collins (active ca. 1890–1920)

65. Mrs. Tell's daughters

Gelatin silver print, ca. 1910–1916

Museum of Afro American History, Inc., Boston, Massachusetts

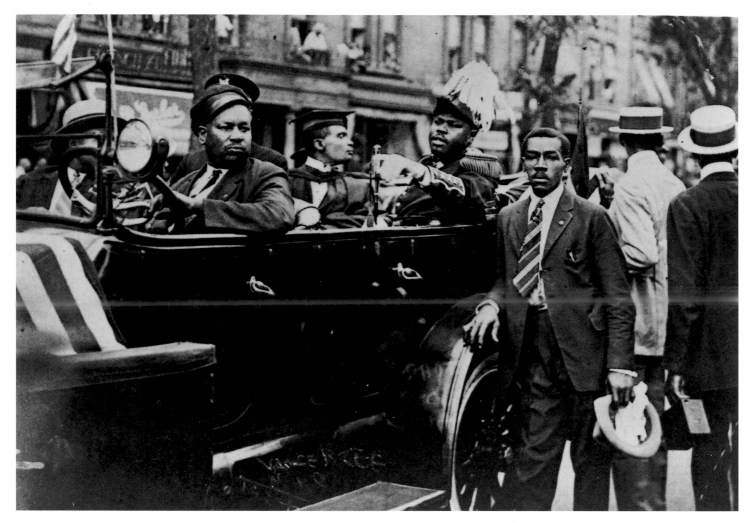

James VanDerZee (1886–1983)

66. Marcus Moziah Garvey (1887–1940) in a Universal Negro Improvement Association parade

Gelatin silver print, 1924

Courtesy of Donna Mussenden VanDerZee, New York, New York

James VanDerZee (1886–1983)

67. A Harlem couple wearing raccoon coats standing next to a Cadillac on West 127th Street

Gelatin silver print, 1932

Courtesy of Donna Mussenden VanDerZee, New York, New York

James VanDerZee (1886–1983)
68. Cousin Susan Porter
Gelatin silver print, 1915
Courtesy of Donna Mussenden VanDerZee,
New York, New York

James VanDerZee (1886–1983)
69. Future Expectations
Gelatin silver print, ca. 1926
Courtesy of Donna Mussenden
VanDerZee, New York, New York

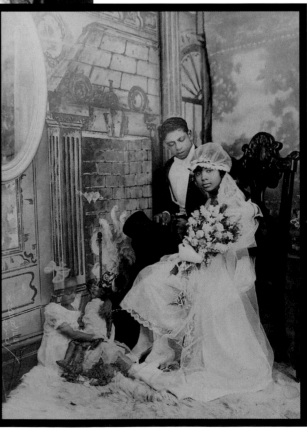

King Daniel Ganaway (1883–?)
70. The Spirit of Transportation
Gelatin silver print, ca. 1924
Harmon Foundation Collection
Still Picture Reference, Special Media
Archives Services Division
National Archives and Records
Administration
200S-HN-GAN-1

King Daniel Ganaway (1883–?)
71. The Gardner's Cart
Gelatin silver print, ca. 1924
Harmon Foundation Collection
Still Picture Reference, Special Media Archives Services Division
National Archives and Records Administration
200S-HN-GAN-2

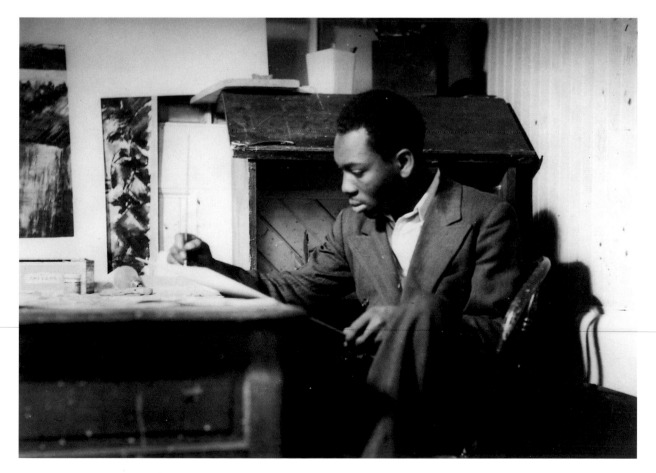

James Latimer Allen (1907–1977)
72. Portrait of Jacob Lawrence, artist (b. 1917)
Gelatin silver print, ca. 1937–1939
Alain Locke Collection
Prints and Photographs Department
Moorland-Spingarn Research Center
Howard University, Washington, D.C.

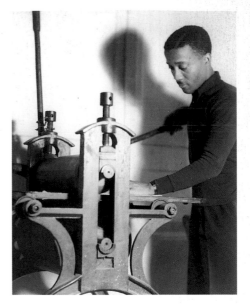

James Latimer Allen (1907–1977)
74. Portrait of Norman Lewis (1909–1979) with etching press
Gelatin silver print, ca. 1937–1939
Alain Locke Collection
Prints and Photographs Department
Moorland-Spingarn Research Center
Howard University, Washington, D.C.

James Latimer Allen (1907–1977)
73. Portrait of Langston Hughes, writer (1902–1967)
Gelatin silver print, ca. 1927
Alain Locke Collection
Prints and Photographs Department
Moorland-Spingarn Research Center
Howard University, Washington, D.C.

James Latimer Allen (1907–1977)
75. Portrait of Richard B. Harrison, actor (1864–1935)
Gelatin silver print, 1933
Harmon Foundation Collection
National Archives and Records Administration
Still Picture Reference, Special Media Archives Services Division

Elise Forrest Harleston (1891–1970)
76. Portrait study (woman with cane)
Gelatin silver print, 1922
Courtesy of Edwina Harleston Whitlock, Atlanta, Georgia

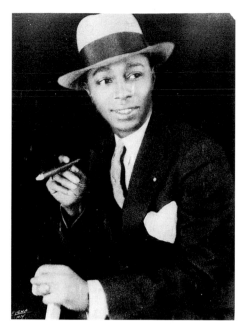

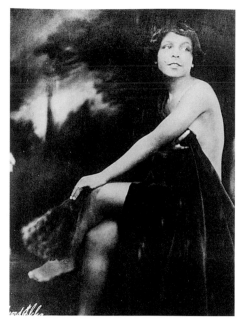

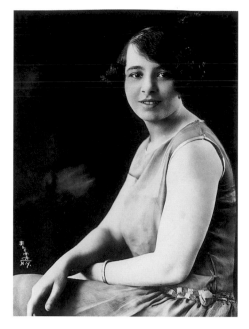

Edward ("Eddie") Elcha (active
1915–1930s)

77. Portrait of a man holding cigar and cane
Gelatin silver print, ca. 1922
Thelma Greene Collection
Prints and Photographs Department
Moorland-Spingarn Research Center
Howard University, Washington, D.C.

Edward ("Eddie") Elcha (active
1915–1930s)

78. Portrait of a woman draped in velvet and
holding a whip
Gelatin silver print, ca. 1922
Thelma Greene Collection
Prints and Photographs Department
Moorland-Spingarn Research Center
Howard University, Washington, D.C.

Edward ("Eddie") Elcha (active
1915–1930s)

79. Portrait of a woman wearing bangle bracelet
Gelatin silver print, ca. 1925
Thelma Greene Collection
Prints and Photographs Department
Moorland-Spingarn Research Center
Howard University, Washington, D.C.

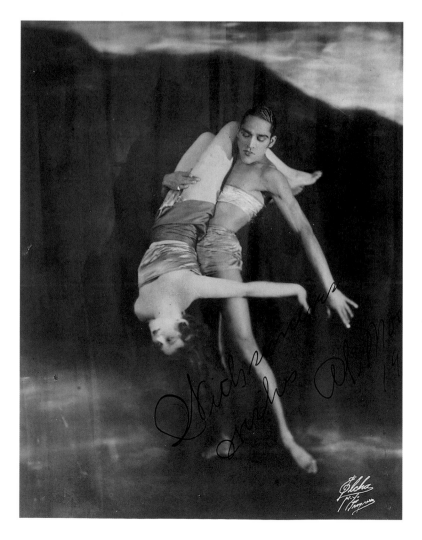

Edward ("Eddie") Elcha (active 1915–1930s)

80. Two dancers, Al Moore and female partner
Gelatin silver print, ca. 1925
Alain Locke Collection
Prints and Photographs Department
Moorland-Spingarn Research Center
Howard University, Washington, D.C.

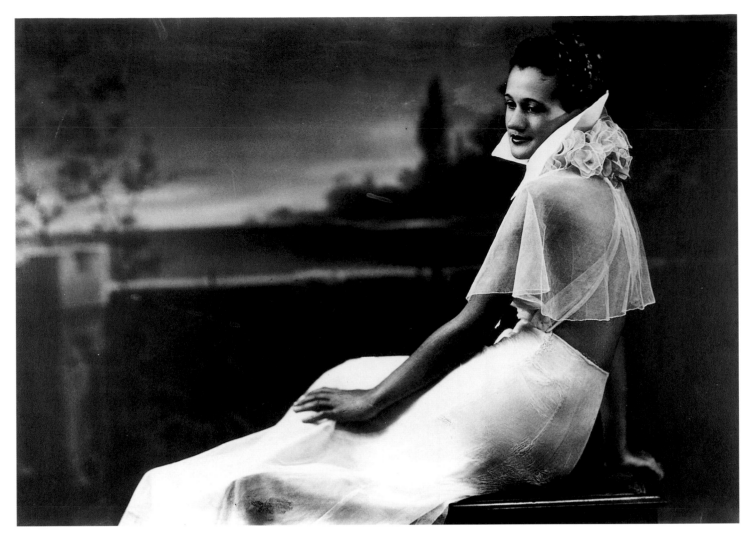

P. (Prentice) H. Polk (1898–1984)
81. Portrait of Mildred Hanson Baker
Gelatin silver print, ca. 1937–1938
Paul R. Jones Collection, Atlanta, Georgia

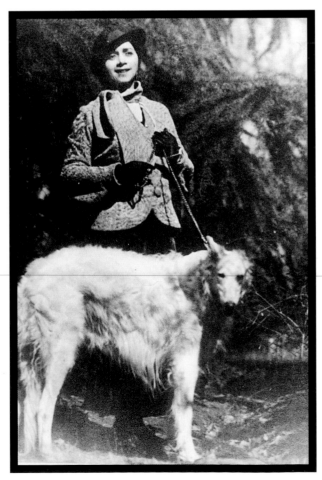

P. (Prentice) H. Polk (1898–1984)
82. Portrait of Lillian Evans Evanti (1890–1967), a lyric
soprano, with her dog
Gelatin silver print, ca. 1935
Owen Dodson Collection
Prints and Photographs Department
Moorland-Spingarn Research Center
Howard University, Washington, D.C.

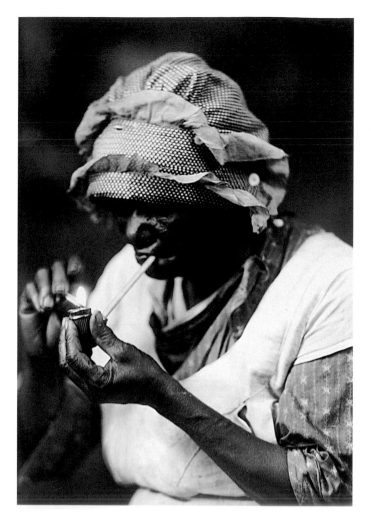

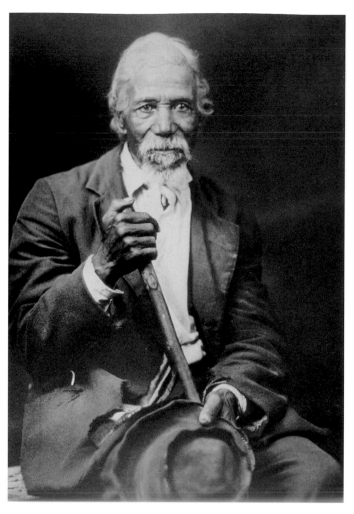

P. (Prentice) H. Polk (1898–1984)
83. *Old Character* series: The Pipe Smoker
Gelatin silver develop-out print, 1932
Museum purchase, Anna E. Clark Fund
Corcoran Gallery of Art, Washington, D.C.
1981.64.3

P. (Prentice) H. Polk (1898–1984)
84. *Old Character* series: Portrait of George Moore
Gelatin silver print, ca. 1930
Paul R. Jones Collection, Atlanta, Georgia

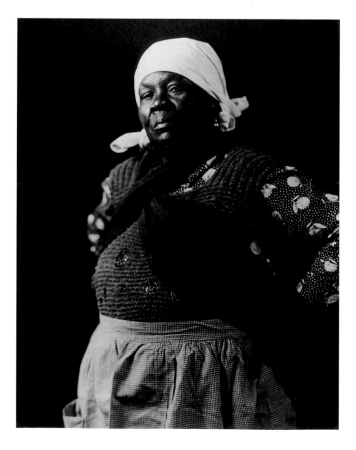

P. (Prentice) H. Polk (1898–1984)
85. *Old Character* series: The Boss
Gelatin silver develop-out print, 1932
Museum purchase, Anna E. Clark Fund
Corcoran Gallery of Art, Washington, D.C.
1981.64.2

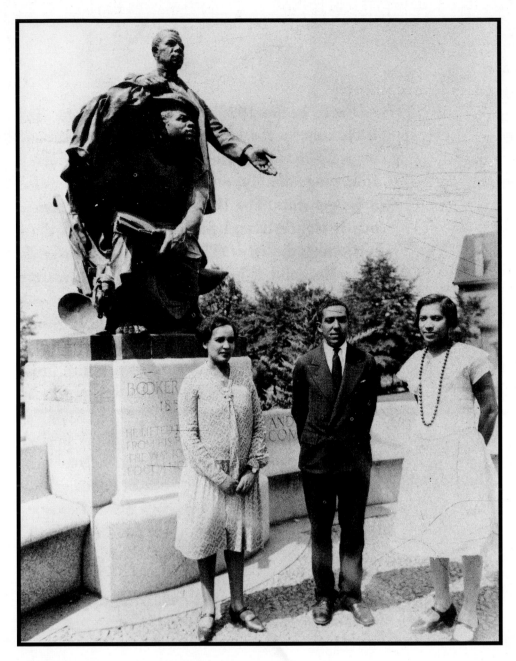

P. (Prentice) H. Polk (1898–1984)

86. Jesse Redmond Fauset, Langston Hughes, and Zora Neale
Hurston posed in front of Booker T. Washington's statute on
Tuskegee Institute's campus
Gelatin silver print, ca. 1932
Paul R. Jones Collection, Atlanta, Georgia

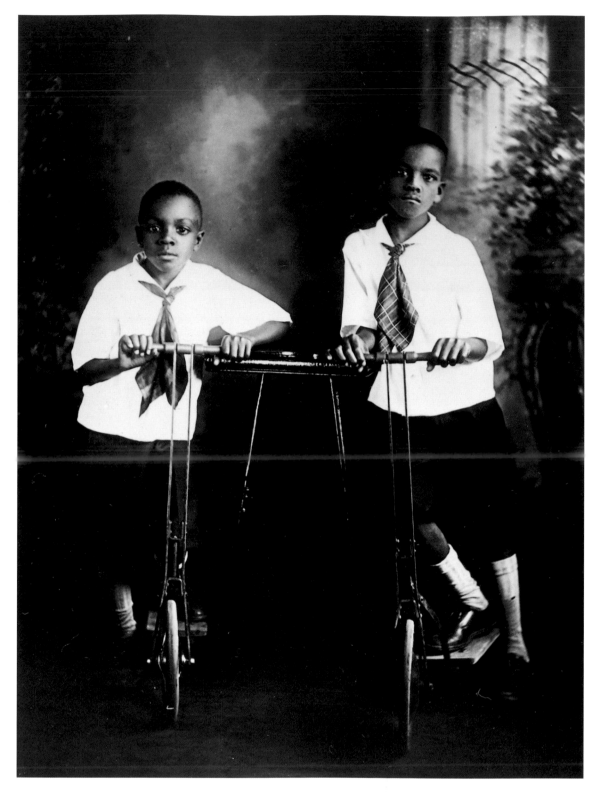

Richard S. Roberts (1881–1936)
87. Portrait of two brothers
Gelatin silver print, ca. 1925
Courtesy of the Wilhelmina Roberts Wynn Collection
Prints and Photographs Division
Schomburg Center for Research in Black Culture
New York Public Library

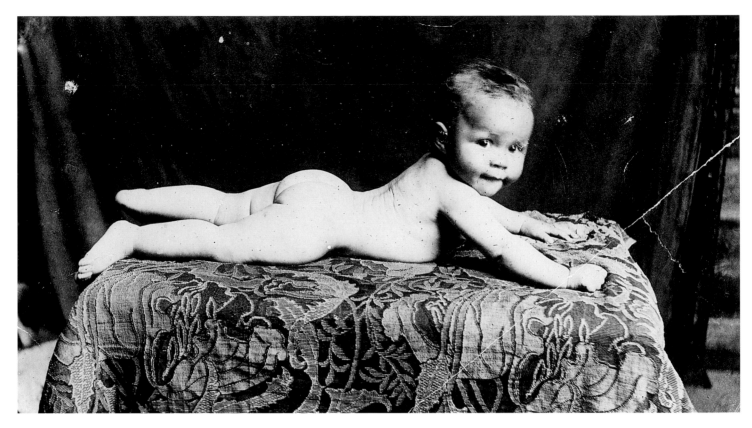

Richard S. Roberts (1881–1936)
88. Portrait of Wilhelmina Roberts at seven months, in Florida
Gelatin silver print, n.d.
Courtesy of Wilhelmina Roberts Wynn, New York, New York

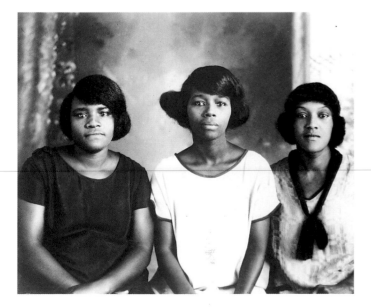

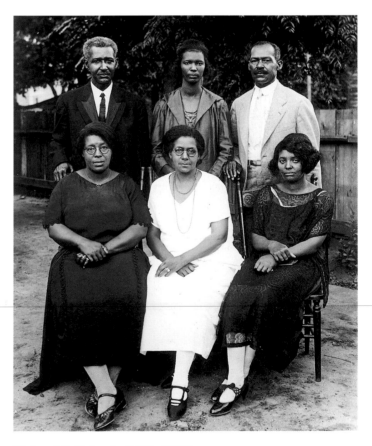

Richard S. Roberts (1881–1936)
89. Portrait of three women
Gelatin silver print, ca. 1930
Courtesy of the Wilhelmina Roberts Wynn Collection
Prints and Photographs Division
Schomburg Center for Research in Black Culture
New York Public Library

Richard S. Roberts (1881–1936)
90. Family portrait
Gelatin silver print, ca. 1930
Courtesy of the Wilhelmina Roberts Wynn Collection
Prints and Photographs Division
Schomburg Center for Research in Black Culture
New York Public Library

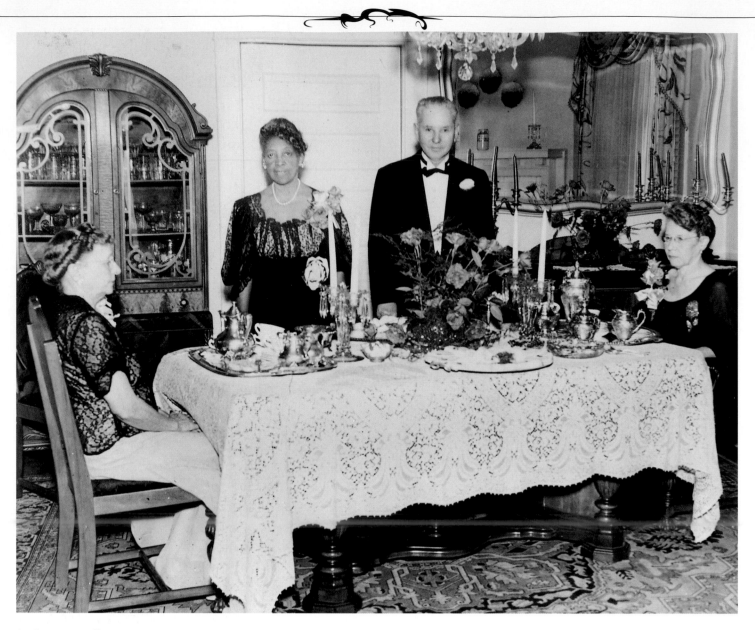

Andrew T. Kelly (ca. 1890–1965)
91. Tea Time with the Holmes Family
Gelatin silver print, ca. 1935
Alice Washington Collection
Courtesy of Herman ("Skip") Mason, Jr.
Digging It Up, Inc., Atlanta, Georgia

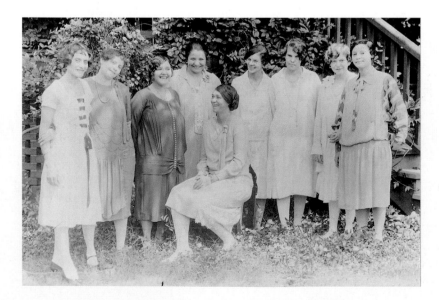

Andrew T. Kelly (ca. 1890–1965)
92. The Junior Matrons
Gelatin silver print, ca. 1928
Harry S. Murphy Collection
Courtesy of Herman ("Skip") Mason, Jr.
Digging It Up, Inc., Atlanta, Georgia

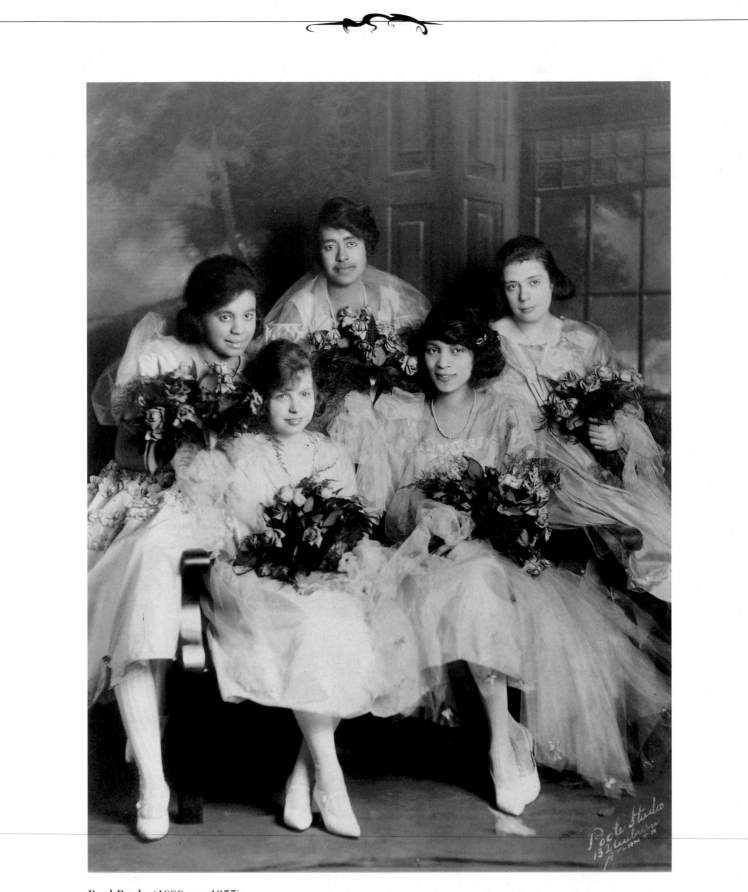

Paul Poole (1886–ca. 1955)

93. Southern Belles

Gelatin silver print, ca. 1921

Harry S. Murphy Collection

Courtesy of Herman ("Skip") Mason, Jr.

Digging It Up, Inc., Atlanta, Georgia

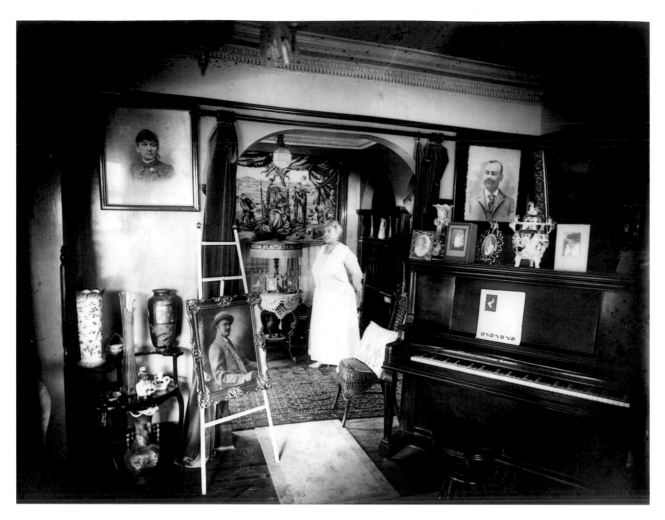

Richard Aloysius Twine (1896–1974)
94. Portrait of Mary ("Mae") Martin at home
Gelatin silver print, ca. 1922–1927
St. Augustine Historical Society, Florida

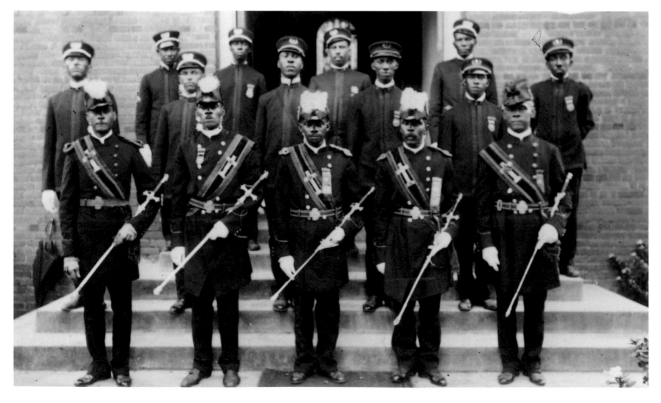

Richard Aloysius Twine (1896–1974)
95. Group portrait of the Roman Catholic Order of the Knights of St. John (swords, epaulets, and special headgear identify the officers)
Gelatin silver print, ca. 1922–1927
St. Augustine Historical Society, Florida

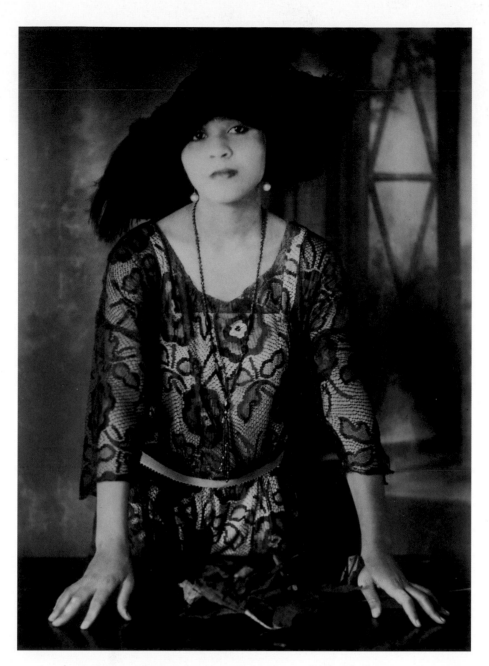

Richard Aloysius Twine (1896–1974)
96. Portrait of Mildred Parsons Mason Larkins
Gelatin silver print, ca. 1922–1927
St. Augustine Historical Society, Florida

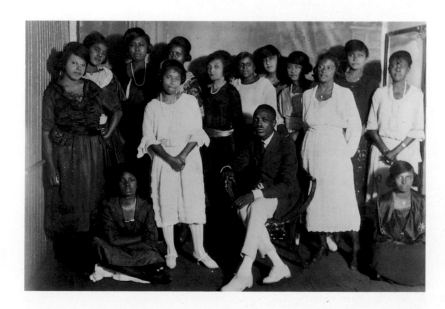

Richard Aloysius Twine (1896–1974)
97. Portrait of the photographer with a group of women
Gelatin silver print, ca. 1922–1927
St. Augustine Historical Society, Florida

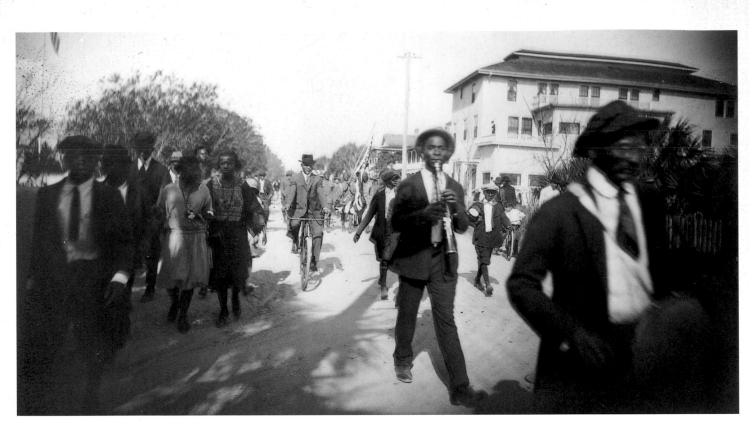

Richard Aloysius Twine (1896–1974)
98. View of Emancipation Day parade (Black communities around the country celebrated the end of slavery as a major holiday. This celebration probably celebrated the sixtieth anniversary of emancipation.)
Gelatin silver print, ca. 1922–1927
St. Augustine Historical Society, Florida

Ellie Lee Weems (1901–1983)
99. Portrait of Mint Jones holding a book
Gelatin silver print, 1935
Weems Photographic Collection
Auburn Avenue Research Center
Atlanta-Fulton Public Library, Georgia

Ellie Lee Weems (1901–1983)
100. Brewster Hospital graduation
Gelatin silver print, 1935
Weems Photographic Collection
Auburn Avenue Research Center
Atlanta-Fulton Public Library, Georgia

Ellie Lee Weems (1901–1983)
101. Portrait of man and woman on porch
Gelatin silver print, n.d.
Weems Photographic Collection
Auburn Avenue Research Center
Atlanta-Fulton Public Library, Georgia

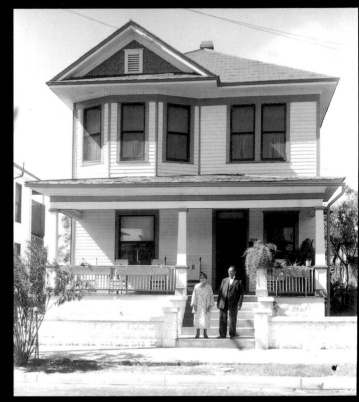

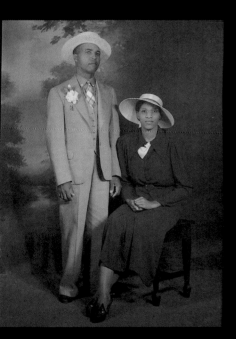

Ellie Lee Weems (1901–1983)
102. Portrait of Mr. and Mrs. Ernest Tyres
Gelatin silver print, 1938
Weems Photographic Collection
Auburn Avenue Research Center
Atlanta-Fulton Public Library, Georgia

Ellie Lee Weems (1901–1983)
103. Portrait of two women with car
Gelatin silver print, 1937
Weems Photographic Collection
Auburn Avenue Research Center
Atlanta-Fulton Public Library, Georgia

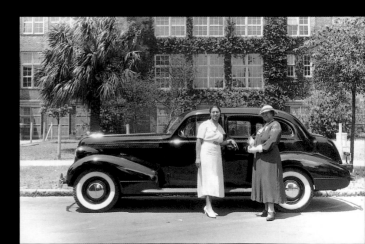

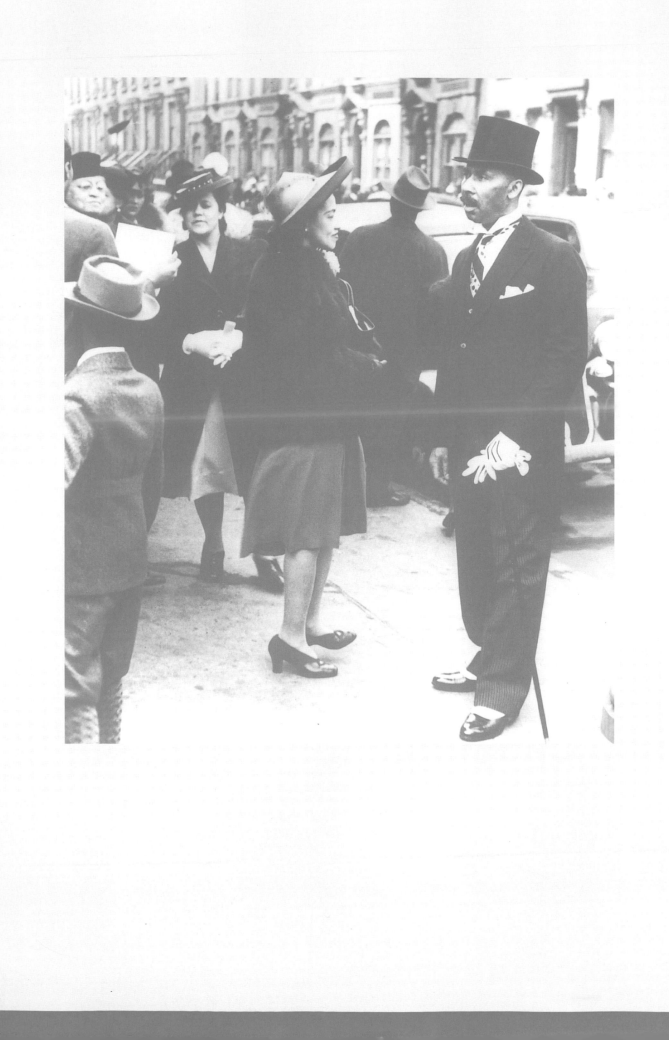

Part III

1930s and 1940s
Photography

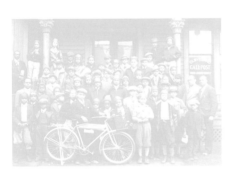

PHOTOGRAPHER: ALLEN E. COLE

Photographers in the 1930s and 1940s began working as photojournalists for local newspapers and national magazines, such as *Our World, Ebony, Sepia, and Flash*, which were marketed to African-American readers. Most learned photography while in the military and studied the subject in schools of journalism. This period also saw a more comprehensive coverage of political events and public protests. What made this more feasible was the introduction of smaller handheld cameras and faster films in the 1930s, which aided photographers in expressing their frustration and discontentment with social conditions and political inequality.

Among the more renowned of this group was Allen Edward Cole (1893–1970), who opened his studio in Cleveland, Ohio, in 1922 and became one of the first black studio photographers in the Cleveland area. After graduating from Storer College in Harpers Ferry, West Virginia, in 1905, Cole found it difficult to find professional work. Searching for lucrative employment, he was hired as a waiter for the Cleveland Athletic Club. While there, he met a white photographer, with whom he studied photography in exchange for work in his commercial studio.

After opening his first studio, Cole later moved to a larger location, where he posted a sign that read SOMEBODY, SOMEWHERE, WANTS YOUR PHOTOGRAPH, a slogan that became his signature. From the early 1920s through the mid-1960s, Cole worked part-time as a photojournalist for the *Call & Post*, the local newspaper, and in doing so, he provided an enduring chronicle of black life in Cleveland for nearly half a century. Never a casual recorder, he photographed a Watkins Products deliveryman, thus showing how important black businesses were to this community. SEE YOUR WATKINS MAN THIS MONTH was emblazoned on the truck, emphasizing the recurring bond this business had with its customers.

The permanence of black family life was a persistent theme in Cole's work. "The family is, of course, the central subject. . . . The beginning of family life—the wedding—constituted a major portion of Cole's business," writes archivist

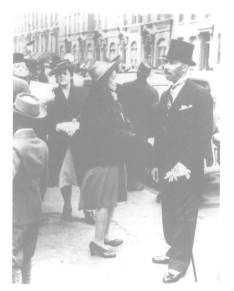

PHOTOGRAPHERS:
MORGAN AND MARVIN SMITH

John J. Grabowski. "Surprising, however, was the fact that the end of life played an equally important role in Cole's activities. He took numerous funeral photographs."[1] Cole's family photography, then, provides great insight into the lives of Cleveland's black community. A photograph titled *Home of Mrs. Sink*, for example, allows the viewer to imagine the couple's life and their concern for preserving family heirlooms (note the portrait on the mantel). Contrary to assumptions that prevail to this day, this photograph shows a black family living a comfortable life during the Depression. Historian Samuel Black writes:

> Cole's portraits were much in demand—and he knew how to create a market. . . . Seizing upon the possibilities inherent in Cedar-Central's tradition as a "walking community" where people would spend entire Sunday afternoons in the streets ambling from one social attraction to the other, he attracted walk-in clients by display portraits on a billboard in front of his studio, inscribed with his slogan, *Somebody, Somewhere, Wants Your Photograph.*[2]

No community remains more deeply etched in the collective African-American experience of the twentieth century than Harlem. In the 1930s it was a colorful and expressive community although it was in the throes of the Great Depression and the waning years of the so-called Harlem Renaissance. Among the most renowned of Harlem's leading photojournalists from 1933 through the early 1950s were Morgan Smith (1910–1993) and his twin brother, Marvin (b. 1910). They operated one of Harlem's most popular commercial portrait studios, M. Smith Studio, located next to the famed Apollo Theater on West 125th Street. Performing artists, writers, politicians, and historians frequented their studio; the Smiths also captured the political rallies, street demonstrations, bread lines, and the deeply impassioned street-corner orators of the Depression. The Smith brothers had moved to New York from Kentucky in 1933. Both were interested in the arts; they later worked as muralists with the Works Progress Administration (WPA) and the Federal Art Project (FAP). Both studied art with sculptor Augusta Savage (1892–1962), who offered open studio classes. In Harlem, the Smiths lived, photographed, and socialized with the black middle class.

"Morgan Smith recalled being invited to social functions with the request to 'bring your camera,' thereby allowing his social life to reinforce his professional opportunities and vice versa," photo historian Melissa Rachleff writes. "The Smith brothers attended events and activities together and were lifelong collaborators."[3]

Their cameras captured Lindy Hoppers in a nightclub, Easter Sunday parades, and, in 1939, they formed a newspaper picture service that provided pictorial editorials of Harlem and its leaders. According to scholar James A. Miller:

> . . . they continued to pursue their interest in photography. Morgan purchased a portable roll-film camera with a slide flash attachment, a major technological leap forward from the awkward and bulky equipment with which the twins had been in-

troduced to photography. They began to experiment with street photography, scouting out social and political events in Harlem.[4]

In one of their photographs of a street-corner orator, the Smiths demonstrate a profound fascination with the fabric of the local community. The orator stands on a makeshift platform while delivering his speech. The crowd seems to be made up of working-class people, who listen intently to the ideas and issues presented by the speaker. The Smiths were drawn to these speakers, who attracted large and enthusiastic audiences. Celeste Tibbets, author of an article on the origins of the Schomburg Library in New York City, describes how significant the street-corner orator was both to the public library in Harlem and to its librarian at the time, Ernestine Rose:

> If you are familiar with Harlem, you are aware of the fact that the streets are frequently made impassable by the many soap box speakers and their enthusiastic audiences. It occurred to us that if people will listen to politics and patent medicines they will listen to education, too, provided it is well presented to them. So we employed one of the most eloquent and the most popular of these speakers and paid him to address large crowds at strategic corners on the streets of Harlem. Once a week these people were urged to come to a meeting at the library. Some two thousand were reached each week. If, out of these, fifty appeared at the library we were confident that something worthwhile had been accomplished. This was one of our most successful attempts to reach the "common man."[5]

Street-corner orators began to appear in Harlem in the early part of the twentieth century. In 1918, for example, Richard B. Moore (1893–1978), a popular orator and historian, preached socialism on the streets of Harlem. The Smith brothers' photographs document the historically important role the street-corner orators played not only in attracting large crowds but in creating a growing political awareness.

As photography became popular and more accessible during this period, images made by other documentary and studio photographers included family portraits, dances, banquets, private parties, convention participants, and large rallies. Therefore, photographs were largely responsible for creating the image of black Americans between the two world wars. As documented in this volume, photographers created a collective portrait of their communities during a particularly rich historical moment, a portrait that was enhanced by their intimate understanding of the distinctive African-American community at a critical juncture in American history.

Also working in New York's Harlem were Austin Hansen and Winifred Hall Allen. Allen was one of the few women photographers operating a studio in Harlem during this period, and she, like Hansen, documented church activities and organizations, as well as the businesses owned and operated by women in that community.

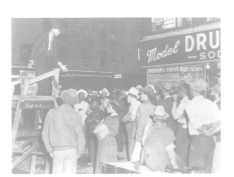

PHOTOGRAPHERS:
MORGAN AND MARVIN SMITH

Like Harlem, Washington, D.C., boasted numerous prominent photographers during this period. One of them, Robert H. McNeill (b. 1917), recalled: "I was an independent freelance photographer, I had to buy my own film, furnish my own transportation. I did all of my darkroom work. I mailed the prints to the papers. . . ."[6] As the Smiths had done in Harlem, McNeill created a comprehensive documentary record of African-American life in the nation's capital during the 1930s and 1940s, photographing everything from political rallies to religious activities. McNeill's photography considered the interests of his subjects as well as his own personal ones. He often wrote his own text for the press photographs. Significant among the many images he produced during this period are photographs of the protest movements in the capital city. Jim Crow and segregation laws were often denounced by way of protest marches in front of the White House. McNeill's images documented these activities, such as the National Association of Colored Women's protest against discriminatory practices. Frequently published in black papers, such as the *Pittsburgh Courier, Washington Afro-American,* and the *Chicago Defender,* McNeill's photographs showed that African-Americans living in a segregated city survived—even thrived—by creating their own social and community organizations.

During the time that he was a student of photography in New York City at the New York Institute of Photography, McNeill embarked on a project that focused on black domestic workers. This historic series of photographs, later known as the *The Bronx Slave Market,* recorded the lives of black women looking for domestic work in New York. The photographer followed the prospective workers as well as the potential employers. His documentation of the long wait for work and the white employers' negotiations shaped this interesting story of the underclass. McNeill explains:

> It was the small things that struck me. . . . How cold it was on that particular morning on that particular corner in the Bronx. The idea that this woman had come up from the South, maybe was staying with relatives in New York and need to help pay the rent, and ended up doing what she had known in the South. Or the expression on the white woman's face, after she offers to pay 15 cents [an hour] and [Windstown, one of the women,] says, "Uh-uh, 20 cents is my price. . . .[7]

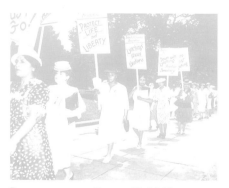

PHOTOGRAPHER: ROBERT H. McNEILL

McNeill's project was published in a black periodical, *Flash!* This powerful study of the plight of black women trying to gain employment would later help McNeill obtain work with the Works Progress Administration. He also photographed black communities in Virginia for the Works Progress Administration's Federal Writers' Project. Many of these photographs were featured in *The Negro in Virginia,* published in 1940. Historian Nicholas Natanson offers a highly persuasive argument about how to consider McNeill's photographs within the context of thirties and forties photography. He cautions the reader to avoid placing McNeill's photographs in the usual categories attributed to images of black subjects photographed during this period. Natanson writes:

PHOTOGRAPHER: GORDON PARKS

Photographic depictions of African Americans during this period tended to fall into distinct genres. Prominent was the Colorful Black, seen frequently in the white-edited mass media, in forms varying from watermelon-eaters and cotton-patch snoozers to high-spirited military enlistees. There was the Noble Primitive. . . . On the other extreme lay the Black Victim, sufficiently pathetic . . . to invite associations with the old colorful stereotypes. There was the Transformed Black, with a dehumanized "before" giving way to an artificial "after." . . . And, especially in the black press, there appeared the glittering Role Model, the polished professional whose visual authority was designed to counter the effect of many of the aforementioned representational modes.[8]

In 1935, Franklin D. Roosevelt created the Resettlement Administration to address the problems of the American farmer. The agency, renamed the Farm Security Administration (FSA) in 1937, was involved with relief activities and land-use administration. Roy Stryker, an economics instructor at Columbia University, was appointed head of the Historical Section, the official name of the agency's photography project. The FSA photography project generated 270,000 images of rural, urban, and industrial America between 1935 and 1943. Many of these photographs documented the activities of black migrant workers in the South. In 1937, Gordon Parks (b. 1912) decided that he wanted to be a photographer after viewing the work of the FSA photographers. In 1941, the Julius Rosenwald Fellowship provided Parks with an opportunity to work with the FSA. Parks received extensive training as a photojournalist under Roy Stryker's direction. During his first month in Washington in 1942, Parks photographed a black government cleaning woman named Ella Watson. He chronicled her life at home, at work, and at church, creating a masterful photographic essay about her life. Offended by the discriminatory practices in the nation's capital, Parks wanted to show the evils of racism. He said:

> What the camera had to do was expose the evils of racism, the evils of poverty, the discrimination and the bigotry, by showing the people who suffered most under it. . . . The photograph of the black cleaning woman standing in front of the American flag with a broom and a mop expressed more than any other photograph I have taken. It was the first one I took in Washington, D.C. I thought then, and Roy Stryker eventually proved it to me, that you could not photograph a person who turns you away from the motion picture ticket window, or someone who refuses to feed you, or someone who refuses to wait on you in a store. You could not photograph him and say "This is a bigot," because bigots have a way of looking like everybody else.[9]

After World War II, during which he had served as an Office of War Information photographer, Parks worked once again with Stryker, this time for Standard Oil. In 1949, he became the first African-American photographer to work on the staff of *Life* magazine. The importance of Parks's work to the genre of documentary photography lies in his ability to capture the plight of his subjects, ranging

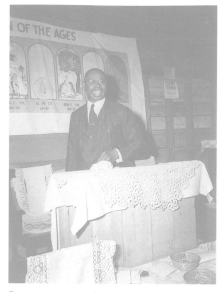

from the dispossessed to the wealthy; he has photographed independent and tenant farmers, fashion models, gang members, religious leaders, and black nationalists.

A contemporary of Parks was Charles Harris (1908–1998), popularly known as "Teenie" in the Hill District of Pittsburgh, Pennsylvania. His major contribution to photography is his extensive documentation of black life in Pittsburgh from the post-Depression period through the post–civil rights era. In 1931, Harris became a photojournalist for a national black news weekly, the renowned *Pittsburgh Courier*. For more than fifty years, Harris photographed numerous black social events, church groups, organizations, restaurants, and nightclubs for the *Courier*. His photographs of the Negro Baseball leagues; jazz musicians and vocalists, such as Duke Ellington, Count Basie, Lena Horne, and Eartha Kitt; and the famous, infamous, and lesser-known people who lived in or frequented Pittsburgh tell a story about the thriving life of blacks in American cities. A self-taught photographer, Harris also supplied photographs to the black-owned *Flash!* magazine. Harris documented the realities of a segregated Pittsburgh at midcentury, and his images covered a wide range of subjects, from protest marches against discriminatory employment practices to the social life of the black fraternities, including a photograph of the newly crowned queen of the Alpha Phi Alpha fraternity. His photographs of these events, coupled with those of interiors of black-owned businesses and photographs of President John F. Kennedy on his visit to Pittsburgh allow the viewer to appreciate the importance of one photographer's vision of his community.

Another photographer working in Pittsburgh in the 1940s was Dwoyid Olmstead (active 1940s). His photographs of the Hill District explore a section of this community. Civic leaders were concerned with documenting the effects of industrial pollution and how the air affected residents in the inner city. Many of the homes Olmstead photographed were demolished to make way for the expansion of the city's business district. Olmstead's extensive record of the living conditions of the poor blacks living in Pittsburgh was made prior to the demolition and explored how the residents coped both with excessive industrial pollution and harsh urban living. His poignant images include that of a smiling woman holding a treasured possession, a picture of a loved one. This woman, devoid of any luxuries, stands in a seemingly uninhabitable room that contains a stove, a bed, and clothes drying on lines, the space illuminated by a bare lightbulb. Other photographs made by him included a group seated around a table, the lone woman, whose husband's hands rest on her shoulder, appearing detached from the ongoing discussion; an interior of a church with a hand-painted sign showing biblical scenes—the minister stands in the pulpit of this wooden structure with its delicate hand-crocheted doilies and wicker offering baskets; two school-age children standing on their front steps; and a father and son seated in a dimly lit room.

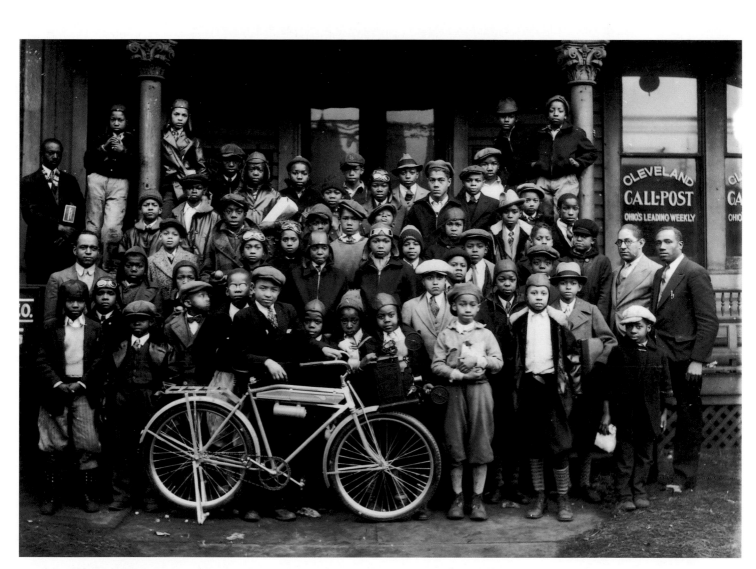

Allen E. Cole (1893–1970)
104. Group portrait of *Call* and *Post* newsboys
Gelatin silver print, ca. 1930s
Western Reserve Historical Society Library, Cleveland, Ohio

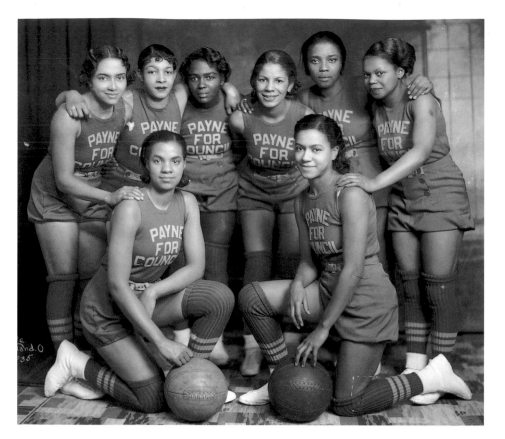

Allen E. Cole (1893–1970)

105. Councilman L. O. Payne's (all female) basketball team

Gelatin silver print, 1935

Western Reserve Historical Society Library, Cleveland, Ohio

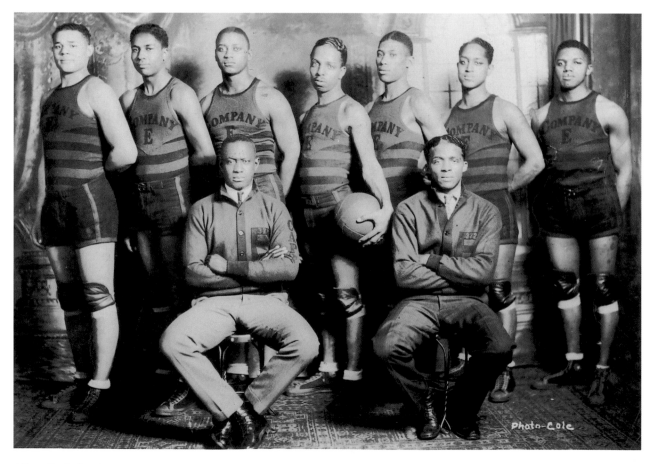

Allen E. Cole (1893–1970)

106. Company E (all male) basketball team

Gelatin silver print, ca. 1920s

Western Reserve Historical Society Library, Cleveland, Ohio

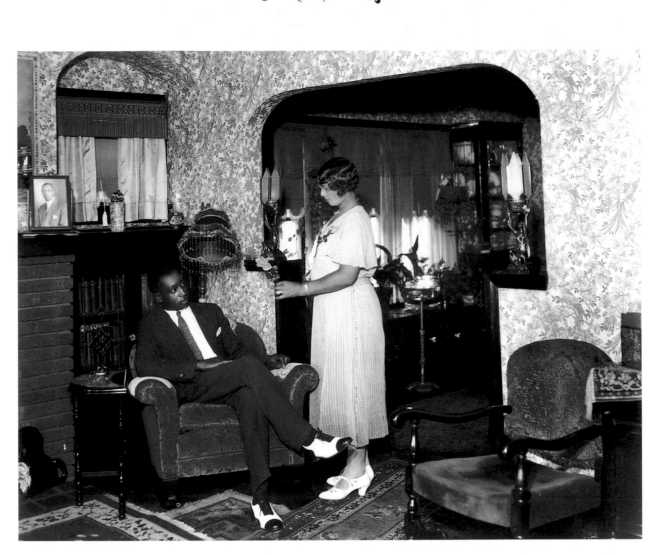

Allen E. Cole (1893–1970)
107. Home of Mrs. H. H. Sink
Gelatin silver print, ca. 1930s
Western Reserve Historical Society Library, Cleveland, Ohio

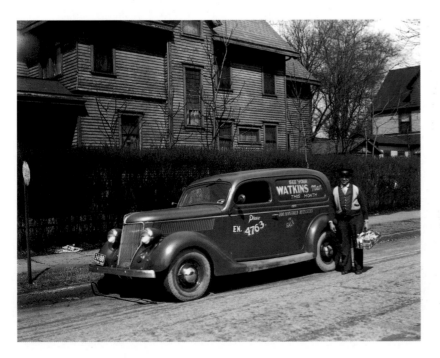

Allen E. Cole (1893–1970)
108. Watkin's Products delivery man
Gelatin silver print, ca. 1930s
Western Reserve Historical Society Library, Cleveland, Ohio

Scurlock Studios: Addison N.
(1883–1964), Robert S. (1916–1994),
George H. (b. 1919)
110. Portrait of Mary McLeod Bethune
(1875–1955), educator
Gelatin silver print, 1947
Afro-American Newspapers Archives and
Research Center, Inc.
Thurgood Marshall Library, Bowie State
University, Bowie, Maryland
Courtesy of the Robert S. Scurlock Estate
National Museum of American History
Smithsonian Institution

Robert S. Scurlock (1916–1994)
109. Portrait of Marion Anderson (1902–1993), opera and concert singer
Gelatin silver print, 1939
Prints and Photographs Division
Moorland-Spingarn Research Center
Howard University, Washington, D.C.
Courtesy of the Robert S. Scurlock Estate
National Museum of American History
Smithsonian Institution

Robert S. Scurlock (1916–1994)
111. Drama coach
Gelatin silver print, 1948
Prints and Photographs Division
Moorland-Spingarn Research Center
Howard University, Washington, D.C.
Courtesy of the Robert S. Scurlock Estate
National Museum of American History
Smithsonian Institution

Scurlock Studios: Addison N. (1883–1964), Robert S. (1916–1994), George H. (b. 1919)
112. Dr. Charles Drew (1904–1950), a surgeon, teaching at Freedmen's (now Howard) University Hospital
Gelatin silver print, n.d.
Prints and Photographs Division
Moorland-Spingarn Research Center
Howard University, Washington, D.C.
Courtesy of the Robert S. Scurlock Estate
National Museum of American History
Smithsonian Institution

Scurlock Studios: Addison N. (1883–1964), Robert S. (1916–1994), George H. (b. 1919)
113. Engineering drawing class, Howard University
Gelatin silver print, n.d.
Prints and Photographs Division
Moorland-Spingarn Research Center
Howard University, Washington, D.C.
Courtesy of the Robert S. Scurlock Estate
National Museum of American History
Smithsonian Institution

Robert H. McNeill (b. 1917)
114. Members of the National Association of Colored Women march
outside the White House to protest a lynching in Georgia
Gelatin silver print, 1946
Courtesy of the photographer, Washington, D.C.

Robert H. McNeill (b. 1917)
115. A view of a "Daddy Grace" baptism (Bishop Marcelino
Manual de Graca "Daddy Grace" [1884–1960], leader of the
church the United House of Prayer for All People, attracted
many followers with his evangelist and fundamentalist
preaching and services noted for being highly charged and
testimonial in style. Hundreds of his followers attended his
pool baptisms in cities such as Washington, D.C., and New
York.)
Gelatin silver print, 1949
Courtesy of the photographer, Washington, D.C.

Robert H. McNeill (b. 1917)
116. *The Bronx Slave Market* series: Untitled (two women)
Gelatin silver print, 1937
Courtesy of the photographer, Washington, D.C.

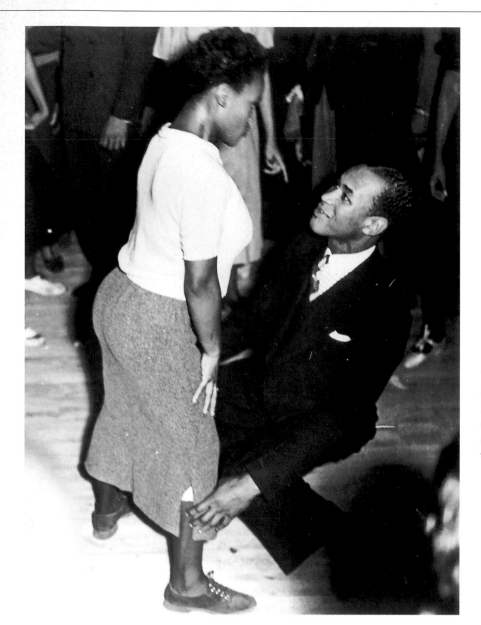

Robert H. McNeill (b. 1917)
117. A couple dancing at the Savoy
Ballroom in New York
Gelatin silver print, 1937
Courtesy of the photographer,
Washington, D.C.

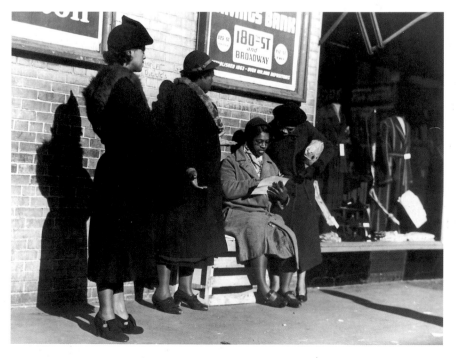

Robert H. McNeill (b. 1917)
118. *The Bronx Slave Market* series: Untitled (four women)
Gelatin silver print, 1937
Courtesy of the photographer, Washington, D.C.

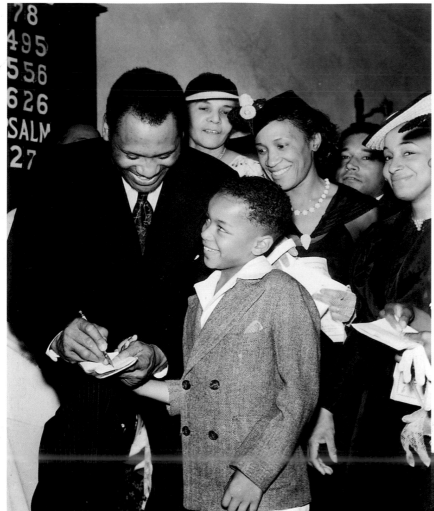

Morgan (1910–1993) and Marvin (b. 1910) Smith

119. Paul Robeson (1898–1976) gives autograph to Ruel Lester after Robeson's concert at the Mother A.M.E. Zion Church in Harlem
Gelatin silver print, 1940
Prints and Photographs Division
Schomburg Center for Research in Black Culture
New York Public Library
Courtesy of Mrs. Monica Smith, New York, New York

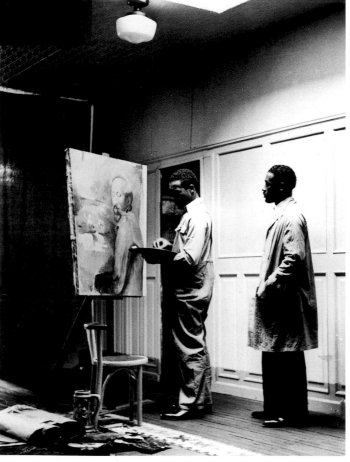

Morgan (1910–1993) and Marvin (b. 1910) Smith

120. Marvin and Morgan Smith
Gelatin silver print, 1938
University of Kentucky Art Museum, Lexington
Gift of Marvin and Morgan Smith

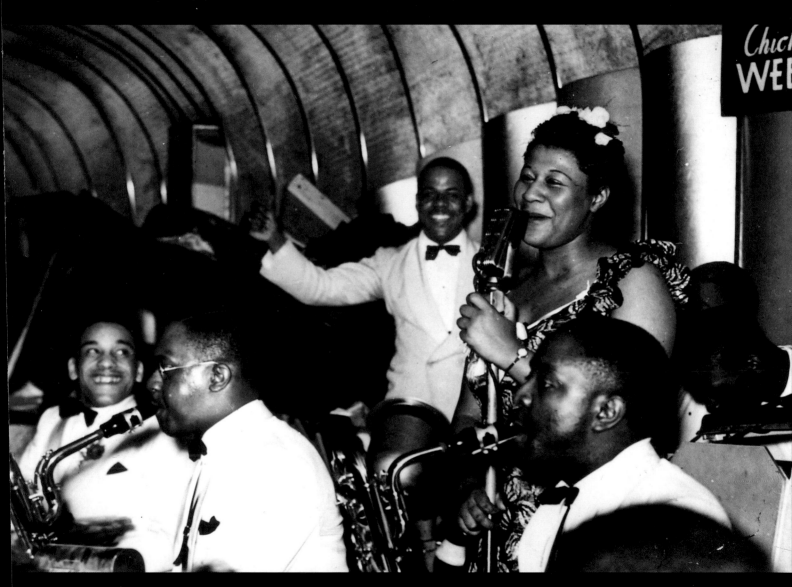

Morgan (1910–1993) and Marvin (b. 1910) Smith

121. Ella Fitzgerald (1918–1997) performing with Chick Webb (1909–1939) and
his orchestra at the Savoy Ballroom; Louis Jordan (1908–1975) on saxophone,
seated to her left.

Morgan (1910–1993) and Marvin (b. 1910)
Smith
122. Easter Sunday in Harlem
Gelatin silver print, 1939
Prints and Photographs Division
Schomburg Center for Research in Black Culture
New York Public Library
Courtesy of Mrs. Monica Smith, New York, New York

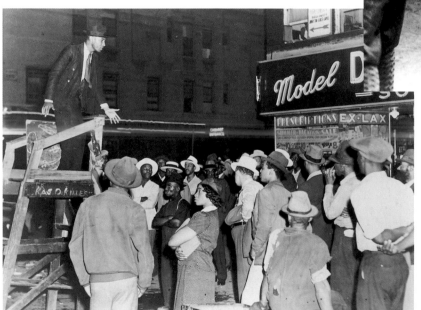

Morgan (1910–1993) and Marvin (b. 1910) Smith
123. Street-corner orator
Gelatin silver print, 1938
Prints and Photographs Division
Schomburg Center for Research in Black Culture
New York Public Library
Courtesy of Mrs. Monica Smith, New York, New York

Morgan (1910–1993) and Marvin (b. 1910) Smith
124. The Reverend Adam Clayton Powell, Jr., leads a protest on
125th Street in Harlem—"Don't Buy Where You Can't Work"
campaign
Gelatin silver print, 1942
Prints and Photographs Division
Schomburg Center for Research in Black Culture
New York Public Library
Courtesy of Mrs. Monica Smith, New York, New York

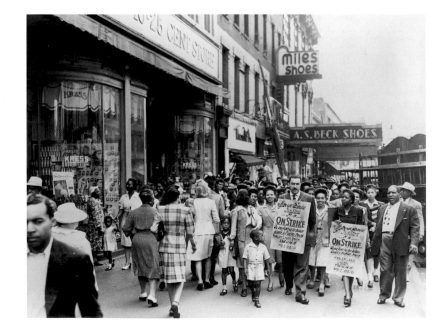

William Anderson Scott III (b. 1923)

125. Journalist C. A. Scott at the annual Butler Street YMCA Christmas party

Gelatin silver print, ca. 1940s

Courtesy of Herman ("Skip") Mason, Jr.

Digging It Up, Inc., Atlanta, Georgia

Gordon Parks (b. 1912)
126. A woman washing clothes in a galvanized tub,
Washington, D.C.
Gelatin silver print, 1942
Prints and Photograph Division
U.S. Office of War Information
Library of Congress
LC-USW3-11058-C

Gordon Parks (b. 1912)
127. Saturday afternoon on 7th Street and Florida Avenue, NW,
Washington, D.C.
Gelatin silver print, 1942
Prints and Photograph Division
Farm Security Administration Files
Library of Congress
LC-USF-34-13448C

Gordon Parks (b. 1912)
128. Boys playing leapfrog near the Frederick Douglass
Housing Project, Washington, D.C.
Gelatin silver print, 1942
Prints and Photograph Division
Farm Security Administration Files
Library of Congress
LC-USF-34-13882C

Gordon Parks (b. 1912)
129. Ella Watson, a government charwoman, with her three grandchildren and
adopted daughter, Washington, D.C.
Gelatin silver print, 1942
Prints and Photograph Division
U.S. Department of Agriculture
Farm Security Administration Files
Library of Congress
LC-USF34-13432-C

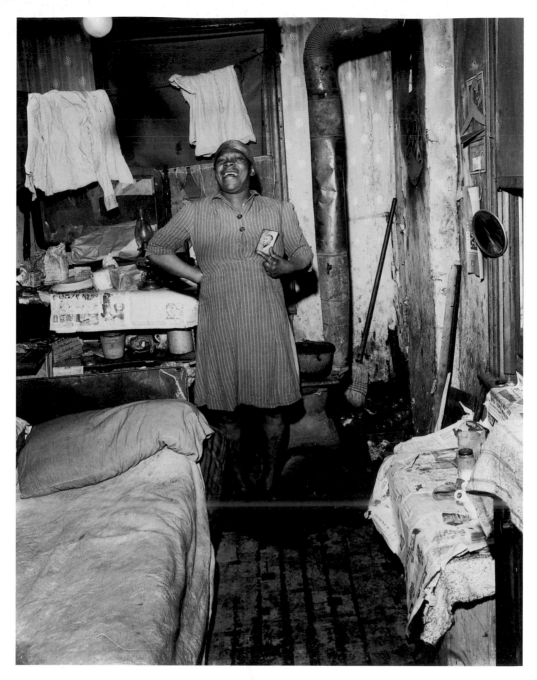

Dwoyid Olmstead (active 1940s)

130. Woman standing in her deteriorated bedroom holding a picture of
a man, Pittsburgh, Pennsylvania
Gelatin silver print, ca. 1949
Archives Center, National Museum of American History
Smithsonian Institution

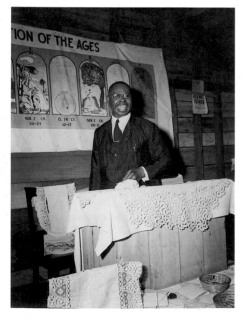

Dwoyid Olmstead (active 1940s)

131. Minister at the pulpit, Pittsburgh, Pennsylvania
Gelatin silver print, ca. 1949
Archives Center, National Museum of American History
Smithsonian Institution

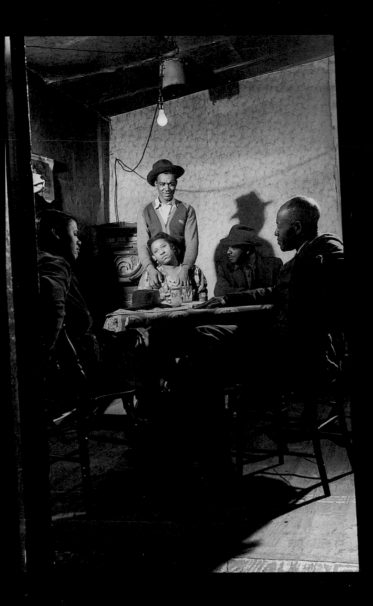

Dwoyid Olmstead (active 1940s)
132. Group of men seated around a table with a
woman, Pittsburgh, Pennsylvania
Gelatin silver print, ca. 1949
Archives Center, National Museum of American
History
Smithsonian Institution

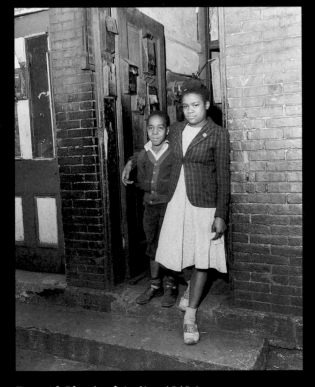

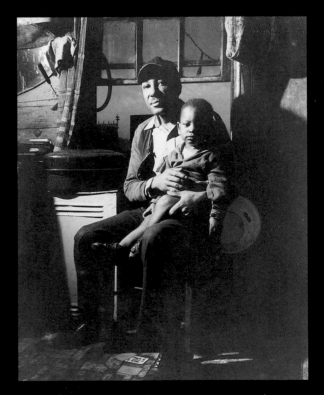

Dwoyid Olmstead (active 1940s)
133. Two children standing on a doorstep, Pittsburgh,
Pennsylvania
Gelatin silver print, ca. 1949
Archives Center, National Museum of American History
Smithsonian Institution

Dwoyid Olmstead (active 1940s)
134. Man holding a child, Pittsburgh, Pennsylvania
Gelatin silver print, ca. 1949
Archives Center, National Museum of American History
Smithsonian Institution

Charles ("Teenie") Harris (1908–1998)

135. Fair Employment Practice Demonstration
Gelatin silver print, n.d.
Courtesy of Charles Harris, Jr., Silver Spring, Maryland

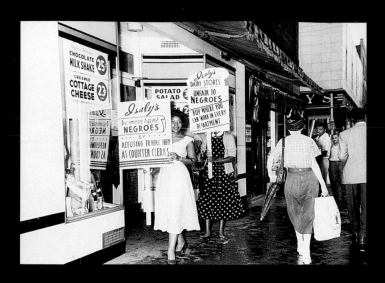

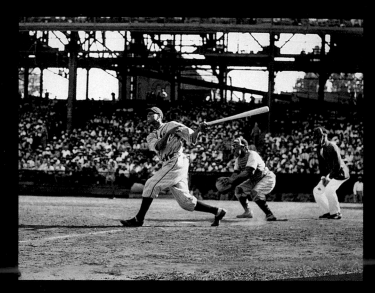

Charles ("Teenie") Harris (1908–1998)

136. Homestead Grays Baseball Game
Gelatin silver print, n.d.
Courtesy of Charles Harris, Jr., Silver Spring, Maryland

Charles ("Teenie") Harris (1908–1998)

137. Workers Outside United Steelworkers of America Office
Gelatin silver print, n.d.
Courtesy of Charles Harris, Jr., Silver Spring, Maryland

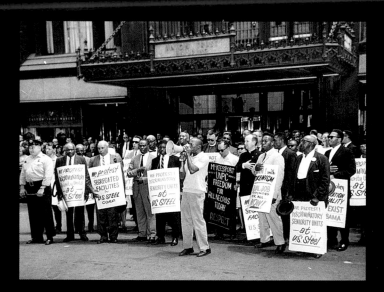

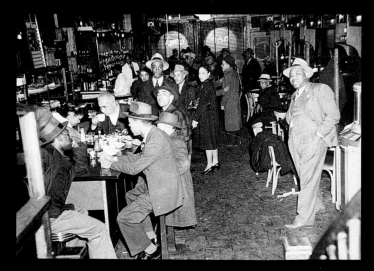

Charles ("Teenie") Harris (1908–1998)

138. Restaurant Scene
Gelatin silver print, ca. 1940s
Courtesy of Charles Harris, Jr., Silver Spring, Maryland

Charles ("Teenie") Harris
(1908–1998)
139. President John F. Kennedy
(1917–1963)
Gelatin silver print, n.d.
Courtesy of Charles Harris, Jr., Silver
Spring, Maryland

Charles ("Teenie") Harris (1908–1998)
140. Beauty Queen
Gelatin silver print, n.d.
Courtesy of Charles Harris, Jr., Silver Spring, Maryland

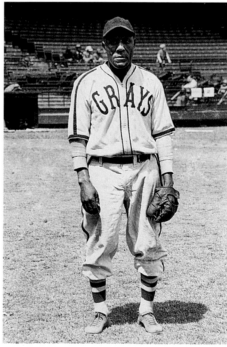

Charles ("Teenie") Harris (1908–1998)
141. Negro League Baseball Player
Gelatin silver print, n.d.
Courtesy of Charles Harris, Jr., Silver Spring,
Maryland

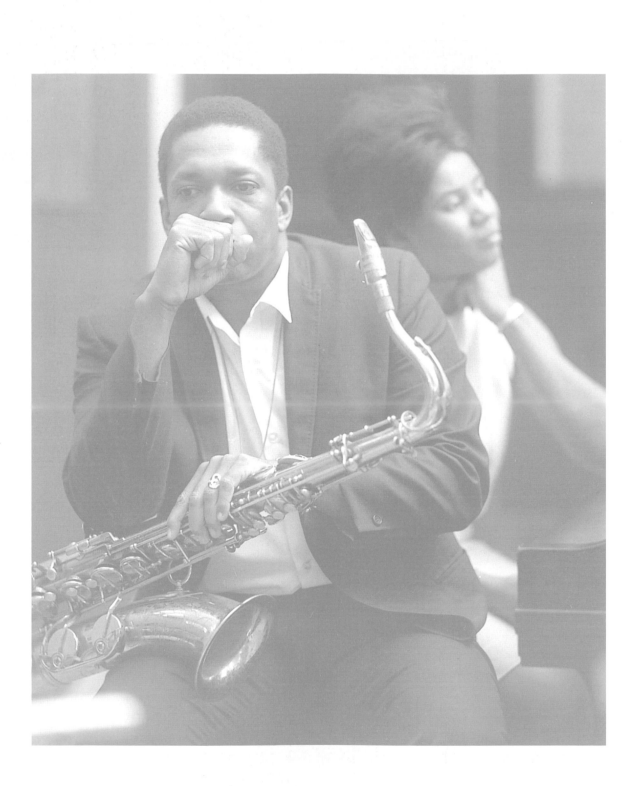

Part IV

Social and Artistic Movements: 1950 — 1979

PHOTOGRAPHER: JACK T. FRANKLIN

On June 19, 1963, a civil rights bill was introduced in the U.S. Senate, seven days after the murder of NAACP leader Medgar Evers in Jackson, Mississippi. Not surprisingly, 1963 was a pivotal year for a large number of black photographers. Throughout the country men, women, and young people were organizing busloads of people who were planning to attend the March on Washington. With unmistakable compassion and a keen sense of composition, numerous photographers captured the events of the period. By the early 1960s, the civil rights movement had become a national crusade for human rights for all oppressed people. Newspapers and magazines throughout the world had published gripping images of racial hatred in Birmingham, in the greatest outpouring of universal sentiment since the days of the abolitionists over one hundred years before. The most brutalizing events caused photographers to speak out en masse. Images convincingly told the story, and the activities of the modern civil rights movement were well documented by black photographers in this country. During the most active years of the civil rights, black power, and black arts movements, a period that began in the early 1960s and 1970s, a significant number of socially committed men and women became photographers. They set a different standard in documenting the struggles, achievements, and tragedies of the freedom movement by focusing on their own communities. SNCC (Student Nonviolent Coordinating Committee) photographers Doug Harris, Elaine Tomlin, and Bob Fletcher were at the forefront, documenting the voter registration drives in the South; Jack Franklin, Roland Freeman, Robert Sengstacke, Howard Bingham, Jonathan Eubanks, and Brent Jones photographed the activities of the Black Panther party and desegregation rallies. In 1969, Moneta Sleet, Jr., became the first African-American photographer to win the coveted Pulitzer Prize in photography, for his photograph of Mrs. Coretta Scott King and her daughter at the funeral of Dr. Martin Luther King, Jr.

The period of the early 1960s also saw a large number of black photographers

begin to study photography in workshops, art schools, and community centers. The common thread among the photographers included documentary and/or social landscape photography. The emphasis on social concerns of the black community and the experiences of its people is prevalent in these works. Art historian Barry Gaither describes this period of black art in this way:

> Black art had roots in: a) the activism of the Civil Rights Movement; b) rising cultural and political nationalism; c) latent resentment of racism and its humiliations; and d) outrage over the brutal treatment of blacks struggling non-violently to gain the most basic rights. Additionally, it was inspired by: a) southern black people's willingness to challenge the overwhelming white power vested in the region's economic and political institutions, and b) the collapse of colonialism internationally after the emergence of Ghana.[1]

Many of these photographers were determined to awaken social consciousness. Their work is a testimony to the depth of understanding and love these photographers have for humanity. As photographer Robert Sengstacke states:

> We saw ourselves as graphic historians, conveyors of love, combating what we felt were negative photographic images of blacks in the major American press. Whether we achieved recognition or not, we knew that someday people would look back and want to know what the black photographer had to say about his experience.[2]

PHOTOGRAPHER: RICHARD SAUNDERS

Richard Saunders (1922–1987) was an award-winning photojournalist throughout his forty-year career. He first became interested in photography as a young boy growing up in Bermuda. A local photographer whom Saunders followed around gave him some old equipment with which to experiment. At the age of eight, he and his family moved to the United States, and he put his early training to use while in school. Saunders's family returned to Bermuda at the outbreak of World War II, and he worked as a photographer with the police department there. During the 1940s, Saunders returned to the United States and received formal training in photography at Brooklyn College and the New School for Social Research in New York City.

In 1951, Saunders was selected by the former head of the Farm Security Administration's Historical Section, Roy Stryker, to join a team of top photojournalists in Pittsburgh. They hoped to depict the city's transition from a decaying steel-mill city to a progressive modern one. Saunders spent nearly two years on the project, taking four thousand photographs in the Hill District, a predominately black community. Also a resident, Saunders documented virtually all facets of the Hill, and his work became a significant part of the documentation project. Photographs like *Parade on Armed Forces Day* of 1951, where a young boy salutes marching soldiers, not only reveal the city's profound patriotism but also reflect Saunders's vision of the community. Saunders also worked outside of Pittsburgh, taking photographs that illustrated the uses of kerosene lanterns on

city streets. Family life is a significant part of Saunders's work, a theme which often appears in his later work for *Fortune, Ladies' Home Journal, Ebony,* and *Look.* In 1964, he went to work for the United States Information Agency (USIA), photographing in Latin America and then throughout Africa, where he focused on independence celebrations and economic, cultural, and agricultural development.

Like Saunders, Moneta J. Sleet, Jr. (1926–1996), born in Owensboro, Kentucky, had a great interest in family life. His career as a photographer began when his parents gave him a box camera as a child. Sleet studied business at Kentucky State College but maintained his interest in photography. After graduating in 1948, he was invited to set up the photography department at Maryland State College. He later studied at New York University, where he obtained a master's degree in journalism in 1950. Early in his career, Sleet worked for the *Amsterdam News* (New York) and *Our World* (New York), a popular black picture magazine, for which he photographed African-American political leaders and families. In 1953, Sleet began a photo essay on family life in the coal-mining town of Superior, West Virginia.

Our World ceased publication in 1955, and Sleet joined the staff of Johnson Publishing Company's *Ebony* magazine. His major contribution to photojournalism is his extensive documentation of the marches, meetings, and rallies of the civil rights movement. Sleet photographed throughout the United States, Africa, and Europe. He writes:

> You try to develop the sensitivity and the "eye" to see that very special mood of the moment. You develop the discipline to block out everything but you, the camera and the subject and you develop the tenacity to stick with it, to have patience. The picture will happen—that very special picture will happen.[3]

A prolific photographer since the early 1940s, Jack Franklin (b. 1922) cannot be easily classified, mainly because of his photographic work, which includes photographs of performing artists, neighborhoods, and family celebrations, among others. Franklin began photographing while in high school. He later worked as a photographer for the U.S. army during World War II, photographing for the 1862nd Aviation Engineers in the South Pacific. Initially a self-taught photographer, he later studied photography at the U.S. Army Signal Corps Photographic center in Astoria, New York, where he later became an instructor in photography. Upon returning to Philadelphia after the war, Franklin became active in photographing social and political events in the city. He became a major figure in photojournalism in Philadelphia, covering protest marches and civic and political leaders in the Philadelphia area.

During the early 1950s, Franklin worked as a staff and freelance photographer for periodicals such as *Sepia* and *Tribune.* He documented numerous social events for churches, clubs, and organizations. Franklin, like the other socially

114

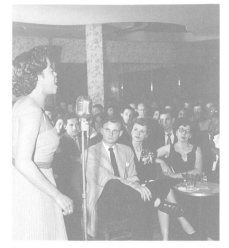

PHOTOGRAPHER: BOB MOORE

committed photographers who emerged during the 1960s, photographed the political milieu during the period of social unrest in the major cities of this country. Commenting on his own photographs Franklin states: "The civil rights movement itself would be the highlight of my photography. The most exciting ones were the march on Washington, the march from Selma when Martin Luther King was alive and after he passed, the Poor People's March (1969) on Washington. And around Philadelphia, of course, the different rallies."[4]

Best known as a jazz photographer, Charles "Chuck" Stewart (b. 1927) studied photography at Ohio University and moved to New York City after graduation. While still in school, he began to photograph jazz musicians primarily. He later freelanced for newspapers and magazines, including *Our World*. He started photographing jazz musicians and vocalists full-time onstage and in his studio. He photographed virtually every musician active between 1950 and 1980. Stewart's coverage eventually included blues, bebop, fusion, salsa, and other popular musical styles. His lively yet contemplative style captures the mood and spirit of the performer, whether in performance or in the photographer's studio. His framing and use of lighting, incorporating the instruments, microphones, and reflections to create abstract patterns, result in portraits that are as lyrical as their subject's musical compositions.

Milton J. Hinton (b. 1910) was born in Vicksburg, Mississippi. His connection with jazz musicians and composers, coupled with his own accomplishment as a jazz bassist, made him the first known jazz musician/photographer. He received his first camera as a birthday present in 1935 while playing with the band of Cab Calloway (1907–1979). Hinton began photographing his friends in candid poses on tour, backstage and in their dressing rooms. He made pictures of his musician friends more as a record of their activities than as a commercial venture, photographing almost every casual encounter. For more than fifty years, he photographed musicians and singers, including John Coltrane (1926–1967), Joe Williams (1918–1999), Billie Holiday (1915–1959), and Lester Young (1909–1959). His fifty-year career and intimate relationship with his peers are powerfully chronicled through his photography.

In Los Angeles in the 1950s and 1960s, black photographers documented the diversity in their own communities as well as elsewhere. Focusing on visiting celebrities, such as jazz vocalists and musicians, gospel singers, and political leaders, these photographers offered an insider's view of the black community. Bob Moore (active 1950s–1970s) photographed athletes like Arthur Ashe (1943–1993); performing artists like Sarah Vaughan (1924–1990) and Illinois Jacquet (b. 1922); and painters like Charles White (1918–1979), capturing the person at work in his own environment.

Similarly, Charles Williams (ca. 1908–1986) recorded celebrities during routine moments, such as Duke Ellington (1899–1974) watching his band members playing cards, Richard Nixon visiting a local barbershop, and "Sweet" Daddy Grace (1881–1960) preaching to his congregation.

Jack Davis (b. 1920) became a freelance photographer in 1949, a year before his arrival in Los Angeles from Waco, Texas. His early photographs were of local nightclub scenes. In 1950 he began taking classes in photography, learning commercial and portrait photography; he has become widely known for his intimate and public images of celebrities. During this period, the Davis Modern Arts Studio was one of the finest portrait studios for the black community in Los Angeles.

Joe Flowers (1937–1996) photographed the aftermath of the five-day Watts riots of 1965, images that are both sympathetic and politically charged. The photograph of a shop window with the identification *Negro owned* highlights the owner's plea to the looters to be mindful of his property. There are other dramatic scenes of rifle-wielding police and national guardsmen on patrol, with rows of isolated and burned-out streets in the background. These photographs show a once-unified community now under siege.

In Texas, individuals such as Louise Ozell Martin (1911–1995) worked as studio and journalistic photographers. Martin was born in Brenham, Texas, and began photographing at a young age. She focused her camera on family and school friends. She and her family moved to Houston in 1930 and, after graduating from high school, she studied photography at the Art Institute of Chicago and later at the University of Denver, where she earned a degree in photography. During World War II, Martin photographed soldiers and their families. In 1946, she opened her own portrait and commercial studio in Houston, the Louise Martin Art Studio. Known as Houston's society photographer, Martin photographed school and church groups, families, and models. Also working as a photojournalist for the local black press, she photographed the funeral of Dr. Martin Luther King, Jr. (1929–1968), which was held in Atlanta, Georgia. Her photographs document the life of her community, from children's pageants to the living conditions of the aged.

Euguene Roguemore (1921–1993) was born in Timpson, Texas. He became interested in photography while in the army during World War II. At the end of the war, he enrolled at Wiley College in Marshall, Texas, and majored in photography. In 1952, he moved to Lubbock, Texas, where he worked part-time as a commercial photographer. His photographs of the social scene in Texas are particularly strong, as he was able to capture the intimacy and spirit of the nightlife there.

Benny A. Joseph (b. 1924) photographed black businesses in Houston; these images are particularly revealing of the support such businesses received from the local residents. Joseph, a documentary and portrait photographer, studied photography at the black-owned Teal School of Photography in the late 1940s. His photograph of the exterior of the radio station KCOH, which also housed a restaurant and club, is a revealing portrait of the local community. Cars are lined up in front of the building, with men and women standing nearby, suggesting the primary role of the radio station in community life.

Elnora Frazier (b. 1924) graduated in 1940 from Houston College. Later she

studied photography with A. C. Teal, a black photographer in Houston, Texas. Graduating in 1942, Frazier photographed various church events and family experiences.

Curtis Humphrey (1907–1996) learned photography in Texas prior to enlisting in the Air Force. During his enlistment he was the base photographer. Later he taught photography at Wiley College in Texas and worked as a community photographer covering various events.

Marion James Porter (1908–1983) grew up in New Orleans, Louisiana, where he worked as a photojournalist for the black press. Porter's photographs of the local businesses tend to be symbolic as well as historical. Such images as two barbers in their local shop, a crowd outside a church on Easter morning, Eartha Kitt in a local nightclub, and musician Joe Turner with the photographer present a vast array of social experiences. A portrait of civil rights activist H. Rap Brown shows him standing near the rest rooms of a local club. At first, this appears to be a casual portrait, upon closer reading, it becomes apparent that Porter has captured the language and culture of his subject. Brown, wearing his signature beret and safari jacket, is positioned next to the SISTERS and BROTHERS signs and whimsical music notes painted on the doors. His pose is relaxed, but in the background, a wall painting of abstracted figures, wearing what appear to be Ku Klux Klan hoods, looms ominously.

New York photographer Robert Haggins (b. 1922) is best known for his photographs of Malcolm X. In the mid- to late 1950s, Haggins made photographs of the increasingly popular leader and activist while Malcolm X was a member of the Nation of Islam. Later, he captured Malcolm X's activities after he left the Nation of Islam. His most striking images are of Malcolm X in crowds in the early 1960s, with a young Muhammad Ali and with family members. Haggins's brilliant framing of this leader placed within the thronged street scene offers the viewer a surprisingly intimate portrait of Malcolm X.

Philadelphia photographer John W. Mosley (1907–1969) was born in Lumberton, North Carolina; he became interested in photography in his early twenties. Moving to Philadelphia in the 1930s, Mosley became recognized as a chronicler of black society in the Philadelphia area. Noted for photographing four to five events a day, Mosley was a dedicated and hardworking photographer. He covered virtually every black social and sporting event between 1936 and 1967, whether a relay race, parade, or football game in the Philadelphia area.

In contrast to Mosley, Roy DeCarava (b. 1919) is perhaps the major link to contemporary street photography. He studied art at Cooper Union in New York City, the Work Progress Administration's Harlem Art Center, and the George Washington Carver Art School. In 1955, DeCarava collaborated with Langston Hughes in producing a book entitled *The Sweetflypaper of Life*, which depicted black family life in Harlem. Also noted for his jazz photography, DeCarava founded a photography gallery in 1954, which became one of the first galleries in the United States devoted to the exhibition and sale of photography as a fine art.

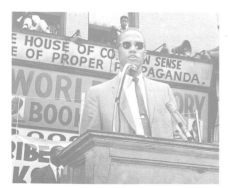

PHOTOGRAPHER: ROBERT L. HAGGINS

Memphis-born photographer Ernest C. Withers (b. 1922) began photographing at the age of fourteen. For more than twenty-five years, he maintained a studio on Beale Street, also known as the "Main Street of Negro America."[5] His photographs document activities of civil rights workers, musicians, and itinerant preachers. Significant within his large body of work is his ability to document the duality of life in this southern town: there are Jim Crow signs (colored only) that are juxtaposed with images of white evangelists preaching to all black congregations; then there is a photograph of blues singer B. B. King (b. 1925) with Elvis Presley (1935–1977) posing in oversized tuxedos. Such photographs offer a view of Withers's community as he knew it. As he writes:

> Photography is a collection of memories. . . . When I go through the negatives with various images out of the past, it has a tendency to jog my mind. The average person who doesn't go through such images doesn't have their minds [sic] as refreshed about the past. It renews your memory. It starts you to thinking retrospectively. . . . In my Civil Rights photographs, I want people to see the conditions of the times. I want them to be a reflection of what transpired. . . .[6]

Photojournalist Bertrand Miles (b. 1928) has been active in photography since 1939. His early photographs are of his friends and family members living in Lake Mary, Mississippi. His first professional assignment was to photograph his high school prom. After relocating to Chicago, Miles worked for *Ebony* and *Jet* magazines as a photojournalist. He moved to New York City in 1952, where he worked in the magazines' offices there for a brief period. With his strong interest in photojournalism, Miles also worked as a freelance photographer for other magazines, such as *Colliers* and *Life.* He captured the leaders of the civil rights movements, such as the congressman, civil rights activist, and clergyman, Adam Clayton Powell, Jr. (1908–1972), and civil rights activist and women's rights advocate Mary Church Terrell (1863–1954), as well as making sensitive self-portraits and portraits of family members.

Robert Sengstacke (b. 1943) started photographing when he was fourteen. At the age of sixteen, he set up a portrait studio in his basement. He photographed his high school classmates and worked part-time as a freelance photographer for his father's newspaper, *The Chicago Defender.* In 1966, he became the staff photographer for the Nation of Islam's newspaper, *Muhammad Speaks.* On assignment for the paper, he photographed every aspect of the Nation of Islam, from personal encounters to public and social events. A socially committed photographer, Sengstacke documented the struggles, achievements, and tragedies of the civil rights movement.

In Oakland, California, Jonathan Eubanks (b. 1927) focused his camera on the activities of the Black Panther party. An important chronicler of the party's activities, Eubanks employed a documentary style that is both emotional and descriptive. His photographs explore the personal world of the young members and

their immediate concern—establishing a breakfast program for children. His photographs of party members' encounters with the police, as well as his portraits of Black Panther leaders and party members, are more than simply documentary. They express his passionate feelings for his subjects and their issues. His undated and unpublished artist statement reads, "Photography to me is a multifaceted experience: It's creative when you consider your subject; capture that subject with your camera; develop and print the image; and when the viewer enjoys the finished picture."

During the decade of the 1960s, many black photographers and artists organized photography workshops in community centers and galleries. In 1963, for example, Roy DeCarava cofounded the Kamoinge Workshop in New York. Among its members were Shawn Walker, Lou Draper, Beuford Smith, Anthony Barboza, and Ming Smith. In the early 1970s, Joe Crawford, a graphic artist, began publishing the *Black Photographer's Annual*, which published the work of black photographers from all over the country. Crawford and photographer Beuford Smith were coeditors, and both were instrumental in recognizing, publishing, and preserving the work of early black photographers such as James VanDerZee and P. H. Polk. The James VanDerZee Institute, which held meetings at the Studio Museum in Harlem, published monthly newsletters on photography and exhibited works of local black photographers.

Adger W. Cowans (b. 1936) attended Ohio University, where he studied photography. During the early 1960s, Cowans photographed the activities of civil rights organizations, particularly the Student Nonviolent Coordinating Committee. In 1962, he won the coveted John Hay Whitney Fellowship for creative photography, and for the last thirty years Cowans has worked as a still photographer for the film industry. His photographs of the people of Surinam at work and at play, are intimate as well as documentary in intention.

Washington, D.C.–based photographer Milton Williams (b. 1940) documents in his photographs black life in the District of Columbia. His images of parades, protest marches, sports figures, and civil rights leaders over the last thirty years chronicle the political and social life of the community.

Winston Kennedy (b. 1944), an educator, printmaker, and photographer, focuses his camera on the black family. His interest in photographing men during reflective moments began in the mid-1970s when he lived in North Carolina, after his participation in the civil rights movement. Kennedy has sought to reveal the commonalities among diverse groups of men living in the North and South. The results are visceral, allowing the viewer to imagine the private moments of these individuals.

St. Clair Bourne (b. 1943) is both a filmmaker and photographer. His photographs of Harlem streets during a snowstorm reveal his interest in urban imagery as well as in abstract form. Bourne began his career in film as a producer for public television and later became known as an award-winning documentary filmmaker. His films include *John Henrik Clarke: A Great and Mighty Walk; Paul*

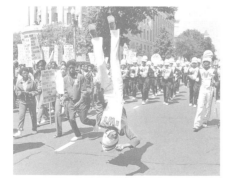

PHOTOGRAPHER: MILTON WILLIAMS

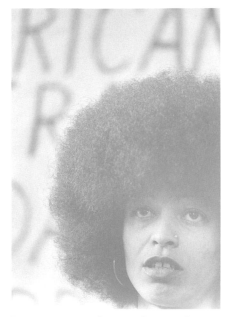

PHOTOGRAPHER: CARROLL PARROTT BLUE

Robeson: Here I Stand!; In Motion: Amiri Baraka; and *Langston Hughes: The Dream Keeper.* As a photographer, he took pictures of a number of black leaders and activists in the civil rights movements.

Influential as both a photographer and folklorist, Baltimore-born Roland L. Freeman (b. 1936) started taking pictures with a borrowed camera in the 1950s, then continued this hobby while he was in the U.S. Air Force. Moved by the enormous crowds at the 1963 March on Washington, the determination of these participants, and the speeches of Dr. Martin Luther King, Jr., Freeman decided to become a photographer and document his personal experiences and the activities of the civil rights movement.

Viewing the camera as a research tool, Freeman became a freelance photographer. His current work explores the rural South's retention of African culture and rituals through quilting, food ways, sewing, religious practices, and the use of herbal medicines. His photographs from the 1970s of the Arabbers—the street merchants selling vegetables and fruit—in Baltimore provide an important record of a local community tradition.

C. Daniel Dawson (b. 1943) is a photographer who also works as an arts and media consultant. He began photographing in the late 1960s and became involved in the 1970s with the Kamoinge Workshop. A fine-art photographer, he is best known for abstractions of reality, which are both mysterious and ambigious. His portraits, on the other hand, reveal his sensitivity and interest in identifying the self-image of his subjects.

Bill Lathan (b. 1937) has documented the black theater movement in New York City since the mid-1960s. His photographs of actors and writers of the now-defunct New Lafayette Theater are particularly important because of the New Lafayette's significance to local black theater and its support of emerging talent, including such actresses as Phylicia Rashad and Debbi Morgan. Once a director of a number of performances of the theater group, Lathan explores the concept of naturalism in his portraiture. His deceptively straightforward photographic style is a conscious choice, which allows the subject to "perform" for the viewer.

Reginald L. Jackson (b. 1945) has documented cultural expressions in North and South America, the Caribbean, and West Africa. During the early 1970s, Jackson's photography explored political movements of the period, such as the Black Panther party. His images often include rallies and campaign drives.

San Diego filmmaker and educator Carroll Parrott Blue (b. 1943) is concerned with presenting visual evidence of the black struggle and African-American identity. She takes photographs of anonymous black people in protest demonstrations and of individual icons of the black power movement in the United States. Her portraits of Angela Davis (b. 1944) and Fannie Lou Hamer (1917–1977) offer visual commentary on the role black women have played in the history of black protest in the United States.

Roy DeCarava (b. 1919)

142. Ketchup Bottles, Table and Coat

Gelatin silver print, 1953

Courtesy of the photographer, Brooklyn, New York

Richard Saunders (1922–1987)
143. Port Authority Bus Terminal, 41st Street and Eighth
Avenue, New York, New York
Gelatin silver print, 1951
Standard Oil (New Jersey) Collection, Photographic Archives
Special Collections, Ekstron Library
University of Louisville, Kentucky
SONJ 68001 M-31

Richard Saunders (1922–1987)
144. Hill District, father and son, Pittsburgh, Pennsylvania
Gelatin silver print, 1951
Carnegie Museum of Art, Pittsburgh
Gift of Carnegie Library of Pittsburgh
86.16.155

Richard Saunders (1922–1987)
145. Kerosene signal lanterns on traffic sign, New York,
New York
Gelatin silver print, 1952
Standard Oil (New Jersey) Collection, Photographic Archives
Special Collections, Ekstron Library
University of Louisville, Kentucky
SONJ 71927

Richard Saunders (1922–1987)
146. Armed Forces Day Parade on Grant Street, Pittsburgh, Pennsylvania
Gelatin silver print, 1951
Carnegie Museum of Art, Pittsburgh
Gift of Carnegie Library of Pittsburgh
86.16.142

Charles ("Chuck") Stewart (b. 1927)
147. Portrait of Dinah Washington (1924–1963),
vocalist
Gelatin silver print, n.d.
Courtesy of the photographer, Teaneck, New Jersey

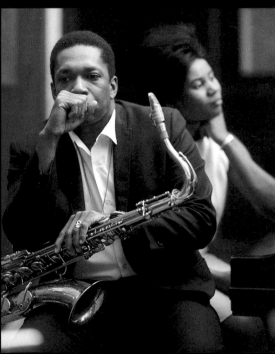

Charles ("Chuck") Stewart (b. 1927)
148. Portrait of Max Roach (b. 1924), jazz percussionist and bandleader
Gelatin silver print, n.d.
Courtesy of the photographer, Teaneck, New Jersey

Charles ("Chuck") Stewart (b. 1927)
149. Portrait of John Coltrane (1926–1967), jazz tenor and
soprano saxophonist, and Alice Coltrane (b. 1937), pianist,
organist, harpist, and composer
Gelatin silver print, 1966
Courtesy of the photographer, Teaneck, New Jersey

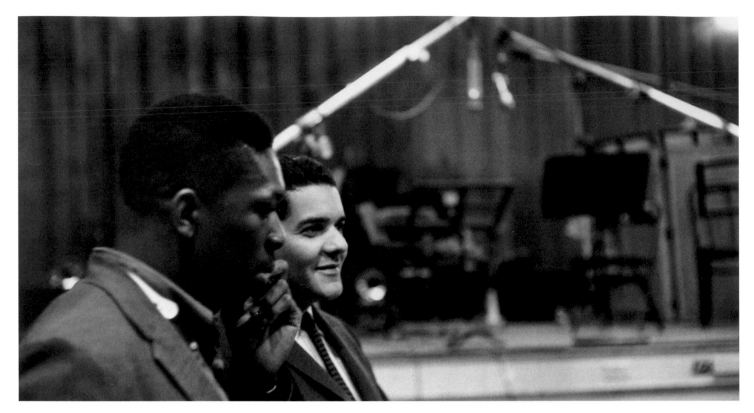

Milton ("Milt") J. Hinton (b. 1910)

150. John Coltrane (1926–1967) and George Russell at recording studio, New York, New York

Gelatin silver print, ca. 1956

Courtesy of the Milton J. Hinton Photographic Collection, New York, New York

822-235

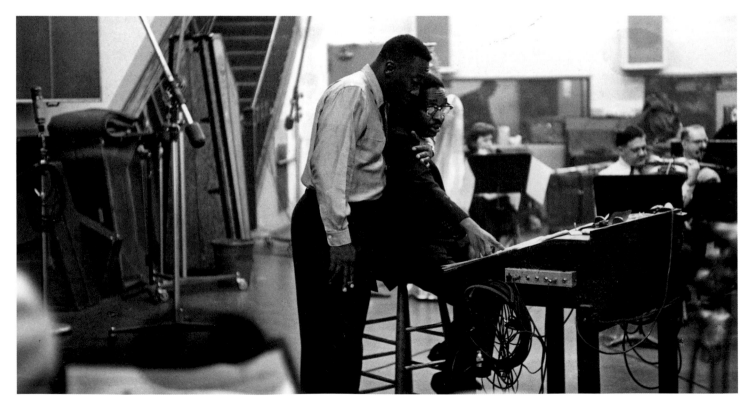

Milton ("Milt") J. Hinton (b. 1910)

151. Joe Williams (1918–1999), jazz and blues singer, and Jimmy Jones at recording studio, New York, New York

Gelatin silver print, ca. 1959

Courtesy of the Milton J. Hinton Photographic Collection, New York, New York

745-541

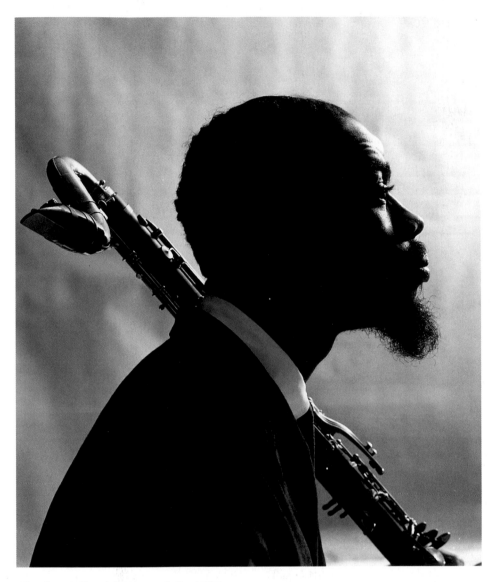

Charles ("Chuck") Stewart (b. 1927)
152. Portrait of Eric Dolphy (1928–1964), alto saxophonist
Gelatin silver print, 1964
Courtesy of the photographer, Teaneck, New Jersey

Milton ("Milt") J. Hinton (b. 1910)
153. Lester Young (1909–1959), jazz tenor saxophonist, and Roy Eldridge
(1911–1989), jazz trumpeter, in Harlem
Gelatin silver print, ca. 1958
Courtesy of the Milton J. Hinton Photographic Collection, New York,
New York
247-226

Milton ("Milt") J. Hinton (b. 1910)
154. Billie Holiday (1915–1959), vocalist, and William James ("Count") Basie (1904–1984),
jazz pianist and bandleader, at television studio in New York, New York
Gelatin silver print, ca. 1957
Courtesy of the Milton J. Hinton Photographic Collection, New York, New York
155-223

Bertrand Miles (b. 1928)

155. Congressman Adam Clayton Powell, Jr. (1908–1972), speaking at the NAACP National
Convention at the Madison Square Garden
Gelatin silver print, 1959
Courtesy of the photographer, New York, New York

Bertrand Miles (b. 1928)

156. The Photographer's Mother, Irma Miles
Gelatin silver print, 1948
Courtesy of the photographer, New York,
New York

Bertrand Miles (b. 1928)

157. Self-Portrait, Chicago
Gelatin silver print, 1948
Courtesy of the photographer, New York, New York

Bertrand Miles (b. 1928)
158. Mary Church Terrell (1863–1954), civil rights and women's rights activist
Gelatin silver print, 1953
Courtesy of the photographer, New York, New York

Bob Moore (active 1950s–1970s)
159. Portrait of artist Charles White (1918–1979) at work in his studio, Los Angeles, California
Gelatin silver print, n.d.
Courtesy of the black gallery of California, Los Angeles

Bob Moore (active 1950s–1970s)
160. Arthur Ashe (1943–1993) at tennis match in Los Angeles, California
Gelatin silver print, ca. 1979
Courtesy of the black gallery of California, Los Angeles

Bob Moore (active 1950s–1970s)
162. Illinois Jacquet (b. 1922) playing saxophone
Gelatin silver print, n.d.
Courtesy of the black gallery of California, Los Angeles

Bob Moore (active 1950s–1970s)
161. Sarah Vaughan (1924–1990) singing in nightclub, Los
Angeles, California
Gelatin silver print, n.d.
Courtesy of the black gallery of California, Los Angeles

Charles Williams (1908–1986)
163. Pearl Bailey (1918–1990) on the set at Paramount Studios
Gelatin silver print, 1955
Courtesy of the black gallery of California, Los Angeles

Charles Williams (1908–1986)

164. Duke Ellington (1899–1974) watching card game on train

Gelatin silver print, ca. 1955

Courtesy of the black gallery of California, Los Angeles

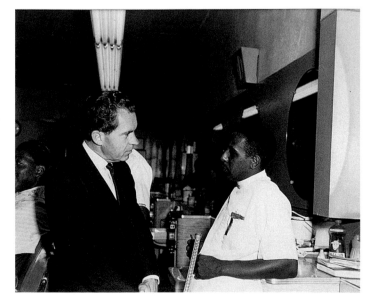

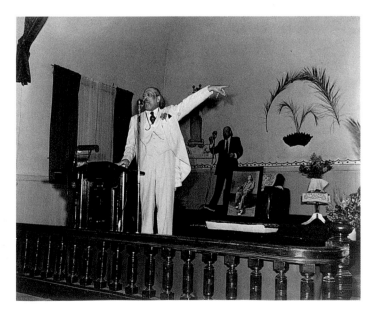

Charles Williams (1908–1986)

165. Richard Nixon with shop owner on Central Avenue in Los Angeles, California

Gelatin silver print, 1955

Courtesy of the black gallery of California, Los Angeles

Charles Williams (1908–1986)

166. "Sweet" Daddy Grace (1881–1960) in Los Angeles church

Gelatin silver print, ca. 1955

Courtesy of the black gallery of California, Los Angeles

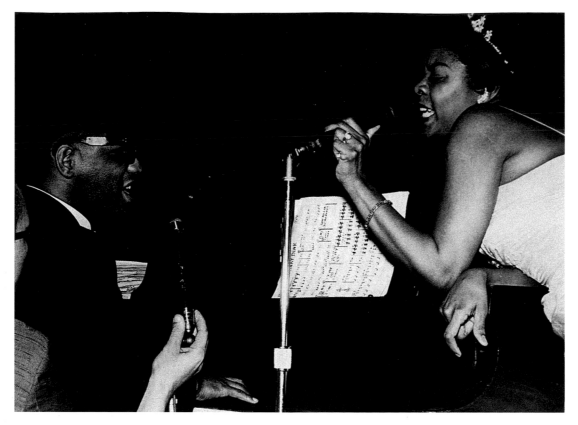

Jack Davis (b. 1920)

167. Dinah Washington (1924–1963) singing with Ray Charles (b. 1930)

Gelatin silver print, ca. 1960

Courtesy of the black gallery of California, Los Angeles

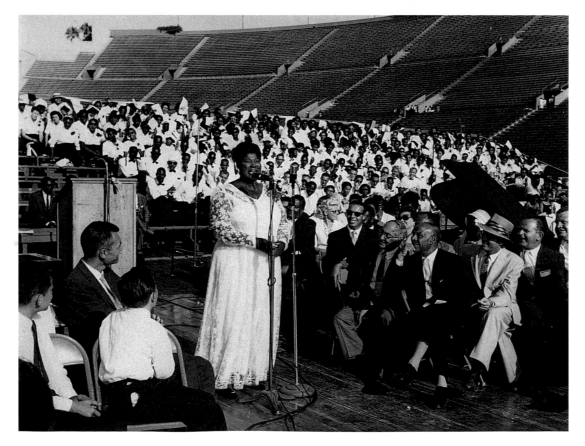

Jack Davis (b. 1920)

168. Mahalia Jackson (1912–1972) singing in the Coliseum, Los Angeles

Gelatin silver print, ca. 1960

Courtesy of the black gallery of California, Los Angeles

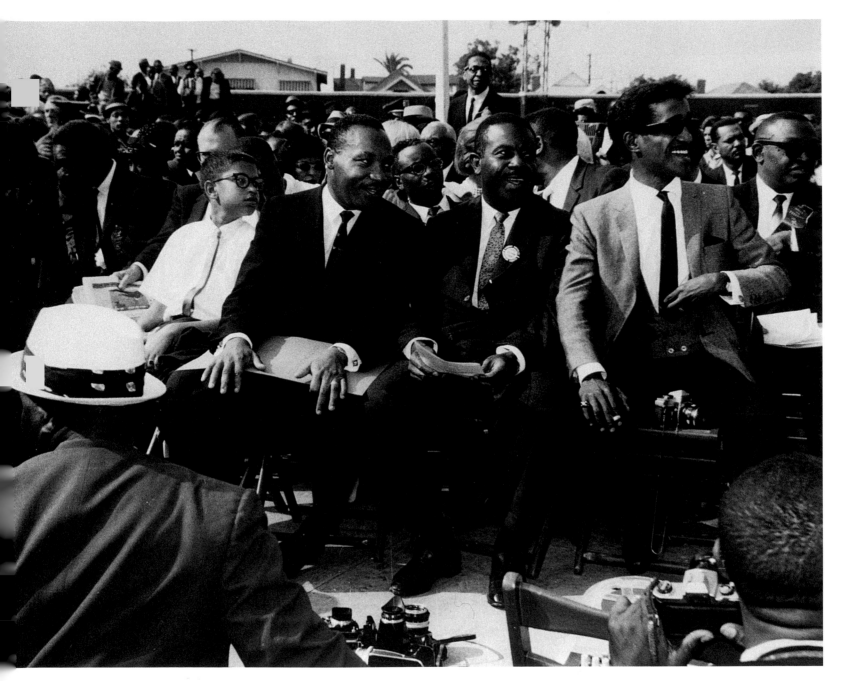

Jack Davis (b. 1920)

169. Martin Luther King, Jr. (1929–1968), with Ralph Abernathy (1926–1990),
Sammy Davis, Jr. (1925–1990), and a group of ministers in Los Angeles
Gelatin silver print, ca. 1960
Courtesy of the black gallery of California, Los Angeles

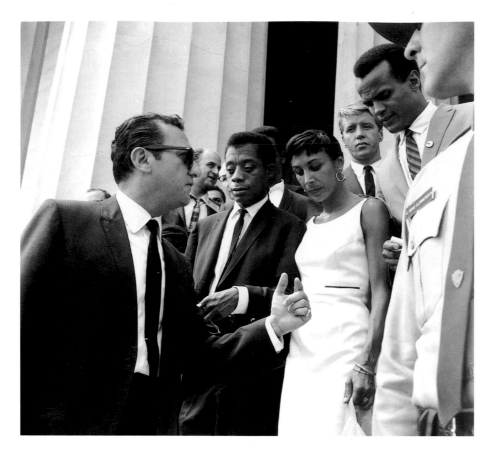

Jack T. Franklin (b. 1922)
170. James Baldwin (1924–1987) and Julie and Harry Belafonte (b. 1927) at the March on Washington
Gelatin silver print, 1963
Jack T. Franklin Collection
Courtesy of the African American Museum in Philadelphia

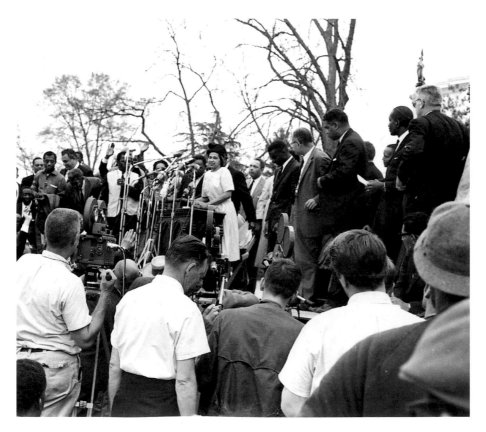

Jack T. Franklin (b. 1922)
171. Civil rights leaders and celebrities join Rosa Parks (b. 1913) as she addresses
demonstrators in front of State Building in Montgomery, Alabama
Gelatin silver print, 1965
Jack T. Franklin Collection
Courtesy of the African American Museum in Philadelphia

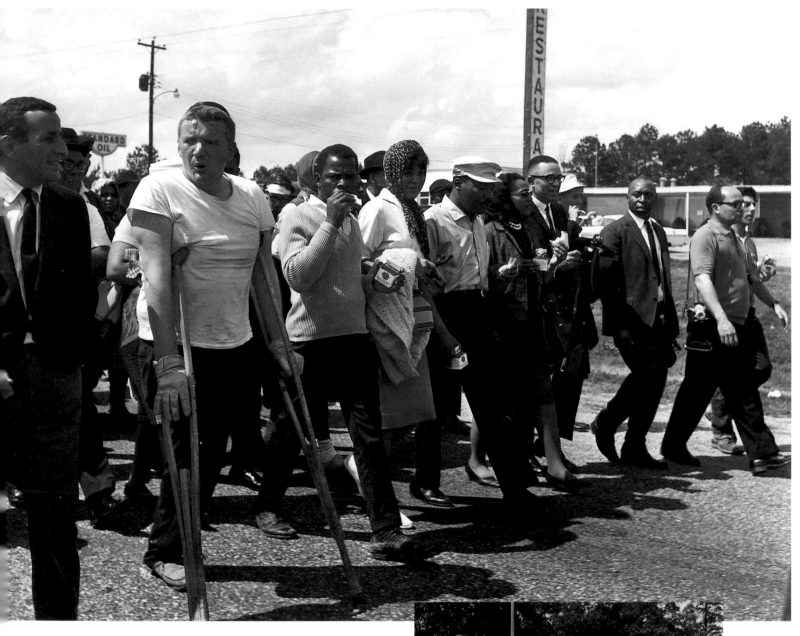

Jack T. Franklin (b. 1922)
172. Coretta Scott King and C. Delores Tucker, left of Dr. Martin
Luther King, Jr., with other marchers at Selma to Montgomery March
Gelatin silver print, 1963
Jack T. Franklin Collection
Courtesy of the African American Museum in Philadelphia

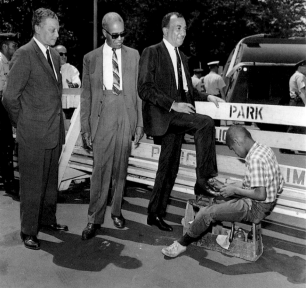

Jack T. Franklin (b. 1922)
173. Judge Herbert Mullen, Roy Wilkins (1901–1981)
(NAACP-National), and Cecil Moore (NAACP-Philadelphia)
Gelatin silver print, 1965
Jack T. Franklin Collection
Courtesy of the African American Museum in Philadelphia

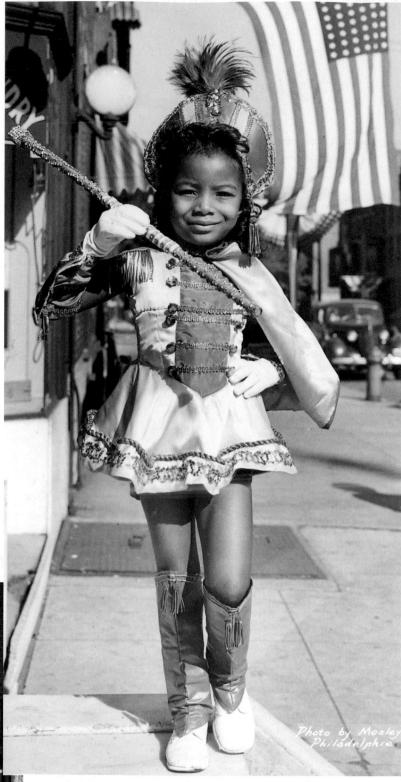

John W. Mosley (1907–1969)

174. Majorette at National Elks Convention

Gelatin silver print, ca. 1945

Charles L. Blockson Afro-American Collection

Temple University, Philadelphia, Pennsylvania

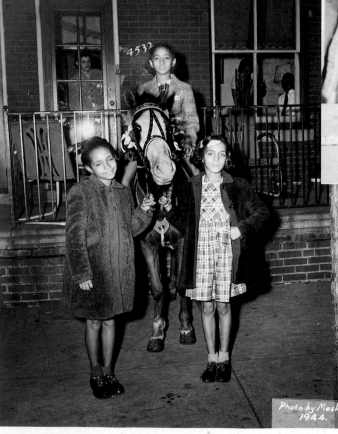

John W. Mosley (1907–1969)

175. Dr. William Hamilton's daughters enjoying a birthday treat, Philadelphia

Gelatin silver print, 1944

Charles L. Blockson Afro-American Collection

Temple University, Philadelphia, Pennsylvania

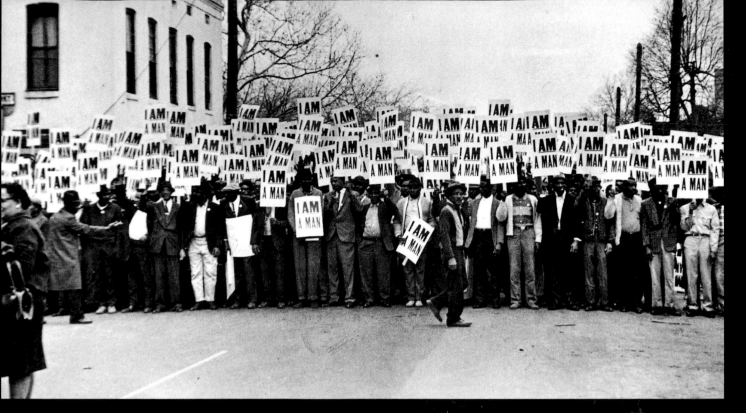

Ernest C. Withers (b. 1922)
176. Sanitation workers' strike, Memphis, Tennessee
Gelatin silver print, 1968
Courtesy of Panopticon Gallery, Boston, Massachusetts
© Ernest Withers

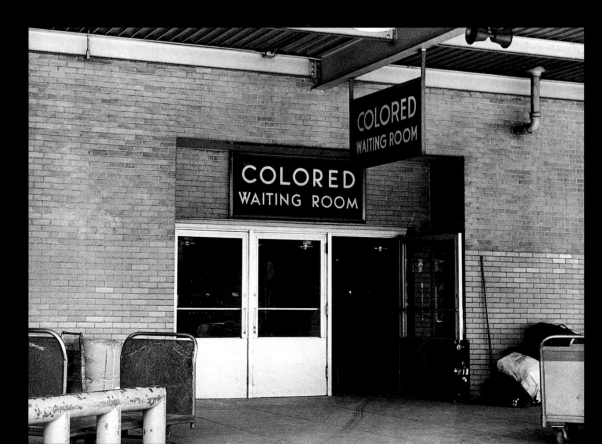

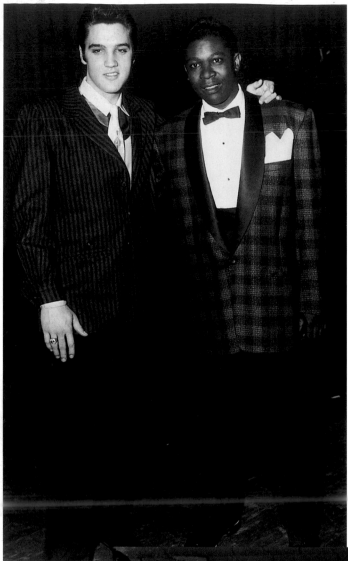

Ernest C. Withers (b. 1922)
178. Elvis Presley (1935–1977) and B. B. King (b. 1925) in
Memphis, Tennessee
Gelatin silver print, 1957
Courtesy of Panopticon Gallery, Boston, Massachusetts
© Ernest Withers

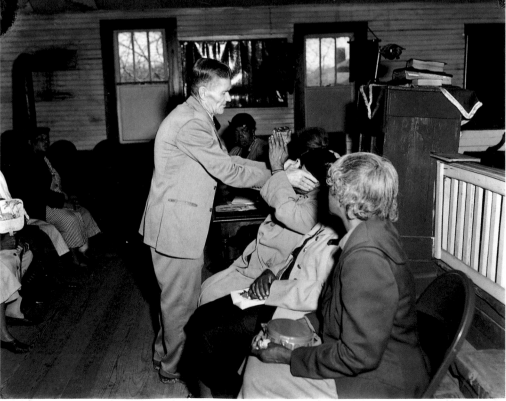

Ernest C. Withers (b. 1922)
179. Faith healer, Memphis, Tennessee
Gelatin silver print, ca. 1960s
Courtesy of the Panopticon Gallery, Boston, Massachusetts
© Ernest Withers

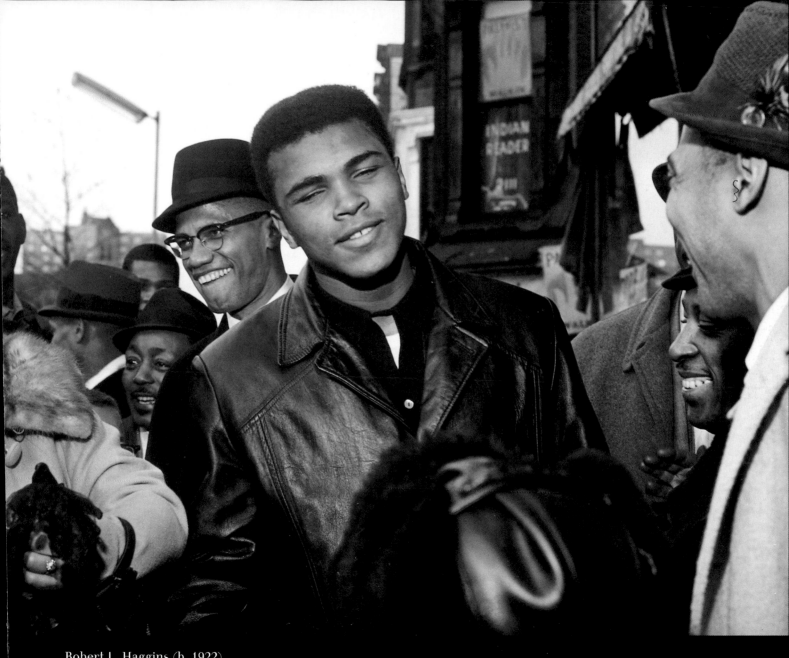

Robert L. Haggins (b. 1922)
180. Malcolm X with Muhammad Ali (b. Cassius Clay, 1942) in Harlem after Ali's championship win
Gelatin silver print, 1964
Courtesy of the photographer, Bronx, New York

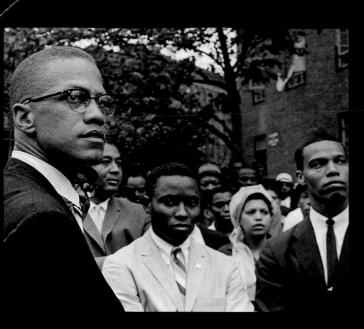

Robert L. Haggins (b. 1922)
181. Watching My Back! (Malcolm X [1925–1965], ministers [including Louis Farrakhan], and Nation of Islam members at Harlem rally at 115th Street and Lenox Avenue)
Gelatin silver print, 1964
Courtesy of the photographer, Bronx, New York

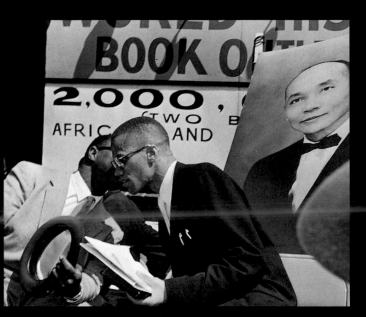

Robert L. Haggins (b. 1922)
182. Malcolm X (1925–1965) with minister James Shabazz at Harlem rally on 125th Street and Lenox Avenue
Gelatin silver print, 1963
Courtesy of the photographer, Bronx, New York

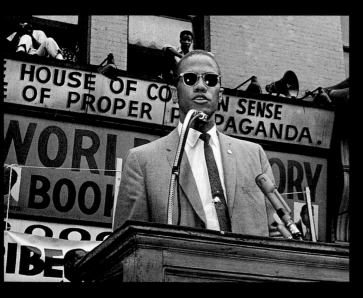

Robert L. Haggins (b. 1922)
183. Malcolm X speaking in front of Micheaux's National Memorial African Bookstore on 125th Street in Harlem
Gelatin silver print, ca. 1960
Courtesy of the photographer, Bronx, New York

Robert L. Haggins (b. 1922)
184. Malcolm X greets Lewis Micheaux, owner of the National Memorial African Bookstore on 125th Street near Lenox Avenue
Gelatin silver print, ca. 1960
Courtesy of the photographer, Bronx, NY

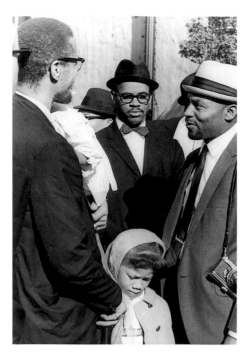

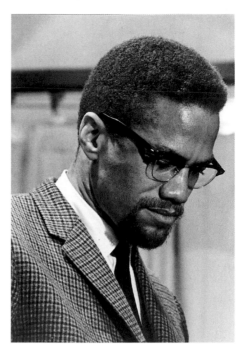

Robert L. Haggins (b. 1922)
185. Malcolm X holding his daughter Qubilah, with
daughter Attallah standing nearby, at rally
Gelatin silver print, 1963
Courtesy of the photographer, Bronx, New York

Robert L. Haggins (b. 1922)
186. Last photograph taken by the photographer of
Malcolm X, February 18, 1965
Gelatin silver print, 1965
Courtesy of the photographer, Bronx, NY

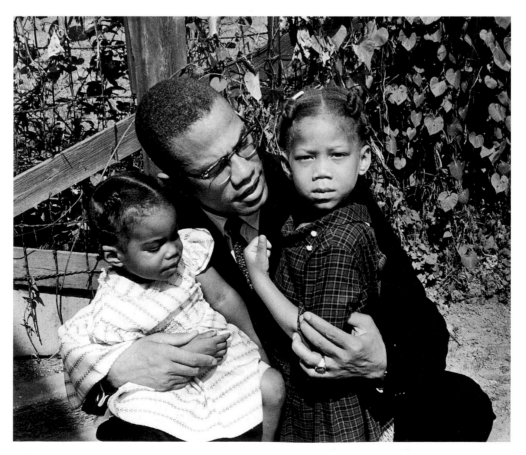

Robert L. Haggins (b. 1922)
187. Malcolm X with daughters Qubilah and Attallah at home in East Elmhurst, Queens
Gelatin silver print, 1963
Courtesy of the photographer, Bronx, New York

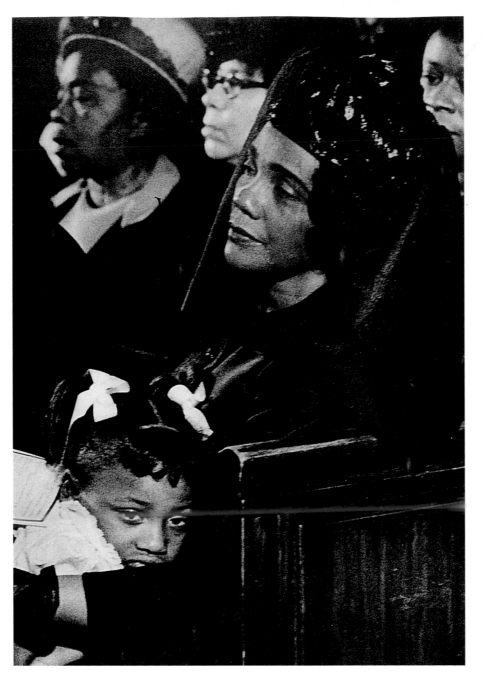

Moneta J. Sleet, Jr. (1926–1996)
188. Mrs. Coretta Scott King and her daughter Bernice at the funeral
of Dr. Martin Luther King, Jr., Atlanta
Gelatin silver print, 1968
Corbis-Bettman, New York, New York
U158289.4

Moneta J. Sleet, Jr. (1926–1996)
189. Street scene, Superior, West Virginia
Gelatin silver print, 1953
Museum purchase with funds provided by the Graham Foundation
Museum of Fine Arts, Houston, Texas

Louise Ozell Martin (1911–1995)
190. Untitled (children's pageant)
Gelatin silver print, ca. 1969
Courtesy of Community Artists' Collective, Houston, Texas

Louise Ozell Martin (1911–1995)
191. Untitled (children's pageant 2)
Gelatin silver print, ca. 1969
Courtesy of Community Artists' Collective, Houston, Texas

Louise Ozell Martin (1911–1995)
192. Dr. Martin Luther King, Jr.'s casket at Morehouse College, Atlanta
Gelatin silver print, 1968
Courtesy of the Museum of Fine Arts, Houston, museum purchase with funds
provided by Sarah Trotty, Joan Morgenstein, and Clinton T. Willour

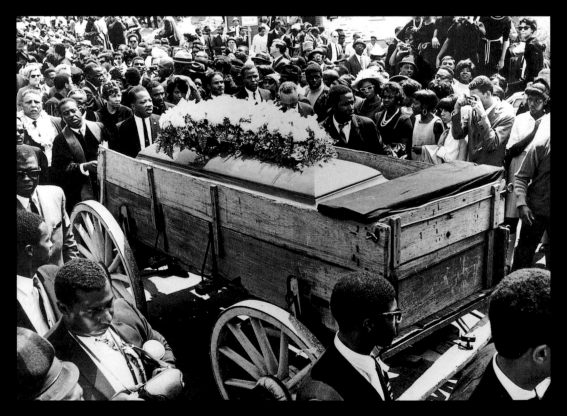

Louise Ozell Martin (1911–1995)
193. Dr. Martin Luther King, Jr.'s funeral, Atlanta
Gelatin silver print, 1968
Courtesy of the Museum of Fine Arts, Houston, museum purchase with funds provided
by Dean Kilgore, John Hansen, Dr. Alice McPherson, and an anonymous donor in
memory of Albert Newell and in honor of Anniebelle Jones

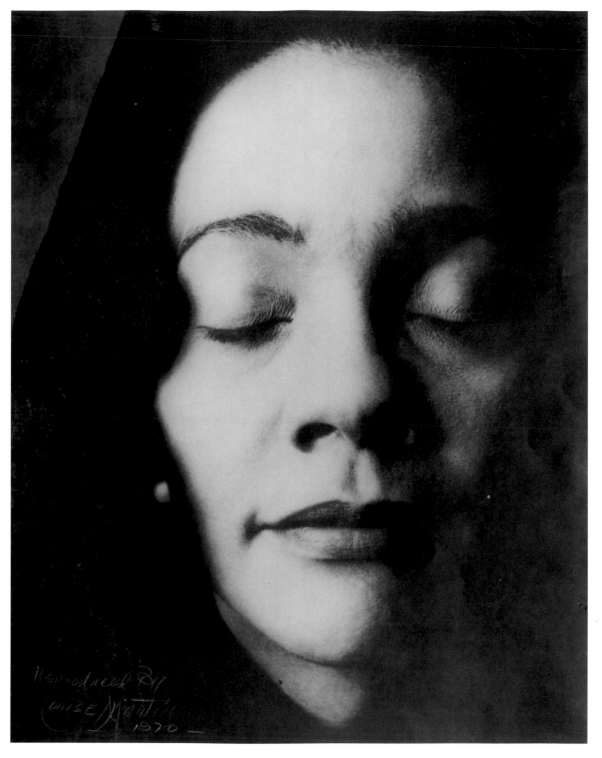

Louise Ozell Martin (1911–1995)

194. Coretta Scott King

Gelatin silver print, 1970

Courtesy of the Texas African American Photography Archive, Documentary
Arts, Dallas

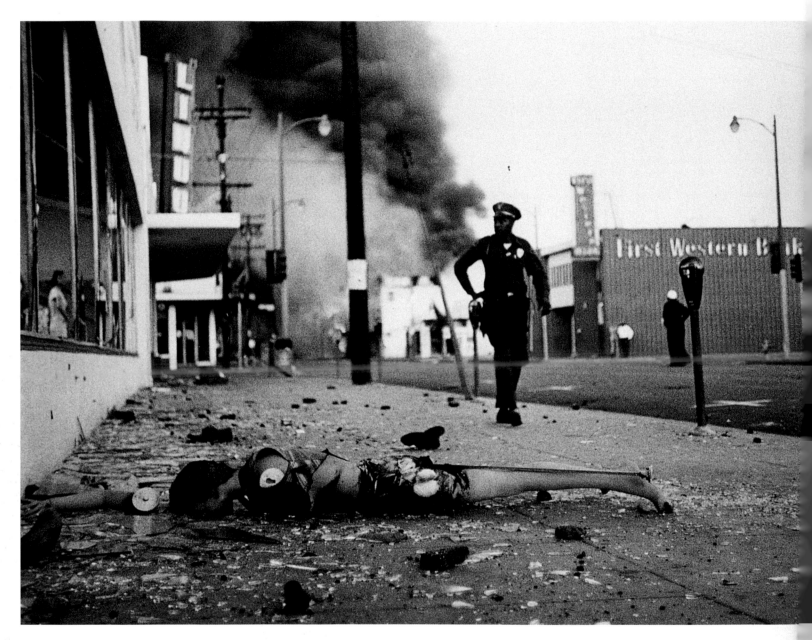

Joe Flowers (1937–1996)
195. Police officer and burned store mannequin, Watts riot,
Los Angeles
Gelatin silver print, 1965
Courtesy of the black gallery of California, Los Angeles

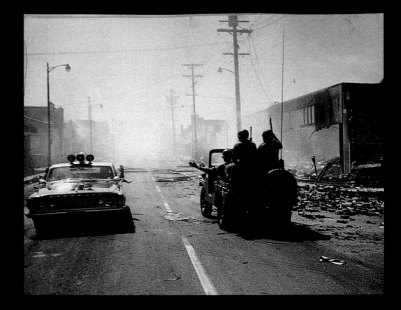

Joe Flowers (1937–1996)
196. Police waving at National Guard, Watts riot, Los Angeles
Gelatin silver print, 1965
Courtesy of the black gallery of California, Los Angeles

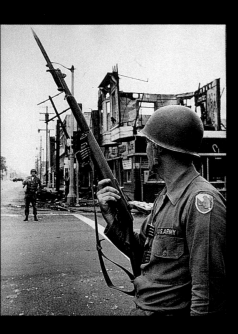

Joe Flowers (1937–1996)
197. U.S. Army soldier talking with National Guard, Watts riot,
Los Angeles
Gelatin silver print, 1965
Courtesy of the black gallery of California, Los Angeles

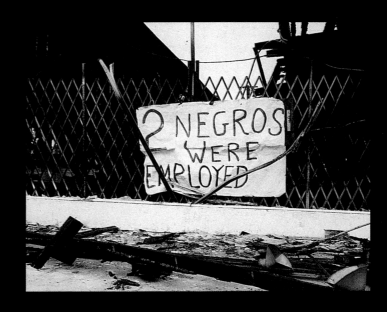

Joe Flowers (1937–1996)
198. Two Negroes Were Employed (sign in window), Watts riot,
Los Angeles
Gelatin silver print, 1965
Courtesy of the black gallery of California, Los Angeles

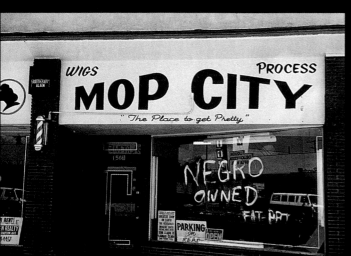

Joe Flowers (1937–1996)
199. Negro Owned (sign in window of Mop City), Watts riot,
Los Angeles
Gelatin silver print, 1965
Courtesy of the black gallery of California, Los Angeles

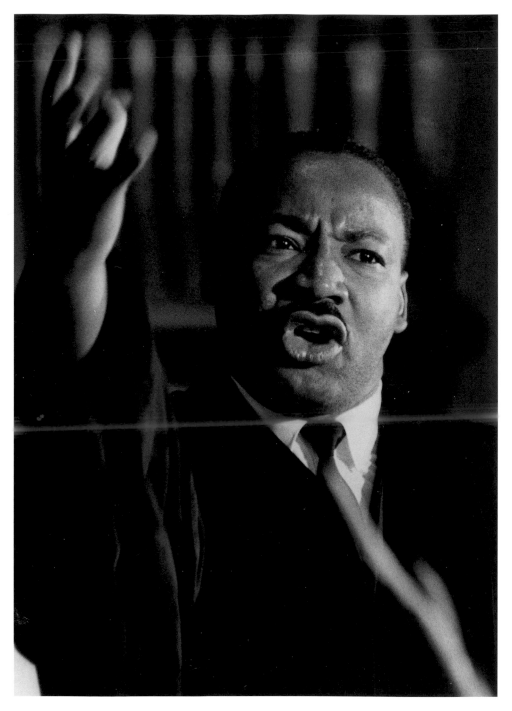

Robert A. Sengstacke (b. 1943)
200. Portrait of Dr. Martin Luther King, Jr. (1929–1968)
Gelatin silver print, 1966
Courtesy of the photographer, Chicago, Illinois

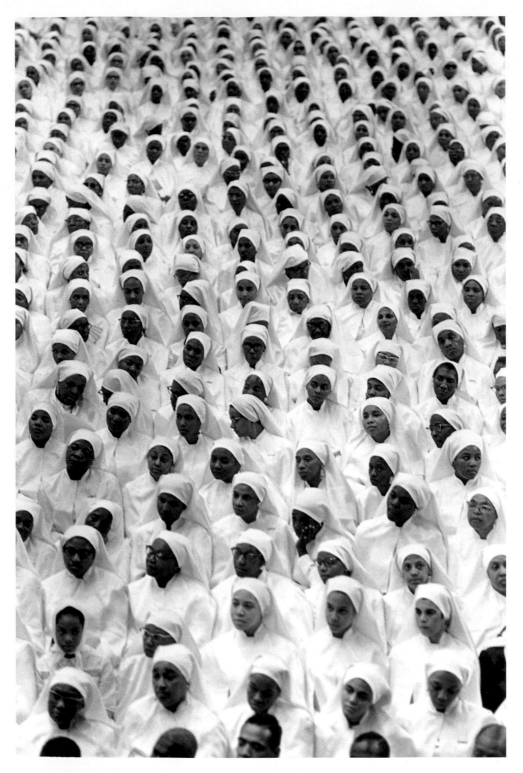

Robert A. Sengstacke (b. 1943)
201. Savior's Day, women's section, Chicago
Gelatin silver print, 1966
Courtesy of the photographer and Williams College Museum of Art,
Williamstown, Massachusetts

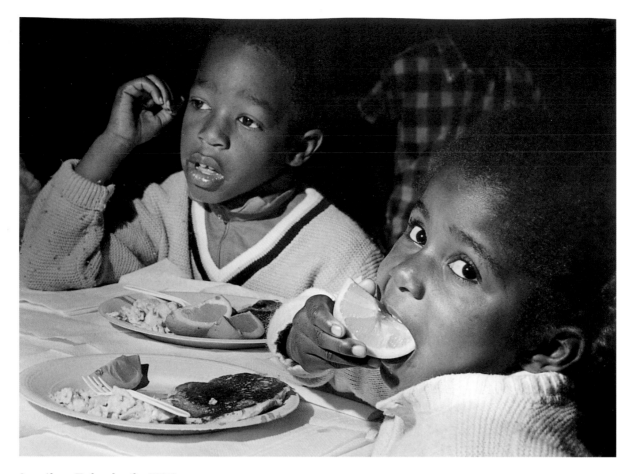

Jonathan Eubanks (b. 1927)
202. *Black Panther* series: Two children in the Panther
Breakfast Program, Oakland
Gelatin silver print, 1970
Courtesy of the photographer, Oakland, California

Jonathan Eubanks (b. 1927)
203. *Black Panther* series: Kathleen Neal Cleaver (b. 1945)
with Black Panther party member and Oakland police
officer
Gelatin silver print, 1969
Courtesy of the photographer, Oakland, California

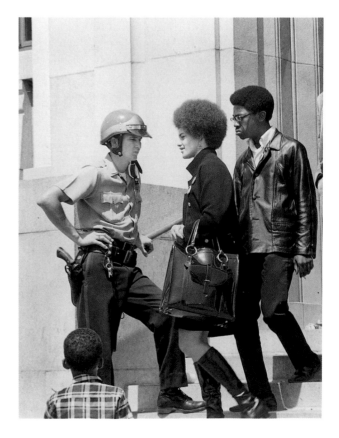

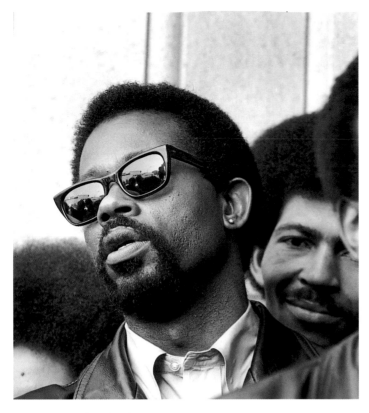

Jonathan Eubanks (b. 1927)
204. *Black Panther* series: Eldridge Cleaver (1935–1998) in Oakland
Gelatin silver print, 1969
Courtesy of the photographer, Oakland, California

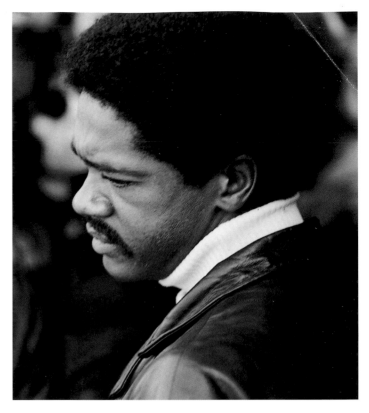

Jonathan Eubanks (b. 1927)
205. *Black Panther* series: Bobby Seale (b. 1936), Black Panther party
member, Oakland
Gelatin silver print, 1969
Courtesy of the photographer, Oakland, California

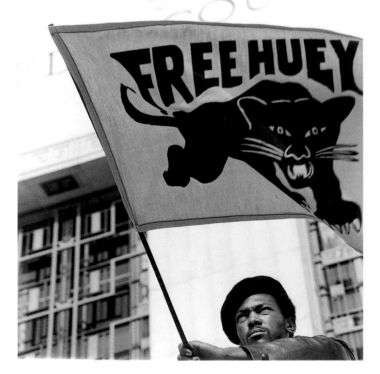

Jonathan Eubanks (b. 1927)
206. *Black Panther* series: Black Panther party member carrying
"Free Huey" flag, Oakland
Gelatin silver print, 1969
Courtesy of the photographer, Oakland, California

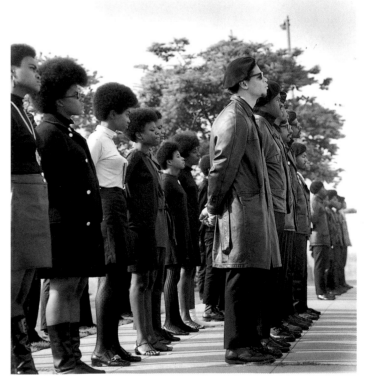

Jonathan Eubanks (b. 1927)
207. *Black Panther* series: Black Panther party members, Oakland
Gelatin silver print, 1969
Courtesy of the photographer, Oakland, California

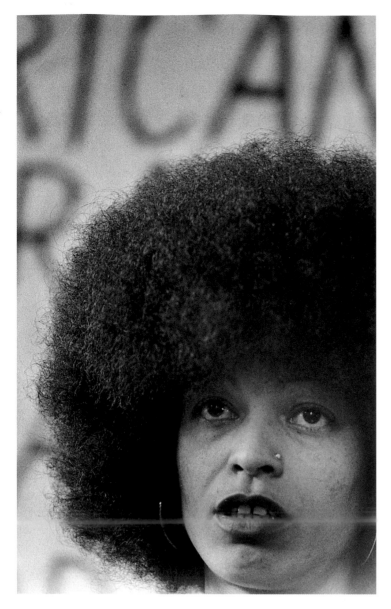

Elnora Frazier (b. 1924)
209. Elaine Williams, Houston, Texas
Gelatin silver print, ca. 1965
Courtesy of the Texas African American Photography Archive,
Documentary Arts, Dallas

(See page 270 for color plates by Carroll Parrott Blue)

Carroll Parrott Blue (b. 1943)
208. Angela Davis (b. 1944), political
activist, in Los Angeles
Gelatin silver print, 1972
Courtesy of the photographer, San Diego,
California

Curtis Humphrey (1907–1996)
210. Postmortem portrait, Tyler, Texas
Gelatin silver print, ca. 1959
Courtesy of the Texas African American
Photography Archive, Documentary Arts,
Dallas

Marion James Porter (1908–1983)

211. Easter Sunday, New Orleans

Gelatin silver print, ca. 1965

Courtesy of the Eric Waters Collection, New Orleans

Marion James Porter (1908–1983)
212. Eartha Kitt, New Orleans
Gelatin silver print, ca. 1960s
Courtesy of the Eric Waters Collection, New Orleans

Marion James Porter (1908–1983)
213. Traditional jazz parade
Gelatin silver print, ca. 1960s
Courtesy of the Eric Waters Collection, New Orleans

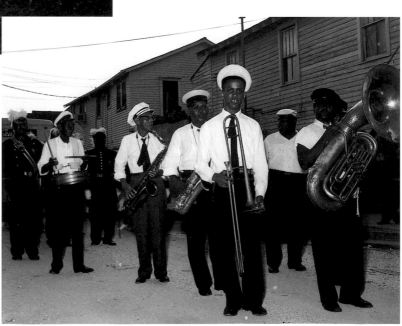

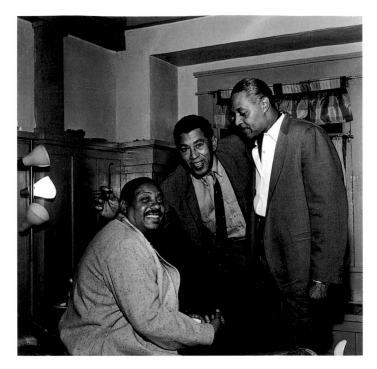

Marion James Porter (1908–1983)
214. Big Joe Turner, Marion Porter, and unidentified man
Gelatin silver print, ca. 1960s
Courtesy of the Eric Waters Collection, New Orleans

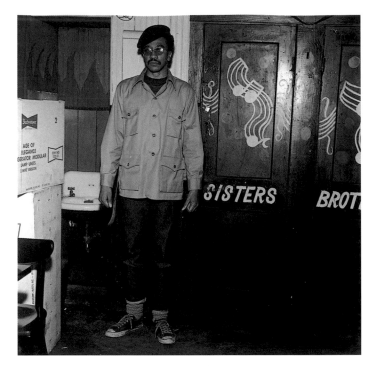

Marion James Porter (1908–1983)
215. H. Rap Brown, at Big Time Crips, New Orleans
Gelatin silver print, ca.1960s
Courtesy of the Eric Waters Collection, New Orleans

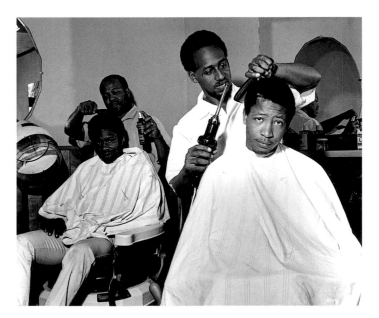

Marion James Porter (1908–1983)
216. Barbershop, New Orleans
Gelatin silver print, ca. 1970s
Courtesy of the Eric Waters Collection, New Orleans

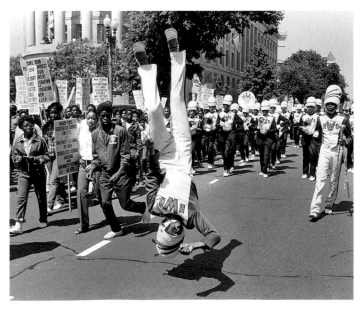

Milton Williams (b. 1940)
217. Parade Thrills, Washington, D.C.
Gelatin silver print, ca.1979
Courtesy of the photographer, Silver Spring, Maryland

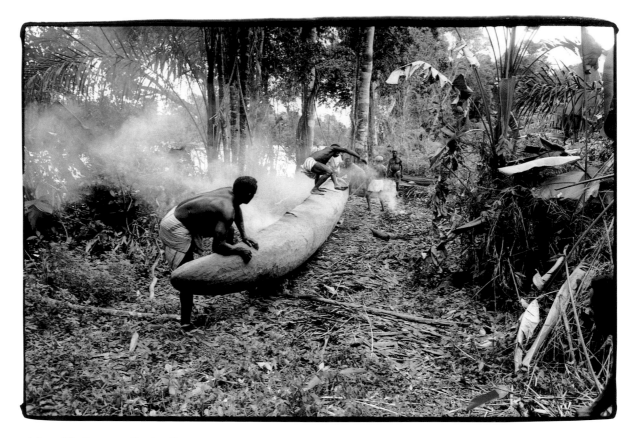

Adger W. Cowans (b. 1936)
218. Djuka Men Making a Boat
Gelatin silver print, 1969
Courtesy of the photographer, New York, New York

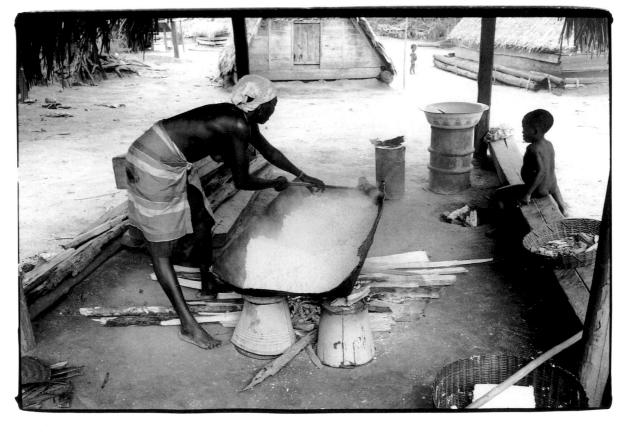

Adger W. Cowans (b. 1936)
219. Djuka Women and Child
Gelatin silver print, 1969
Courtesy of the photographer, New York, New York

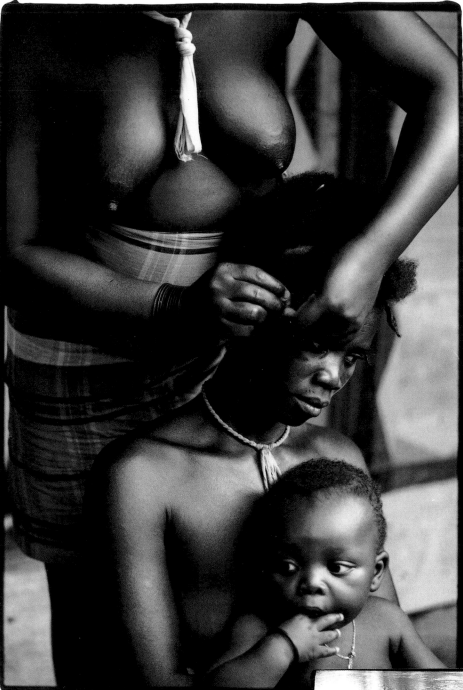

Adger W. Cowans (b. 1936)
220. Djuka Women
Gelatin silver print, 1969
Courtesy of the photographer, New York, New York

Adger W. Cowans (b. 1936)
221. Djuka Women by the Water
Gelatin silver print, 1969
Courtesy of the photographer, New York, New York

157

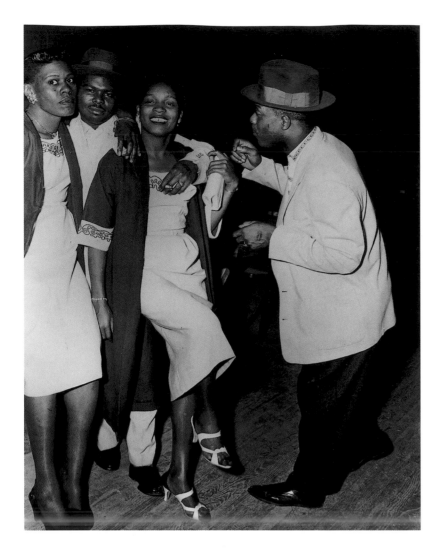

Eugene Roquemore (1921–1993)
222. Cotton Club, Lubbock, Texas
Gelatin silver print, ca. 1955
Courtesy of the Texas African American Photography
Archive, Dallas

Benny A. Joseph (b. 1924)
223. KCOH Mobile Studio, Houston, Texas
Gelatin silver print, ca. 1957
Courtesy of the Texas African American
Photography Archive, Dallas

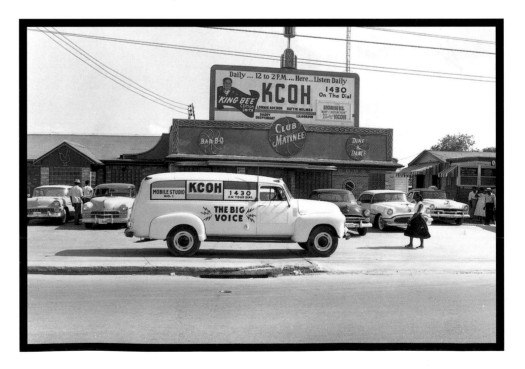

St. Clair Bourne (b. 1943)
224. Harlem Snowstorm
Gelatin silver print, ca. 1969
Courtesy of the photographer, New York, New York

St. Clair Bourne (b. 1943)
225. Harlem Snowstorm
Gelatin silver print, ca. 1969
Courtesy of the photographer, New York, New York

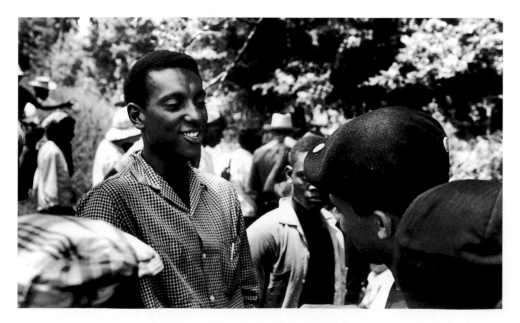

St. Clair Bourne (b. 1943)
226. Stokely Carmichael (1941–1998)
Gelatin silver print, 1969
Courtesy of the photographer, New York,
New York

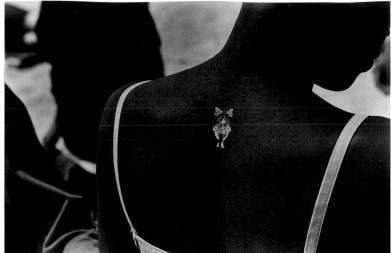

C. Daniel Dawson (b. 1943)
227. Backscape #2
Gelatin silver print, 1970
Courtesy of the photographer, New York, New York

C. Daniel Dawson (b. 1943)
228. Backscape #1
Gelatin silver print, 1967
Courtesy of the photographer, New York, New York

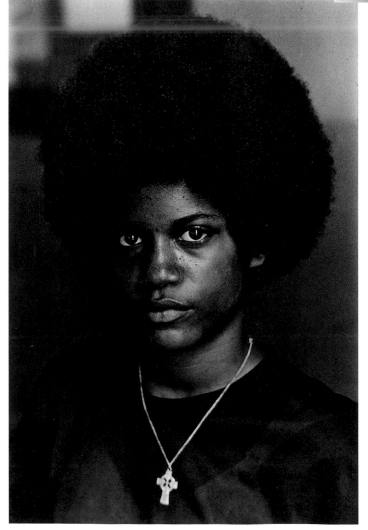

C. Daniel Dawson (b. 1943)
229. Girl
Gelatin silver print, 1970
Courtesy of the photographer, New York, New York

Winston Kennedy (b. 1944)

230. Uncle Johnny in Bridgeton, New Jersey

Gelatin silver print, 1980

Courtesy of the photographer, Washington, D.C.

C. Daniel Dawson (b. 1943)
231. Amiri Baraka (b. 1934)
Gelatin silver print, ca. 1970
Courtesy of the photographer, New York, New York

Ptah Hotep (b. 1942)

232. Muhammad Ali (b. Cassius Clay, 1942)
Gelatin silver print, 1972
Courtesy of the photographer, Brooklyn, New York

Bill Lathan (b. 1937)

233. Robert Macbeth (artistic director, New Lafayette Theatre, New York, 1967–1973) and Helen Macbeth
Gelatin silver print, 1979
Courtesy of the photographer, Ardsley, New York

Bill Lathan (b. 1937)

234. Loretta Green, Veronica Redd, and Debbi Morgan, as they appeared in *The Sirens* by Richard Wesley, directed by Bill Lathan at the Manhattan Theatre Club
Gelatin silver print, 1974
Courtesy of the photographer, Ardsley, New York

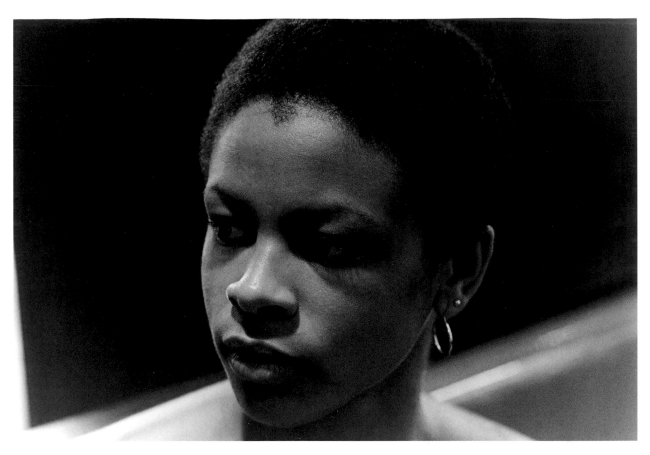

Bill Lathan (b. 1937)
235. Melvina Lathan
Gelatin silver print, 1974
Courtesy of the photographer, Ardsley, New York

Bill Lathan (b. 1937)
236. Phylicia Ayers-Allen, actress
Gelatin silver print, 1974
Courtesy of the photographer, Ardsley, New York

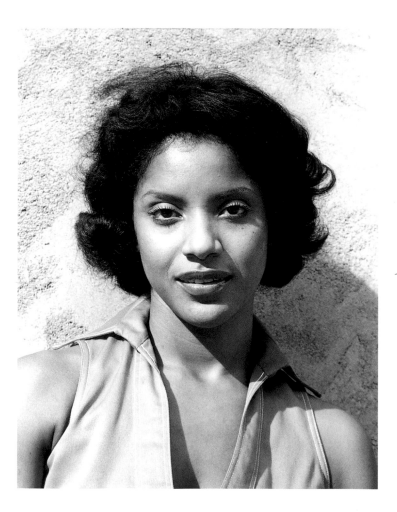

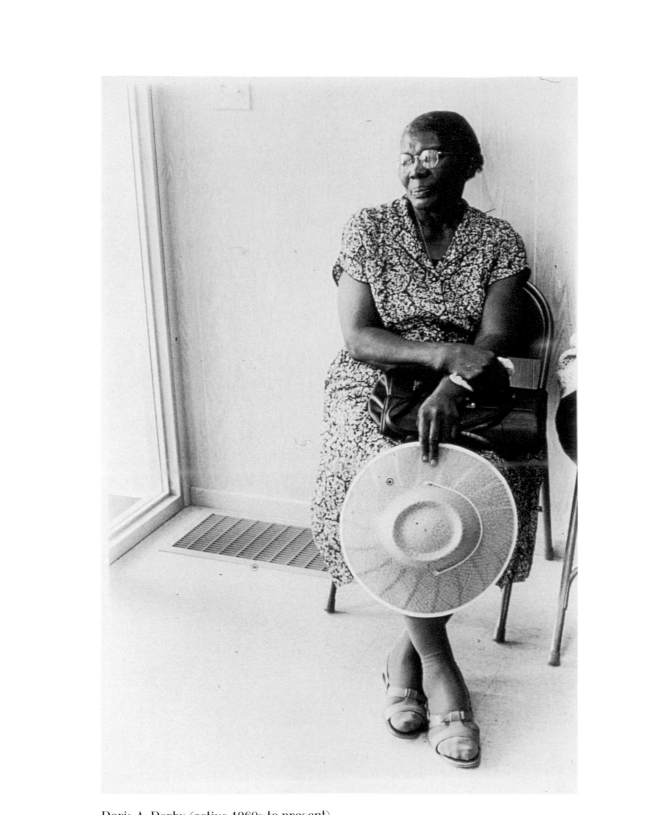

Doris A. Derby (active 1960s to present)
237. Meditation (woman with hat)
Gelatin silver print, 1968
Courtesy of the photographer, Atlanta, Georgia

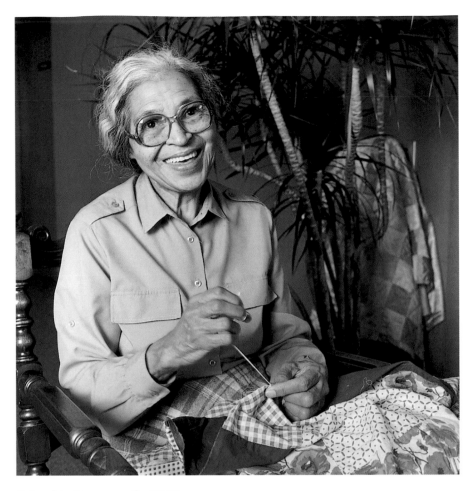

Roland L. Freeman (b. 1936)
238. Quilter Ms. Rosa Parks, "Mother of the Civil Rights Movement," Detroit, Michigan
Gelatin silver print, 1986
Courtesy of the photographer, Washington, D.C.

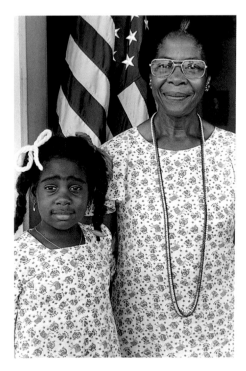

Roland L. Freeman (b. 1936)
239. Nellie G. Morgan and granddaughter,
Tammie Pruitt Morgan, Mississippi, July 4, 1976
Gelatin silver print, 1976
Courtesy of the photographer, Washington, D.C.

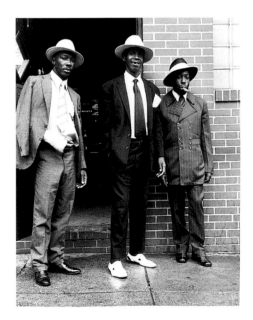

Roland L. Freeman (b. 1936)
240. June, Monk, and Winfield: Arabbers (street
vendors), East Baltimore, Maryland, June
Gelatin silver print, 1972
Courtesy of the photographer, Washington, D.C.

167

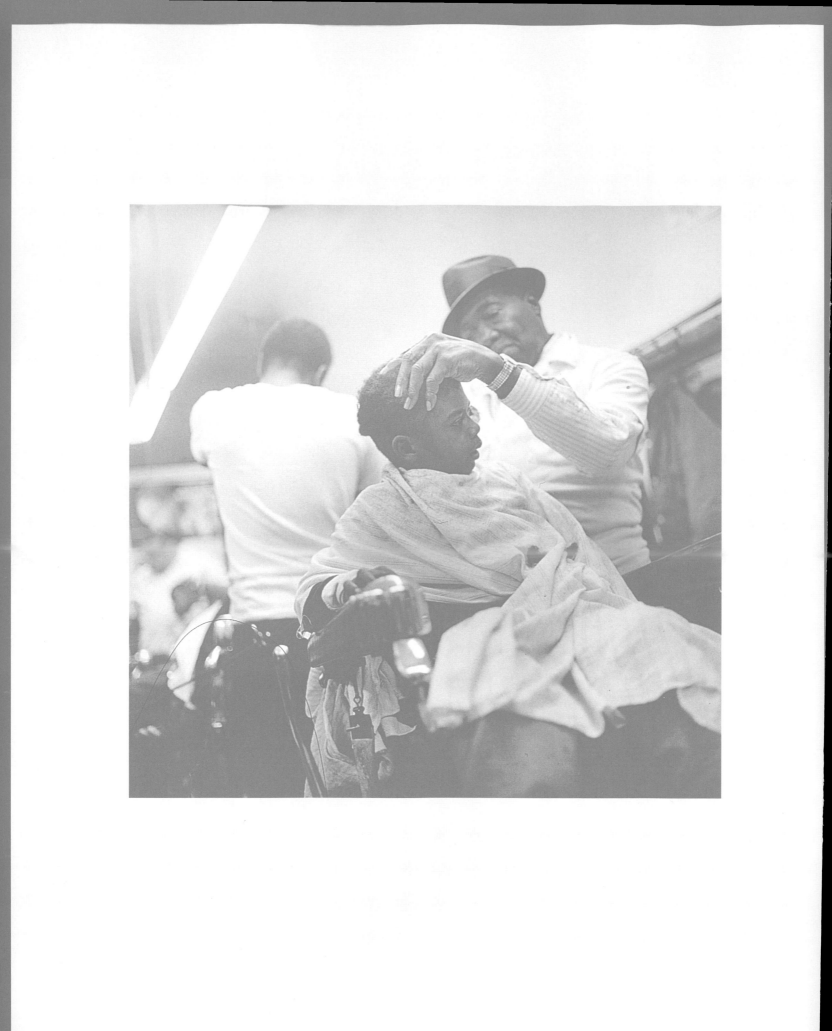

Part V

PHOTOGRAPHY IN THE 1980s AND 1990s

By the 1970s, many universities and art schools began to offer undergraduate and graduate degrees in photography. As a result, African-American photographers began studying photography and creating works purely for exhibition as fine art. Outside of academia, others studied in community centers and workshops. These photographers explored and redefined the photographic image. They respected the photograph as a document and, by combining graphic abstraction and conceptual photography in their imagery, simultaneously looked at the photograph as a metaphor, thus bringing a new vision to documentary photography.

Both the symbolic and expressive imagery of the works produced in the 1980s and 1990s offer sociological and psychological insights into the past. Many of the themes explored by these photographers focus on their own families and communities and deal with social issues like racism, unemployment, child and sexual abuse, death and dying. Most of these works are informed by personal experiences. For the first time, the viewer becomes a participant, asked to contextualize his or her own experiences within the visual referents offered by the photographer, and in doing so to find her or his own historical perspective, interpretation, or meaning in these works.

The photographers of this period recall the nineteenth-century photographers in that they are chroniclers of their communities. Contemporary photographers, many of them engaging storytellers, have discovered the intersection of the private and public in art. Many challenge contemporary art practices, and as photographer and writer Rick Bolton states, these artists have created "a new social basis for art."[1] Some are "photobiographers," who use appropriation, multiple printing, prints on fabric, straight images, and manipulated photographs to make compelling visual statements about modern-day culture and to create narratives about our collective history in multiethnic America. They employ themes ranging from identity, spirituality, gender, family, and race to cultural differ-

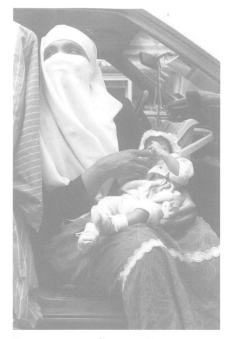

PHOTOGRAPHER: COLLETTE FOURNIER

ence and stereotyping. Some are concerned with the implications of historical and contemporary references to women and have offered new strategies in incorporating their personal perspectives in the construction of their work. Others are focusing on teen culture and the implications of style and identity.

Not until the late 1980s and early 1990s did the American public begin to see images of African-American teenagers in a wider context. Since that time, advertisers have used language, fashion, and the faces of teenagers to present teen culture as a commodity. Open a magazine, read a newspaper, look at a billboard, and you will see powerfully composed and constructed photographic images of black teens. Some are positive, some negative, but very few are representative. In cities across the country, images of teen culture are being reexamined, commodified, and reinterpreted in an artistic and social context, providing a provocative overview of issues that affect not only young people's lives but those of others, as well. Many of the photographers create provocative visual references to these experiences and to the African-American cultural experience in particular.

STREET PHOTOGRAPHY AND CULTURAL LANDSCAPE

O'Neal Lancy Abel (b. 1941) began photographing in 1963 while working with the Harlem Education Project. His early work, like that of many of the civil rights photographers, depicts student protest marches, political leaders, and social events. He continues to focus his camera on contemporary political rallies in the Harlem community.

Cary Beth Cryor (1947–1997) is best known for her self-portraits during the birth of her own child. For the last ten years of her life, she continued within that autobiographical theme, photographing her aging grandmother. Her photographs offer an invaluable personal record of Cryor's family at work and at social gatherings.

Collette Fournier (b. 1952) has worked as a freelance photographer for magazines and newspapers. Fournier, a recipient of awards for her photography, teaches photography, all aspects of photojournalism, and camera techniques. She often photographs in the Caribbean, documenting the activities of women; her camera also captures women in the United States at social gatherings.

Mel Wright (b. 1942), a commercial and portrait photographer since the mid-1960s, has extended his subject matter from family scenes to landscapes in South America and the Near East. His photographs of jazz bandleader Sun Ra (1914–1993) provide a poetic reading of the bandleader and pianist whose mantra was "Space is the Place."

Born in Chicago, Jeanne Moutoussamy-Ashe (b. 1951) is now a resident of New York. Her photographs on Daufuskie Island in South Carolina are particularly revealing, given the collective memory they reveal of the families on the island. Her images are informative, creating a visual record of a time gone by: people

who display photographs of their loved ones, children in a yard with relatives, the funeral of a long-time resident of the island. Moutoussamy-Ashe's research on black women photographers is considered the definitive record on the activities of black women working in the medium for the first hundred years.

David "OGGI" Ogburn (b. 1942) has chronicled rhythm-and-blues vocalists and musicians' lives on the road for more than thirty years, giving a backstage glimpse into this world's roller-coaster experiences of hope and loneliness. Ogburn has lived in Washington, D.C., since the early 1970s and has focused his camera both on emerging young musicians as well as those involved with political movements of the period.

Born in Alabama, Chester Higgins, Jr. (b. 1946), is the photographer and author of the recent book *Feeling the Spirit: Searching the World for People of Africa.* He has been documenting the African diaspora for more than thirty years, evidencing a particular sensitivity to black spirituality. Best known for his publications *Black Women* and *Drums of Life,* Higgins, a staff photographer for the *New York Times,* has provided a significant body of images of African-Americans and Africans during the post–civil rights/post-independence era of the 1960s. Higgins began photographing while a student at Tuskegee Institute, often working with P. H. Polk. While there, he published his first photographs in *The Negro Digest.* His early photographs were of campus life.

New York photographer Shawn W. Walker (b. 1940) has taken self-portraits that are surreal studies of his own shadow. In documenting his reflection on various surfaces, he creates ambiguous forms that demonstrate his interest in photographic tableaux. Using text and images based on Ralph Ellison's book *Invisible Man* (1952), Walker successfully analyzes his presence in American society. He writes:

> Brothers and sisters, my text this morning is the blackness of blackness. And a congregation of voices answered: "That blackness is most black. . . . In the beginning there was blackness. . . . I lived in the darkness into which I was chased, but now I see. . . . I've illuminated the blackness of my invisibility and vice versa; and so I play the invisible music of my isolation.[2]

Shawn Walker's uncle, a photographer, introduced him to the medium. From the time he was five until he was sixteen, he photographed family and friends in his Harlem neighborhood. Walker began to take his photography seriously at twenty-one. In the 1960s, he joined other photographers who had just formed the Kamoinge Workshop, including Lou Draper, Al Fennar, Ray Francis, and Herb Robinson.

Throughout the 1960s, Walker, echoing a historical tradition begun decades previously, photographed in the streets of Harlem. He exhibited in shows organized by the Kamoinge group in area libraries and galleries. In the 1970s, he traveled to Nigeria, Cuba, and Guyana to photograph. "The period 1962–1972

was the most intense time of shooting for me," he wrote. "It was a period where a whole lot of cultural, social, political change took place in Harlem and I found myself at the center of a lot of it. I consider this time to be a monumental, historical period. . . ."[3] Walker continues to be an advocate for black photographers, documenting the community where he lives and teaches, and he continues to exhibit and meet with old and new Kamoinge Workshop members.

Midwestern photographer Carl Robert Pope, Jr. (active 1980–present), takes dark and suspenseful photographs of body parts partially covered by soil. These images achieve their sense of foreboding and mystery not only because of the sinister subject matter, but also because of Pope's use of dramatic contrast, which increases the tension within the compositions.

Mansa K. Mussa (b. 1956) first exhibited his work in 1974 at the Newark Museum during the Mayor's Teen Arts Festival. A self-taught photographer, he is best known for his collection of black dance concert photographs. He has studied Media Arts at Jersey City State College and has worked as a graphic designer for over twenty years, during which time he has documented street culture in Cuba, New York City, and Newark, New Jersey.

Marilyn Nance (b. 1953) is a photojournalist based in New York City. She has photographed the black Indians of New Orleans, Appalachian folk musicians, the funeral of an Akan priest, and an African-styled village in South Carolina. For the last fifteen years, she has focused her attention on African-based religions and spiritual expressions of African-Americans.

In her nostalgic photographs of Pittsburgh's Hill District, Ming Smith Murray (active 1970s–present) evokes and attempts to recapture moments of the past. In the early 1970s, she was a member of the Kamoinge Workshop. A fine-art photographer living in New York City and Los Angeles, Smith has also traveled and photographed in Europe. Her photographs have been used on jazz albums and have been shown in group and solo exhibitions.

Chandra McCormick (b. 1957) and Keith M. Calhoun (b. 1955) photograph depictions of sugar cane workers and social life of New Orleans that provide a moving record of black life in that port city. Their photographs of cultural rituals, such as funerals and parades, reveal an unchanging cycle of traditions. Their work demonstrates a willingness to share the experience with the workers as well as the viewer. "Collectively, their work captures the closeness of these communities [community of sugar cane workers], the character of the physical work, and the transformation or disappearance of this culture as mechanized harvesters replace 'scrappers' who harvested the cane manually."[4]

Harlem-based Jeffrey Henson Scales (b. 1954) addresses cultural and sociological issues through his images of commonplace occurrences within his community. His portraits are selective, framed to highlight the bond among the people living there. Known primarily for his images of black men, Scales portrays them in their fraternities, barbershops, and on street corners. He says of his Harlem series:

PHOTOGRAPHER: KEITH M. CALHOUN

In these photographs I have focused on Harlem of the 1980s. I try to make images that allude to the reality of being Black in the America of the 80s. Perhaps to even help us to see ourselves more clearly. That is, as clearly as I can affect the medium of photography. My work does not take or direct the observer. Instead the photographs are descriptions of my perceptions of ordinary places and people—in the complexities of living. I do not pretend to understand them, each person. In fact, the discoveries are most often within myself, observing these documents of my own sights.[5]

The dusk and night images of Orville Robertson (b. 1957) are formal compositions. His control of light creates a visually quiet sensibility in these photographs of the urban landscape. He writes that since 1978 his images have been shaped by street-photography aesthetics. "This involves balancing a child's curiosity and informality against an adult's need for structure and meaning. The streets can possess a wonderful energy. Passers-by within their self-made worlds create dynamic relationships that are constantly changing before and after I have captured my tiny portion on film."[6]

Philadelphia-based Raymond W. Holman, Jr. (b. 1948), initially concentrated on landscapes in his photographs; in the past ten years his work has shifted toward capturing special or celebratory moments of the African cultural continuum. Aware that most actions create reactions, Holman captures white resistance to the African tradition continuum in his photograph of white residents turning their backs at an African-American protest parade in Philadelphia.

In his images of spiritual processions in Salvador da Bahia and Sao Paulo, Charles Martin (b. 1952) captures a sense of intense devotion, as evidenced in his photographs of the people in Bahia during a moment of prayer. Martin, a professor of literature and photography, began photographing as a young child, then worked as a feature writer for newspapers in Philadelphia and New York City. He has spent a number of years photographing in Brazil and New York, creating a project entitled *Home and Away.* The photographs in the series convey "a strong spirit of the diaspora, as people differently address the questions of roots, displacements, adjustments and adaptations—continuity and change together. In the New World there are breaks from tradition, re-establishments of ancient traditions, and creations of new traditions."[7]

In his photographs of church women, Baltimore photographer Carl Clark (b. 1933) shows the wide diversity of hat styles worn by contemporary church women. The hats establish individual identities and styles. These adornments serve as a counterpoint to a community in disrepair and provide the viewer with hope and faith for the future. Clark has been working on his *Sunday Morning Women* series for the last ten years. He has created a body of work that underscores the beauty of the Sunday morning church services.

Sheila Pree (b. 1967) has created portraits of street preachers that are both

176

PHOTOGRAPHER: SHEILA PREE

theatrical and documentary in nature. Her love of irony is coupled here with her keen awareness of gesture. Printed material, including Bibles and other religious paraphernalia, are seen as props that not only enhance the work but also allow the viewer to explore the ways people express religious beliefs in a public arena. She says in her artist's statement:

> As I walked the streets of downtown Atlanta, amongst the commotion of traffic, loud music, and vendors, I was allured by the sounds of chanting and preaching. I followed the voices until I stood in front of Little Five Points metro station. In the midst of the hustle and bustle of pedestrians stood "everyday people" ministering to anyone who would listen. These people were not your stereotypical missionaries. They didn't have on long robes, and didn't ask for money. They were compelled only to give the world a message.[8]

Pree captures this experience without apology. Her transcendent images are of plastic-wrapped Bibles and cardboard signs carried or worn by people who believe that they embody the spiritual world.

In his group portraits, Gerald G. Cyrus (b. 1957) depicts families scenes, musicians, and customers at a neighborhood bar. Cyrus is clearly fascinated by the great range of human characters, and he captures the nuances in his subjects' personalities. In one photograph, the customer at a table listens intently to the music with his eyes closed; behind him are men whose attention is distracted from the performance by something happening behind the bar; at the bar and to the rear a young lady sits with a serene look on her face. Each person is telling his or her own story within a single frame. Writer Lisa Henry says of Cyrus's work:

> The energy conveyed by human gestures, and the visual compositions that depend on modulated tones and forms, seems a parallel to Jazz and Blues which rely on variation, improvisation, and an emotional expression. His work expresses a "blues aesthetic" by virtue of its humanism, as well as the value placed on interaction, spontaneity, and an empathetic focus on the Black community.[9]

Born in Fort Gibson, Oklahoma, Ron Tarver (b. 1957) is known for his photographic studies of urban cowboys in north Philadelphia, which depict scenes of past life in an urban community. His street portraits of men, children, and horses juxtaposed to painted murals of contemporary icons such as Malcolm X offer iconic symbols of life in the city. His photographs speak of memory and isolation, paying homage to his own Oklahoma roots and to the history of black cowboys in the West.

Kenneth George Jones (b. 1956) explores the legacy of the Western cowboy, taking unique photographs of black rodeo performers and rodeo fans in Liberty, Texas, which highlight the experiences of black cowboys. His images recall the

vital role played by black cowboys in the westward expansion of the United
States. Born in Birmingham, Alabama, Jones studied photography and art at
Texas Southern University and the Maryland Institute College of Art. A photog-
raphy teacher and photojournalist, Jones has been documenting the life of these
men, on the rodeo circuit and on ranches and farms in Texas, since 1985. He
writes:

> Through my work, I am attempting to go beyond this misconception surrounding
> the role of black men in the American West. My interest is to capture in pho-
> tographs some of the spirit, intensity, and pride of a culture which is fundamental
> to the development of the Southwest, but which never receives enough media or
> academic attention. My goal is to illustrate a lifestyle which in many cases has been
> handed down through generations. I have an obligation to myself and to the de-
> scendants of these talented and daring men and women who keep the spirit of
> Afro-American cowboys alive and vibrant. Still obscure but proud, these men con-
> tinue to ride the forgotten black rodeo circuits of the Southwest. Cowboys are real
> and very often black.[10]

Louisiana-born Roland Charles (b. 1941) focuses in his work on black commu-
nities in New Orleans and Los Angeles. His interests lie in black families;
Bobtown, a project Charles has worked on over the last twenty-five years, is the
story of a community founded by African-Americans. His photographs of that
community "offer an intimate view of this quaint, rural enclave of kinfolk set in
the middle of Louisiana. . . . It is obvious in the telling photographs that Roland
is accepted warmly by the people and perhaps his camera could capture the true
essence of this close knit community."[11] Since the early 1980s, Charles, an active
photographer and curator, has been documenting and preserving the works of
black photographers in California. He is the executive director of black photog-
raphers of California.

Earlie Hudnall, Jr. (b. 1946), has been working on a study of Houston's oldest
neighborhoods for over twenty years. His study *Images of the Wards* captures the
changing faces and facades of these distinguished communities. In his own
words:

> I chose to use the camera as a tool to document different aspects of life—who we
> are, what we do, how we live, what our communities look like. These various pat-
> terns are all interwoven like a quilt into important patterns of history. A unique
> commonality exists between young and old because there is always a continuity be-
> tween the past and the future. It is this commonality which I strive to depict in my
> work. The camera really does not matter; it is only a tool. What is important is the
> ability to transform an instance, a moment into a meaningful, expressive, and pro-
> found statement, some of which are personal, some of which have a symbolic and
> universal meaning. My photographs are mere archetypes of my childhood. They
> represent a literal transcription of actuality—the equivalent of what I saw or felt.

The viewer must accept the image as his own and respond emotionally as well as aesthetically to the captured image.[12]

PHOTOGRAPHER: KEN ROYSTER

Salimah Ali (b. 1954) is an educator and freelance photographer. In recording the life of black women, especially the activities of Muslim women, she offers an insider's view of the daily activities of each woman, whether at work or involved in social activities.

Leroy W. Henderson (b. 1936) began his career as a fine artist, with an emphasis on painting, drawing, and printmaking. Henderson focuses on documentary photography, specifically in urban areas. His interest in photography began as a child when he would pore over picture magazines such as *Life* and *Look.* He was also fascinated by looking at old photographs through his grandmother's stereoscopic viewer.

Born in West Africa, Alfred Olusegun Fayemi (active 1980s–present) is a pathologist and documentary photographer who focuses his camera on the lives and activities of African women and children. His graceful photographs of young children at play elicit from the viewer a sense of freedom and communion.

In his photographs of church leaders and pool and river baptisms, Ken Royster (b. 1944) provides a visual record of spiritual life in the Baltimore area. His photographs document Sunday rituals, the personalities of the church leaders and parishioners, and the vibrant experience of celebrants at baptismal services.

Georgia-based photographer Ronnie Phillips (active 1980s–present) transforms black-and-white photographs into multichromatic images through the use of hand-coloring. Through this hand-coloring process, he is able to create a greater intensity in his compositions.

Harlee Little (b. 1947) has been photographing since the early 1960s. His current work consists of editorial and commercial work for magazines and organizations. A Washington, D.C.–based photographer, he often photographs families on the streets of the city and musicians performing in the city.

Bob Gore (b. 1947) photographs in the churches of Harlem. His current interest focuses on the Abyssinian Baptist Church in Harlem, providing an intimate portrait of the activities and parishioners.

Linda Day Clark (b. 1963) photographs in Baltimore, Maryland. She creates photographs of life on North Avenue. She walks the streets encountering the various residents and shoppers. Her photographs provide us with an endearing and critical view of the city. Clark currently teaches photography in the Baltimore area.

New Yorker Cheryl Miller (b. 1953) is interested in those humanistic issues associated with social conditions and culture extension in the African-American lifestyle. In her belief that significant negative images of Africans and African-Americans have existed in the visual canon of photography since its beginning, Miller attempts to offer images of positive cultural affirmation through her photographic works.

Joe Harris (b. 1940) teaches photography in New York. He was named one of the top photographers in 1972 by *Art Direction* magazine. His photography focuses on the Harlem community and the changing environment since the 1970s.

Texas photographer Carl Sidle (b. 1945) began photographing in the 1970s. Photographing on the streets of Dallas and documenting the day-to-date experience, Sidle now uses digital photography to advance his graphic interest in black-and-white photography.

June DeLairre Truesdale (active 1980s–present) lives and works in New York City where she creates portraits of African-American cultural leaders. She uses these images of artists and writers to transform a negative view of black identity into a positive one.

Atlanta-based Susan J. Ross (b. 1952) calls herself a "photo-griot," because of her interest in documenting and interpreting activities in the African-American community, whether cultural, political, or social. An active member and organizer in Atlanta, Ross is a founding member of Sistagraphy, a collective of black women photographers.

Steven Cummings (b. 1965) depicts black life in Washington, D.C., through black-and-white images. He seeks to contrast the old and new in back alleys and on sidewalks, where itinerant auto repairmen work on old cars, musicians play their music, and young girls jump rope.

Constance Newman (b. 1935), an arts administrator and photographer, photographs in many areas of the world, recording various festivals and cultural celebrations. Her straightforward photographic approach allows her to preserve the spirit of these events for a wide audience.

Gerald Straw (b. 1943) has created photographs that are documentary in style. His images of decayed buildings and isolated streets possess a sense of irony and loss. Debris and empty streets are what is left of a seemingly once-active working-class neighborhood.

Sunny Nash (b. 1951) has completed a series of photographs of storefront churches and small abandoned churches in the black community. Her photographs attest to a vibrant ministry. They inspire hope for new religious beginnings associated with these small houses of worship. Visible on the front of these churches are handmade signs calling for redemption and deliverance.

Frank Stallings (b. 1946) has produced photographs from many areas of the African diaspora. His 1995 photographs taken in Brazil provide an important statement about African culture in the Western hemisphere.

Craig Herndon (b. 1947) is an editorial photographer for the *Washington Post*. His photographs document African-American life in the city. His most recent photographic essay records the life of a professional jazz musician who has devoted himself to the teaching of young jazz musicians at the Ellington High School of the Arts.

Moira Pernambuco (b. 1969) photographs women who find the sea to be a source of spirituality and mystery. Her photographs of women observing the

ocean are meditative images. They refer to Yoruba-based spirituality—in partic-
ular, Iemenja/Yemaya, the protector of those who seek safe passage on the wa-
ters. An intense quietude combined with a powerful sense of spiritual beckoning
pervades her photographs.

Andre Lambertson (b. 1962) has focused his attention on gang warfare, drug
abuse, and poverty in the streets of Baltimore, New York City, and Washington,
D.C. He is concerned with the lives of black teenagers and the delicate balance
these young people must maintain in this culture. His images are a heart-
rending testimony to life in the inner city. He writes that his aim is to "address
and better understand the complex swirl of issues that provoke the high levels of
crime and violence now plaguing youth in America. The project's goal is to sim-
ply attempt to place youth violence into context by closely examining some con-
ditions that produce youth offenders."[13]

In the tradition of his grandfather, who was also a photographer, New
York–based Hank Sloane Thomas (b. 1976) has been photographing family life
and cultural festivals in New York, Philadelphia, and Washington, D.C. Thomas
studied photography at New York Unviersity. In addition to photographing his
own family, he has also taken pictures of men at work, framing specific moments
within the context of the larger scene.

Also living in New York City and documenting popular culture, Kambui Olu-
jimi (b. 1976) creates photographs of artists and personalities involved with
hip-hop culture. His images of young performers in clubs and other venues form
a fresh photographic interpretation of this vibrant force in contemporary cul-
ture.

D. M. Pearson (active 1990s–present) photographs artists, singers, and per-
formers in hip-hop culture. His images are physical indicators of the fashion,
style, and persona of popular culture.

Delphine A. Fawundu (b. 1971) began to explore photography early in life. At
the age of fourteen, she began photographing her surroundings. She has exhib-
ited her work in New York galleries and published photographs in magazines.
Interested in looking at the female body, Fawundu has been making images
about self-discovery while celebrating the human form.

Nekeisha Durrett's (b. 1976) current work addresses how people reinvent
themselves before the camera. Photographing her family and friends, she is able
to investigate and explore the notion of reinvention.

THE CONSTRUCTED IMAGE

Family experiences are the core inspiration for the work of Clarissa Sligh (b.
1939), along with political and racial messages. She draws on her own family's
relationships in order to render a more profound statement about men, women,
and children. Since childhood, Sligh has been the keeper of her family's album

PHOTOGRAPHER: ANDRE LAMBERTSON

of photographs and she is cognizant of the role she plays in preserving family history. Using family photographs and archival materials, she directs her audience's gaze to African-American communities in the nineteenth and twentieth centuries, placing her family history within the larger context of American history. In shifting attention away from her personal experiences, she is able to analyze other shared experiences of black children across many generations.

Sligh's work is important not only because she addresses the realities of racism and sexism in a direct yet nonconfrontational style but also because she is an accomplished storyteller. Her work is provocative and historically introspective as she focuses on images of black men. She writes:

> As a young black child, I was told how bad things are out there in the world for us. It was a fear put into me to prepare me for the real world. Since we couldn't talk about it, since no one could relate to our hurt or pain, we learned to be silent, to hide our disappointments, to hide our anger at the distortion of our identity and the exclusion of our reality. I tried to use images that had a certain grounding, a certain power, and where everyone is not necessarily smiling or being agreeable about being photographed. It was wonderful to discover afterward that a lot of people related to the period in terms of the way the children were dressed, and they related to the images and had to tell me their stories. Of course, you have to be over a certain age to totally understand it.[14]

Albert Chong (b. 1958) uses family photographs, religious icons, and animal remains to explore ritual as it is translated into art. He likens his working methods to the task of archaeologists in unearthing the past to explore family history. Chong's highly individualized, spiritually oriented images are strongly conscious of composition and form. The exact placement of cultural objects acts as a signifier and provides authentication to his cultural roots. Of African and Chinese ancestry, Chong, who was born in Jamaica, creates works imbued with cultural references relating to each of his cultural heritages; although obviously aware of the differences, he draws attention to the similarities among ritual practices. The series *The Thrones for the Ancestors* exemplifies Chong's incorporation of personal objects in the production of individualized images that affirm his relationship to his ancestors. Writer and poet Quincy Troupe has aptly pointed out the cultural reality in Chong's work:

> There is magic, music, myth and mystery in [the] photographs of Albert Chong because he sees and creates it within his frames: after all, the whole point of photography is seeing and Albert Chong sees very well. The way he composes within his photographic frame is similar to a musical composition—many of his prints are a little off center in the same way that much of great music is played off the beat. Like searching on the piano for the flatted 5th, music is created by Chong's constant interplay with dark and light. Sometimes dissonant, sometimes luminous, sometimes rough around the edges, his creations are always challenging for the eye.[15]

PHOTOGRAPHER: ALBERT CHONG

In writing about his own images, Chong states:

Several years ago, my mother sent me the only remaining picture of herself as a child—an old torn and yellowing photograph of three girls. She is the smallest child in the picture; the other two girls are her cousins. She asked me to repair the picture. I could not heal it, but I could rephotograph it incorporating the torn area of the image.

While re-photographing the picture, I became overwhelmed by the simple beauty of the image in its recording of three sisters of African-Chinese ancestry as they poised themselves for history. Jamaica was a mere sixty years out of slavery, and she was an orphan at the time. Her father, a Chinese musician, had died in his sleep while she played in the bed around his body. Her mother had left Jamaica when she was an infant to live with a man in Honduras. She learned of her mother's death months after the fact—that she had died of hemorrhaging caused by fright, as her man tried to play a joke on her. I thought of the importance of this photograph to her, how as a child it must have been an affirmation of her existence, if only to her. I thought of the many old historical photographs I had seen, and of the fact that few contained people of color. I realized in that instant how inconsequential this photograph, and the lives that it illuminates, was to white civilization. I knew that I could not merely copy this picture, that it meant too much and should remain in the world meaning something to others. In this spirit of cultural retrieval, "The Sisters" emerge.[16]

Like Clarissa Sligh, Lorna Simpson (b. 1960) focuses on the construction of meaning and values by juxtaposing text and image. Her style creates a format for her critical examination of race and gender. She focuses specifically on the notion of invisibility, representing black women as survivors, protagonists, and victims. Simpson's work is rooted in the tradition of African-American story-telling. Simpson's work, which is informed by historical, contemporary, and personal references, incorporates visual narratives that border on biography. It disrupts even as it embodies a sense of clarity for the viewer. As writer Andy Grundberg states:

She stands language on its head and turns her subjects' backs to the camera as a means of dislocating the conventional relationship between the viewer and the viewed. . . . Simpson's approach to photography is in one sense linked to the venerable traditions of the medium: like social-documentary photographers, "concerned" photographers and even environmental landscape photographers, she wants her work to change the world for the better, and she believes that photographs have a unique ability in this regard.[17]

Christian Walker (b. 1954) uses the format of the family photo album to "document" a history of the extended or archetypal African-American family. He enlarges this form with paint and pigment as well as with rephotographed vintage

images, a manipulation that emphasizes the artistic rather than the technical aspects of the medium. Walker is concerned with social, political, and racial issues in his work, and he uses the camera both as a social and an aesthetic tool.

Walker himself states:

> *Bargaining With the Dead* concerns the charged emotions surrounding the deaths of my parents in 1985. It is a photo album of sorts, of the extended black family. . . . The central images follow my mother from age 19 to 55, yet they are larger, in the sense that they comment on the journey of a black woman through life. Each photograph of her, not only shows her physical changes and the depth of her struggle, these images also reveal her strength and fortitude.[18]

Walker's family portraits and art historical images (Gothic Madonnas, etc.) evoke the artist's own family ties and the exclusion of African-Americans and Africans from the cultural mainstream of history.

Lynn Marshall-Linnemeir (b. 1954) bases her work on historical narratives from the past. She began her *Sanctuary* series in 1990 in Mound Bayou, Mississippi, while working on a collaborative documentary project for the Center for Southern Folklore in Jackson, Mississippi, and the Center for Documentary Studies at Duke University in North Carolina. Mound Bayou is the oldest African-American community in the United States founded by former slaves.

Marshall-Linnemeir was inspired by the visual references in Mound Bayou. One of her first photographs from that experience references her personal loss. She states:

> *Sanctuary* is a simple hero myth. My father died in April 1990. Mound Bayou and the people who live there provided a kind of surrogate family for me. These early self-portraits represent my first attempts to paint on photographs. I had not yet included text. They are important in that they grew out of my investigations of "primitive" cultures, particularly Australian Aboriginal ritual and fascination with the origins of writing and communication.[19]

Carrie Mae Weems (b. 1950) creates sequential photographs and insightful text, which examine the experiences of women in general and black women specifically. Her portraits bring to life worlds where fantasy and reality collide. Gesture is seen as metaphor in her work. Weems is a photographer well known for her series of family pictures, installation art; iconographic pieces on glass, ceramic, and fabric; and her sociopsychological depictions of race through documentary reenactment of stereotypical subject matter. Weems's photographs are skillfully revealing. She is a compassionate storyteller who is involved with the matrix of family stories. Most of her work records or reflects social and cultural aspects of the African-American family experience. Some of her most distinctive works are her *Kitchen Table* series. The kitchen table is, for many of us, the spir-

itual place for open discussion. Many people gravitate to the kitchen when they smell food cooking. The kitchen table is a place where one finds comfort after a difficult day at work or school; where children spread their schoolbooks; where card and chess players convene. Topics discussed range from healing family strife to sharing family folklore.

Weems is also known for her photographic installations and series referring to experiences of slavery and the black family. She is an artist who weaves stories from the kitchen table to remind us of the collaborative nature of the art process—that is, biography. The *Kitchen Table* series has a set of twenty images. In examining the series, I became intrigued with the mother/daughter photographic tableaux. The text and images explore a relationship that is central to the family structure. Weems presents a fictive narrative and explores the complexity within various relationships: man to woman, woman to woman, woman to child, and woman alone. She concentrates on the experience of family and expands on that central theme with the compelling narrative and realism of her photographic expression.[20]

The work of Todd Gray (b. 1954) reflects his interest in visual autobiography as it is related through photography. He combines text and images, constructing references to identity, race, and sexuality. As he explains: "My work deals with my investigations into Western (Greek), African, and urban (African/American) mythology. It represents a journey into my past—a past I can only trace back four generations—and my present."[21] Using abstract and figurative elements, Gray critiques the experiences of blacks in America through coded symbols that rely on gesture and language.

Writing about the work of Accra Shepp (b. 1962), curator Jeff Hoone states, "In its strictest form photography is a medium that expresses precision. In its freest form photography is a tool to forge the expression of ideas onto the platen of believability."[22] Shepp's view-camera studies of bridges and factories reveal his ability to transform his most recent leaf-print series into the precise images of the steelwork of these structures. His portraits executed on found objects are connected to the concept of the photogram. Shepp's use of translucent materials, such as leaves, made light-sensitive, are imbued with nineteenth-century aesthetic sensibilities. The photographs are beautifully constructed portraits that conjure memory.

Pat Ward Williams (b. 1948) employs an intimate narrative form in her visual constructions. She chronicles black women's history as well as her personal experiences. Her work addresses a multiplicity of societal and autobiographical issues, including race, culture, and identity. Williams's early work is based on old family snapshots and experiences. The coded messages allow the viewer to focus on the words, which provides both a narrative and visual reading of her work. Her use of self portraits, family photographs, and memory lends nuance to the work.

The constructed photographs of Terry E. Boddie (b. 1965) explore themes of migration and his Caribbean heritage. Boddie uses materials such as burlap,

PHOTOGRAPHER: TODD GRAY

maps, family photographs, and passports to create a narrative about his family's past. By combining these disparate, immutable materials along with such temporal ones as flowers, Boddie explores identity and memory. He uses these images as evidence of racial hegemony on the island.

In contrast to photographers who add text to their photographs after the film is exposed and processed, Dennis Olanzo Callwood (b. 1942) photographs young men who have already applied text to their bodies through the application of tattoos. His textual materials, therefore, exist before the exposure is made. Additional text is added by the subjects of the photograph. Callwood encourages collaboration in order to allow his subjects' voices and stories to emerge more clearly. His work is emotionally charged and engaging, and he continues to experiment freely with the medium. Callwood writes:

> The body of work focuses on Los Angeles County Juvenile Street Gang Inmates at a Correctional Institution . . . a work-in-progress that fuses the aesthetics of fine art photography with the aesthetics of graffiti produced by gang members and taggers. These inmates, who had no formal art training, were given a photograph of themselves and asked to respond to it by producing their own art work to compliment the photograph. The result was a blending of style and aesthetic. The completed photograph represents a system of communication on several levels. Each level contains its own key and code of ethics. The audience may or may not have all the keys to crack the codes but it is my hope that they might gain some insight and pleasure from the words and language of the gang members. In addition, this fusion of aesthetics added soul, content, energy and life to the idea of body marks and to the markings on bodies. Each completed photograph is a one of a kind creation, not solely an art object but one with therapeutic component. This collaboration has had a positive effect on the inmates, as well as on me. It gave them an avenue of expression, and it provided a safe channel for venting their frustration, anger and creative energy. It gave them an immediate feeling of accomplishment and self-esteem as well as a can-do attitude. Most of all it gave them access to that coveted desire to be called "Mr." and to be referred to with the respect that they once demanded even at the cost of their lives. For me, it offers a new world to explore.[23]

Callwood provides insight into the lives of these young men by focusing his camera on them and offering his pen to each.

Amalia Amaki (b. 1949) uses family photographs and historical images to reinterpret and transform the media image of black America. She transfers photographs of jazz vocalists such as Billie Holiday and Bessie Smith onto cloth and arranges the images with American icons and symbols such as flags, patriotic colors, and buttons. She writes that her

> objective is to truthfully present my perception of a component of America based upon my own experience, my own thoughts, and following the dictates of my own spirit. . . . I frequently [arrange] piecemeal [images] and apply self-imposed

meanings to previously disassociated materials. . . . Blues singers and cakewalkers are signifiers of not only the rocky racial experience in America but also of the generation of new people whose ethnically rooted sounds and habits evolved to become a vital part of the global American descriptive.[24]

Chris Johnson (b. 1948) emphasizes non-traditional portraiture through autobiography and text in large-format black-and-white fine-art photographs. He writes:

> [M]y work deals with complex psychological and emotional projections onto women in my life. Recently I have been exploring a process of self-generated images whereby the portraits are created by an unconscious, intuitive ordering dynamic—the images are not planned [; they] are fluid, transparent, and suggestive. These long exposures create an instant dreamlike psychodrama scenario.[25]

His triptychs include three panels with text. The photographs are ones taken by Johnson and ones from family albums. These photographs convey fear, love, isolation, and anger. Johnson writes:

> There's probably nothing more deadly to creative growth than the overarching need to be "good." How does one know what "good" is if not by accepting the dogma of those around and above you? How can one strive to be "good" without internalizing a prior assumption that one is somehow "bad"? And, if one even momentarily becomes convinced that "goodness" has been achieved, what incentive do you have to grow beyond that state? . . . Everywhere else is a wilderness of risky "badness." I associate the inception of this second prior restraint with a cruel and penetrating incident that my mother visited upon me when I was six or seven years old. I had, I am sure, been warned not to play with matches, like every child, but I was convinced that I'd figure out a legitimate way to satisfy my curiosity about how matches worked, and by the way, what was that bead of water that seemed to lead the flame from one end of the match to the other? After securing a free period of time, I conducted my experiments in the broiler pan of our stove. What could be a safer place for fire than a stove? I somehow failed to account for the fact that smoke leaves a telltale odor and dozens of burned matches in the garbage are not easy to explain. With an expression that I remember as being calm, with a trace of pleasure, my mother told me that she would punish me in a way I would not forget. In that, she succeeded very well. She told me to strip, [then proceeded] to tie my hands and feet and beat me with a belt as I lay on a couch in our Brooklyn apartment. From that moment on, I knew that it was not a just world; that my instinct to explore was a profoundly dangerous part of myself; and that failing to be "good" had devastating consequences. I also never trusted or loved my mother in the same way after that moment.[26]

In re-creating this memory photographically, Johnson began a healing process, which he explains in this way:

The argument for the healing power of art making is dubious, but I've known for years that this is an issue I needed to work with eventually. Two key elements were the discovery that my great-great-grandmother had abused my grandmother in a strikingly similar way to what my own mother had done; and the text of a journal my mother kept during the last two months of her life. Whatever the degree I had resolved the wounds myself, the issue suddenly constellated into a pattern with a history, a clearly defined core, and some sense of the outcome.[27]

PHOTOGRAPHER: DARREL ELLIS

For Darrel Ellis (1958–1992), family photographs became the catalysts for the very materials of his art, while the contrast between temporal continuity and the unpredictability of family structure and history becomes its subject. By rephotographing images made by his father, Thomas, a postal worker and amateur photographer in the 1950s, and further modifying these images through the use of other media, Ellis questioned and reexamined past experiences. He reframed his family memory by constructing a revised visual narrative that is both critical and loving. The family images that Ellis used encompass single posed subjects as well as couples, groups, and children at play, which, considered as a whole, evoke pride, unity, pleasure, and loneliness. By rearranging the order of the images, Ellis created a subtext that results in a reinterpretation of the material. The evocative power of Ellis's work resides in its creation of a social and mythic existence, one apart from and contrasting with the depiction of family members as a seemingly comfortable group of people content with their lives. Through his photography and the layering of other images and materials, Ellis created a sense of disorientation that affects the viewer's understanding of the work: What were once documents of family history have become photographs of personal inventory and self-therapy. In his early work, Ellis focused on self-portraits, in the last years of his life, he concentrated on family images.

Holly Block, director of Art in General, writes:

> As a young artist, Darrel Ellis experimented with various media, building a body of work that included photographing, painting, and drawing. Looking beyond boundaries, allowing media to overlap and intermix—these are devices he used to free his art as well as himself: a life and work without constraints. As his technique developed, he provided a richer blend of photography, painting, and drawing of portraiture and representational subjects, building strong relationships between media whether or not these divisions have historically overlapped.[28]

The Harris Brothers, Thomas Allan (b. 1962) and Lyle Ashton (b. 1965), use photography and film to explore memory and the meaning of spirituality within the African diaspora. The *Alchemy* series takes as its subject matter Yoruba religious practices. *Alchemy*, the title of the 1998 collaboration, is an investigation that reimagines African cosmologies. It includes large color photographs, video projections, and music. This piece is an expanded view of the Harrises' earlier work, which explored race, sexuality, and identity. The brothers state:

This work comes out of our own experience of aesthetic and cultural hybridization, from living and working within community across the African diaspora, whether in Paris, London, Ouagadougou, Bahia, Rio de Janeiro, Dar-Es-Salaam, Nairobi, Caracas, Belize or Veracruz.[29]

Alchemy, in which both ritual and myth and nude and clothed bodies are juxtaposed, becomes a performance that transforms itself into a highly stylized and imagined narrative of African religious ceremonies found in Yoruba, Santeria, Candomble, Voudou, and Egyptology services.

Photographing her own muscular body, Renée Cox (b. 1958) presents herself as an icon of strength and beauty in her photographic work and examines her powerful body and that of the children it produced. Wielding her son like a battle shield, she equates her physical strength with the power of motherhood. Through the act of self-presentation, black women have begun to challenge and reinvent what it means to be black and female within a culture that often values neither quality. As Cox asserts:

The *Yo Mama* series is a dispassionate representation of women claiming their womanhood and power in the world of art and commerce, white male dominance, and gender. . . . At that particular moment in my personal life and career, I came to the realization that there was a major problem with the art world in terms of female artists naturally expressing themselves through the procreation of life. The greatest misgivings that eclipsed women of the arts, who chose to become mothers, was that their male and misguided female contemporaries and business associates resisted viewing the artist and her works in a respectable and serious manner. Many assumed that a woman's career ended the instant she proudly stated, "I'm pregnant." For too many years women have been conditioned to take a backseat, feel inferior, and be physically and verbally victimized. But through the *Yo Mama* series . . . I've figuratively stated, with conviction, that women as artists and mothers must "PICK UP THEIR CHILDREN, PUT ON THEIR HEELS, AND KEEP ON PRESSING ON" in the efforts to sustain our sex, our power, and ability to nurture, educate and guide the next generation of leaders and scholars. The world's survival rests simply within our hands.[30]

Conceptually, Cox creates a new paradigm for the black female by reenvisioning her presence.

In photographs and text, Cynthia Wiggins (active 1990s–) provides a narrative about the hard work done by men in her family. She employs memory and the repeated images of hands. The photographs as a group emphasize the backbreaking and dangerous nature of black men's labor.

Atlanta-based Sheila Turner (b. 1961) uses old windows as a framing device for her multiple-image compositions of juke joints. The worn old wooden frames provide a formal counterpoint in these compositions. By placing the pho-

PHOTOGRAPHER: BEUFORD SMITH

tographs within the frame, she offers an imagined setting or experience where blues musicians and dancers perform.

New York photographer Anthony Beale (b. 1970) creates images that explore the role of identity in American culture. His work deals with color-consciousness, race, and visual representation—often as seen through advertising and popular culture.

Oakland-based Keba Konte (b. 1968) began making photographs when he was fourteen. His interest in photography was prompted by the gift of a camera from his mother, also a photographer. This gift inspired the young photographer to take pictures of the familiar. In his current work, he expands familiar references by printing his images on unconventional surfaces. Konte calls this process "photomontage on wood." He says, "Most of my pieces are based on my own experiences . . . wherever I may happen to be and I find something that's powerful or pleasing to my eye. . . ."[31] His images show how Konte's interest in subtle gesture gives form and shape to his work.

Painter and arts educator Nashormeh Lindo (b. 1953) has photographed many doors and ornamental doorknobs in Venice, Italy. The sculptured images of Moors on these door knockers are evidence of the presence of Africans in this ancient city during its early years. Some of the door handles are hauntingly beautiful and offer a history about the African trading posts in this area. Lindo says:

> The *Venice Door* series came as a result of my exploration and search for the image of the lion in Venice architecture. . . . I became fascinated with these doors, some of them ancient, the grain of the wood breathing a life and history. I then discovered images of the black men of Venice, the Moors, the Othellos on many of the doors. This led to an exploration of images of Africans all around Venice. In addition to door knockers, the images appeared on jeweled brooches, as lamp holders and small statuary and marble sculpture. Trade and Africans had been a major force in early Venice, the trade bead business was centered there and everywhere there was evidence, traces of Africans there. Using the metaphor as Venice as a gateway, I make images of these door knockers and collaged beads, jewelry, currency and other ephemera to express my ideas about history, culture, and geography as it pertains to Venice.[32]

PORTRAITS

Born in Cincinnati, Ohio, Beuford Smith (b. 1941) became interested in photography in the early 1960s, after seeing images by Roy DeCarava in the book *The Sweetflypaper of Life.* He later moved to New York and met other black photographers who were interested in forming a collaborative. He is one of the founding members of the Kamoinge Workshop, a group of black photographers who met in Harlem to critique work by its members and to discuss photography and

its role in the black community. Smith became a freelance photographer in 1966 and a cinematographer in 1968. In an interview in *Ten8* magazine, Val Wilmer writes: "Beuford Smith is one of the outstanding documentary photographers who got out of what has been called the 'cauldron of the sixties.' His concerns are diverse, his vision humane and thoughtful. . . ."[33] His early portraits depicted the residents of Harlem and Brooklyn, visually expressing the community life in New York City. Smith continues to explore community portraiture by focusing on family members in private moments.

A former news photographer, Philadelphia-based Don Camp (b. 1940) creates mixed-media portraits that are uniquely inventive studies of black men. Camp has been photographing black visual, literary, and performing artists for the last ten years. His photographs are mediated images that offer the viewer insight into the photographers' personal fascination with these artists.

> Camp worked in a documentary mode until he became outraged at the stereotypical and negative ways in which black men were repeatedly portrayed in the news media. Seeking ways to convey more positive images of black masculinity and the specific qualities of individuals, he became "interested in creating unique photographic prints with tones, shapes, and masses of light to express human emotion and evoke human reaction.[34]

Camp employs a nineteenth-century photographic process that uses pigment to make the image appear to dissolve. Additionally, these photographs have a worn and weathered appearance, as if they are fading. Camp states, "The prints evoke a mystery and enigma that I hope will disappear over time. Not that I hope the modesty of the prints will fade but that the present fear and distrust of the men will end. What I hope remains are reflections of modesty, humility, and perhaps the struggle that is evident in the faces I've chosen."[35]

Vincent Alan W. (1960–1996) created numerous photographic essays on gay black life in New York City. These essays convey an understanding of the lifestyle of these men, and they are visually engaging as documents of the street life and fashion of youth, night club, and city life. The photographs reproduced in this book are from his 1986–87 essay *Queens Without a Country: Afro-American Homosexuals Who Have Changed the Face of Berlin*. The studio portraits of his subjects are straightforward and include biographical text about these men who moved to Germany in the 1980s.

Dawoud Bey (b. 1953) makes unique studio portraits of families by using a basic grid structure. He uses these divisional elements to focus on various parts of the portrait, thereby allowing the viewer to obtain a more intimate visual understanding of his subjects. His photographs encourage the viewer to see black subjects in new ways as he pushes the delicate balance between metaphor and lived experience. Bey's photographs are collaborations with his subjects, who speak to us with their seemingly impenetrable gazes. His portraits are not pas-

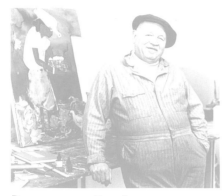

PHOTOGRAPHER: FERN LOGAN

sive; they speak from what Max Kozloff calls a "privileged eye." Born in Queens, New York, Bey has been photographing since the mid 1970's; since the late 1980s he has focused his camera on teenagers. Bey states:

> My interest in young people has to do with the fact that they are the arbiters of style in the community; their appearance speaks most strongly of how a community of people define themselves at a particular historical moment. I want that sense of specific time to be present in the photographs. And you know that in the black community style is king! Also, I think that young black males in particular have been demonized by the media. Their presence and voice in my photographs brings a much needed human face to a group of people that have historically been seriously maligned.[36]

Coreen Simpson (b. 1942) makes portraits that speak to us about the experience of young black men and women living in New York City. Many are oversized images that are highly stylized and convey a visually expressive dialogue between the photographer and her subject. Early in her career, Simpson constructed and printed on mural-size paper using acrylic and oil paint, fingernail polish, and colored markers. She is a photographer who takes chances with the medium and with her subjects. One of her photographic projects, entitled *B-Boys*, consists of enlarged portraits of young black and Latino boys and girls involved in the 1980s hip-hop phenomenon. All of Simpson's portraits stress pride and dignity, whether of a cook in a Harlem restaurant or a transvestite in a local nightclub. Simpson writes:

> Self-presentation is an art which I grew up with and deeply respect and understand. The personal style of my subjects in the *B-Boy* prints is the B-boy style which has come out of the rap and hip-hop music and dance scene of the eighties. This style of dress, however not necessarily new to this particular generation, just updated and revamped. Many of these fine young people often feel alienated in the white world surrounding them, as many young people do. Through alienation they have developed a style through which they feel a kinship.[37]

Fern Logan (b. 1945) photographs African-American artists in a way that reveals their character, personality, and grace. Some of these artists were already well established when she photographed them, while others were just becoming known, yet their individual identities emerge in Logan's genuinely refreshing photographic view.

> When shooting photographs I become excited by the contrast of light and shadow. I am particularly interested in using very dark elements to accentuate isolated light areas within the image. My goal is to utilize the full range of photographic tones from deepest black, through the subtle grays, to truest white. My favorite photos achieve this with dramatic clarity. Drama and mood are two elements that I am

trying to capture in my work. In portraiture these are elements that I try to create. . . .[38]

By the time Logan began her series of portraits in the 1980s, the artists involved in this project were from two different generations: those who had lived and worked in the 1930s and 1940s, those who had begun exhibiting their works in major museums and galleries in the 1970s. Working on this series raised many fundamental issues for Logan, such as her own role as a fine artist and graphic designer.

Carla Williams (b. 1965) explores in her portraits and self-portraits the complexity of the human body. Her self-portraits are consciously posed, and they draw inspiration from the photographic tableaux of the nineteenth-century imagery and from cultural history. Williams has been photographing herself at different stages for the past sixteen years. She challenges the viewer to explore changing notions of beauty and desirability. As both object and director of the gaze, Williams examines the issues of responsibility and identity in the image-making process.

In his photographs, Bill Gaskins (b. 1953) captures the vast array of black hairstyles, underscoring the importance of the African tradition of adornment in the modern African-American community. His photos reflect his interest in answering questions he had as a young child as to the meaning of phrases like "good hair" and "bad hair." The project has led the photographer to document many hairstyles—permed, shaven, weaved, locked, and natural—all over the country. This has resulted in what poet Nikky Finney called "a visual language that has everything to do with aboriginal human memory recovered strand by strand."[39] Amy Hufnagel comments, "Gaskins' images show that Black cultures, and specifically the younger generation, are wearing hairstyles that exert their individual and cultural pride and in doing so they create a form of cultural expression that is a vital part of contemporary American life."[40]

Lou Jones (b. 1945) photographs black men and women on death row. His book, *Final Exposure: Portraits from Death Row*, was published in 1997. Jones's powerful images are so engaging that the viewer temporarily disregards the crimes committed by these people. These photographs are both disconcerting and visually arresting because of the finality of the subjects' situation. In the foreword to Jones's book, attorney Gerry Spence wrote:

> . . . Few [had] ever looked in the face of a human being who was destined to be killed, purposely, with premeditation, on an hour and day certain. Now we looked at the faces, and what we saw from Jones's penetrating camera were not names or numbers, nor writs of habeas corpus or titles on legal documents, but people: people who were living in abject terror, or who had no fear at all; who were resigned to their fate, or who felt sorrow and shame; who were confused and knew not what was happening to them, or who knew full well their fate and had long ago abandoned hope.[41]

Jones, a Boston-based photographer, wanted to investigate a "subculture that was right in our midst—men and women who know exactly the moment they are going to die." He photographed twenty-seven inmates for over six years. Six have been executed since the project began.

LANDSCAPES

Known for his scholarship and for his paintings, Maryland-based David C. Driskell (b. 1931), in his photographic work, draws on African cosmology, the world of nature and its constant renewal. His well-composed photographs simplify the complexity of the natural environment. He allows us to see and, therefore, appreciate this continually changing natural world. Primarily, he photographs scenes from his garden and the forest and seaside areas of Maine.

In his *Nature Series*, Washington, D.C.–based John H. Brown (b. 1957) shows the delicate forms and interesting shapes of an endless variety of grass and flowers, contrasted with ever-changing configurations of clouds moving slowly across the sky. These photographs, begun in 1995, "rely solely for impact on their sensuous properties: texture, pattern and the transformative play of light and shadow."[42]

Jeffrey John Fearing (b. 1949) explores the landscape within an urban context. His images include those of city parks. He expands the theme by focusing on crowds of people at large gatherings. A sense of isolation permeates the conceptual space.

John Pinderhughes (b. 1946) is well known for his narrative portrait series, yet he also photographs landscapes on the Atlantic coastline. The images, also conceived in a series format, are deeply moving and poetic. Pinderhughes, who confines expansive vistas within the frame, is drawn to both land and sea; his photographs reveal a tender and detailed intimacy with each. He explores a range of tonal variation, pattern and textural design, light, and delineated line.

Landscape is also the subject matter of Californian photographer George Durr (active 1980s–present). His images of isolated highways and roads create a sense of longing and belonging, highlighting a personal experience that is enriched by the expansive space of the western landscape.

Linda L. Ammons (b. 1953) creates carefully composed studies that are both personal and sentimental. The southwestern landscape in her photographs is contrasted with the adobe architecture and gate frame, whose tracery breaks up the land in the distance.

Ken D. Ashton (b. 1963) captures haunting and mysterious images of the urban landscape. In his photographs of empty streets, vacant buildings, and alleyways, he reveals a seemingly desolate environment without people. In some instances, old and unused buildings become contemporary monuments to past history. Ashton worked for ten years on his series *Megalopolis*, which is composed of

photographs of the Northeast corridor, the area from Washington, D.C., to Boston, Massachusetts.

William Earle Williams (b. 1950) considers both history and the contemporary landscape in photographing Civil War battlegrounds in the South and North, recording both historically recognizable as well as forgotten sites. Through his images, he evokes the time when men died on these battlefields, echoing in his work the eloquent orations given at the dedications of these places where so much carnage occurred. Williams writes, "My photographs strive to emphasize the social history of American life as determined on the Gettysburg battlefield. The images are interpretations which capture certain concerns about the Civil War history and its ramifications for our present and future."[43]

Lewis Watts (b. 1946) photographs the customs and practices of people living on the West coast and in the South. He captures decaying advertising signs and cultural symbols of both the past and present, and his intimate documentary style details graphic remnants that have been found. "His approach to his subject matter falls into two basic categories: photographs of people in their environments, and photographs of the architectural environments in which his subjects have manifested themselves and their culture."[44]

Calvin Hicks (active 1980s–present) combines images of the female human body with landscape scenes. His photographs explore connections between the mind, body, and nature, which are compelling metaphors for constructing the feminine body in relationship to the environment. His work is both performance and body art.

Digital Imagery

Stephanie Dinkins's (b. 1964) double-exposed portraits are densely layered compositions with the family as subject matter. Although she uses text in her photographs and videos to resharpen the meaning of the images, and to move her photographic composition toward a more explicit representation of her initial idea, she intentionally hides the meaning of the images presented, requiring the viewer to imagine the experiences depicted in a more evocative way. While her work is autobiographical, Dinkins references a collective experience as well.

New Jersey educator and photographer Wendel A. White (b. 1956) makes digital photographs of nature, and his seascapes are surrealistic studies in technology. White's interest in creating myth and mystery through color and placement allows the viewer to imagine different spatial relationships.

Stephen Marc's (b. 1954) imagery deals with memory issues in terms of the paradoxical experience of the African diaspora. Marc makes autobiographical montages by combining family snapshots, found imagery, and his own photographs of landscapes and portraits made in Ghana, Jamaica, England, and the United States. He writes, "My digital montages are primarily autobiographical. I

PHOTOGRAPHER: STEPHEN MARC

combine my photographs, drawings, and computer-generated imagery with snapshots. . . . They are an eclectic blend that weaves together my ideas, memories and discoveries in order to enshrine the symbols and curios of my life."[45] The title of this project, *Soul Searching*, refers to his interest in documenting the African diaspora.

Roshini Kempadoo (b. 1959) says she is involved in the cultural, aesthetic, and political practice of making art. She utilizes image and text and embraces new technologies as she integrates memory and historical events. By using fragments of the past, she explores the impact of racism, sexism, and stereotyping on our daily lives. She uses technology to critique and examine issues such as identity and representation, and she employs symbolic references to investigate these issues. She says:

> At the very core of my work is a visual mapping and exploration of stories, place and environment. Images produced against and within particular assumptions, histories and attitudes. As an image producer, I see my work coming from a documentary tradition. I rework the photograph to produce what I call constructions which are generated by using a computer. I make use of photography's unique alliance with notions of reality and representations.[46]

Carl E. "Djinn" Lewis, (b. 1951) uses laser technology to create his imagery. These laser images are abstractions of natural environments and environments created by the artist. In his work, high technology and fine art meet; he transforms static forms into shapes that imply movement, energy, and three-dimensionality. For a number of years, Lewis has been a consultant on laser-generated art for theatrical productions as well as for publishing companies.

Many of the photographers working today respond to social issues that extend beyond the sometimes-insular concerns of the photographic community. They comment on political issues, culture, family, and history from individual and collective viewpoints. The fact that many of these photographers have likely witnessed societal injustice has not clouded their vision, however. In interpreting these works, the viewer is open to multiple readings. The issues addressed in contemporary photography and the interpretations implied coalesce to create an exhilarating vision of African-American life today. These photographers are not only creating and constructing their own biographies; they are also participating as artists in the evolution of their medium. Their work reexamines and redefines the very future of imagery and technique, for, now more than ever before, the photographer has become the narrator as well as the image maker.

STREET PHOTOGRAPHY AND CULTURAL LANDSCAPE

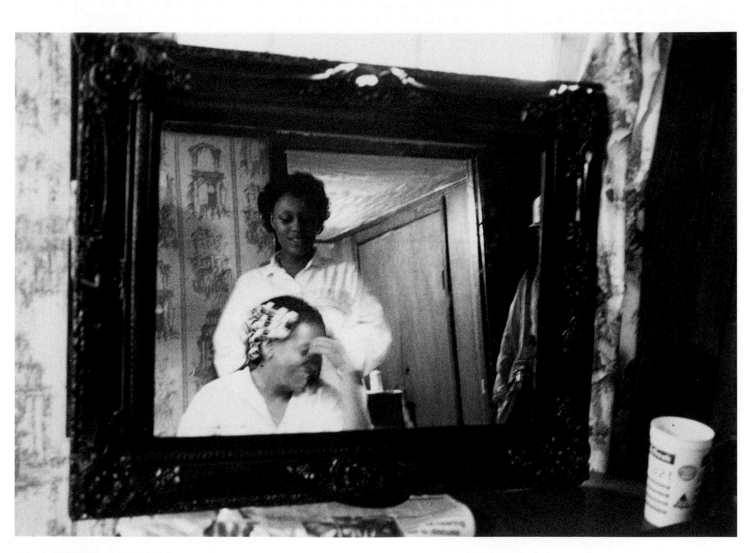

Roland Charles (b. 1941)
241. *Bobtown* series: Doing Hair
Gelatin silver print, ca. 1970–1995
Courtesy of the black gallery of California, Los Angeles

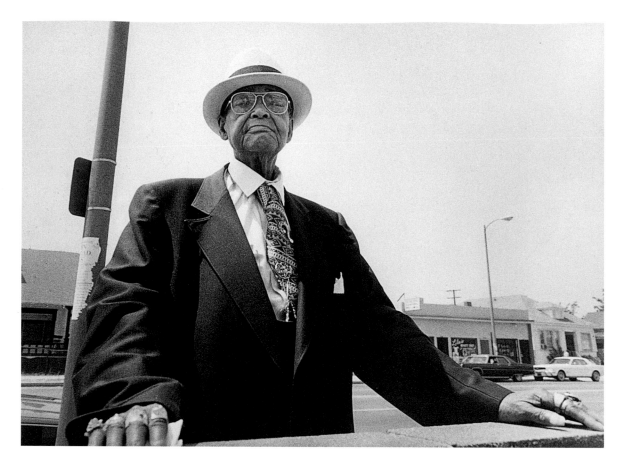

Roland Charles (b. 1941)

242. Man on Central Avenue, Los Angeles

Gelatin silver print, ca. 1970–1995

Courtesy of the black gallery of California, Los Angeles

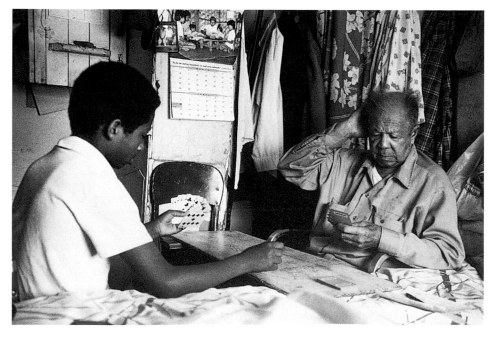

Roland Charles (b. 1941)

243. *Bobtown* series: Sholumbo playing cards with his grandpa

Gelatin silver print, ca. 1970–1995

Courtesy of the black gallery of California, Los Angeles

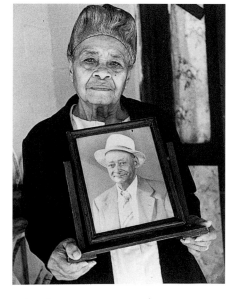

Roland Charles (b. 1941)

244. *Bobtown* series: Geneva Clark Celestin holding portrait of her father, Robert

Gelatin silver print, ca. 1970–1995

Courtesy of the black gallery of California, Los Angeles

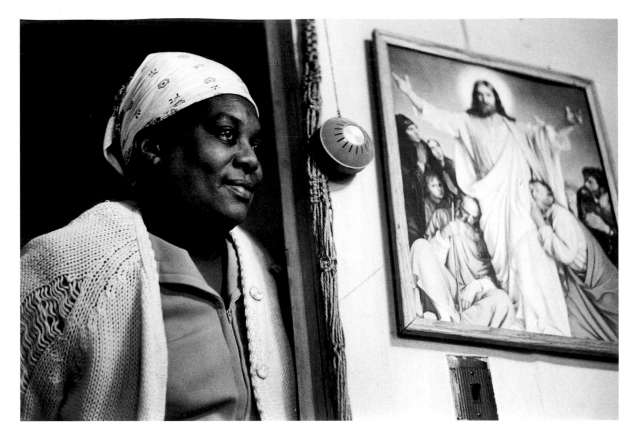

Jeanne Moutoussamy-Ashe (b. 1951)
245. Susie standing next to holy picture in her living room
Daufuskie Island, South Carolina
Gelatin silver print, 1980
Courtesy of the photographer, New York, New York

Jeanne Moutoussamy-Ashe (b. 1951)
246. Jake with his boat arriving on Daufuskie's shore. Daufuskie
Island, South Carolina
Gelatin silver print, 1981
Courtesy of the photographer, New York, New York

Jeanne Moutoussamy-Ashe (b. 1951)
247. A ninety-eight-year-old Edisto Islander with
his family photographs, South Carolina
Gelatin silver print, 1979
Courtesy of the photographer, New York, New York

Jeanne Moutoussamy-Ashe (b. 1951)
248. Emily's kitchen, Daufuskie Island, South Carolina
Gelatin silver print, 1980
Courtesy of the photographer, New York, New York

Jeffrey Henson Scales (b. 1954)
249. House's Barber Shop, Harlem
Gelatin silver print, n.d.
Courtesy of the photographer, New York, New York

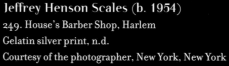

Jeffrey Henson Scales (b. 1954)
250. House's Barber Shop, Harlem
Gelatin silver print, 1986
Courtesy of the photographer, New York, New York

(See page 271 for color plates by Jeffrey Henson Scales)

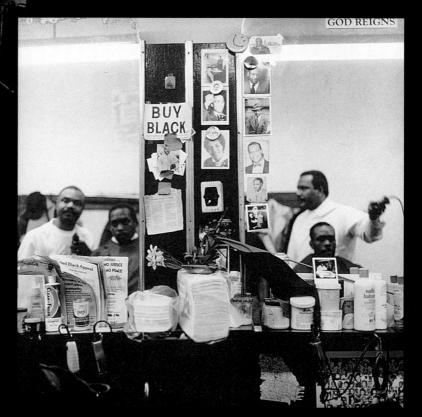

Jeffrey Henson Scales (b. 1954)
251. House's Barber Shop, Harlem
Gelatin silver print, 1987
Courtesy of the photographer, New York, New York

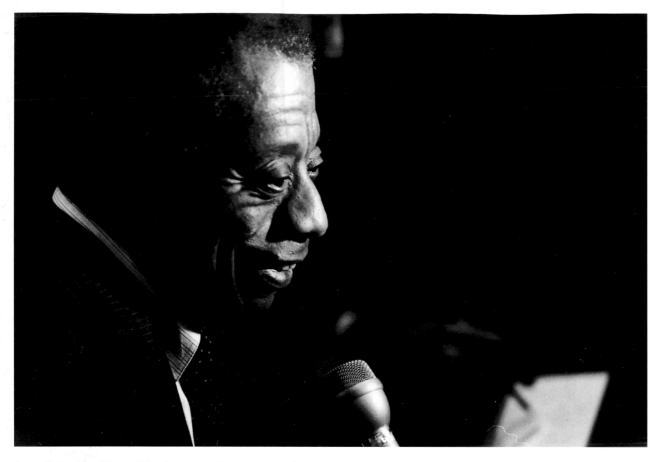

June DeLairre Truesdale (active 1970s to present)
252. James Baldwin (1924–1987), writer and civil rights activist
Gelatin silver print, 1986
Courtesy of the photographer, New York, New York

June DeLairre Truesdale (active 1970s to present)
253. Peter Tosh, musician
Gelatin silver print, 1981
Courtesy of the photographer, New York, New York

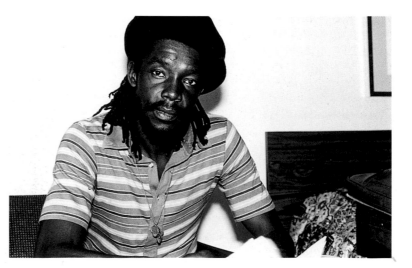

Joe Harris (b. 1940)
254. Speedo and Smiley in Harlem
Gelatin silver print, 1969
Courtesy of the photographer, Croton-on-Hudson, New York

Joe Harris (b. 1940)
255. Crucifixion #2
Gelatin silver print, 1994
Courtesy of the photographer, Croton-on-Hudson, New York

David ("Oggi") Ogburn (b. 1942)
257. Backstage Pass—Gerald Levert
Gelatin silver print, 1987
Courtesy of the photographer, Washington, D.C.

David ("Oggi") Ogburn (b. 1942)
256. Process and the Doorags
Gelatin silver print, 1985
Courtesy of the photographer, Washington, D.C.

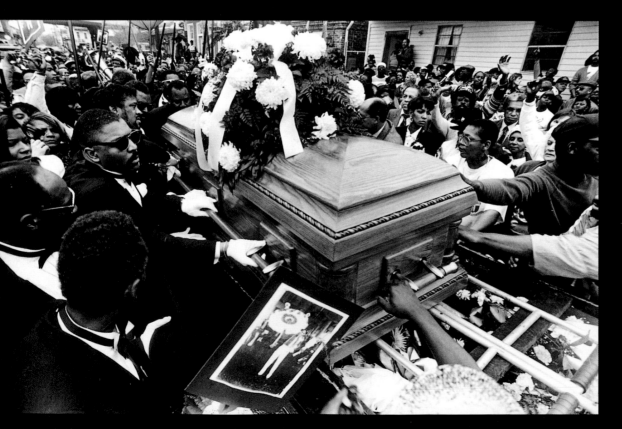

Keith M. Calhoun (b. 1955)
258. Big Chief Joe Pete Adams's Jazz Funeral
Gelatin silver print, 1992

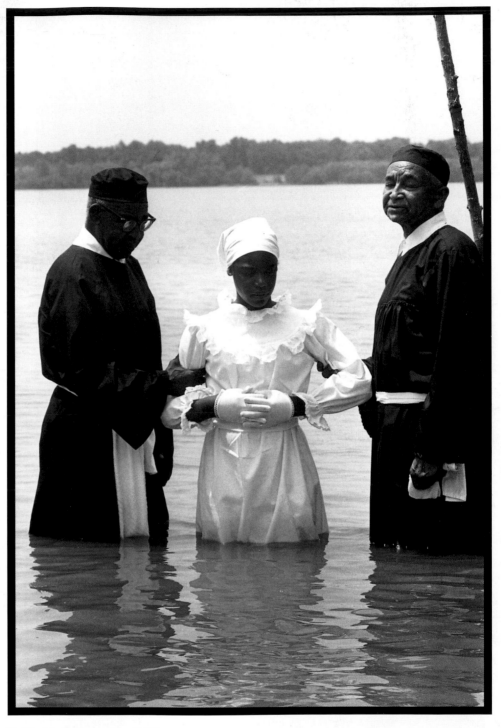

Keith M. Calhoun (b. 1955)

259. The Baptism, Louisiana

Gelatin silver print, 1986

Courtesy of the photographer, New Orleans, Louisiana

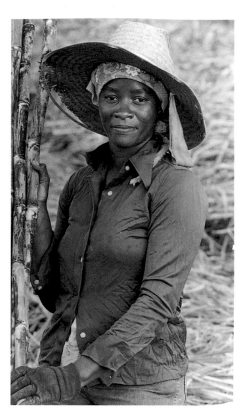

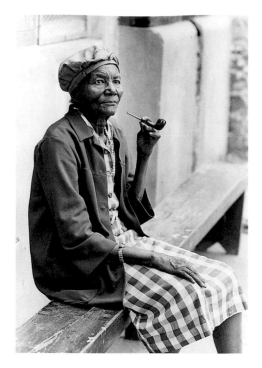

Keith M. Calhoun (b. 1955)
261. Dora Lee
Gelatin silver print, 1980
Courtesy of the photographer, New Orleans, Louisiana

Keith M. Calhoun (b. 1955)
260. Gail Dorsey, Sugarcane Scrapper
Gelatin silver print, 1987
Courtesy of the photographer, New Orleans, Louisiana

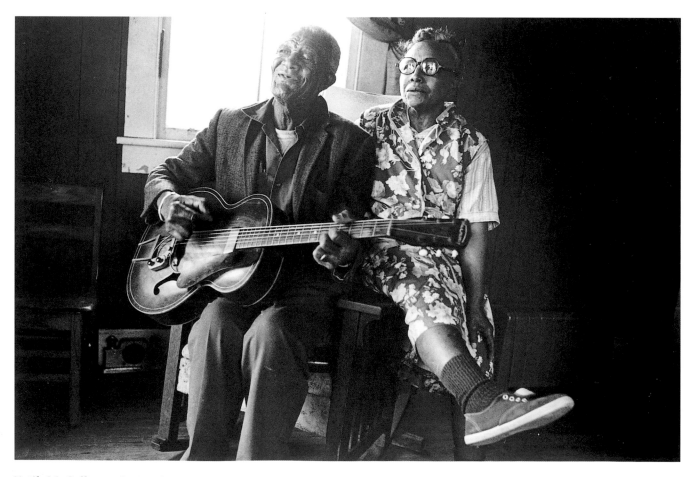

Keith M. Calhoun (b. 1955)
262. Mr. Rushing Plays the Blues
Gelatin silver print, 1982
Courtesy of the photographer, New Orleans, Louisiana

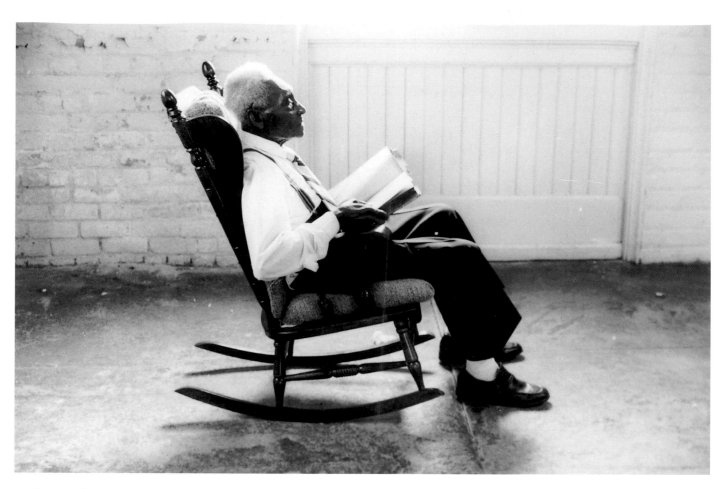

Keith M. Calhoun (b. 1955)
263. Reverend Brown, New Orleans, Louisiana
Gelatin silver print, 1980
Courtesy of the photographer, New Orleans, Louisiana

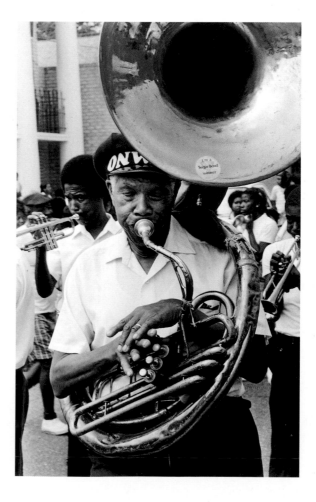

Keith M. Calhoun (b. 1955)
264. Mr. Jerry Green, New Orleans's oldest, upright tuba player
still active
Gelatin silver print, ca. 1986
Courtesy of the photographer, New Orleans, Louisiana

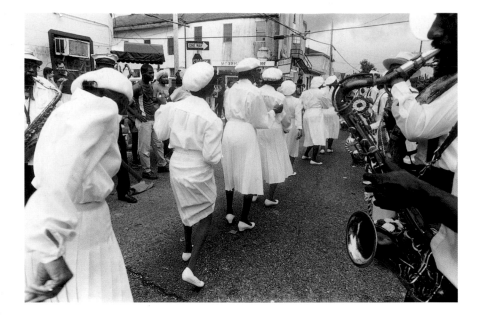

Chandra McCormick (b. 1957)
265. Lady Zulu's
Gelatin silver print, 1993
Courtesy of the photographer, New Orleans, Louisiana

Chandra McCormick (b. 1957)
266. The Prayer, Louisiana
Gelatin silver print, 1986
Courtesy of the photographer, New Orleans,
Louisiana

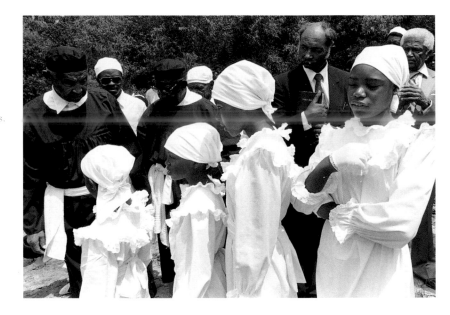

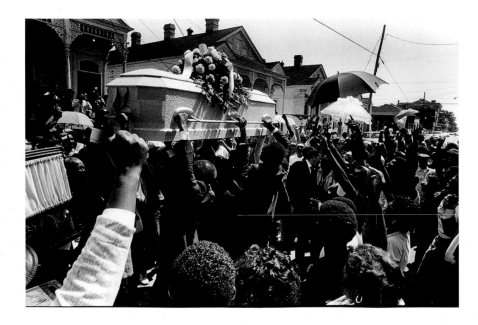

Chandra McCormick (b. 1957)
267. New Orleans Jazz Drummers' Jazz Funeral of
James Black
Gelatin silver print, 1987
Courtesy of the photographer, New Orleans, Louisiana

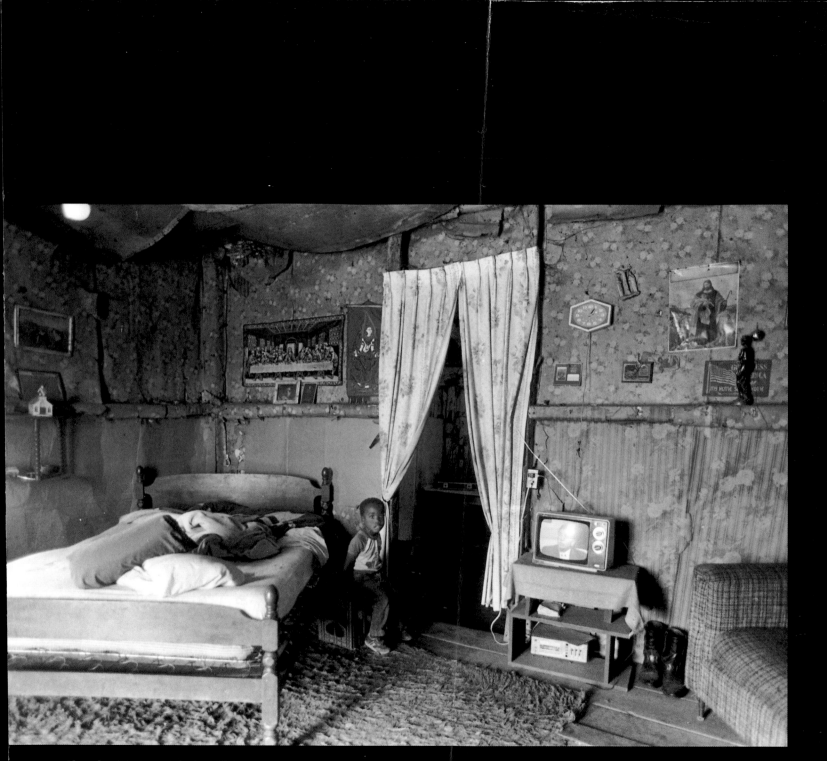

Chandra McCormick (b. 1957)
268. Untitled (boy with television)
Gelatin silver print, ca. 1987
Courtesy of the photographer, New Orleans, Louisiana

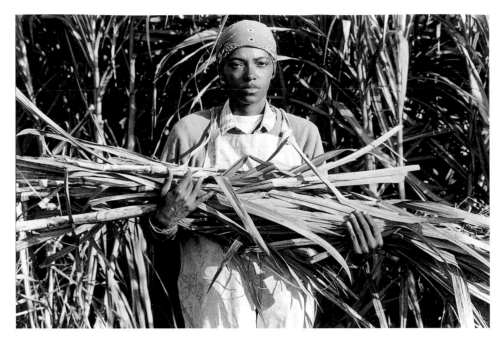

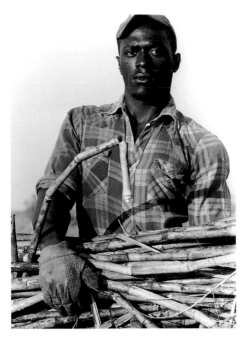

Chandra McCormick (b. 1957)
269. Untitled (female cane worker)
Gelatin silver print, 1987
Courtesy of the photographer, New Orleans, Louisiana

Chandra McCormick (b. 1957)
270. Untitled (male cane worker)
Gelatin silver print, 1987
Courtesy of the photographer, New Orleans, Louisiana

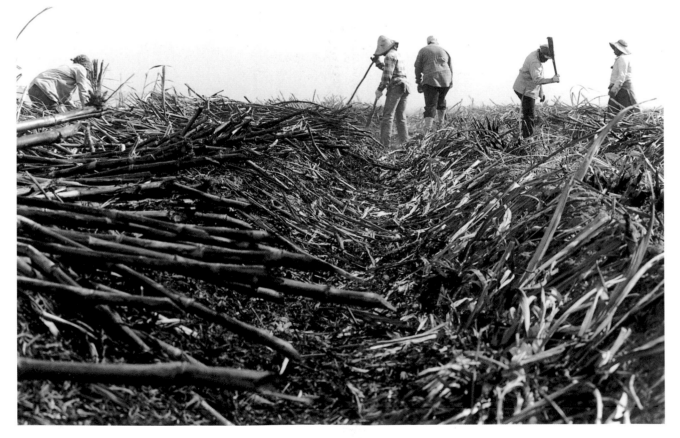

Chandra McCormick (b. 1957)
271. Untitled (cane workers)
Gelatin silver print, 1987
Courtesy of the photographer, New Orleans, Louisiana

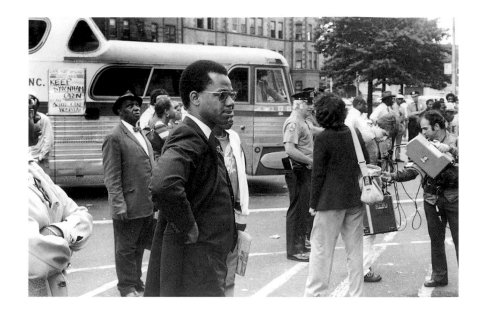

O'Neal Lancy Abel (b. 1941)
272. Rev. Calvin O. Butts III of the Abyssinian
Baptist Church at a Harlem Rally
Gelatin silver print, 1980
Courtesy of the photographer, New York, New York

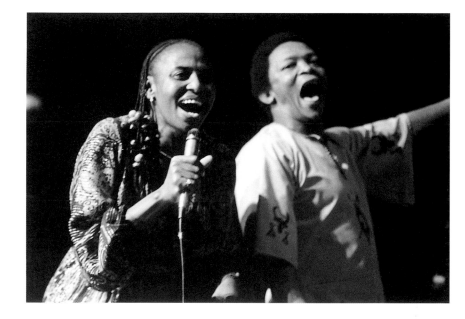

O'Neal Lancy Abel (b. 1941)
273. Miriam and Hugh Masakela, musicians
Gelatin silver print, 1980
Courtesy of the photographer, New York, New York

O'Neal Lancy Abel (b. 1941)
274. Queen Mother Moore in Harlem
Gelatin silver print, 1980
Courtesy of the photographer, New York, New York

Harlee Little (b. 1947)
275. The photographer's son
Gelatin silver print, 1979
Courtesy of the photographer, Washington, D.C.

Harlee Little (b. 1947)
276. Author Shireen Dodson and daughters
Gelatin silver print, 1998
Courtesy of the photographer, Washington, D.C.

212

Harlee Little (b. 1947)
277. Untitled, Washington, D.C.
Gelatin silver print, n.d.
Courtesy of the photographer, Washington, D.C.

Harlee Little (b. 1947)
278. Betty Carter (1930–1999) in performance
Gelatin silver print, 1979
Courtesy of the photographer, Washington, D.C.

Mansa K. Mussa (b. 1951)
279. Rumba, Havana, Cuba
Gelatin silver print, 1990
Courtesy of the photographer, Newark, New Jersey

Mansa K. Mussa (b. 1951)
280. Harlem Girl
Gelatin silver print, 1982
Courtesy of the photographer, Newark, New Jersey

Mansa K. Mussa (b.1951)
281. The Philadelphia Dance Company (Philadanco)
Gelatin silver print, 1998
Courtesy of the photographer, Newark, New Jersey

Gerald Straw (b. 1943)
282. Untitled
Gelatin silver print, ca. 1980s
Courtesy of the photographer, Atlanta, Georgia

Gerald Straw (b. 1943)
283. Untitled
Gelatin silver print, ca. 1980s
Courtesy of the photographer, Atlanta, Georgia

Gerald Straw (b. 1943)
284. Untitled
Gelatin silver print, ca. 1980s
Courtesy of the photographer, Atlanta, Georgia

Mel Wright (b. 1942)
285. Sun Ra in Flight 1
Gelatin silver print, 1978
Courtesy of the photographer, New York, New York

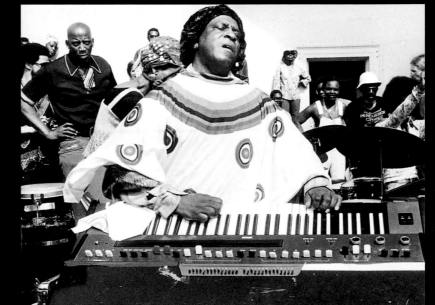

Mel Wright (b. 1942)
286. Sun Ra in Flight 2
Gelatin silver print, 1978
Courtesy of the photographer, New York, New York

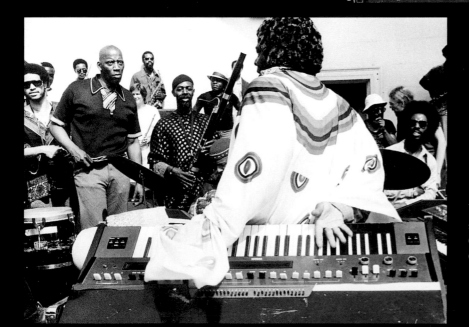

Mel Wright (b. 1942)
287. Sun Ra in Flight 3
Gelatin silver print, 1978
Courtesy of the photographer, New York, New York

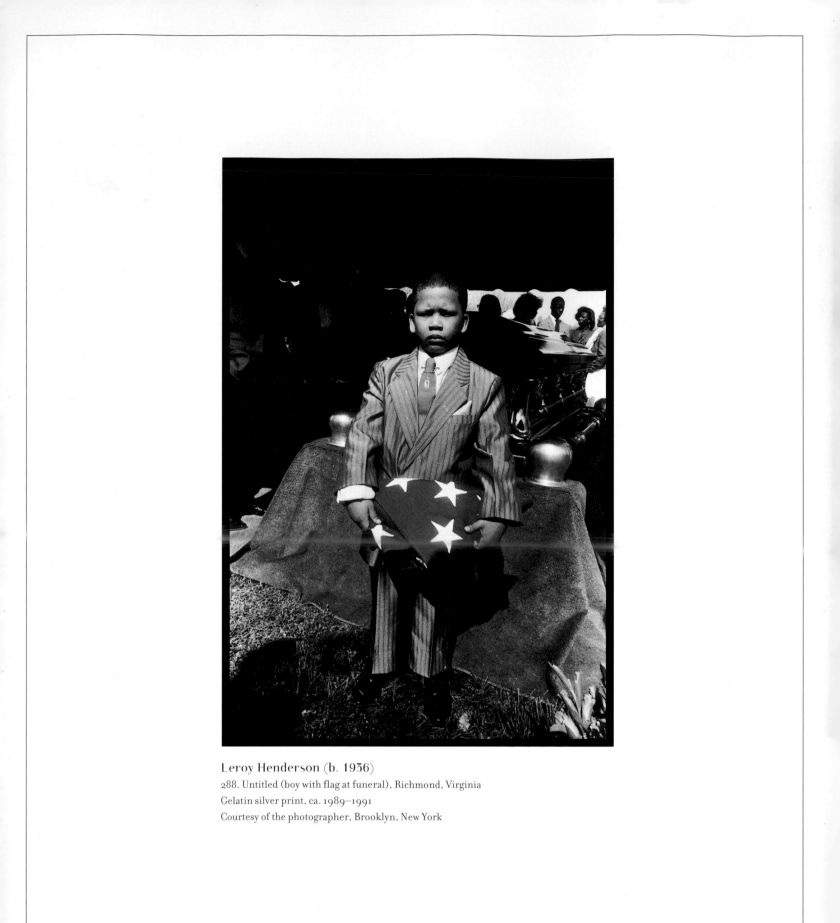

Leroy Henderson (b. 1936)

288. Untitled (boy with flag at funeral), Richmond, Virginia

Gelatin silver print, ca. 1989–1991

Courtesy of the photographer, Brooklyn, New York

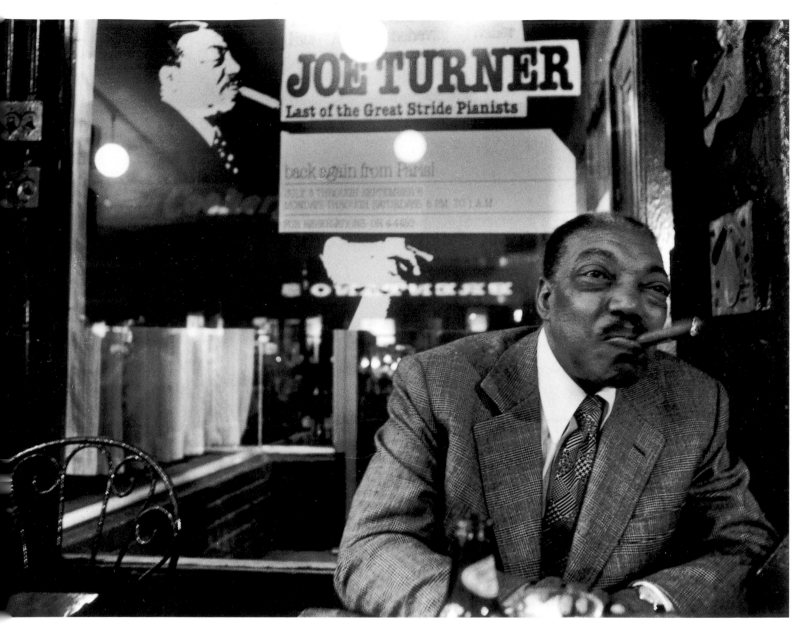

Leroy Henderson (b. 1936)
289. Untitled (Joe Turner), Greenwich Village
Gelatin silver print, ca. 1980
Courtesy of the photographer, Brooklyn, New York

Sunny Nash (b. 1951)
290. Storefront Church, New York City
Gelatin silver print, 1991
Courtesy of the photographer, Seal Beach,
California

Sunny Nash (b. 1951)
291. Woman in Church, Nashville
Gelatin silver print, 1992
Courtesy of the photographer, Seal Beach, California

Bob Gore (b. 1947)
292. Untitled (girl with doll), Abyssinian Baptist Church, Harlem, New York
Gelatin silver print, 1990
Courtesy of the photographer, Brooklyn, New York

Bob Gore (b. 1947)
293. Untitled (baptism)
Gelatin silver print, 1992
Courtesy of the photographer, Brooklyn, New York

Bob Gore (b. 1947)
294. Untitled (the Reverend Calvin O. Butts III with ministers)
Gelatin silver print, n.d.
Courtesy of the photographer, Brooklyn, New York

Bob Gore (b. 1947)
295. Untitled (Dr. Samuel D. Proctor signing books at the Abyssinian Baptist Church, Harlem, New York)
Gelatin silver print, n.d.
Courtesy of the photographer, Brooklyn, New York

Cheryl Miller (b. 1953)
296. Sunglass Corner
Gelatin silver print, 1980
Courtesy of the photographer, Queens, New York

Cheryl Miller (b. 1953)
297. Card Game
Gelatin silver print, 1988
Courtesy of the photographer, Queens, New York

Cheryl Miller (b. 1953)
298. Thelma Jones
Gelatin silver print, 1988
Courtesy of the photographer, Queens, New York

Salimah Ali (b. 1954)
299. Day of Atonement at United Nations Plaza, New York, New York
Gelatin silver print, 1996
Courtesy of the photographer, Queens, New York

Salimah Ali (b. 1954)
300. Million Women March in Philadelphia, Pennsylvania
Gelatin silver print, 1997
Courtesy of the photographer, Queens, New York

Cary Beth Cryor (1947–1997)
301. *Grandmother's Hands* series: #1 with Hymnal
Gelatin silver print, 1993
Courtesy of the Estate of Cary Beth Cryor, Baltimore,
Maryland

Cary Beth Cryor (1947–1997)
302. *Grandmother's Hands* series: #2 with Sewing Needle
Gelatin silver print, 1993
Courtesy of the Estate of Cary Beth Cryor, Baltimore, Maryland

Earlie Hudnall, Jr. (b. 1946)
3o3. Cowboy, Houston, Texas
Gelatin silver print, 1993
Courtesy of the Texas African American Photography Archive,

Earlie Hudnall, Jr. (b. 1946)

304. Aunt B.

Gelatin silver print, 1979

Courtesy of Museum of Fine Arts, Houston, museum purchase with funds
provided by Mr. and Mrs. Joe S. Mundy

Earlie Hudnall, Jr. (b. 1946)

305. Lady in Black

Gelatin silver print, 1988

Courtesy of Museum of Fine Arts, Houston, Sonia and Kaye Marvins Portrait
Collection, museum purchase with funds provided by the Accessions
Subcommittee in honor of Michael H. and Michele Sharney Marvins

Earlie Hudnall, Jr. (b. 1946)

306. Bouncing Boys, Houston, Texas

Gelatin silver print, 1981

Courtesy of the Texas African American Photography Archive,
Documentary Arts, Inc., Dallas

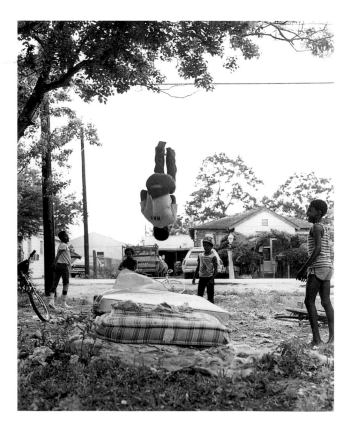

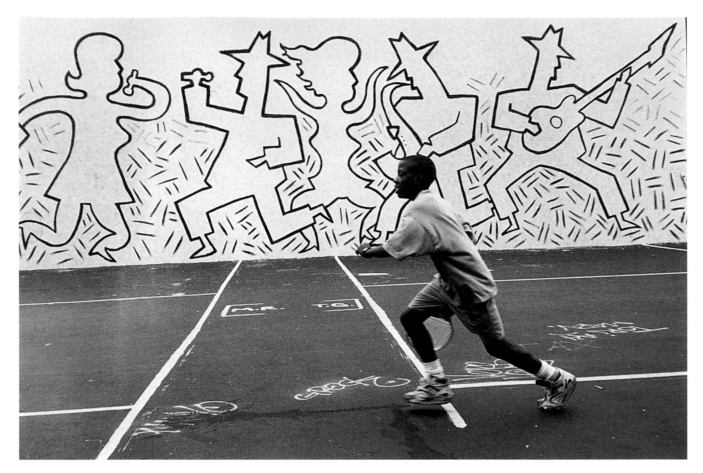

Orville Robertson (b. 1957)
307. Tennis Player, Amsterdam Avenue
Gelatin silver print, 1992
Courtesy of the photographer, Long Island City, New York

Orville Robertson (b. 1957)
308. Rainy Steps, Metropolitan Museum
Gelatin silver print, 1985
Courtesy of the photographer, Long Island City,
New York

Orville Robertson (b. 1957)
309. Bus and World Financial Center Under
Construction
Gelatin silver print, 1985
Courtesy of the photographer, Long Island City,
New York

Raymond W. Holman, Jr. (b. 1948)
310. Havana, Cuba
Gelatin silver print, 1997
Courtesy of the photographer, Philadelphia,
Pennsylvania

Raymond W. Holman, Jr. (b. 1948)
311. African American March on Grays Ferry,
Philadelphia, Pennsylvania (The white residents in the
area turned their backs on the marchers.)
Gelatin silver print, 1997
Courtesy of the photographer, Philadelphia,
Pennsylvania

Raymond W. Holman, Jr. (b. 1948)
312. Day of Atonement, New York, New York
Gelatin silver print, 1996
Courtesy of the photographer, Philadelphia,
Pennsylvania

Charles Martin (b. 1952)
313. Carnival, Labor Day, Brooklyn
Gelatin silver print, 1996
Courtesy of the photographer, Flushing, New York

Charles Martin (b. 1952)
314. Christian Procession, Salvador da Bahia
Gelatin silver print, 1994
Courtesy of the photographer, Flushing, New York

Charles Martin (b. 1952)
315. As Meninas, Salvador da Bahia
Gelatin silver print, 1994
Courtesy of the photographer, Flushing, New York

Charles Martin (b. 1952)
316. Veneration, São Paulo
Gelatin silver print, 1992
Courtesy of the photographer, Flushing, New York

Carl Clark (b. 1933)
318. Image no. 43 from the *Woman* series: Sunday
Morning While Considering a Decisive Moment
Gelatin silver print, 1991
Courtesy of the photographer, Baltimore,
Maryland

Carl Clark (b. 1933)
317. Image no. 5 from the *Man and Woman* series (Image no. 65
from the *Woman* series)
Gelatin silver print, 1997
Courtesy of the photographer, Baltimore, Maryland

Carl Clark (b. 1933)
319. Image no. 72 from the *Woman* series
Gelatin silver print, 1998
Courtesy of the photographer, Baltimore, Maryland

Linda Day Clark (b. 1963)
320. North Avenue, image no. 30 (babies)
Gelatin silver print, 1993
Courtesy of the photographer, Baltimore, Maryland

(See page 272 for color plates by Linda Day Clark)

Linda Day Clark (b. 1963)
321. North Avenue, image no. 28 (church)
Gelatin silver print, 1993
Courtesy of the photographer, Baltimore,
Maryland

Sheila Pree (b. 1967)
322. Man with Sign
Gelatin silver print, 1998
Courtesy of the photographer, Atlanta, Georgia

Sheila Pree (b. 1967)
323. Woman with Sign
Gelatin silver print, 1998
Courtesy of the photographer, Atlanta, Georgia

Sheila Pree (b. 1967)
324. Man Preaching
Gelatin silver print, 1998
Courtesy of the photographer, Atlanta, Georgia

Ken D. Ashton (b. 1963)
325. The Howard Theatre, Washington, D.C.
Gelatin silver print, 1998
Courtesy of the photographer, Washington, D.C.

(See page 273 for color plate by Ken D. Ashton)

Sheila Pree (b. 1967)
326. Man with Bible
Gelatin silver print, 1998
Courtesy of the photographer, Atlanta, Georgia

Ming Smith Murray (active 1970s to present)
327. Hill District, Pittsburgh (girl in church)
Gelatin silver print, ca. 1994
Courtesy of the photographer, Los Angeles, California

Ming Smith Murray (active 1970s to present)
328. Hill District, Pittsburgh (man in pool room)
Gelatin silver print, ca. 1994
Courtesy of the photographer, Los Angeles, California

(See page 273 for color plate by Ming Smith Murray)

Ming Smith Murray (active 1970s to present)
329. Hill District, Pittsburgh (man in restaurant)
Gelatin silver print, ca. 1994
Courtesy of the photographer, Los Angeles, California

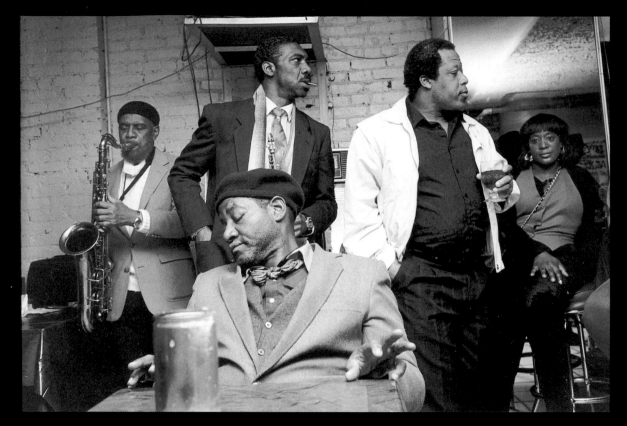

Gerald G. Cyrus (b. 1957)
330. Untitled (St. Nick's Pub), Harlem, New York
Gelatin silver print, 1994
Courtesy of the photographer, Brooklyn, New York

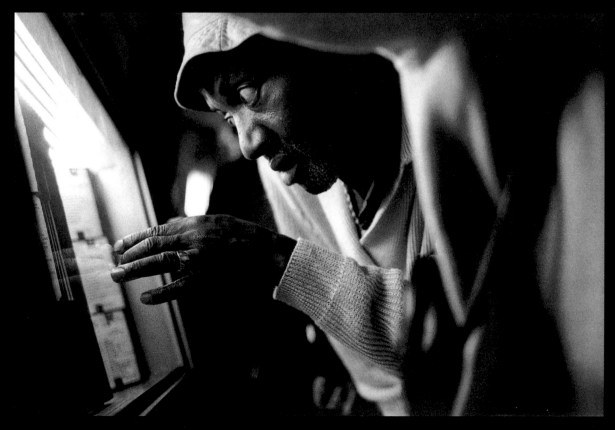

Gerald G. Cyrus (b. 1957)
331. Fergie at the juke box, Harlem, New York
Gelatin silver print, 1994
Courtesy of the photographer, Brooklyn, New York

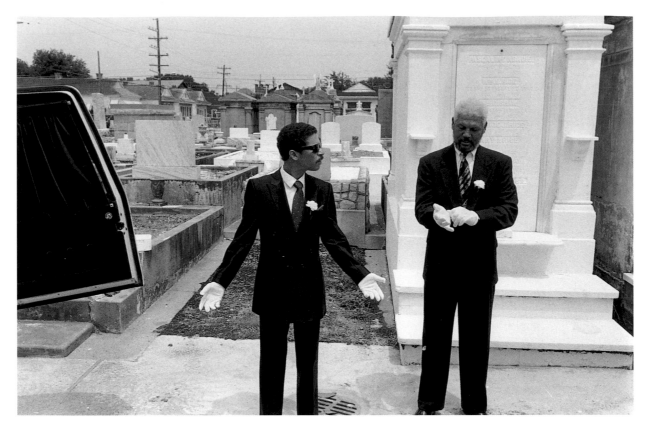

Gerald G. Cyrus (b. 1957)
332. Untitled, New Orleans, Louisiana
Gelatin silver print, 1993
Courtesy of the photographer, Brooklyn, New York

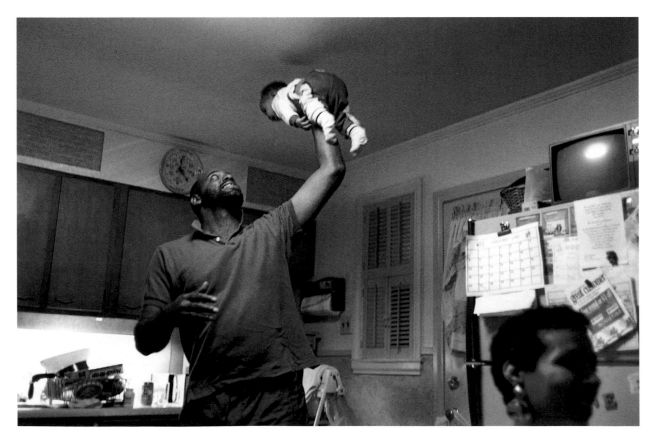

Gerald G. Cyrus (b. 1957)
333. Keith hoisting Seth, New Orleans, Louisiana
Gelatin silver print, 1992
Courtesy of the photographer, Brooklyn, New York

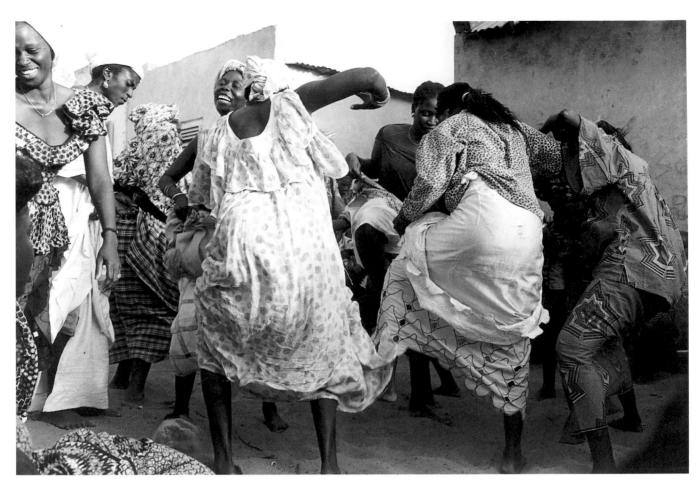

Alfred Olusegun Fayemi (active 1970s to present)
334. Senegal (women dancing)
Gelatin silver print, 1993
Courtesy of the photographer, White Plains, New York

Alfred Olusegun Fayemi (active 1970s to present)
335. Niger (boys swimming in river)
Gelatin silver print, 1995
Courtesy of the photographer, White Plains, New York

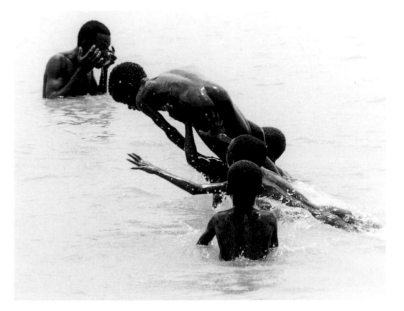

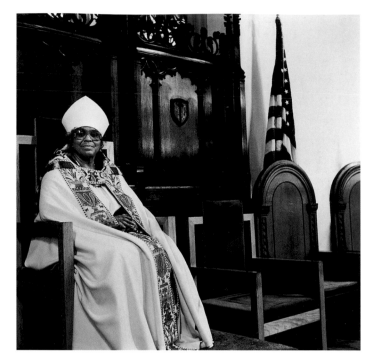

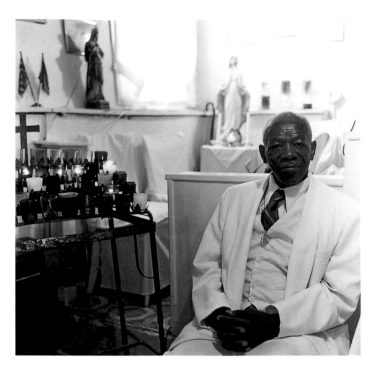

Ken Royster (b. 1944)

336. Archbishop Naomi Durant

New Refuge Deliverance Cathedral, Baltimore, Maryland

Gelatin silver print, 1994

Courtesy of the photographer, Baltimore, Maryland

Ken Royster (b. 1944)

337. Deacon with candles, St. Elijah Holiness Church, Baltimore, Maryland

Gelatin silver print, 1992

Courtesy of the photographer, Baltimore, Maryland

Ken Royster (b. 1944)

338. *River Baptism* series: The Baptism

Gunpowder State Park, Baltimore County, Maryland

Gelatin silver print, 1996

Courtesy of the photographer, Baltimore, Maryland

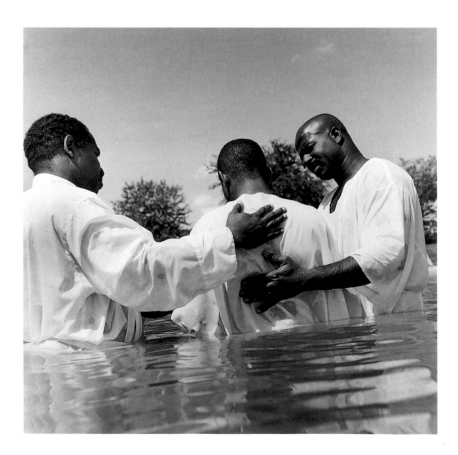

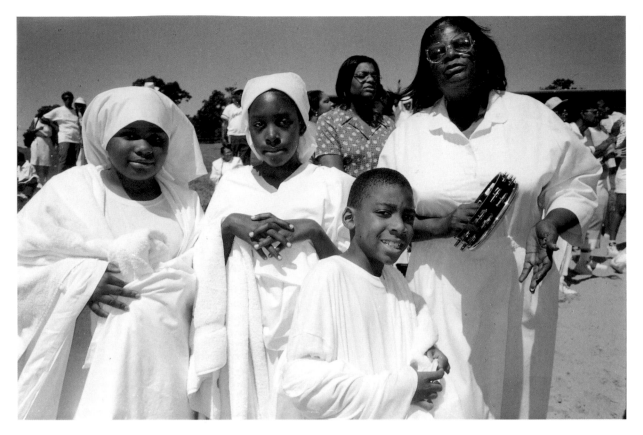

Ken Royster (b. 1944)
339. *River Baptism* series: Mother and Children
Gunpowder State Park, Baltimore County, Maryland
Gelatin silver print, 1998
Courtesy of the photographer, Baltimore, Maryland

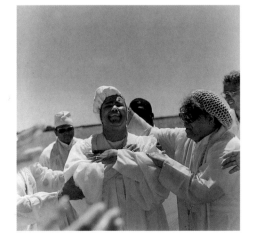

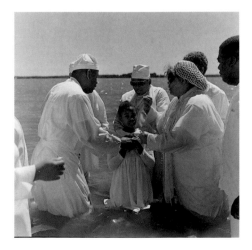

Ken Royster (b. 1944)
340. *River Baptism* series: Baptism, No. IV
Gunpowder State Park, Baltimore County,
Maryland
Gelatin silver print, 1996
Courtesy of the photographer, Baltimore,
Maryland

Ken Royster (b. 1944)
341. *River Baptism* series: Baptism, No. V, Solid
Rock Pentecostal Church
Gunpowder State Park, Baltimore Co., Maryland
Gelatin silver print, 1995
Courtesy of the photographer, Baltimore,
Maryland

Chester Higgins, Jr. (b. 1946)
342. African Burial Ground, New York City (A Yoruba priestess and a Khamite priest from New York City perform
a libation ceremony for the ancestors on the seventeenth-century burial site uncovered in lower Manhattan.)
Gelatin silver print, 1992
Courtesy of the photographer, Brooklyn, New York

Chester Higgins, Jr. (b. 1946)
343. Mali (Getting from Mopti to the Fulani village of Sara Seli meant hiring a boat for an hour's ride across and up
the immense Niger River. Once the boat reached deep water and the outboard motor was started, the poleman took
time to relax on the floor of the boat just outside the canopy designed to protect passengers from the hot sun.)
Gelatin silver print, 1993
Courtesy of the photographer, Brooklyn, New York

Chester Higgins, Jr. (b. 1946)
344. New York City (a young Moslem woman in Brooklyn)
Gelatin silver print, 1990
Courtesy of the photographer, Brooklyn, New York

Chester Higgins, Jr. (b. 1946)
345. New York City (Brazilian immigrant Magda
Silvana dressed as Oshun, the African deity of the
River and Love)
Gelatin silver print, 1989
Courtesy of the photographer, Brooklyn, New York

Chester Higgins, Jr. (b. 1946)
346. Lalibela, Ethiopia (This young Ethiopian
Orthodox deacon is holding a processional cross.)
Gelatin silver print, 1993
Courtesy of the photographer, Brooklyn, New York

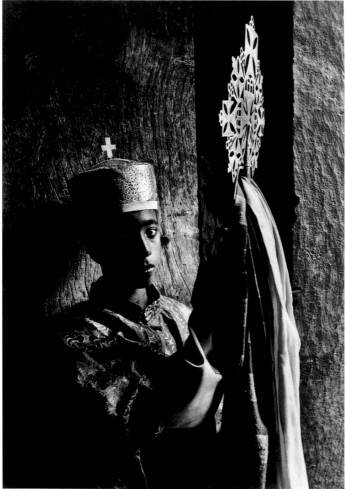

Chester Higgins, Jr. (b. 1946)
347. The first haircut, Alabama
Gelatin silver print, 1969
Courtesy of the photographer, Brooklyn, New York

Ken Jones (b. 1956)
348. Mr. Journet's Repose, Memorial Park, Houston, Texas
Gelatin silver print, 1996
Courtesy of the photographer, Houston, Texas

Ken Jones (b. 1956)
349. Rough Rider, Rodeo Patron at an African American Rodeo,
Liberty, Texas
Gelatin silver print,1995
Courtesy of the photographer, Houston, Texas

Ken Jones (b. 1956)
350. Bull's Eye (Rodeo hands prepare to
release a bull with rider on its back, Arcola,
Texas.)
Gelatin silver print, 1995
Courtesy of the photographer,
Houston, Texas

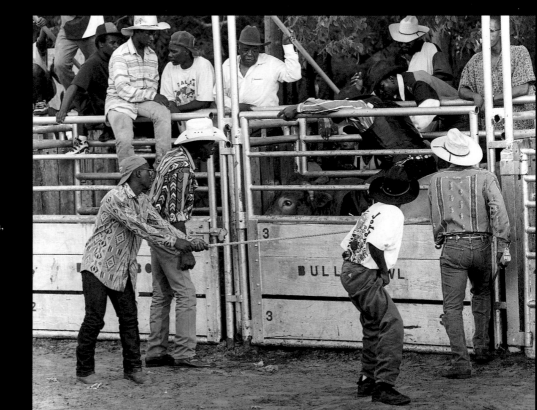

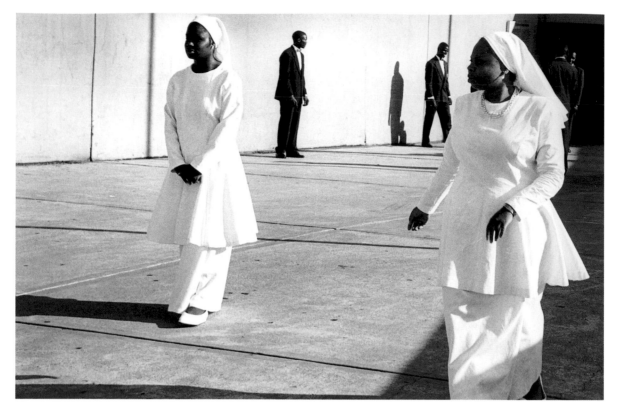

Ken Jones (b. 1956)
351. Family Day, Members of the Nation of Islam, Houston, Texas
Gelatin silver print, 1994
Courtesy of the photographer, Houston, Texas

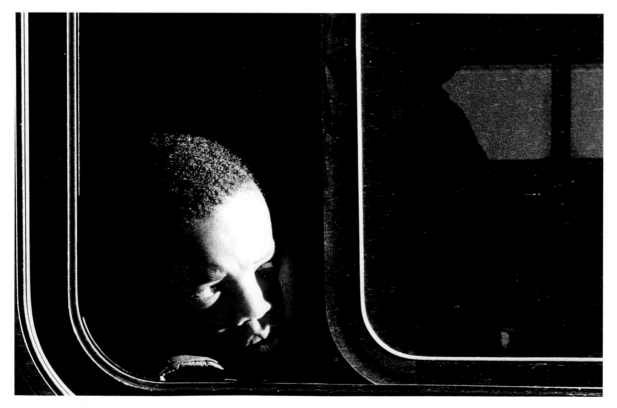

Carl N. Sidle (b. 1943)
352. Bus Ride (Dallas Transit Bus)
Gelatin silver print, 1991
Courtesy of the Texas African American Photography Archive, Documentary Arts, Dallas

Shawn W. Walker (b. 1940)

353. " 'Brothers and sisters, my text this morning is the blackness of blackness.'

And a congregation of voices answered: 'That blackness is most black. . . .'

In the beginning there was blackness. . . . I lived in the darkness into which I was chased, but now I see. . . .

I've illuminated the blackness of my invisibility and vice versa; and so I play the invisible music of my isolation."

Fom *Invisible Man* by Ralph Ellison

Gelatin silver print, 1991

Courtesy of the photographer, New York, New York

Shawn W. Walker (b. 1940)

354. "Who knows? All sickness is not unto death, neither is invisibility . . . but to whom can I be responsible, and why should I be, when you refuse to see me? . . . I am an invisible man. . . . I am a man of substance, of flesh and bone, fiber and liquids—and I might even be said to possess a mind. I am invisible, understand, simply because people refuse to see me. . . ."

From *Invisible Man* by Ralph Ellison

Gelatin silver print, 1991

Courtesy of the photographer, New York, New York

Shawn W. Walker (b. 1940)

355. "Whatever the dead may know, they cannot know the beauty, the marvel of being alive in the flesh. The dead may look after the afterworld. But the magnificent here and now of life in the flesh is ours, and ours alone."

From *Wandering in Eden* by Michael Adam

Gelatin silver print, 1991

Courtesy of the photographer, New York, New York

Shawn W. Walker (b. 1940)

356. To secure success in any new endeavor, Hindus wear mascots shaped as elephants, the elephant-headed god who was the son of Siva. By doing so they gain wisdom and foresight, as well as ensuring that all obstacles are removed from their path.

Gelatin silver print, 1991

Courtesy of the photographer, New York, New York

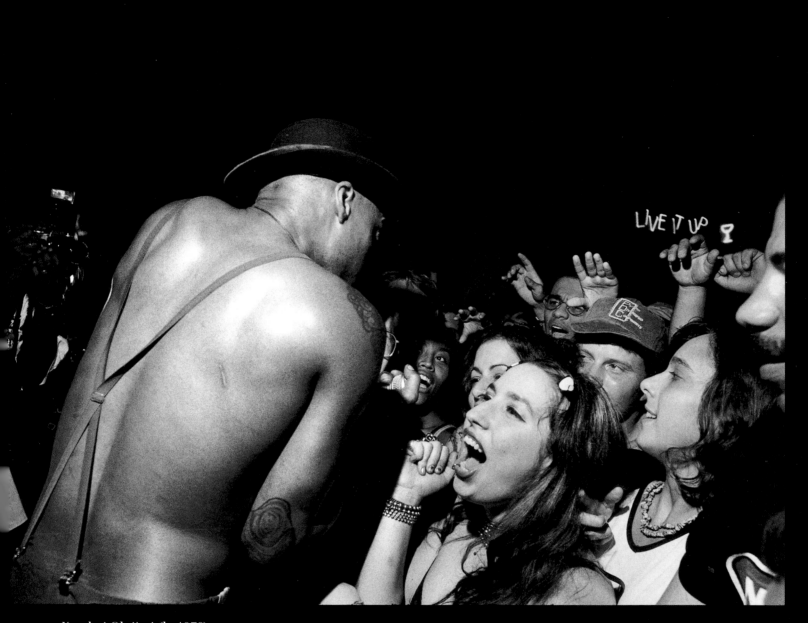

Kambui Olujimi (b. 1976)
357. Lukmon, lead singer of Funkface at CBGB's
Gelatin silver print, 1996
Courtesy of the photographer, New York, New York

Kambui Olujimi (b. 1976)
358. Greg Tate, a founding member of the Black
Rock Coalition at his Harlem apartment
Gelatin silver print, 1998
Courtesy of the photographer, New York, New York

Kambui Olujimi (b. 1976)
359. Angelo, lead singer of Fishbone at Tramps
Gelatin silver print, 1997
Courtesy of the photographer, New York, New York

Kambui Olujimi (b. 1976)
360. Nature, singer and songwriter at Euphoria Studios
Gelatin silver print, 1996
Courtesy of the photographer, New York, New York

Steven Cummings (b. 1965)
361. *Washington, D.C.* series: Untitled (street
scene with truck)
Gelatin silver print, 1998
Courtesy of the photographer,
Washington, D.C.

Steven Cummings (b. 1965)
362. *Washington, D.C.* series: Untitled
(girls jumping rope)
Gelatin silver print, 1997
Courtesy of the photographer,
Washington, D.C.

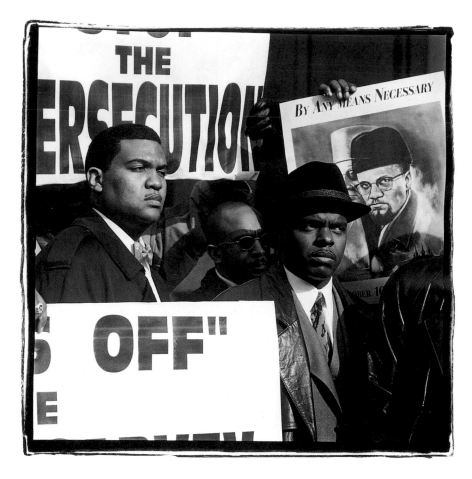

Steven Cummings (b. 1965)
363. By Any Means Necessary
Gelatin silver print, 1996
Courtesy of the photographer, Washington, D.C.

Steven Cummings (b. 1965)
364. We All Got The Blues
Gelatin silver print, 1998
Courtesy of the photographer, Washington, D.C.

Collette Fournier (b. 1952)
365. Women of the Sunset Riders, Buffalo, New York
Gelatin silver print, 1985
Courtesy of the photographer, Spring Valley, New York

Collette Fournier (b. 1952)
366. Women of Rastafari, Jamaica
Gelatin silver print, 1983
Courtesy of the photographer, Spring Valley,
New York

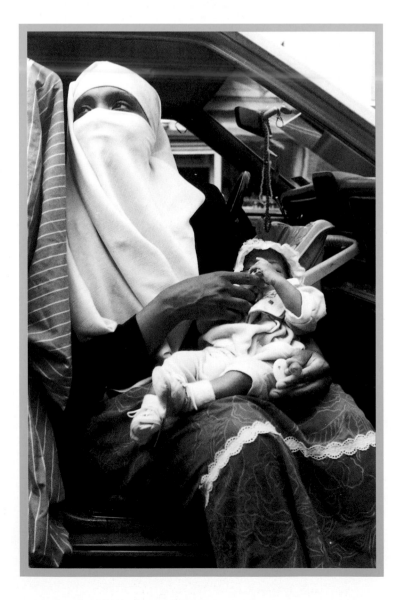

Collette Fournier (b. 1952)
367. Muslim Woman and Child, Paterson, New Jersey
Gelatin silver print, 1991
Courtesy of the photographer, Spring Valley, New York

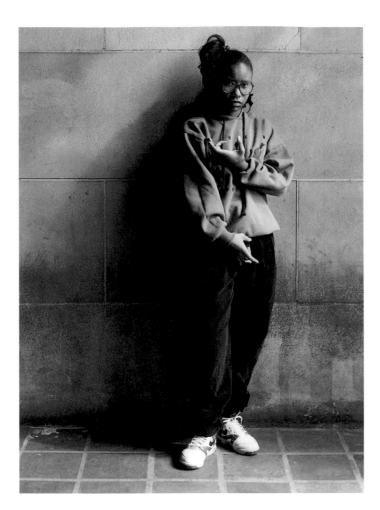

Lonnie Graham (b. 1954)
368. Westinghouse High School Student, Pittsburgh, Pennsylvania
Gelatin silver print, 1994
Courtesy of the photographer, Pittsburgh, Pennsylvania

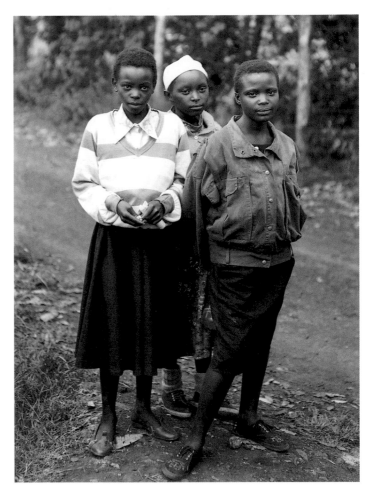

Lonnie Graham (b. 1954)
369. Three Girls on Road, Muguga, Kenya
Gelatin silver print, 1995
Courtesy of the photographer, Pittsburgh, Pennsylvania

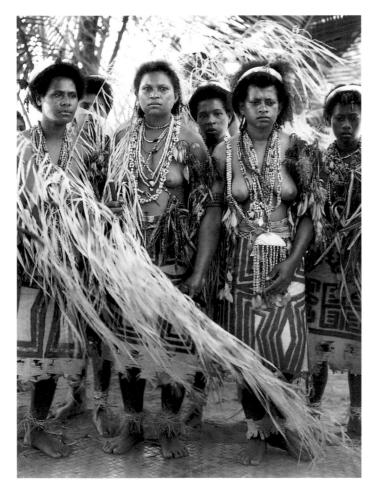

Lonnie Graham (b. 1954)
370. Gangaja Village, Papua New Guinea
Gelatin silver print, 1997
Courtesy of the photographer, Pittsburgh, Pennsylvania

Frank Stallings (b. 1946)

372. *Portraits from a Brazilian Favala* series: Man in Window, Calabar
Gelatin silver print, 1995
Courtesy of the photographer, Annapolis, Maryland

Frank Stallings (b. 1946)

371. *Portraits from a Brazilian Favala* series: Friends, Calabar
Gelatin silver print, 1996
Courtesy of the photographer, Annapolis, Maryland

Frank Stallings (b. 1946)

373. *Portraits from a Brazilian Favala* series: Clothesline, Calabar
Gelatin silver print, 1996
Courtesy of the photographer, Annapolis, Maryland

254

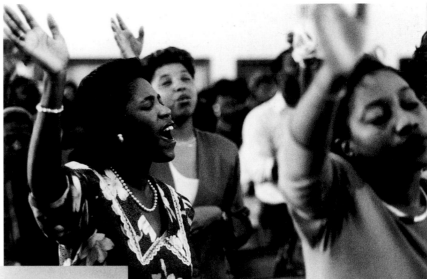

Jeffery L. St. Mary (b. 1955)
374. Joy Tabernacle (women singing)
Gelatin silver print, 1991
Courtesy of the photographer, Missouri City, Texas

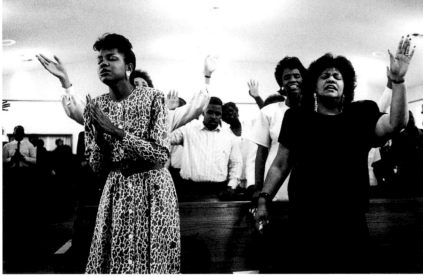

Jeffery L. St. Mary (b. 1955)
375. Joy Tabernacle (group praying)
Gelatin silver print, 1991
Courtesy of the photographer, Missouri City, Texas

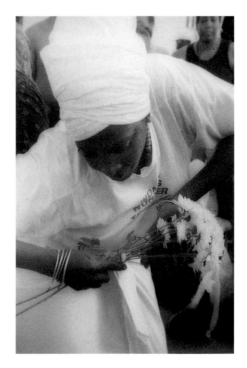

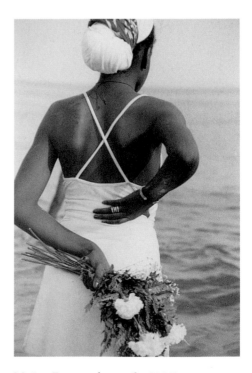

Moira Pernambuco (b. 1969)
376. *Remembrance and Ritual: Tribute to the*
Ancestors of the Middle Passage series: Offering
Gelatin silver print, 1996
Courtesy of the photographer, Brooklyn,
New York

Moira Pernambuco (b. 1969)
377. *Remembrance and Ritual: Tribute to the Ancestors*
of the Middle Passage series: Across Waters
Gelatin silver print, 1997
Courtesy of the photographer, Brooklyn, New York

Delphine A. Fawundu (b. 1971)
378. Assata Shakur in political exile in Cuba
Gelatin silver print, 1998
Courtesy of the photographer, Brooklyn, New York

Delphine A. Fawundu (b. 1971)
379. *South Africa* series: Mountain View
Gelatin silver print, 1995
Courtesy of the photographer, Brooklyn, New York

Hank Sloane Thomas (b. 1976)
380. Million Man March, Washington, D.C.

Hank Sloane Thomas (b. 1976)
381. Million Man March, Washington, D.C.
Gelatin silver print, 1995
Courtesy of the photographer, New York, New York

(See page 277 for color plates by Hank Sloane Thomas)

Hank Sloane Thomas (b. 1976)
382. The Late, Late Show
Gelatin silver print, 1996
Courtesy of the photographer, New York, New York

Craig Herndon (b. 1947)

383. Young musician, Duke Ellington High School of the Arts Jazz Orchestra
Gelatin silver print, 1998
Courtesy of the photographer, Washington, D.C.

Craig Herndon (b. 1947)

384. David Yarborough, musician and teacher, with student
Gelatin silver print, 1998
Courtesy of the photographer, Washington, D.C.

Nekeisha Durrett (b. 1976)

385. Two Children with Book
Gelatin silver print, 1998
Courtesy of the photographer, Upper Marlboro, Maryland

PORTRAITS

Beuford Smith (b. 1941)
386. Evelyn # 16
Gelatin silver print, 1994
Courtesy of Beuford Smith/Césaire, Brooklyn, New York

Fern Logan (b. 1945)
387. *Artists' Portrait* series: Self-Portrait
Gelatin silver print, 1985
Courtesy of the photographer, Carbondale, Illinois

Fern Logan (b. 1945)
388. *Artists' Portrait* series: Joseph Delaney (1904–1991), painter
Gelatin silver print, 1985
Courtesy of the photographer, Carbondale, Illinois

Fern Logan (b. 1945)
389. *Artists' Portrait* series: Romare Bearden (1912–1988), painter
Gelatin silver print, 1983
Courtesy of the photographer, Carbondale, Illinois

Fern Logan (b. 1945)
390. *Artists' Portrait* series: Jacob Lawrence (b. 1917), printmaker
Gelatin silver print, 1995
Courtesy of the photographer, Carbondale, Illinois

Carla Williams (b. 1965)
391. Shawna and Evelyn
Gelatin silver contact print, 1995
Courtesy of the photographer, Los Angeles, California

Carla Williams (b. 1965)
392. Self-Portrait
Gelatin silver contact print, 1990
Courtesy of the photographer, Los Angeles,
California

Carla Williams (b. 1965)
393. Grandmother
Gelatin silver contact print, 1995
Courtesy of the photographer, Los Angeles,
California

Vincent Alan W. (1960–1996)

394. *Queens Without a Country* series: Vincent Alan W.

33 years old, 3 years in Berlin, 8 years in Germany

"I guess the main reason for leaving America was that I was frustrated
with my life as an artist—I wasn't one."

Gelatin silver print, ca. 1986–1987

Courtesy of the Estate of Vincent Alan W., P. Celina Lunsford,
Frankfurt, Germany

Vincent Alan W. (1960–1996)

395. *Queens Without a Country* series: Michael Hall

28 years old, 3 years in Berlin

"I want to be a Pop star, just wait."

Gelatin silver print, ca. 1986–1987

Courtesy of the Estate of Vincent Alan W., P. Celina Lunsford,
Frankfurt, Germany

Vincent Alan W. (1960–1996)

396. *Queens Without a Country* series: Colin ("Coco") Rich

21 years old, 2 years in Berlin

"I just love to sing and I think living in Germany will help my career."

Gelatin silver print, ca. 1986–1987

Courtesy of the Estate of Vincent Alan W., P. Celina Lunsford,
Frankfurt, Germany

Vincent Alan W. (1960–1996)

397. *Queens Without a Country* series: Jason Pitts

23 years old, 1 year in Berlin

"I never knew that the German man had a thing for black men."

Gelatin silver print, ca. 1986–1987

Courtesy of the Estate of Vincent Alan W., P. Celina Lunsford,
Frankfurt, Germany

Vincent Alan W. (1960–1996)

398. *Queens Without a Country* series: Donald Streeter

28 years old, 4 years in Berlin

"The black and white Americans here are much nicer to each
other here in Berlin than they are in the States."

Gelatin silver print, ca. 1986–1987

Courtesy of the Estate of Vincent Alan W., P. Celina Lunsford,
Frankfurt, Germany

Dawoud Bey (b. 1953)
399. Peg, Brooklyn, New York
Gelatin silver print, 1988
Courtesy of the artist and the Rhona Hoffman
Gallery, Chicago, Illinois

Dawoud Bey (b. 1953)
400. A Girl in a Deli Doorway
Gelatin silver print, 1988
Courtesy of the artist and the Rhona Hoffman
Gallery, Chicago, Illinois

(See page 280 for color plates by Dawoud Bey)

Dawoud Bey (b. 1953)
401. A Man at Fulton Street and Cambridge Place
Gelatin silver print, 1988
Courtesy of the artist and the Rhona Hoffman Gallery, Chicago, Illinois

Lou Jones (b. 1945)
402. *Portraits from Death Row* series: Mumia
Abu-Jamal, Huntingdon, Pennsylvania
Gelatin silver print, 1994
Courtesy of the photographer, Boston,
Massachusetts

Lou Jones (b. 1945)
403. *Portraits from Death Row* series:
Abdullah Bashir, Texas
Gelatin silver print, 1993
Courtesy of the photographer, Boston,
Massachusetts

Lou Jones (b. 1945)
404. *Portraits from Death Row* series:
Ed Kennedy, Storke, Florida
Gelatin silver print, 1992
Courtesy of the photographer, Boston,
Massachusetts

Lou Jones (b. 1945)
405. *Portraits from Death Row* series:
Daniel Webb, Somers, Connecticut
Gelatin silver print, 1994
Courtesy of the photographer, Boston,
Massachusetts

Coreen Simpson (b. 1942)
406. Jamien
Gelatin silver print, 1982
Courtesy of the photographer, New York, New York

Coreen Simpson (b. 1942)
407. Robert
Gelatin silver print, 1982
Courtesy of the photographer, New York, New York

Bill Gaskins (b. 1953)
408. Stylist's model, Philly vs. D.C. Hairstyling Competition, Philadelphia, Pennsylvania
Gelatin silver print, 1994
Courtesy of the photographer, Princeton, New Jersey

Reginald L. Jackson (b. 1945)
409. *Black Panther Party* series:
Panther Boys, New Haven, Connecticut
Color print, 1970
Courtesy of the photographer, Boston,
Massachusetts

Reginald L. Jackson (b. 1945)
410. *Black Panther Party* series: May Day, New Haven,
Connecticut
Color print, 1970
Courtesy of the photographer, Boston, Massachusetts

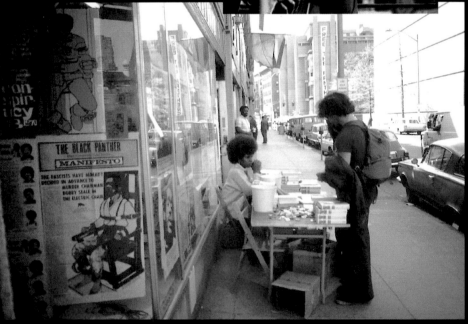

Reginald L. Jackson (b. 1945)
411. *Black Panther Party* series: "Kidnapped," New
Haven, Connecticut
Color print, 1970
Courtesy of the photographer, Boston,
Massachusetts

Reginald L. Jackson (b. 1945)
412. *Black Panther Party* series: Chapel Street, New Haven, Connecticut
Color print, 1970
Courtesy of the photographer, Boston, Massachusetts

Carroll Parrott Blue (b. 1943)

413. Kathleen Cleaver (b. 1945), civil rights activist, in San Francisco

C-print, ca. 1968

Courtesy of the photographer, San Diego, California

Carroll Parrott Blue (b. 1943)

414. Fannie Lou Hamer (1917–1977), civil rights activist, in Berkeley

C-print, ca. 1967

Courtesy of the photographer, San Diego, California

Carroll Parrott Blue (b. 1943)

415. Free Huey! Los Angeles Black Panther headquarters after shootout in December

C-print, 1969

Courtesy of the photographer, San Diego, California

Jeffrey Henson Scales (b. 1954)
416. Doorway, West 116th Street, 1993
C-Print
Courtesy of the photographer, New York, New York

Jeffrey Henson Scales (b. 1954)
417. Revival Tent, 117th Street and Lenox Avenue, 1993
C-print
Courtesy of the photographer, New York, New York

Susan J. Ross (b. 1952)
418. Pearl Primus (1919–1994), choreographer and dancer
C-print, 1990
Courtesy of the photographer, Atlanta, Georgia

Susan J. Ross (b. 1952)
419. Miles Davis (1926–1991) Runs the Voodoo Down
C-Print, 1989
Courtesy of the photographer, Atlanta, Georgia

Ronnie Phillips (active 1970s to present)
420. Untitled (two boys in doorway)
Gelatin silver print, hand-colored, 1993
Courtesy of the photographer, Atlanta, Georgia

Linda Day Clark (b. 1963)
421. North Avenue, image no. 85 (young Islamic girl)
Color print, 1994
Courtesy of the photographer, Baltimore, Maryland

Linda Day Clark (b. 1963)
422. North Avenue, image no. 24 (girl with Barbie doll)
Color print, 1993
Courtesy of the photographer, Baltimore, Maryland

Ming Smith Murray (active 1970s to present)
423. Nude Study (Thanksgiving Day)
Gelatin silver print, hand-colored, 1995
Courtesy of the photographer, Los Angeles, California

Ken D. Ashton (b. 1963)
424. Downtown Baltimore, Maryland
Color print, 1998
Courtesy of the photographer, Washington, D.C.

Ron Tarver (b. 1957)
425. South Philadelphia Barbecue
Color print, 1993
Courtesy of the photographer,
Philadelphia, Pennsylvania

Ron Tarver (b. 1957)
426. Rodeo Queen, Moskogee, Oklahoma
Color print, 1994
Courtesy of the photographer,
Philadelphia, Pennsylvania

Ron Tarver (b. 1957)
427. The Basketball Game, Philadelphia, Pennsylvania
Color print, 1993
Courtesy of the photographer, Philadelphia, Pennsylvania

Ron Tarver (b. 1957)
428. Legends, Philadelphia, Pennsylvania
Color print, 1993
Courtesy of the photographer, Philadelphia, Pennsylvania

Constance Newman (b. 1935)
429. The Largest Marketplace in Addis Abba
C-print, n.d.
Courtesy of the photographer, Washington, D.C.

Hank Sloane Thomas (b. 1976)
430. King of Promise Keepers
C-print, 1997
Courtesy of the photographer, New York, New York

Hank Sloane Thomas (b. 1976)
431. Million Woman March
C-print, n.d
Courtesy of the photographer, New York, New York

Suede (active 1990s to present)
432. Vocalist Lauryn Hill Onstage
Color print, 1998
Courtesy of the photographer, New York, New York

Suede (active 1990s to present)
433. Vocalist Erykah Badu in Concert
Color print, 1998
Courtesy of the photographer, New York, New York

Andre Lambertson (b. 1962)
434. A Young Life Lost
Color print, 1995
Courtesy of the photographer, Brooklyn, New York

Andre Lambertson (b. 1962)
435. Charm City, Baltimore, Maryland
Color print, 1995
Courtesy of the photographer, Brooklyn, New York

Andre Lambertson (b. 1962)
436. A Mother's Love
Color print, 1996
Courtesy of the photographer, Brooklyn, New York

Andre Lambertson (b. 1962)
437. A Young Life Lost
Color print, 1995
Courtesy of the photographer, Brooklyn, New York

Dawoud Bey (b. 1953)

438. Nikki and Manting

Polacolor ER prints, 1992

Courtesy of the David Beitzel Gallery, New York, New York

Dawoud Bey (b. 1953)

439. The James Twins

Polacolor ER prints, 1992

Courtesy of the Rhona Hoffman Gallery, Chicago, Illinois

Don Camp (b. 1940)

440. *Man Who Paints* series: Charles Burrell

Mixed media/photo monoprint, 1997

Courtesy of the photographer, Philadelphia, Pennsylvania

Don Camp (b. 1940)

441. *Man Who Writes* series: John Edgar Wideman (b. 1941)

Mixed media/photo monoprint, 1997

Courtesy of the photographer, Philadelphia, Pennsylvania

Don Camp (b. 1940)

442. *Man Who Hears Music* series: Douglass ("Jocko") Henderson

Mixed media/photo monoprint, 1997

Courtesy of the photographer, Philadelphia, Pennsylvania

John Pinderhughes (b. 1946)
443. Portrait series: Untitled (woman in chair)
Gelatin silver print, toned, 1997
Courtesy of the photographer, New York, New York

John Pinderhughes (b. 1946)
444. Portrait series: Untitled (profile in mirror)
Gelatin silver print, toned, 1997
Courtesy of the photographer, New York, New York

John Pinderhughes (b. 1946)
445. Portrait series: Untitled (reflection in mirror)
Gelatin silver print, toned, 1997
Courtesy of the photographer, New York, New York

John Pinderhughes (b. 1946)
446. Portrait series: Untitled (back)
Gelatin silver print, toned, 1997
Courtesy of the photographer, New York, New York

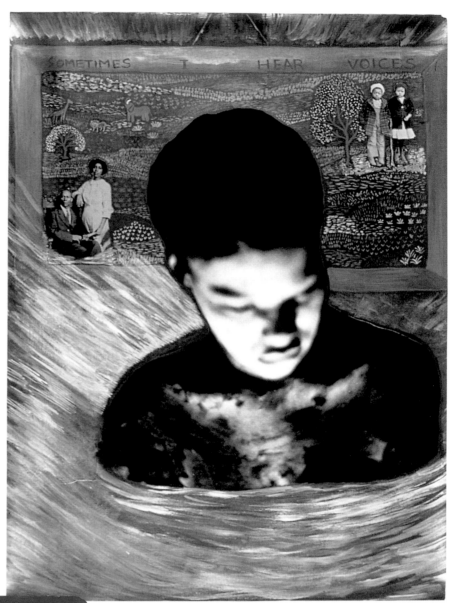

Lynn Marshall-Linnemeir (b. 1954)

447. Sometimes I Hear Voices

Gelatin silver print, hand-colored, 1992

Courtesy of the photographer, Atlanta, Georgia

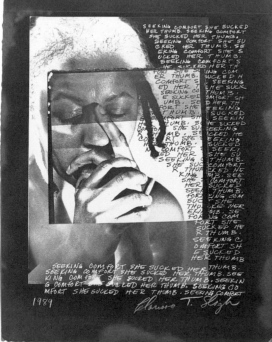

Clarissa Sligh (b. 1939)

448. Seeking Comfort I Suck My Thumb

Cyanotype, 1989

Courtesy of the photographer and the Corcoran Gallery of Art, Washington, D.C.

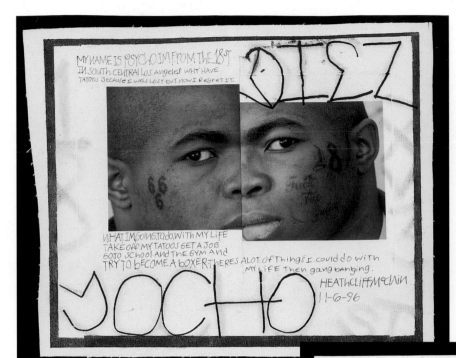

Dennis Olanzo Callwood (b. 1942)
449. *Signs/Signos: In Their Own Words* series:
Psycho from 18th Street
Manipulated gelatin silver print, 1996
Courtesy of the photographer, Los Angeles,
California

Dennis Olanzo Callwood (b. 1942)
450. *Signs/Signos: In Their Own Words* series:
Peckerwood Family
Manipulated gelatin silver print, 1994
Courtesy of the photographer, Los Angeles,
California

Dennis Olanzo Callwood (b. 1942)
451. *Signs/Signos: In Their Own Words* series: Mr. Wolfy
Manipulated gelatin silver print, 1994
Courtesy of the photographer, Los Angeles, California

Dennis Olanzo Callwood (b. 1942)

452. *Signs/Signos: In Their Own Words* series: In Memory of Jasmine
Manipulated gelatin silver print, 1994
Courtesy of the photographer, Los Angeles, California

Dennis Olanzo Callwood (b. 1942)

453. *Signs/Signos: In Their Own Words* series: Pac-Man
Manipulated gelatin silver print, 1993
Courtesy of the photographer, Los Angeles, California

Amalia Amaki (b. 1949)
454. Three Cheers for the Red, White & Blue, #8
Cyanotype on cotton, 1995
Courtesy of the photographer, Atlanta, Georgia

Amalia Amaki (b. 1949)
455. Three Cheers for the Red, White & Blue, #16
Cyanotype on cotton, 1995
Courtesy of the photographer, Atlanta, Georgia

Amalia Amaki (b. 1949)
456. Three Cheers for the Red, White & Blue, #15
Cyanotype on cotton, 1995
Courtesy of the photographer, Atlanta, Georgia

Pat Ward Williams (b. 1948)

457. Delia

Mural print and mixed media, 1992

Courtesy of the photographer and Peter and Eileen
Norton, Santa Monica, California

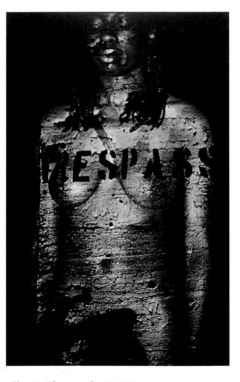

Albert Chong (b. 1958)

458. Untitled

C-print, 1998

Courtesy of the photographer, Boulder, Colorado

Albert Chong (b. 1958)

459. Trespass

Ilfochrome print, 1994

Courtesy of the photographer, Boulder, Colorado

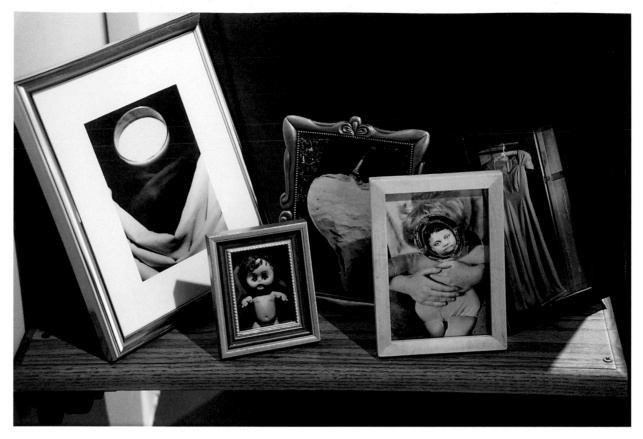

Camille Gustus
460. Towards the Mirror
C-print, 1998
Courtesy of the photographer, Baltimore, Maryland

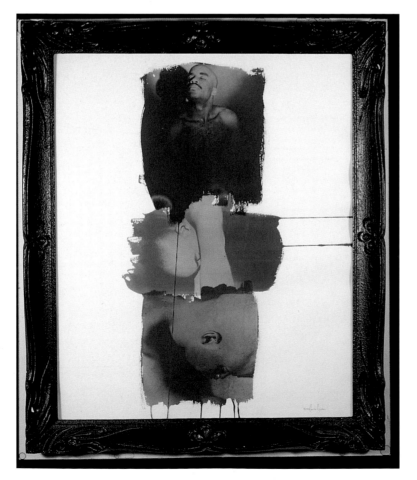

Camille Gustus
461. Trimeditate
VanDyke print, 1995
Courtesy of the photographer, Baltimore,
Maryland

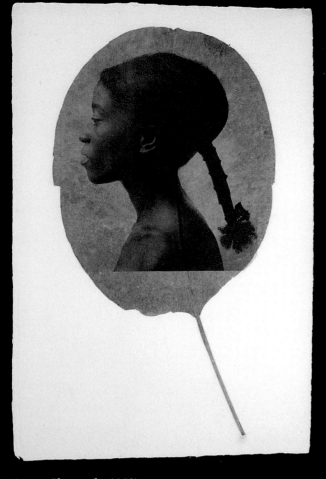

Accra Shepp (b. 1962)

462. Atlas

Silver gelatin emulsion on leaf, 1997

Courtesy of the photographer, Brooklyn, New York

Accra Shepp (b. 1962)

463. Dream of Open and Closed

Silver gelatin emulsion on leaf, 1997

Courtesy of the photographer, Brooklyn, New York

Accra Shepp (b. 1962)

464. I Am

Silver gelatin emulsion on leaf, 1993

Courtesy of the photographer, Brooklyn, New York

Nashormeh Lindo (b. 1953)
465. *Venetian Doors* series: Mysteries
Photo collage, 1998
Courtesy of the artist, Oakland, California

Nashormeh Lindo (b. 1953)
466. *Venetian Doors* series: Moor on the Door #2 (detail)
Photo collage, 1998
Courtesy of the artist, Oakland, California

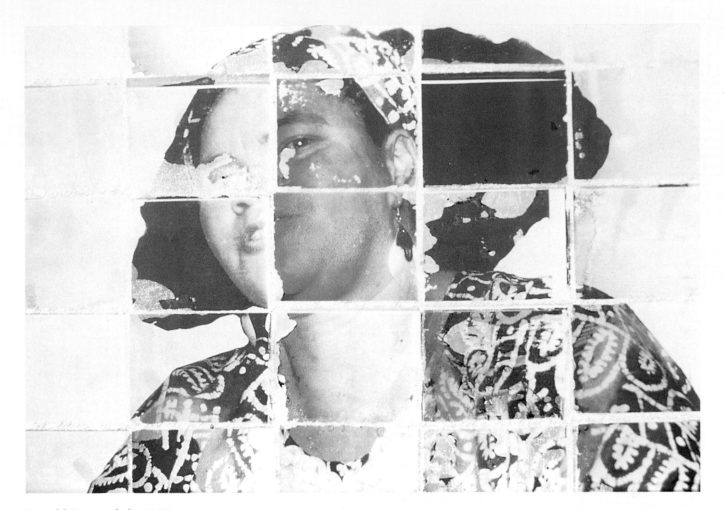

Donald Bernard (b. 1942)
467. Giftgiver
Polaroid transfer, 1997
Courtesy of the photographer, Chino Hills, California

Donald Bernard (b. 1942)
468. Earth Mother
Polaroid transfer, 1997
Courtesy of the photographer, Chino Hills, California

Harris Brothers (Thomas Allen, b. 1962;
Lyle Ashton, b. 1965)
469. *Alchemy* series: Firebird
DuraFlex print, 1998
Courtesy of Lyle Ashton Harris and Thomas Allen
Harris, Los Angeles, California

Harris Brothers (Thomas Allen,
b. 1962; Lyle Ashton, b. 1965)
470. *Alchemy* series: Mother
DuraFlex print, 1998
Courtesy of Lyle Ashton Harris and
Thomas Allen Harris, Los Angeles,
California

Harris Brothers (Thomas Allen, b. 1962; Lyle Ashton, b. 1965)
71. *Alchemy* series: Procession
DuraFlex print, 1998
Courtesy of Lyle Ashton Harris and Thomas Allen Harris, Los Angeles, California

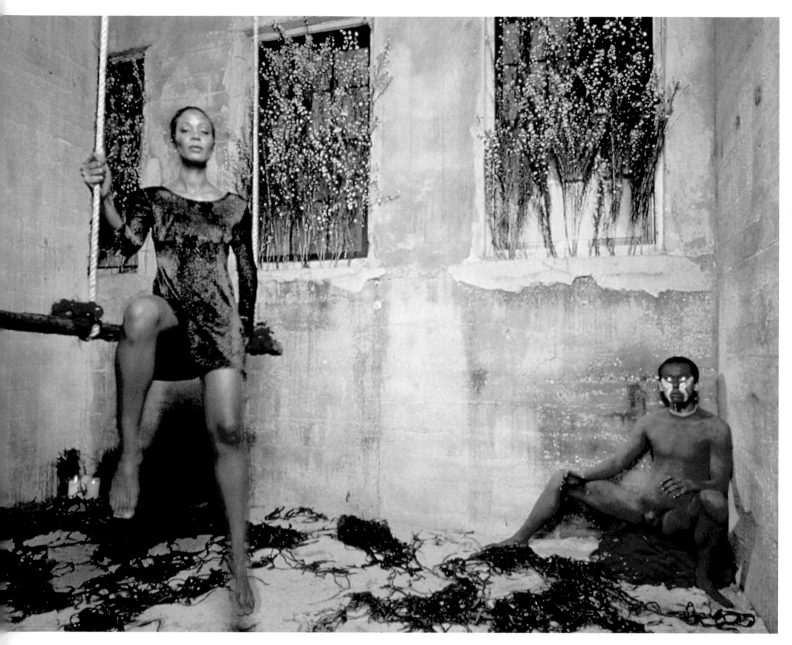

Harris Brothers (Thomas Allen, b. 1962; Lyle Ashton, b. 1965)
472. *Alchemy* series: Blue
DuraFlex print, 1998
Courtesy of Lyle Ashton Harris and Thomas Allen Harris, Los Angeles, California

Keba Konte (b. 1966)
473. Angel Boy
Photo montage on wood, 1997
Courtesy of the photographer, Oakland, California

Keba Konte (b. 1966)
474. Semion
Photo montage on wood, 1998
Courtesy of the photographer, Oakland, California

Shelia Turner (b. 1961)
475. An Invitation to Juke
Mixed media, 1996
Courtesy of the photographer, Atlanta, Georgia

Shelia Turner (b. 1961)
476. Untitled (man)
Mixed media, 1997
Courtesy of the photographer, Atlanta, Georgia

Anthony Beale (b. 1970)

477. The Irony of Acquiring Color triptych (detail)
Color print, 1995
Courtesy of the photographer, New York, New York

Linda L. Ammons (active 1980s to present)

478. Scenes from the Southwest
C-print, 1990
Courtesy of the photographer, University Heights, Ohio

David C. Driskell (b. 1931)
479. Boa Morte, Brazil
C-print, 1987
Courtesy of the photographer, Hyattsville, Maryland

David C. Driskell (b. 1931)
480. Window, Old City, Salvador, Bahia
C-print, 1983
Courtesy of the photographer, Hyattsville, Maryland

David C. Driskell (b. 1931)
481. Pelecypoda
C-print, 1997
Courtesy of the photographer, Hyattsville,
Maryland

Wendel A. White (b. 1956)
482. Trees with band
Pigment on paper, inkjet, 1995
Courtesy of the photographer, Abescon, New Jersey

Wendel A. White (b. 1956)
483. Trout and Trees
Pigment on paper, inkjet, 1995
Courtesy of the photographer, Abescon, New Jersey

Wendel A. White (b. 1956)
484. Starfish and Cube
Pigment on paper, inkjet, 1998
Courtesy of the photographer, Abescon, New Jersey

Wendel A. White (b. 1956)
485. Tigerfish Landscape
Pigment on paper, inkjet, 1995
Courtesy of the photographer, Abescon, New Jersey

Stephen Marc (b. 1954)
486. *Soul Searching* series: Untitled
Digital color print, 1995
Courtesy of the photographer, Tempe, Arizona

Carl Lewis (b. 1951)
487. Headroom
Laser-generated C-print, n.d.
Courtesy of the photographer, Dallas, Texas

Carl Lewis (b. 1951)
488. Torso Walking
Laser-generated C-print, n.d.
Courtesy of the photographer, Dallas, Texas

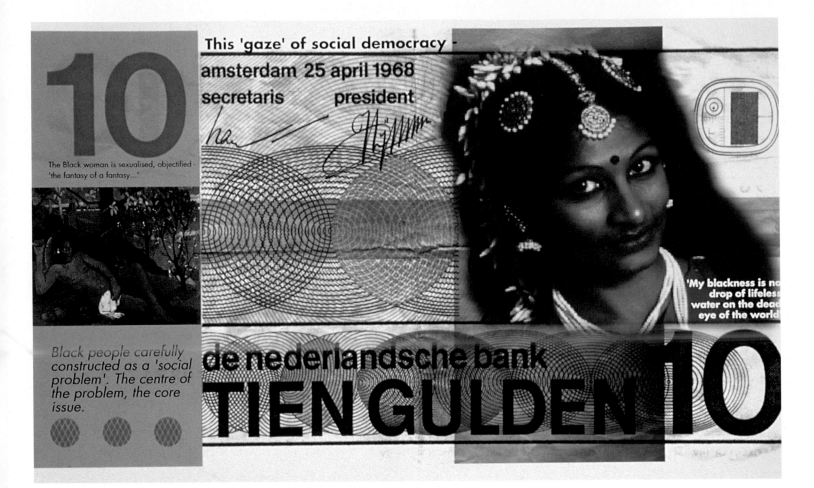

Roshini Kempadoo (b. 1959)

489. ECU: European Currency Unfolds

Digital montage print, 1992

Courtesy of the photographer, London, England

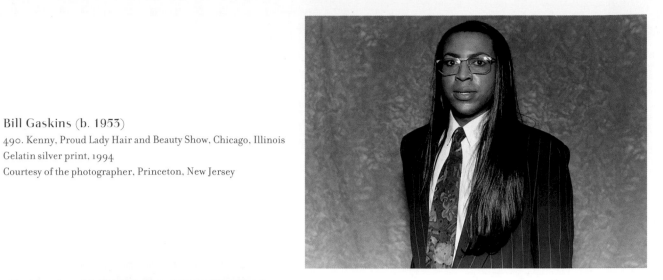

Bill Gaskins (b. 1953)
490. Kenny, Proud Lady Hair and Beauty Show, Chicago, Illinois
Gelatin silver print, 1994
Courtesy of the photographer, Princeton, New Jersey

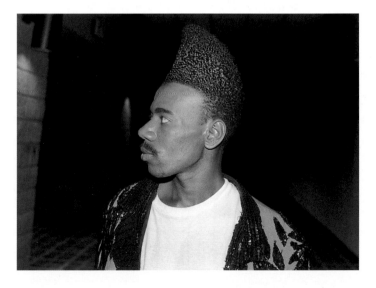

Bill Gaskins (b. 1953)
491. Nicole, Baltimore, Maryland
Gelatin silver print, 1993
Courtesy of the photographer, Princeton, New Jersey

Bill Gaskins (b. 1953)
492. Stanley, Brommer Brothers Beauty Show, Atlanta, Georgia
Gelatin silver print, 1991
Courtesy of the photographer, Princeton, New Jersey

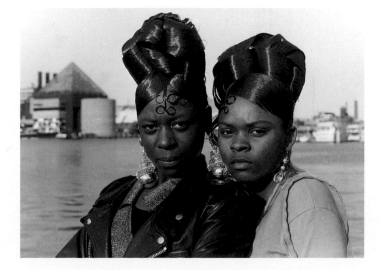

Bill Gaskins (b. 1953)
493. Tireka and Tamana, Easter Sunday, Baltimore, Maryland
Gelatin silver print, 1996
Courtesy of the photographer, Princeton, New Jersey

THE CONSTRUCTED IMAGE

Todd Gray (b. 1954)

494. When Is Now?

Gelatin silver print, charcoal, conte, 1987

Courtesy of the photographer, Los Angeles, California

Todd Gray (b. 1954)
495. History Repeating Itself
Gelatin silver print, charcoal, conte, 1987
Courtesy of the photographer, Los Angeles, California

Todd Gray (b. 1954)
496. Memory Sleeps
Gelatin silver print, 1987
Courtesy of the photographer, Los Angeles, California

Todd Gray (b. 1954)
497. Odysseus
Gelatin silver print, 1983
Courtesy of the photographer, Los Angeles, California

Todd Gray (b. 1954)
498. The Problem
Gelatin silver print, 1987
Courtesy of the photographer, Los Angeles, California

Darrel Ellis (1958–1992)

499. Untitled (mother from father's photograph)

Oil, ink gouache, and wax on paper on canvas, ca. 1990

Courtesy of the Estate of the Darrel Ellis and Art in General, New York, New York

Darrel Ellis (1958–1992)

500. Untitled (man with car on street)

Ink on paper, ca. 1982–1983

Courtesy of the Estate of Darrel Ellis and Art in General, New York, New York

Carlton Wilkinson (b. 1958)
501. Black Skin: Consciousness
Gelatin silver print, 1997
Courtesy of the photographer, Nashville,
Tennessee

Carlton Wilkinson (b. 1958)
502. Can I Fly?
Gelatin silver print, 1997
Courtesy of the photographer, Nashville, Tennessee

Carlton Wilkinson (b. 1958)
503. Reaching Out
Gelatin silver print, 1992
Courtesy of the photographer, Nashville, Tennessee

Carlton Wilkinson (b. 1958)
504. Holding the Fate of My Ancestors
Gelatin silver print, 1997
Courtesy of the photographer, Nashville,
Tennessee

Clarissa Sligh (b. 1939)
505. What's Happening with Momma?
Photo silkscreen with acrylic ink, 1988
Courtesy of the photographer, New York, New York

(See page 283 for color plate by Clarissa Sligh)

Clarissa Sligh (b. 1939)
506. Emmanuel Gillespie with daughter,
Sagai, Dallas, Texas
Gelatin silver print, 1995
Courtesy of the photographer, New York,
New York

Clarissa Sligh (b. 1939)
507. Raymond with Bible, Washington, D.C.
Gelatin silver print, 1999
Courtesy of the photographer, New York, New York

Clarissa Sligh (b. 1939)
508. John El Badr, Washington, D.C.
Gelatin silver print, 1999
Courtesy of the photographer, New York, New York

Pat Ward Williams (b. 1948)

509. I Think

Gelatin silver print, 1996

Courtesy of the photographer, North Long Beach, California

(See page 287 for color plate by Pat Ward Williams)

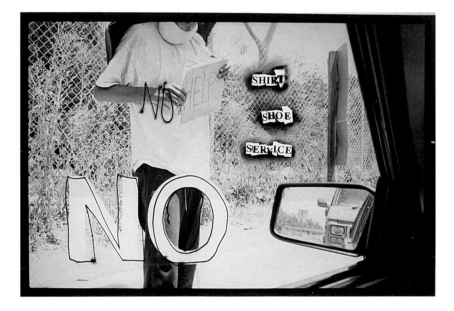

Pat Ward Williams (b. 1948)

510. No

Gelatin silver print, 1996

Courtesy of the photographer, North Long

Beach, California

Chris Johnson (b. 1948)
511–513. Untitled triptych
Gelatin silver prints with text, 1991
Courtesy of the photographer, Oakland, California

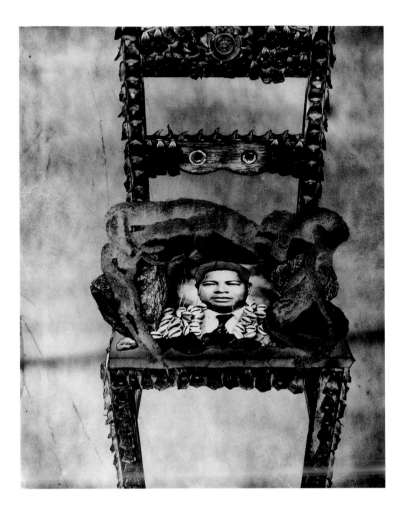

Albert Chong (b. 1958)
514. Throne for the Ancestors
Gelatin silver print, 1990
Courtesy of the photographer and the Museum of Art, Rhode
Island School of Design, Providence, Walter H. Kimball Fund

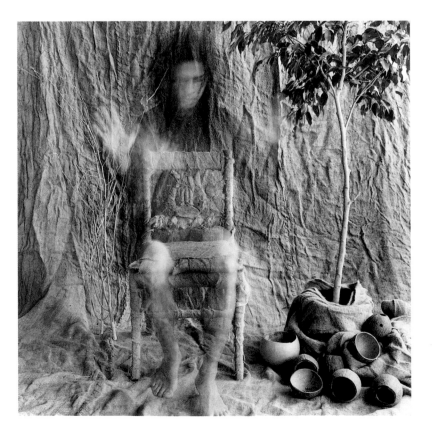

Albert Chong (b. 1958)
515. Natural Mystic, Heralding
Gelatin silver print, 1982
Courtesy of the photographer, Boulder, Colorado

310

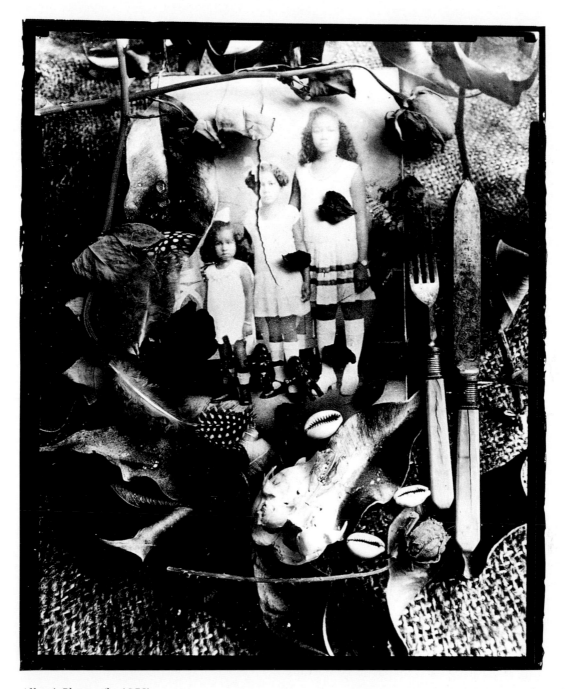

Albert Chong (b. 1958)
516. The Sisters
Gelatin silver print, 1986
Courtesy of the photographer, Boulder, Colorado

(See page 287 for color plates by Albert Chong)

IT WAS CLEAR, I WAS NOT MANET'S TYPE
PICASSO--WHO HAD A WAY WITH WOMEN--
ONLY USED ME & DUCHAMP NEVER
EVEN CONSIDERED ME

BUT IT COULD HAVE BEEN WORSE
IMAGINE MY FATE HAD
DE KOONING GOTTEN
HOLD OF ME

STANDING ON SHAKEY GROUND
I POSED MYSELF FOR CRITICAL STUDY
BUT WAS NO LONGER CERTAIN
OF THE QUESTIONS TO ASK

I KNEW, NOT FROM MEMORY,
BUT FROM HOPE, THAT THERE WERE OTHER
MODELS BY WHICH TO LIVE

I TOOK A TIP FROM FRIDA
WHO FROM HER BED PAINTED INCESSANTLY--BEAUTIFULLY
WHILE DIEGO SCALED THE SCAFFOLDS
TO THE TOP OF THE WORLD

Carrie Mae Weems (b. 1953)
517–521. *Not Manet's Type* series
Gelatin silver prints, 1997
Courtesy of the artist, New York, New York, and
P.P.O.W. Gallery, New York, New York

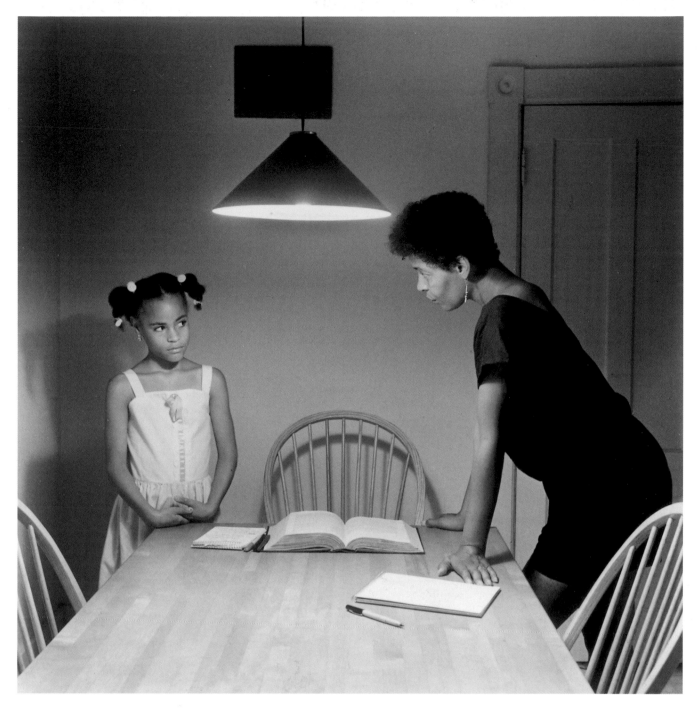

Carrie Mae Weems (b. 1953)

522. *Kitchen Table* series: Untitled (woman with daughter)
Gelatin silver print, 1991
Courtesy of the artist and P.P.O.W. Gallery, New York, New York

Carrie Mae Weems (b. 1953)

523. *Kitchen Table* series: Untitled (combing hair)
Gelatin silver print, 1991
Courtesy of the artist, New York, New York, and the
Saint Louis Art Museum, funds given by Mr. and
Mrs. John Peters MacCarthy

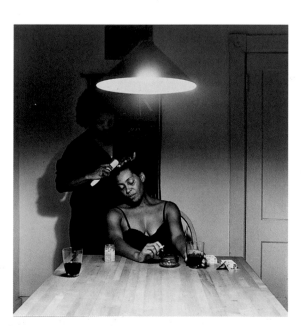

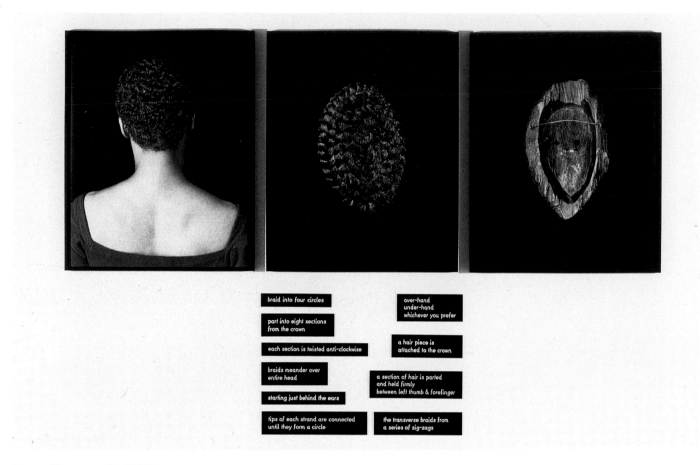

braid into four circles

part into eight sections
from the crown

each section is twisted anti-clockwise

braids meander over
entire head

starting just behind the ears

tips of each strand are connected
until they form a circle

over-hand
under-hand
whichever you prefer

a hair piece is
attached to the crown

a section of hair is parted
and held firmly
between left thumb & forefinger

the transverse braids from
a series of zig-zags

Lorna Simpson (b. 1960)
524. Coiffure
Gelatin silver print, 1991
Courtesy of the photographer, New York, New York, and the Corcoran Gallery of Art, Washington, D.C.

Lorna Simpson (b. 1960)
525. Partitions & Time
Gelatin silver print, 1991
Courtesy of the photographer, New York, New York, and the Williams College
Museum of Art, Williamstown, Massachusetts
93.3.9

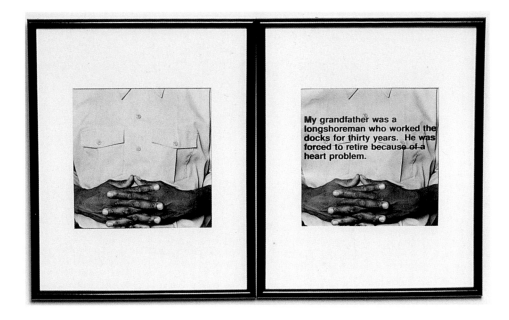

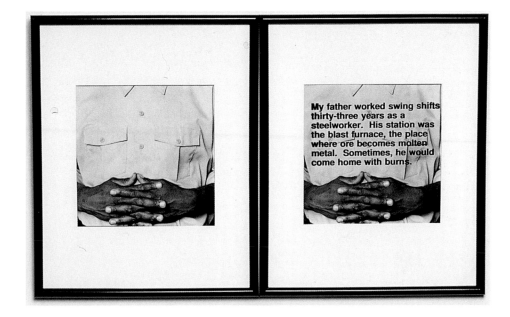

Cynthia Wiggins (active 1990s to present)
526–528. Idle Hands triptych
Gelatin silver prints, wood frames, 1995
Courtesy of the photographer, New York, New York

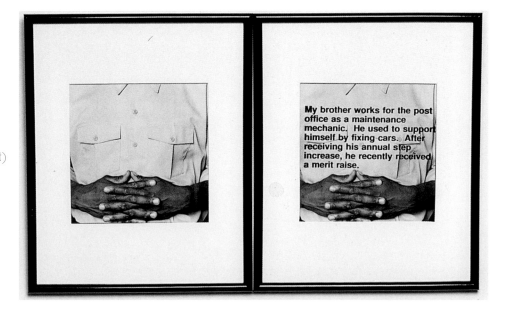

Renée Cox (b. 1958)
529. Hott-en-tot
Gelatin silver print, 1996
Courtesy of the photographer, New York, New York

Renée Cox (b. 1958)
530. *Yo Mama* series: The Sequel
Gelatin silver print, 1995
Courtesy of the photographer, New York, New York

Renée Cox (b. 1958)
531. Eve
Gelatin silver print, 1994
Courtesy of the photographer, New York, New York

Terry E. Boddie (b. 1965)
532. Expatriate
Gelatin silver, ink, burlap, 1997
Courtesy of the photographer, New York, New York

Terry E. Boddie (b. 1965)
533. Separation
Gelatin silver, ink, burlap, 1997
Courtesy of the photographer, New York, New York

Terry E. Boddie (b. 1965)
534. The Return
Gelatin silver, ink, burlap, 1997
Courtesy of the photographer, New York, New York

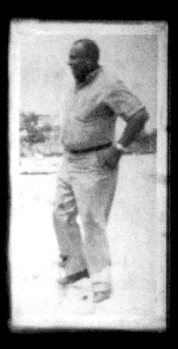

Christian Walker (b. 1954)
535. From *Bargaining with the Dead* series
Manipulated gelatin silver prints, 1986
Courtesy of the photographer

Christian Walker (b. 1954)
536. Evidence of Things Not Seen
Manipulated gelatin silver print, 1986
Courtesy of the photographer

LANDSCAPE

John Pinderhughes (b. 1946)

537. *Landscape* series: Untitled (clouds)
Gelatin silver print, 1998
Courtesy of the photographer, New York, New York

(See page 282 for color plates by John Pinderhughes)

John Pinderhughes (b. 1946)

538. Untitled (window)

Gelatin silver print, 1998

Courtesy of the photographer, New York, New York

John Pinderhughes (b. 1946)

539. *Landscape* series: Untitled (beach stones)

Gelatin silver print, 1998

Courtesy of the photographer, New York, New York

William Earle Williams (b. 1950)

540. Canaan Baptist Church, Tennessee Highway 87W near Fort Pillow. Grave sites of five generations of Bates family; site of Major Bates, a private who served in United States Colored Troops Regiment.
Gelatin silver print, 1995
Courtesy of the photographer, Haverford, Pennsylvania

William Earle Williams (b. 1950)

541. Fort Neagley, Nashville, Tennessee. This fort was built by blacks and later defended by black soldiers during the battle of Nashville.
Gelatin silver print, 1995
Courtesy of the photographer, Haverford, Pennsylvania

William Earle Williams (b. 1950)

542. Jamestown Island, Virginia. Site where African people first landed in Jamestown; later this site became a Civil War fort built by enslaved Africans for the Confederacy.
Gelatin silver print, 1996
Courtesy of the photographer, Haverford, Pennsylvania

William Earle Williams (b. 1950)

543. 8th Pennsylvania Cavalry Monument, Gettysburg National Military Park, Pennsylvania
Gelatin silver print, 1986
Courtesy of the photographer, Haverford, Pennsylvania

Calvin Hicks (active 1970s to present)
544. Synthesis
Gelatin silver print, 1976
Courtesy of the photographer, Los Angeles, California

Calvin Hicks (active 1970s to present)
545. Nude Form
Gelatin silver print, 1985
Courtesy of the photographer, Los Angeles, California

John Brown (b. 1957)

546. *Nature* series: Untitled (flowers)

Gelatin silver print, 1995

Courtesy of the artist and Hemphill Fine Arts, Washington, D.C.

John Brown (b. 1957)

547. *Nature* series: Untitled (clouds)

Gelatin silver print, 1995

Courtesy of the artist and Hemphill Fine Arts,
Washington, D.C.

John Brown (b. 1957)

548. *Nature* series: Untitled (blades of grass)

Gelatin silver print, 1995

Courtesy of the artist and Hemphill Fine Arts, Washington, D.C.

John Brown (b. 1957)

549. *Nature* series: Untitled (reflection in water)

Gelatin silver print, 1995

Courtesy of the artist and Hemphill Fine Arts,
Washington, D.C.

George Durr (active 1980s to present)
550. Some Hi-Way, Arizona
Gelatin silver print, n.d.
Courtesy of the photographer, Santa Monica, California

George Durr (active 1980s to present)
551. Rock in Merced
Gelatin silver print, n.d.
Courtesy of the photographer, Santa Monica, California

Jeffrey John Fearing (b. 1949)
552. Snow, Rock Creek Park, Washington, D.C.
Gelatin silver print, 1989
Courtesy of the photographer, Laurel, Maryland

Jeffrey John Fearing (b. 1949)
553. Untitled, Big Sur, California
Gelatin silver print, 1984
Courtesy of the photographer, Laurel, Maryland

Jeffrey John Fearing (b. 1949)
554. Million Man March, Washington, D.C.
Gelatin silver print, 1995
Courtesy of the photographer, Laurel,
Maryland

Lewis Watts (b. 1946)

555. Fresh Killed Poultry, West Oakland

Gelatin silver print, 1993

Courtesy of the photographer, San Anselmo, California

Lewis Watts (b. 1946)

556. Beale Street, Memphis

Gelatin silver print, 1994

Courtesy of the photographer, San Anselmo, California

Lewis Watts (b. 1946)

557. Downtown, Oakland, California

Gelatin silver print, 1997

Courtesy of the photographer, San Anselmo, California

Lewis Watts (b. 1946)

558. John's Island, South Carolina

Gelatin silver print, 1995

Courtesy of the photographer, San Anselmo, California

Digital Imagery

Stephen Marc (b. 1954)

559. *Soul Searching* series: Untitled

Digital montage print on gelatin silver paper, 1995

Courtesy of the photographer, Tempe, Arizona

Stephen Marc (b. 1954)
560. *Soul Searching* series: Untitled
Digital montage print on gelatin silver paper, 1997
Courtesy of the photographer, Tempe, Arizona

Stephen Marc (b. 1954)
561. *Soul Searching* series: Untitled
Digital montage print on gelatin silver paper, 1995 (See page 299 for color plate by Stephen Marc)
Courtesy of the photographer, Tempe, Arizona

Stephen Marc (b. 1954)
562. *Soul Searching* series: Untitled
Digital montage print on silver gelatin paper, 1995
Courtesy of the photographer, Tempe, Arizona

Roshini Kempadoo (b. 1959)
563. Untitled
Digital montage print, n.d.
Courtesy of the photographer, London, England

(See page 300 for color plate by Roshini Kempadoo)

Roshini Kempadoo (b. 1959)
564. Colonised #3
Digital montage print, 1993
Courtesy of the photographer, London, England

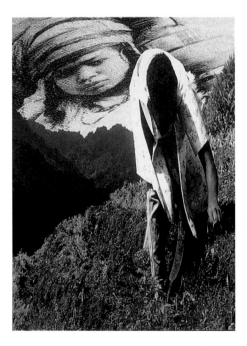

Roshini Kempadoo (b. 1959)
565. Colonised #2
Digital montage print, 1993
Courtesy of the photographer, London, England

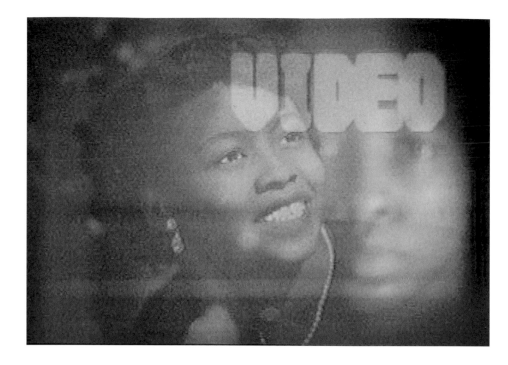

Stephanie Dinkins (b. 1964)
566. Spittin' Image
Video still, 1997
Courtesy of the photographer, Staten Island,
New York

Stephanie Dinkins (b. 1964)
567. Run (2nd view)
Video still, 1997
Courtesy of the photographer, Staten Island,
New York

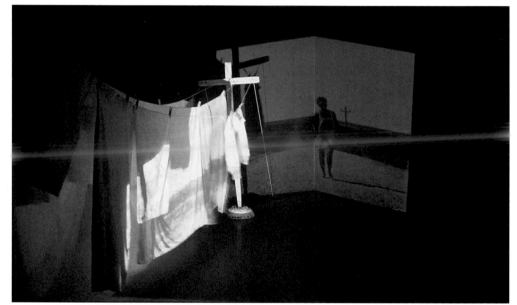

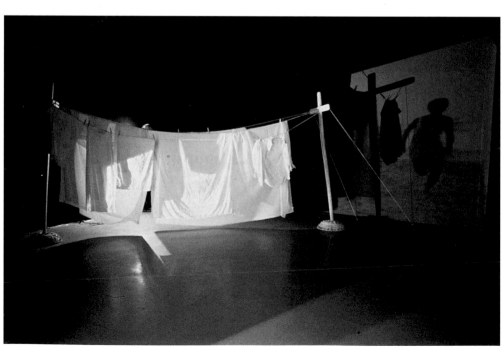

Stephanie Dinkins (b. 1964)
568. Run (1st view)
Video still, 1997
Courtesy of the photographer, Staten Island,
New York

Notes

INTRODUCTION

1. E. Barry Gaither, "Imagining Identity and African American Art, or It's Me You See!" in *Convergence: 8 Photographers*, Anita Douthat, ed. (Boston: Photographic Resource Center, 1990), p. 10.

2. Margaret Denton Smith and Mary Louise Tucker, *Photography in New Orleans: The Early Years, 1840–1865* (Baton Rouge: Louisiana State University Press, 1982), p. 19.

3. The French inventor Joseph Nicephore Niepce (1765–1833) had produced the earliest extant photographic image, made by a camera obscura, in 1827.

4. Michel Frizot, ed., *A New History of Photography* (Cologne: Konemann, 1998), p. 23.

5. William Welling, *Photography in America: The Formative Years 1839–1900* (New York: Thomas Y. Crowell, 1978), p. 17.

6. Frederick Douglass, "A Tribute to the Negro," *The North Star*, April 7, 1849.

7. Douglas H. Daniels, *Pioneer Urbanites: A Social and Cultural History of Black San Francisco* (Philadelphia: Temple University Press, 1980), p. 9.

1. THE FIRST SIXTY YEARS: 1840–1900

1. *New Orleans Bee*, advertisement, March 14, 1840.

2. Ibid.

3. Patricia Brady, "A Mixed Palette: Free Artists of Color of Antebellum New Orleans," *The International Review of African American Art* 12, no. 3 (1995): 9.

4. John Wood, "Southern Shadows Reflections of a Bygone Era," in *The Daguerreian Annual 1996*, p. 106.

5. *Ball's Splendid Mammoth Pictorial Tour of the United States Comprising Views of the African Slave Trade; of Northern and Southern Cities; of Cotton and Sugar Plantations; of the Mississippi, Ohio and Susquehanna Rivers, Niagara Falls, & C.* (Cincinnati: Achilles Pugh, Printer, 1855), p. 7.

6. Ibid., p. 7.

7. Ibid., p. 39.

8. David C. Driskell, *Two Centuries of Black American Art* (Los Angeles: Los Angeles County Museum of Art, 1976), p. 39.

9. Floyd Rinhart and Marion Rinhart, *The American Daguerreotype* (Athens: University of Georgia Press, 1981), p. 40.

10. *Frederick Douglass' Paper*, April 28, 1854.

11. "Daguerrean Gallery of the West," *Gleason's Pictorial Drawing-Room Companion*, April 1, 1854, p. 208.

12. George W. Williams, *History of the Negro Race in America from 1619 to 1880: Negroes as Slaves, as Soldiers and as Citizens* (New York: G. P. Putnam's Sons, 1883), p. 141.

13. *St. Paul Western Appeal*, March 19, 1887.

333

14. *The Colored Citizen* published articles about African-Americans in the Northwest, including highly charged editorials about the plight of blacks who lived in the city of Helena.

15. William L. Lang, "Helena, Montana's Black Community, 1900–1912," in *African Americans on the Western Frontier* eds. Monroe Lee Billington and Rodger D. Hardaway (Niwot: University Press of Colorado, 1998), p. 198.

16. David O. White, "Augustus Washington, Black Daguerreotypist of Hartford," *The Connecticut Historical Society* 39 (January 1974): 14–19.

17. Carol Johnson, "Faces of Freedom: Portraits from the American Colonization Society Collection," in *The Daguerrean Annual 1996*, p. 269.

18. Martin R. Delaney, *The Condition, Elevation, Emigration and Destiny of the Colored People of the United States* (Philadelphia: 1852), p. 126.

19. Johnson, p. 269.

20. *Frederick Douglass' Paper*, May 18, 1855.

21. Johnson, p. 270.

22. Ibid., p. 272.

23. The ambrotype process used a collodion wet plate: Prior to exposure, a sheet of glass was coated with nitrocellulose dissolved in ether and alcohol, sensitized with potassium iodide and silver nitrate; this plate was then exposed and developed before the emulsion dried. The glass was based with black velvet or paper or lacquered in black, causing it to appear positive.

24. Stereoscopic photographs were taken either with a camera with two lenses side by side, separated by two and a half inches, or with a single-lens camera that took first one picture, then was moved slightly to one side for a second exposure. Most such photographs were ethnographic portraits or depicted genre scenes, events, and places. When utilizing the stereoscopic viewing glasses, the viewer saw an image that appeared to be three-dimensional.

25. In the years prior to the Civil War, the Underground Railroad was primarily run, maintained, and funded by African-Americans. Black working-class men and women collected the bulk of the money, food, and clothing and provided the shelter and transportation for the fugitives.

26. John V. Jezierski, "The Goodridge Brothers: Saginaw's Pioneer Photographers," The Saginaw Art Museum exhibition catalog (January 1982), p. 4.

27. *St. Paul Appeal*, July 13, 1889.

28. Ibid.

29. Bonnie G. Wilson, "Working the Light: Nineteenth-Century Professional Photographers in Minnesota," *Minnesota History, the Quarterly of the Minnesota Historical Society* 52, no. 2 (Summer 1990): 58.

30. "Harry Shepherd," *Afro American Advance*, March 3, 1900.

31. Wilson, p. 58.

32. The Niagara Movement, organized in 1905, was the first important organized black protest movement in the twentieth century.

33. Quoted in Harriet McLeod, "Everyone Knew the Browns," *Richmond News Leader*, February 7, 1985.

34. Andrew J. Cosentino and Henry H. Glassie, *The Capital Image: Painters in Washington, 1800–1915* (Washington, D.C.: Smithsonian Institution Press, 1983), p. 172.

35. Hilyer, Andrew F., *The Twentieth Century Union League Directory: A Historical, Biographical and Statistical Study of Colored Washington, at the Dawn of the Twentieth Century and After a Generation of Freedom* (Washington, D.C.: self-published, January 1901).

36. According to historian Louise Daniel Hutchinson, Frelinghuysen University operated in the early years as a galaxy of satellite "home schools" with educational centers at several locations and maintained an effort to carry an interdisciplinary program to the "unreached." It offered adult education evening classes in academic, religious, and trade programs. See Louise Daniel Hutchinson, *Anna J. Cooper: A Voice from the South* (Washington, D.C.: Smithsonian Institution Press, 1981), p. 169.

37. Hutchinson, pp. 50, 160.

38. Colin L. Westerbeck, "Frederick Douglass Chooses His Moment," Art Institute of Chicago, *Museum News* 24:2 (1999), p. 154.

2. THE NEW NEGRO IMAGE: 1900–1940

1. Cary D. Wintz, *Black Culture and the Harlem Renaissance* (Houston: Rice University Press, 1988), p. 31.

2. Ibid.

3. Henry Louis Gates, Jr., "The Face and Voice of Blackness," in Guy C. McElroy, *Facing History: The Black Image in American Art 1710–1940* (San Francisco: Bedford Arts, Publishers, in association with the Corcoran Gallery of Art, 1990), p. xxxiii.

4. Ibid., p.xxxix.

5. Cheryl A. Wall, *Women of the Harlem Renaissance* (Bloomington: Indiana University Press, 1995), p. 2.

6. Henry Louis Gates, Jr., "New Negroes, Migration and Cultural Exchange," in ed. Elizabeth Hutton Turner, *Jacob Lawrence: The Migration Series* (Washington, D.C.: Rappahannock Press, in association with The Phillips Collection, 1993), p. 19.

7. Wall, p. 2.

8. Jan Nederveen Pieterse, *White on Black: Images of Africa and Blacks in Western Popular Culture* (New Haven: Yale University Press), 1992, p. 190.

9. bell hooks, "In Our Glory: Photography and Black Life," in *Picturing Us: African American Identity in Photography*, ed. Deborah Willis (New York: The New Press, 1994), p. 48.

10. Elizabeth Brayer, *George Eastman: A Biography* (Baltimore: Johns Hopkins University Press, 1996), p. 275.

11. *Opportunity*, May 1927, p. 126.

12. *Crisis*, May 1917, p. 32.

13. Girard P. Mouton III and Alma D. Williams, "The Eyes of Jazz," *The Jazz Archivist* 6, no. 1 (May 1991): 8.

14. Valencia Collins Coar, *A Century of Black Photographers: 1840–1960* (Providence: Museum of Art, Rhode Island School of Design, 1983), p. 181,

15. Mouton and Williams, p. 10.

16. Marc H. Miller, *Louis Armstrong: A Cultural Legacy* (Seattle: University of Washington Press and Queens Museum of Art, New York, 1994), p. 6.

17. Quoted in ibid., p. 6.

18. Edith M. Lloyd, "This Negro Butler Has Become a Famous Photographer," *American Magazine*, May 1925, pp. 54–56.

19. Alain Locke to the Harmon Foundation, 1928, letter of recommendation for King Daniel Ganaway, candidate for a William E. Harmon Award. Harmon Foundation Papers, Library of Congress, Manuscript Division, Washington, D.C.

20. Jane Freundel Levey, "The Scurlock Studio," in *Visual Journal: Harlem and D.C. in the Thirties and Forties*, eds. Deborah Willis and Jane Lusaka (Washington, D.C: Smithsonian Institution Press, 1996), p. 150.

21. Ibid., p. 154.

22. Edward P. Jones, "A Sunday Portrait" in *Picturing Us*, p. 36.

23. *Negro Artists: An Illustrated Review of Their Achievements* (New York: Harmon Foundation, 1935).

24. Langston Hughes to the Harmon Foundation, 1928, letter of recommendation for James L. Allen, candidate for a William E. Harmon Award. Harmon Foundation Papers, Library of Congress, Manuscript Division, Washington, D.C.

25. Quoted in Arthé Anthony, "Reading Visual Autobiographies: Reconstructing Women's Lives in a Creole of Color Community in New Orleans, 1900–1930, excerpt from the manuscript of a forthcoming, as-yet-untitled book on the photographer, p. 10.

26. Ibid., p. 11.

27. Meredith K. Soles, "Mementos, Documents and Signs: the Portrait Photographs of P. H. Polk, in eds. Janet Gardner Broske, Carole Marks, Meredith K. Soles, *Through These Eyes: The Photographs of P. H. Polk* (Newark: University Gallery, University of Delaware, 1998), p. 26.

28. Amalia K. Amaki, "To Make A Picture," in ibid., p. 21.

29. Richard S. Roberts's business card, in the Wilhemina Roberts Wynn Collection, New York, New York.

30. "Richard Aloysius Twine: Photographer of Lincolnville, 1922–1927," *The East-Florida Gazette*, vol. 12, no. 4, published by the St. Augustine Historical Society, February 1990, p.6.

31. Herman "Skip" Mason, Jr., *Hidden Treasures: African American Photographers in Atlanta, 1870–1970* (Atlanta: African-American Family History Association, Inc., 1991), unpaginated.

32. Ibid.

33. Ibid.

34. Blacks were being segregated and subjected to Jim Crow laws in the American South, images of them circulated widely by means of advertising. . . . Black men were desexualized while black women were both eroticized and desexualized. The primary condition for the commercial representation of black men is that they be shown as nonthreatening, in clearly recognizable, usually marginal positions. See Jan Nederveen Pieterse, *White on Black: Images of Africa and Blacks in Western Popular Culture* (New Haven: Yale University Press, 1992), p. 188.

35. Camara Dia Holloway, *Portraiture and the Harlem Renaissance: The Photographs of James L. Allen* (New Haven: Yale University Art Gallery, 1999), p. 35.

3. 1930s AND 1940s PHOTOGRAPHY

1. John J. Grabowski, *Somebody, Somewhere, Wants Your Photograph: A Selection from the Work of Allen E. Cole (1893–1970): Photographer of Cleveland's Black Community* (Cleveland: Western Reserve Historical Society, 1980), p. 7.

2. Samuel Black, *Yet Still We Rise: African American Art in Cleveland* (Cleveland: Cleveland Artists Foundation, 1996), p. 12.

3. Melissa Rachleff, "Photojournalism in Harlem: Morgan and Marvin Smith and the Construction of Power, 1934–1943," in *Visual Journal: Harlem and D.C. in the Thirties and Forties*, eds. Deborah Willis and Jane Lusaka (Washington, D.C.: Smithsonian Institution Press, 1996), p. 18.

4. James A. Miller, ed., *Harlem: The Vision of Morgan & Marvin Smith* (Lexington: University Press of Kentucky, 1998), p. 8.

5. Celeste Tibbets, *Ernestine Rose and the Origins of the Schomburg Center*, Schomburg Center Occasional Papers Series, no. 2 (New York: New York Public Library, 1989), p. 21.

6. Jane Lusaka, "Seeking a Cultural Equality: The Visual Record of Robert H. McNeill," in *Visual Journal*, p. 67.

7. Nicholas Natanson, "Robert H. McNeill and the Profusion of Virginia Experience," in ibid., p. ld.

8. Ibid., p. 100.

9. Martin H. Bush, *The Photographs of Gordon Parks* (Wichita, Kansas: Ulrich Museum of Art, Wichita State University, 1983), p. 38.

4. SOCIAL AND ARTISTIC MOVEMENTS: 1950–1979

1. E. Barry Gaither, "Social Art," *The International Review of African American Art* 15 no. 1 (1998): 61.

2. Robert Sengstacke, artist's statement, in Deborah Willis-Thomas, *An Illustrated BioBibliography of Black Photographers: 1940–1988* (New York: Garland Publishing, 1989), p. 125.

3. Ibid., p. 131.

4. Interview with the photographer, Spring 1989, Philadelphia, Pennsylvania.

5. Jack Salzman et al., eds., *Encyclopedia of African-American Culture and History*, vol. 3 (New York: Macmillan, 1996), p. 1754.

6. Willis-Thomas, p. 159.

5. PHOTOGRAPHY IN THE 1980S AND 1990S

1. Richard Bolton, ed., *The Contest of Meaning: Critical Histories of Photography* (Cambridge: MIT Press, 1990), p. xii.

2. Artist's statement, unpublished.

3. Willis-Thomas, p. 146.

4. John Lawrence, "Raising Cane: 200 Years of Louisiana Sugar Production: An Exhibition," *The Historical New Orleans Collection Quarterly* XIII, no. 4 (Fall 1995): 7.

5. Artist's statement, unpublished and undated.

6. *Memory and Loss* (catalog) (New York: Mary Anthony Galleries, September 1998), p. 12.

7. Charles Martin, ed., *Charles Martin: Home & Away: Conversation on the African Diaspora* (New York: Queens College, October 1987), p. 10.

8. Unpublished artist's statement, 1998.

9. Lisa Henry, "Gerald Cyrus," *Contact Sheet 88* (Syracuse, N.Y.: Light Work, 1996), p. 1.

10. Artist's statement, unpublished and undated.

11. Cheryl Dixon, "Bobtown: The Legacy of Robert Celestin," undated pamphlet in the Collection of the Black Gallery of California.

12. Artist's statement, unpublished and undated.

13. Artist statement, unpublished and undated.

14. Artist's statement, unpublished, 1988.

15. Quincy Troupe, "In the Eyes, Memory Lies," in Albert Chong, *Ancestral Dialogues: The Photographs of Albert Chong*. (San Francisco: The Friends of Photography, 1994), p.1.

16. Ibid., p. 15.

17. Andy Grundberg, afterword, in Deborah Willis, *Untitled 54 Lorna Simpson* (San Francisco: The Friends of Photography, 1992), p. 61.

18. Deborah Willis, ed., *Constructed Images: New Photography* (New York: Schomburg Center for Research in Black Culture, New York Public Library, 1989), p.23.

19. Artist's statement, unpublished, 1992.

20. Andrea Kirsch and Susan Fisher Sterling, *Carrie Mae Weems*, (Washington, D.C.: National Museum of Women in the Arts, 1993), pp. 11–12.

21. Artist's statement, unpublished 1988.

22. Jeffrey Hoone, "Accra Shepp," *Contact Sheet 68*, (Syracuse, New York: LightWork 1990.) p. 2.

23. Charles Biasny-Rivera, ed., "Dennis Callwood," *Nueva Luz: a Photographic Journal*, vol. 5, no. 3, p.2.

24. Artist's statement, unpublished.

25. Artist's statement, unpublished.

26. Ibid.

27. Ibid.

28. Holly Block, ed., in *Darrel Ellis*, (New York: Art in General, 1996), p.6.

29. Artists' statement, unpublished, 1998.

30. Artist's statement, unpublished.

31. "Singular Technique Makes Lasting Image," *Hills Publications*, April 2, 1998, p. 17.

32. Artist's statement, unpublished, 1998.

33. "Beuford Smith: In the Humane Tradition," *Ten8*, quarterly photographic magazine no. 24, *Evidence: New Light on Afro-American Images*, p. 14.

34. "Dust-Shaped Hearts: Photography of African-American Men by Don Camp," exhibition brochure, Museum of Art, University of Michigan at Ann Arbor, January 10–April 19, 1998.

35. Ibid.

36. Kellie Jones, *Dawoud Bey: Portraits 1975–1995* (Minneapolis: Walker Art Center, 1995), p. 106.

37. Artist's statement, unpublished, 1987.

38. Kellie Jones, "A Contemporary Portfolio," *exposure* 27, no. 4 (Fall 1990): 28.

39. Nikky Finney, "To Be Beheld," in Bill Gaskins, *Good Hair, Bad Hair* (New Brunswick, New Jersey: Rutgers University Press, 1997), p. 4.

40. "Bill Gaskins," *Contact Sheet 78* (Syracuse, New York: LightWork), p. 2.

41. Lou Jones, *Final Exposure: Portraits from Death Row* (Boston: Northeastern University Press, 1997).

42. Jean Lawlor Cohen, "Where Washington," *Art & Antiques*, July 1998, p. 32.

43. *Visual Griots: Four African-American Photographers* Tom Beck and Cynthia Wayne, eds., (exhibition catalog, Albin O. Kuhn Library and Gallery, University of Maryland, 1996), p. 18.

44. "Lewis Watts," exhibition brochure, Vision North Gallery, San Francisco, California, 1994.

45. Artist's statement, unpublished, 1998.

46. Artist's statement, unpublished, 1997.

BIBLIOGRAPHY

Adams, John Henry, Jr. "Rough Sketches: The New Negro Man." *Voice of the Negro*, October 1904, pp. 447–452.

———. "Rough Sketches: A Study of the Features of the New Negro Woman." *Voice of the Negro*, August 1904, pp. 323–326.

Adjaye, Joseph K., and Adrianne R. Andrews, eds. *Language, Rhythm and Sound: Black Popular Cultures into the Twenty-First Century*. Pittsburgh: University of Pittsburgh Press, 1997.

Andrews, Bert. *In the Shadow of the Great White Way*. New York: Thunder's Mouth Press, 1989.

Avi-Ram, Amitai F., "The Unreadable Black Body: 'Conventional' Poetic Form in the Harlem Renaissance." *Genders* 7 (Spring 1990): 32–46.

Bailey, David A. and Stuart Hall, eds., vol. 2, no. 3 (Spring 1992): "Critical Decade: Black British Photography in the 80's."

Baker, Jean Claude, and Chris Chase. *Josephine: The Hungry Heart*. New York: Random House, 1993.

Banta, Melissa, and Curtis M. Hinsley. *From Site to Sight: Anthropology, Photography, and the Power of Imagery*. Cambridge: Peabody Museum Press, 1986.

Bearden, Romare, and Harry Henderson. *A History of African-American Artists*. New York: Pantheon, 1993.

Beloff, Halla. *Camera Culture*. Oxford, England: Basil Blackwell, 1985.

Billeter, Erika. *Self-Portrait in the Age of Photography: Photographers Reflecting Their Own Image*. Lousanne, Switzerland: Musée Cantanal des Beaux-Arts, 1985.

Black Samuel. *Yet Still We Rise: African American Art in Cleveland*. Cleveland: Cleveland Artists Foundation, 1996.

Blockson, Charles L. *The Journey of John W. Mosley*. Philadelphia: Quantum Leap Publishing, 1992.

Bogle, Donald. *Toms, Coons, Mulattoes, Mammies, and Bucks: An Interpretative History of Blacks in American Films*. New York: Bantam, 1973.

———, ed. *Blacks Arts Annual 87/88*. New York: Garland Publishing, 1989.

———, ed. *Black Arts Annual 88/89*. New York: Garland Publishing, 1990.

———, ed. *Black Arts Annual 89/90*. New York: Garland Publishing, 1991.

Bonner, Frances, et al., eds. *Imagining Women: Cultural Representations and Gender (Open University U207 Issues in Women's Studies)*. Blackwell Pub. Milton Keynes: Polity Press in association with the Open University, 1992.

Bourdieu, Pierre. *Photography: A Middle Brow Art*. Stanford, California: Stanford University Press, 1990.

Braive, Michel F. *The Photograph: A Social History*. New York: McGraw-Hill, 1966.

Brayer, Elizabeth. *George Eastman: A Biography*. Baltimore: Johns Hopkins University Press, 1996.

Brown, Sterling A. "A Century of Negro Portraiture in American Literature." *Massachusetts Review* 7, no. 1 (1966): 73–96.

Burger, Barbara Lewis, ed. *Guide to the Holdings of the Still Picture Branch of the National Archives*. Washington, D.C.: National Archives and Records Administrative, 1990.

Bush, Martin H. *The Photographs of Gordon Parks*. Wichita, Kansas: Ulrich Museum of Art, Wichita State University, 1983.

Byrd, Moira, ed., *Transforming the Crown: Afrian, Asian and Caribbean Artists in Britain, 1966–1996*. New York: The Franklin H. Williams Carribean Cultural Center, 1998.

Campbell, Mary Schmidt. *Harlem Renaissance: Art of Black America*. New York: Harry N. Abrams, 1987.

———. *Tradition and Conflict: Images of a Turbulent Decade, 1963–1973*. New York: Studio Museum in Harlem, 1985.

Chadwick, Whitney. *Mirror Images: Women Surrealism and Self-Representation*. Cambridge: MIT Press, 1998.

Charles, Roland, and Toyomi Igus. *Life in a Day of Black L.A.: The Way We See It*. Los Angeles: UCLA/Center for African American Studies and Black Photographers of California, 1992.

Chong, Albert. *Ancestral Dialogues: The Photographs of Albert Chong*. San Francisco; The Friends of Photography, 1994.

Coar, Valencia Hollins. *A Century of Black Photographers: 1840–1960*. Providence: Museum of Art, Rhode Island School of Design, 1983.

Coke, Van Deren and Diana C. Dupont. *Photography: A Facet of Modernism*. New York: Hudson Hills Press, 1986.

Cole, Carolyn Kozo, and Kathy Kobayshi. *Shades of LA: Pictures from Ethnic Family Albums*. New York: The New Press, 1996.

Coleman, A. D. *Critical Focus*. Munich: Nazaraeli Press, 1995.

Coleman Floyd, and John Adkins Richardson. "Black Continuities in the Art of the Renaissance." *Papers on Language and Literature* 12 (September 1976): 402–421.

Collins, Charles M., and David Cohen. *The African Americans*. New York: Viking Studio Books, 1993.

Collins, Lisa. "Historic Retrievals: Confronting Visual Evidence and the Documentation of Truth." *Chicago Art Journal* (Spring 1998): 5–17.

Cosentino, Andrew J., and Henry H. Glassie. *The Capital Image: Painters in Washington, 1800–1915*. Washington, D.C.: Smithsonian Institution Press, 1983.

Cottman, Michael H., and Deborah Willis. *The Family of Black America*. New York: Crown, 1996.

———. *Million Man March*. New York: Crown, 1995. Paperbacks, 1996.

Crawford, Joe, ed. *The Black Photographers Annual*. Brooklyn, New York: The Black Photographers Annual, Inc., 1973.

———, ed. *The Black Photographers Annual*, vol. 2. Brooklyn, New York: The Black Photographers Annual, Inc., 1974.

———, ed. *The Black Photographers Annual*, vol. 3. Brooklyn, New York: The Black Photographers Annual, Inc., 1976.

———, ed. *The Black Photographers Annual*, vol. 4. Brooklyn, New York: Another View, Inc., 1980.

Curtis, James. *Mind's Eye, Mind's Truth: FSA Photography Reconsidered*. Philadelphia: Temple University Press, 1989.

Daniel, Pete, and Merry A. Foresta. *Official Images: New Deal Photography*. Washington, D.C.: Smithsonian Institution Press, 1987.

Daniels, Douglas, H. *Pioneer Urbanites: A Social and Cultural History of Black San Francisco*. Philadelphia: Temple University Press, 1980.

Darrah, William L. *Cartes-de-Visite in Nineteenth Century Photography*. Gettysburg, Pennsylvania: W. C. Darrah, Publishers, 1981.

Davis, Angela Y. *Blues Legacies and Black Feminism*. New York: Pantheon Books, 1998.

Davis, Keith. *An American Century of Photography: From Dry-Plate to Digital*. Kansas City, Missouri: Hallmark Cards, 1995.

———. *The Passionate Observer: Photographs by Carl Van Vechten*. Kansas City, Missouri: Hallmark Cards, 1993.

Davis, Thulani. *Malcolm X: The Great Photographs*. New York: Stewart, Tabori and Chang, 1993.

DeCarava, Roy. *Roy DeCarava: A Retrospective*. New York: The Museum of Modern Art, 1996.

———., and Langston Hughes. *The Sweet Flypaper of Life*. Washington, D.C.: Howard University Press, 1988.

Delaney, Martin R. *The Condition, Elevation and Destiny of the Colored People of the United States*. Philadelphia: privately printed, 1852.

Diawara, Manthia. "Black Spectatorship: Problems of Identification and Resistance." *Screen* 29 (Autumn 1988): 66–76.

Dotterer, Ronald, and Susan Bowers, eds. *Sexuality, the Female Gaze, and the Arts*. Cranbury, New Jersey: Associated University Presses, 1992.

Douglas, Ann. *Terrible Honesty: Mongrel Manhattan in the 1920's*. New York: Noonday Press, 1997.

Driskell, David C., ed. *African American Visual Aesthetics: A Postmodernist View*. Washington, D.C.: Smithsonian Institution Press, 1995.

———. *Two Centuries of Black American Art*. Los Angeles: Los Angeles County Museum of Art, 1976.

Dugan, Ellen, ed. *Picturing the South: 1860 to the Present*. San Francisco: Chronicle Books and the High Museum of Art, 1996.

During, Simon, ed. *The Cultural Studies Reader*. London and New York: Routledge, 1993.

Evans, Harold. *The American Century*. New York; Alfred A. Knopf, 1998.

Ewing, Preston. *Let My People Go*. Carbondale: Southern Illinois University Press, 1996.

Fernandez, Benedict. *Countdown to Eternity*. Pittsburgh: Manchester Craftsman's Guild, 1993.

Fleischchauer, Carl, and Beverly W. Brannan. eds. *Documenting America, 1935–1943*. Berkeley: University of California Press, 1988.

Foresta, Merry A. *American Photographs: The First Century*. Washington, D.C.: Smithsonian Institution Press, 1997.

Francis, Armet. *The Black Triangle: The People of the African Diaspora*. London: Seed Publications, 1985.

Franklin, Jack T. *Protest and Participation: Freedom Ain't Free*. Philadelphia: Afro-American Historical and Cultural Museum, 1992.

Frederickson, George M. *The Black Image in the White Mind. The Debate on Afro-American Character and Destiny, 1817–1914*. New York: Harper & Row, 1972.

Freeman, Roland L. *Southern Roads/City Pavements*. New York: M & R, 1981.

Freund, Gisele. *Photography & Society*. Boston: David R. Godine, 1980.

Gaither, E. Barry, "Imagining Identity and African American Art, or It's Me You See!" In *Convergence: 8 Photographers*. Boston: Photographic Resource Center, 1990.

Galassi, Peter. *Pleasures and Terrors of Domestic Comfort*. New York: Harry N. Abrams, 1991.

Gaskins, Bill. *Good Hair, Bad Hair*. New Brunswick, New Jersey—Rutgers University Press, 1997.

Gates, Henry Louis, Jr., ed., *"Race," Writing, and Difference*. Chicago: University of Chicago Press, 1985.

Gay, Geneva, and Willie L. Baber, eds. *Expressively Black: The Cultural Basis of Ethnic Identity*. New York: Praeger, 1987.

Golden, Thelma, Herman Gray, and John G. Hanhardt. *Black Male: Representations of Masculinity in Contemporary Art*. New York: Whitney Museum of American Art, 1994.

Goldstein, Laurence. *The Male Body: Features, Destinies, Exposures*. Ann Arbor: University of Michigan Press, 1994.

Gomez, Jewelle. "Showing our Faces: A Century of Black Women Photographers." *Ten 8*, no. 24, (1987): p. 13.

Goude, Jean-Paul. *Jungle Fever*. New York: Xavier Moreau, 1981.

Govenar, Alan, *Portraits of Community: African American Photography in Texas*. Austin: Texas State Historical Association, 1986.

Grabowski, John J. *Somebody, Somewhere, Wants Your Photograph: A Selection from the Work of Allen E. Cole (1893–1970) Photographer of Cleveland's Black Community*. Cleveland: Western Reserve Historical Society, 1980.

Hambourg, Maria Morris. *The Waking Dream: Photography's First Century*. New York: Metropolitan Museum of Art, 1993.

Harley, Sharon, and Rosalyn Terborg-Penn. *The Afro-American Woman: Struggles and Images*. 1978.

Hattersley, Ralph. *Discover Yourself through Photography*. Dobbs Ferry, New York: Morgan and Morgan, 1971.

Haynes, David. *Catching Shadows: A Directory of 19th Century Texas Photographers*. Austin: Texas State Historical Society, 1993.

Hickman, R.C. *Behold the People*. Austin: Texas State Historical Association, 1994.

Higgins, Chester, Jr. *Black Woman*. New York: Doubleday, 1970.

———. *Feeling the Spirit: Searching the World for the People of Africa*. New York: Bantam, 1994.

Hilyer, Andrew F. *The Twentieth Century Union League Directory: A Historical, Biographical and Statistical Study of Colored Washington at the Dawn of the Twentieth Century and After a Generation of Freedom*. Washington, D.C.: self-published, 1901.

Hine, Darlene Clark, and Kathleen Thompson. *A Shining Thread of Hope: The History of Black Women in America*. New York: Broadway Books, 1988.

Hirsch, Marianne. *Family Frames: Photography, Narrative and Postmemory*. Cambridge: Harvard University Press, 1997.

Hirsch, Robert. *Exploring Color Photography*. Madison, Wisconsin: Brown and Benchmark, 1997.

Holloway, Karla F. C. *Codes of Conduct: Race, Ethics, and the Color of Our Character*. New Brunswick, New Jersey: Rutgers University Press, 1995.

Honour, Hugh. *The Image of the Black in Western Art IV: From the American Revolution to World War I*. Houston: Menil Foundation, 1989.

hooks, bell. *Black Looks: Race and Representation*. Toronto: Between the Lines, 1992.

Hoone, Jeffrey. ed., *Contact Sheet 97*. Syracuse, New York: LightWork, 1998.

Hutchinson, Louise Daniel. *Anna J. Cooper: A Voice from the South*. Washington, D. C.: Smithsonian Institution Press, 1981.

International Center of Photography, *The I.C.P. Encyclopedia of Photography*. New York: Pound Press Books, 1984.

Jenks, Chris, ed. *Visual Culture*. London: Routledge, 1995.

Jewell, K. Sue. *From Mammy to Miss American and Beyond: Cultural Images and the Shaping of U. S. Social Policy*. New York: Routledge, 1993.

Johnson, Thomas L., and Phillip C. Dunn, eds. *A True Likeness: The Black South of Richard Samuel Roberts 1920–1936*. Columbia, South Carolina: Bruccoli Clark, 1986; Chapel Hill, North Carolina: Algonquin, 1986.

Johnston, Francis Benjamin. *The Hampton Album*. New York: Museum of Modern Art, 1966.

Jones, Kellie. *Dawoud Bey, 1975–1995*. New York: Distributed Art Publishers, 1995.

Jordan, Glenn, and Chris Weedon. *Cultural Politics: Class, Gender, Race and the Postmodern World*. Oxford, England: Blackwell Publishers, 1995.

King, Graham. *Say "Cheese"!* New York: Dodd, Mead & Co., 1984.

Kirsh, Andrea, and Susan Fisher Sterling. *Carrie Mae Weems*. Washington, D.C.: National Museum of Women in the Arts, 1993.

Kozloff, Max. *The Privileged Eye*. Albuquerque: University of New Mexico Press, 1987.

LeFalle-Collins, Lizzetta, and Shifra M. Goldman. *In the Spirit of Resistance: African-American Modernists and the Mexican Muralist School*. New York: American Federation of Arts, 1996.

Locke, Alain LeRoy, ed. *The New Negro*, New York: Touchstone, 1997 edition.

McElroy, Guy C. *Facing History: The Black Image in American Art 1710–1940*. San Francisco: Bedford Arts, Publishers, in association with the Corcoran Gallery of Art, 1990.

Magubane, Peter. *Black Child*. New York: Alfred A. Knopf, 1982.

———. *Magubane's South Africa*. New York: Alfred A. Knopf, 1978.

Marsalis, Wynton, and Frank Stewart. *Sweet Swing Blues on the Road*. New York: W. W. Norton & Company, 1994.

Mason, Herman, Jr. *Going Against the Wind: A Pictorial History of African Americans in Atlanta*. Atlanta: Longstreet, 1992.

———. *Hidden Treasures: African American Photographers in Atlanta, 1870–1970*. Atlanta: African-American Family History Association, Inc., 1991.

———. *Images of America: African-American Life in Jacksonville*. Dover, New Hampshire: Arcadia Publishing, 1997.

———. *Images of America: Black Atlanta in the Roaring Twenties*. Dover, New Hampshire: Arcadia Publishing, 1997.

Mayer, Robert. *Blacks in America: A Photographic Record*. Rochester: International Museum of Photography at George Eastman House, 1986.

Mercer, Kobena. *Welcome to the Jungle: New Positions in Black Cultural Studies*. New York: Routledge, 1994.

Miller, Frederic M., Morris J. Vogel, and Allen F. Davis. *A Photographic History, 1920–1960*. Philadelphia: Temple University Press, 1988.

Miller, James A., ed. *Harlem: The Vision of Morgan & Marvin Smith*. Lexington: University of Kentucky Press, 1998.

Miller, Marc H. *Louis Armstrong: A Cultural Legacy*. Seattle: University of Washington Press and Queens Museum of Art, New York, 1994.

Miller, R. Baxter. *The Art and Imagination of Langston Hughes*. Lexington: University of Kentucky Press, 1989.

Morton, Patricia. *Disfigured Images: The Historical Assault on Afro-American Women*. New York: Praeger, 1991.

Moutoussamy-Ashe, Jeanne. *Daufauskie Island*. Columbia: University of South Carolina Press, 1982.

———. *Viewfinders: Black Women Photographers*. New York: Dodd, Mead & Company, 1986.

Myers, Walter Dean. *One More River to Cross: An African American Photography Album*. New York: Harcourt Brace, 1995.

Natanson, Nicholas. *The Black Image in the New Deal: The Politics of FSA Photograph*. Knoxville: The University of Tennessee Press, 1992.

Neumair, Diane. *Reframings: New American Feminist Photographies*. Philadelphia: Temple University Press, 1995.

Newhall, Beaumont. *The History of Photography*. New York: Museum of Modern Art, 1964.

Nochlin, Linda, and Thomas B. Hess, eds. *Woman as Sex Object: Studies in Erotic Art, 1730–1970*. New York: Newsweek, 1972.

Null, Gary. *Black Hollywood: The Negro in Motion Pictures*. Secaucus, New Jersey: Citadel Press, 1975.

Okwu, Julian C. R. *Face Forward: Young African American Men in a Critical Age*. San Francisco: Chronicle Books, 1997.

Pacteau, Francette. *The Symptom of Beauty*. Cambridge: Harvard University Press, 1994.

Parks, Gordon. *Camera Portraits: The Techniques and Principles of Documentary Portraits*. New York: Franklin Watts, 1948.

———. *A Choice of Weapons*. New York: Harper & Row, 1972.

———. *Voices in the Mirror: An Autobiography*. New York: Doubleday, 1990.

Patton, Sharon F. *African-American Art*. Oxford, England: Oxford University Press, 1998.

Philadelphia African Americans: Color, Class and Style. Philadelphia: Balch Institute for Ethnic Studies, 1985.

Belena Chapp, ed., *P. H. Polk: Through These Eyes, The Photographs of P. H. Polk*. Newark: University Gallery, University of Delaware, 1998.

Pieterse, Jan Nederveen. *White on Black: Images of Africa and Blacks in Western Popular Culture*. New Haven: Yale University Press, 1992.

Powell, Richard. *Black Art and Culture in the 20th Century*. London: Thames and Hudson, 1997.

———. *Rhapsodies in Black: Art of the Harlem Renaissance*. Berkeley: University of California Press, 1997.

Pultz, John. *The Body and the Lens: Photography 1839 to the Present*. New York: Harry N. Abrams, 1995.

Read, Alan, ed. *The Fact of Blackness: Frantz Fanon and Visual Representation*. Seattle: Bay Press, 1996.

Reed, Eli. *Black in America*. New York: W. W. Norton & Company, 1997.

Reynolds, Gary A., and Beryl J. Wright. *Against the Odds: African-American Artists and the Harmon Foundation*. Newark: Newark Museum of Art, 1989.

Rinhart, Floyd, and Marion Rinhart. *The American Daguerreotype*. Athens: The University of Georgia Press, 1981.

Ritchin, Fred. *In Our Own Image: The Coming Revolution in Photography*. New York: Aperture, 1990.

Roberts, Diane. *The Myth of Aunt Jemima: Representations of Race and Region*. London: Routledge, 1994.

Rony, Fatima Tobing. *The Third Eye: Race, Cinema, and Ethnographic Spectacle*. Durham: Duke University Press, 1996.

Rosenblum, Naomi. *A World History of Photography*. New York: Abbeville Press, 1989.

Saunders, Doris E., ed. *Special Moments In African-American History: 1955–1996: The Photographs of Moneta Sleet, Jr.* Chicago: Johnson Publishing Company, 1998.

Schoener, Allon. *Harlem on My Mind: Cultural Capital of American, 1900–1968*. New York: Random House, 1968.

Severa, Joan. *Dressed for the Photographer: Ordinary Americans and Fashion, 1840–1900*. Kent, Ohio: Kent State University Press, 1995.

Sichel, Kim. *Black Boston*. Boston: Boston University Art Gallery, 1994.

Siskind, Aaron. *Harlem Document: Photographs 1932–1940*. Providence, Rhode Island: Matrix, 1981.

Smith, Felipe. *American Body Politics: Race, Gender, and Black Literary Renaissance*. Athens: University of Georgia Press, 1998.

Smith, Jessie Carney, ed. *Images of Blacks in American Culture: A Reference Guide to Information Sources*. Westport, Connecticut: Greenwood Press, 1988.

Smith, Joshua P. *The Photography of Invention: American Pictures of the 1980's*. Washington, D.C.: Smithsonian Institution Press, 1989.

Smith, Margaret Denton and Mary Louise Tucker. *Photography in New Orleans: The Early Years 1840–1865*. Baton Rouge: Louisiana State University Press, 1982.

Smith, Ming. *A Ming Breakfast: Grits & Scrambled Moments*. New York: De Ming Dynasty, 1991.

Snyder, Robert E. *The American South*. London: Taylor and Francis, 1995.

Solomon-Godeau, Abigail. *Photography at the Dock: Essays on Photographic History, Institutions, and Practices*. Minneapolis: University of Minnesota Press, 1991.

Sontag, Susan. *On Photography*. New York: Farrar, Straus & Giroux, 1973.

Spence, Jo. *Putting Myself in the Picture*. London: Camden Press, 1986.

Steichen, Edward. *A Life in Photography*. New York: Bonanza Books, 1985.

Stewart, Charles, and Paul Carter Harrison. *Jazz Files*. Boston: New York Graphic Society, 1985.

Suleiman, Susan Rubin, ed. *The Female Body in Western Culture: Contemporary Perspectives*. Cambridge: Harvard University Press, 1986.

Sullivan, George. *Black Artists in Photography 1840–1940*. Dutton, New York: Cobblehill Books, 1996.

Summers, Barbara. *Skin Deep: Inside the World of Black Fashion Models*. New York: Amistad Press, 1998.

Stack, Carol B. "The Culture of Gender: Women and Men of Color," *Signs* 11, no. 2 (1986): 321–324.

Stange, Maren. *Symbols of Ideal Life: Social Documentary Photography in America 1890–1950*. Cambridge, England: Cambridge University Press, 1989.

Stott, William. *Documentary Expression and Thirties America*. New York: Oxford University Press, 1973.

Sunshine, Linda. *Our Grandmothers: Loving Portraits by 74 Granddaughters*. New York: Welcome Enterprises, 1998.

Tagg, John. "The Currency of the Photograph." In *Thinking Photography*, edited by Victor Burgin. London: Macmillan, 1982.

Taylor, Lucien, ed. *Visualizing Theory*. London: Routledge, 1994.

Tucker, Marcia and Marcia Tanner. *Bad Girls*, The New Museum of Contemporary Art, in association with Cambridge: MIT Press, 1994.

VanDerZee, James, Camille Billops, and Owen Dodson. *The Harlem Book of the Dead*. Morgan and Morgan Dobbs Ferry, New York: 1978.

Walker, John A., and Sarah Chaplin. *Visual Culture: An Introduction.* Manchester, England: Manchester University Press, 1997.

Welling, William. *Photography in America: The Formative Years 1839–1900.* New York: Thomas Y. Crowell, 1978.

Williams, Cecil J. *Freedom and Justice: Orangeburg, South Carolina:* Mercer University Press, 1995.

Williams, George W. *History of the Negro Race in American from 1619 to 1880: Negroes as Slaves, as Soldiers and as Citizens.* New York: G. P. Putnam's Sons, 1883.

Williams, Milton. *Moments in Time: 1973–1993.* Nashville: James C. Winston Publishing Co., 1996.

Willis, Deborah. *Picturing Us: African American Identity in Photography,* New York: The New Press, 1994.

———. *Untitled 54: Lorna Simpson.* San Francisco: The Friends of Photography, 1992.

———, and Rodger Birt. *VanDerZee: Photographer 1886–1983.* New York, Harry Abrams, 1993.

———, and Jane Lusaka. *Visual Journal: Harlem and DC in the Thirties and Forties.* Washington, D.C.: Smithsonian Institution Press, 1996.

Willis, Susan. *Specifying: Black Women Writing the American Experience.* Madison: The University of Wisconsin Press, 1987.

Willis-Thomas, Deborah. *Black Photographers 1840–1940: A Bio-Bibliography.* New York: Garland Publishing, 1985.

———. *An Illustrated Bio-Bibliography of Black Photographers: 1940–1988.* New York: Garland Publishing, 1989.

Witkin, Lee P., and Barbara London. *The Photograph Collector's Guide.* Boston: New York Graphic Society, 1979.

Wright, Richard, and Edwin Rosskam. *Twelve Million Black Voices: A Folk History of the Negro in the United States.* New York: Viking, 1941.

Index

Page numbers in *italics* refer to illustrations.